A History of the
Modern Movement:
Art Architecture Design

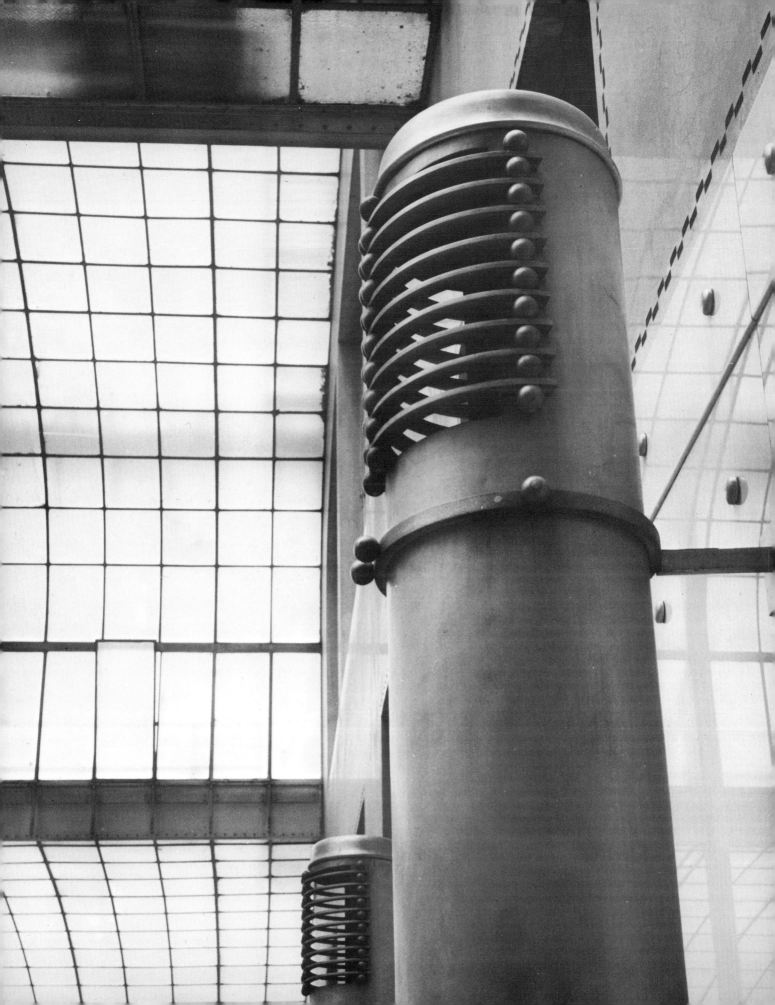

KURT ROWLAND

A HISTORY OF THE MODERN MOVEMENT: ART ARCHITECTURE DESIGN

GINN AND COMPANY LTD

Contents

© Kurt Rowland 1973
Third impression 1980 01.58004
Library of Congress Catalog Card Number 73-7117
In the USA: ISBN 0 442 27172 7
In Great Britain: ISBN 0 903923 00 9 (Cased edition)
 ISBN 0 903923 04 1 (Limp edition)
Published in 1973 in the United States of
America by Van Nostrand Reinhold Company
a Division of Litton Educational Publishing Inc.
450 West 33rd Street, New York, NY 10001
16 15 14 13 12 11 10 9 8 7 6 5 4 3 2 1
Van Nostrand Reinhold Company Regional
Offices: New York Cincinnati Chicago
Milbrae Dallas
Van Nostrand Reinhold Company International
Offices: London Toronto Melbourne

Published in Great Britain by
Ginn and Company Ltd
Elsinore House, Buckingham Street
Aylesbury, Bucks HP20 2NQ

Printed in Great Britain at the
University Press, Cambridge

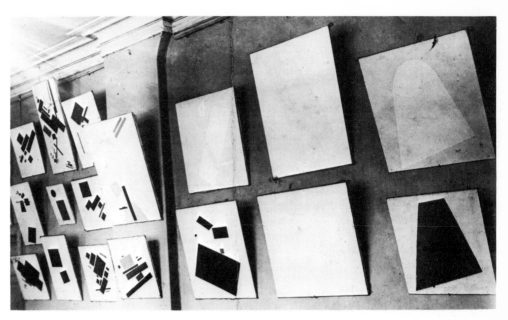

The first quarter of the twentieth century witnessed an artistic revolution without equal in the history of art. In an unbelievably short time many new ideas and styles were originated and followed to their conclusion so that the succeeding generation found it difficult to make any significant additions to them.

The years leading up to the First World War may be described as the most explosive: even a perfunctory look at the works of this period confirms that the principles of modern art, architecture and design – and therefore the manner in which today we experience and approach our environment – were laid down before 1914.

These principles were not forged in isolation, nor did the period which followed see a mere elaboration of them. At all times there was an intense interaction and cross-fertilisation at work which vitalised their development.

In the present book an attempt has been made to describe the continuous story of the parallel and overlapping movements which, even though they often competed with each other and offered alternative solutions, yet affected each other profoundly; and, as the story unfolds, to fill in the most relevant details of those conditions which made the evolution of modern art, architecture and design a necessity; in short, why they evolved in the forms they did.

Wagner's Post Office Savings Bank (frontispiece), Gropius' Fagus factory (above left) and Malevich's early Suprematist paintings (above right) were all produced in the early years of the twentieth century, yet they are modern in the sense in which we use the word today.

It is the duty of the artist of today to penetrate the still unrecognised defects of our biological functioning, to investigate the new fields of the industrial society and to translate the new discoveries into the stream of our emotions.

Laszlo Moholy-Nagy

. . . if the insufficiently developed eye cannot sense pictorial depth . . . it will not be able to emancipate itself from the material plane and perceive indefinable space. The experienced eye must have the ability partly to see the picture plane as such and partly to look beyond it, to sense its spatial qualities. . . .

Wassily Kandinsky

Introduction: Style and Feeling

We are at our best when our actions and our feelings reinforce each other; when our deeds and our emotions are in harmony; when our thoughts are a crystallisation of our deepest feelings. In such conditions the whole organism works towards the same end, internal frictions are reduced and weaknesses or difficulties in one department are compensated by strengths in another. It is then that achievement is at its highest. We may never arrive at this ideal state of balance yet we strive for it all our lives. We call on our reason to support or to allay our irrational drives. Conversely, we instinctively allow our emotions to guide us when we find it impossible to make a rational choice between several possibilities. In this way we continually try to harmonise our rational and irrational functioning in an attempt to make life more coherent and rewarding. It is also for this reason that we need to surround ourselves with objects which have not only functional significance in a material sense but also emotional and spiritual meaning. Our environment must help us in our life-long struggle to co-ordinate the rational and irrational parts of our personalities.

At no time in history has any society been content with an environment which functions only on the material plane. When the environment speaks to only a part of our personalities we feel unbalanced, out of joint, because our thoughts and feelings are not simultaneously engaged. We may even sense that in such conditions there is a danger of thoughts and feelings being permanently separated and the coherence of the human organism endangered. Our mental health, not merely our physical well-being, is ultimately bound up with the quality of our environment.

The great styles of the past allowed for the simultaneous exercise of both thought and feeling. The mathematical convolutions and spatial interpenetrations of the Baroque corresponded as much to the rising scientific spirit of the age as to its desire for a religion set in mystery. The delicate, almost disembodied structures of the Gothic era combined technological daring with spiritual fervour. The achievement of a style is to make the environment relevant to different aspects of life, acceptable at different levels of consciousness and applicable to the different personalities which comprise a society. Such art discharges its multifarious functions simultaneously and within the same overall form. But during the nineteenth century

this universality of the great styles no longer seemed to work as it had done in the past. Under the impact of the Industrial Revolution the cultural mesh was loosened; the attitude to the environment changed.

The nineteenth century was a period of unparalleled industrial expansion but also of utter confusion. This confusion can be read in the ideals and motives of the times but nowhere was it given more tangible form, nowhere did it affect human life more directly, than in the new physical environment – whether in the intimacy of domestic surroundings or in the wider structure of the city.

Even if those concerned with building the new environment had had a clear vision of creating cities worthy of human beings, it would probably have been impossible to keep abreast of the unprecedented and breathtaking changes, both social and technological, which were taking place. But the builders had no vision, no plan, until it was already too late.

Much has been said of the inhuman social conditions of Victorian England: the slums, the dwellings devoid of light and air, the child labour, but less attention has been given to the deteriorating quality of the environment, suffered even by the rich. 'Every man was for himself', writes Lewis Mumford, 'and the Devil, if he did not take the hindmost, at least reserved for himself the privilege of building cities.' These 'man-heaps', thrown up from motives of geometric and industrial expediency, were incapable of filling the dignified role of cities of the past: to contain and enhance the varied aspects of human life. The lack of overall planning, exacerbated by the debased form of every constituent element, from town halls to teaspoons, ensured that many nineteenth century industrial and residential developments would end up as slums.

The change in the environment – the creation of a new habitat for human beings which resulted in diminished sensibilities – was accompanied by a new social polarisation. Before the Industrial Revolution both landowning aristocracy and those who worked on the land had had their own ways of moulding their environment. The upper classes, while importing foreign ideas, styles and materials, used their sense of propriety to give these foreign imports a peculiarly English character. The lower classes on the other hand, lacking resources and needing to make the best use of what

they had, learned to handle available materials to the best advantage. Sometimes there was a merging of these two streams. The Industrial Revolution changed all this. For the landowning aristocracy substitute the industrialists, for the farmworkers and craftsmen the industrial proletariat, and there emerges a rough social picture of the nineteenth century. Both new social classes lacked a tradition. The industrialist, often a self-made man, had not been exposed to the classical education of his eighteenth century counterpart nor inherited his feeling for aristocratic elegance. The proletarian, now one or two generations removed from his former rural surroundings, had forgotten the vernacular tradition, which in any case would no longer have matched the new conditions of his life.

It was for this polarised but equally traditionless industrial population that the new mass-produced goods were made and marketed. Without informed and discriminating purchasers the manufacturer could get away with anything that was to his economic advantage. In the past there had been balanced relationships between elements of the environment, or within the constituent parts of each element. Such relationships, which had been dictated by tradition, educated values and the resulting sensitivity, were now no longer recognised.

These impaired social conditions had a further consequence: the hypocritical attitude of the new rich, who, from feelings of guilt, cloaked the objects of their money-making efforts with pious principles and high-minded morality. But nineteenth-century piety had also other sources, for now the continued progress of science had given rise to spiritual uncertainty, it disorientated all those who had previously relied on the orderly beliefs of tradition. When values which support and give meaning to life are eroded, either one can try to adjust to new, untried and uncomfortably unfamiliar conditions or one can entrench oneself more deeply than ever in the old and familiar, as a defence in the face of demoralising uncertainty. The latter, easier, course often leads, as it did in nineteenth century England, to religious frenzy and zealotry.

The visual counterpart of this new piety was a renewed interest in the Gothic – the pious – style. The most clearly argued call for a return to the Middle Ages and to the Gothic came from Augustus Welby Northmore Pugin who declared it to be the

only Christian style. Although a romantic yearning for the past had been partly responsible for the reintroduction of the Gothic style, one reason for its application to many private, civic and industrial buildings was that the ethical motives of those who commissioned them could be *seen* to be beyond reproach.

Neo-Gothic was not, however, the only stylistic expression of the Victorian era. Neo-Classicism, derived from an architecture which also claimed a tradition in England, grew up alongside. Its implication was clearly of a more reasoned and detached attitude, in opposition to the passionate and bigoted ideas underlying neo-Gothic. And there were other historical styles to be followed, with their Egyptian columns and Dutch gables, and often a mixture of different idioms.

Stylistic pre-occupation of this nature can lead to a fossilisation of thought and feeling. If the manufacture of an object, the building of a house, must be preceded by a vision of its style, like a readymade mould into which it is to be poured, this process also works in reverse and any element of the environment is approached with the key of style, to unlock its meaning. Under these conditions style is the dress, rather than the soul, of the environment. We concentrate on manners, rather than on character. But what is the alternative?

Let us imagine we enter a building which we have never seen before. We are not aware of its function; we have no knowledge of style in architecture. If we approach a building in this innocent way — if such innocence were conceivable — that is to say, with an unprejudiced but receptive mind, we should sense some of its visual qualities. For instance, the massiveness of the pillars, or the delicacy of the decoration may arouse in us certain sensations which will naturally be accompanied by our reactions to other qualities of the building, such as its scale, or the relationship between the solid forms and the open spaces between them, or the proportions of the overall space. These different visual qualities may reinforce or modify each other so that an inclusive pattern is built up in our minds. We may quite unconsciously associate this complex of sensations with other sensations which we might have felt in the past in an entirely different situation, and with the emotions we experienced. We now become aware of any elements which do not fall in with the visual or emotional patterns in our minds. We may sense the rightness or wrongness of certain elements or of the manner in which they are put together. We may even feel that certain elements — columns, cornices, or windows — do not fit into the overall pattern, are unsuited to the character of the building, even though we like them

in their own right.

On the other hand if someone less sensitive to pure visual stimuli, or less innocent, enters the same building, he may draw on his knowledge rather than his vision. He will classify it according to its type, mentally referring it to other buildings in the same or similar style — Gothic churches, Classical town halls, etc. — and construct an emotional attitude from his recognition.

In the first instance the intrinsic visual quality of the elements of the building, their proportions, shapes, relationships and the manner in which they are assembled, will be of primary importance for it is from these that the effect of the building derives. In the second case the quality of the elements and their assemblage are less important. What matters is the presence of the elements themselves. It is this, not their intrinsic qualities, which is identified by the observer. In fact such an observer receives visual stimuli in very much the same way as one who reads printed letters. For instance either of these letters is recognisable as a

letter A, therefore their actual form is immaterial to him and he may feel satisfied with either. So long as the architect of a building keeps to a recognisable set of elements he will meet with little criticism from our second observer even if the forms of the elements are distorted.

Under these conditions the approach to the environment becomes a game of recognition; and even on the deepest level little more than stock responses will be elicited, responses which neither stimulate nor expand the emotions.

These two different attitudes to the environment — perceptual and conceptual — cannot be completely separated. There will always be an area where they overlap. Even so, it can be said that the conceptual attitude which grows out of stylistic concern was the most commonly accepted approach to the environment during much of the nineteenth century. It indicates a state of affairs in which both individual and society have grown numb to purely visual stimuli as such and must elaborate them in verbal form to give them value.

In its proper sense, as a coordinator of thought and feeling, style presupposes not only a visually sensitive architect but also a visually sensitive observer. By the end of the Victorian era both had become rarities. People were dependent on style as a crude

means of communication in which feelings were induced by conscious and even verbal means rather than aroused by visual experience.

The preponderance of conceptual values in most fields of visual design in the nineteenth century was largely due to the emergence of new patrons: industrialists, city councillors, merchants, stockbrokers. This kind of patron, who commissioned the new architecture, new design, and new environment of the period, lacked the sensibility of his eighteenth-century predecessor. He knew nothing of composition and design, his life revolved round practical and financial matters. He believed that the more ornate a building or an object, the greater was its worth, the richer its appearance, the more profound, even staggering, its effect on observers. Under such influences both Gothicism and Classicism were reduced to vulgar expressions of materialism.

But if this new type of patron understood little about the formal qualities of design, he knew even less of the deeper implications

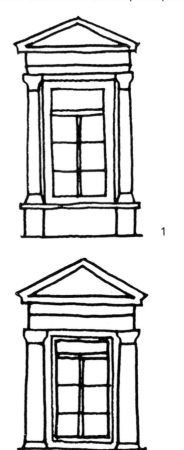

1, 2 *A conceptual observer notices things, not visual qualities. The component parts of 1 are identical to those of 2, when viewed as things; therefore the difference between them is minimal, if noticed at all*

of visual experience and visual language. He knew nothing of the causes underlying the original Gothic or Classical buildings which acted as models for his environment; he may have contacted Rococo and Romanesque in vulgarised versions, in his lamps or chairs; but he was completely ignorant of the emotions experienced by the originators of these styles and of the conditions which produced them.

It is true that for the nineteenth century patron the styles were not copied but were re-interpreted in a new way. But this was done through a conscious rather than an instinctive process. A church built in the Gothic style was pious because people *knew* it was pious, not because they sensed at the deepest level of their being the elation, the gentleness, the soaring spirituality of the building. Such awareness is brought about by perception — subconsciously — and not by knowledge of what makes a style suitable. It is reinforced — as it was in the original Gothic churches — by a realisation of the magnitude of the technological triumph which enhances the splendour of the artistic achievement. In this way the inner and outer life are brought together; thought and feeling, rational and irrational faculties, complement each other.

In its original medieval context the Gothic visual language was the expression of Christianity, but it was also the outcome of other forces: technology, economics, social and civic conditions. Had these forces been different, it is conceivable that a different style would have evolved.

One can argue that in the nineteenth century, when Pugin was putting forward his case for a return to Gothic architecture, there existed conditions similar to those which saw the birth of the original style. There was again a religious revival; new churches were needed for the expanding industrial towns. Many towns received their charters during this period and wanted to vie with older foundations in the magnificence of their buildings.

But the parallel ends when we consider the architecture and the whole environment as a visual expression of the fusion of thought and feeling. When the Gothic cathedrals were built they embodied the most advanced building methods then known. In the nineteenth century technological developments took place outside the Gothic or indeed any revived style. They were in the province of engineers, with whose work no self-respecting Victorian architect would have any truck, apart from the need to conceal it; in the viaducts and bridges and other constructions where a new building material — cast iron — made its debut, a material which had yet to develop its own language of expression. But Victorian architects did little to assimilate the new ideas into the environment they were building.

Even in the work of the best Victorian architects stylistic revivals could no longer cope with the growing complexities of modern life and of technological progress. Stylistic architecture was obliged to treat technology as though it did not exist. Where its existence could no longer be denied architecture had the task of softening the blow. Instead of bringing the inner and the outer world together, instead of making the new technological, industrial environment accessible to the emotions, architecture and every other stylistic manifestation separated them. In the new traditionless society the old styles no longer corresponded to human need or human knowledge; nor had they a place in a social structure which was significantly different from that which had given rise to these styles.

The adherence to Gothic, Classical and other styles during the nineteenth century was undoubtedly passionate and often deeply desired, but its long-term effect was disastrous for it resulted in the separation of what in great periods of architecture and design had always been inseparable: thought and feeling.

An unbalanced environment generates imbalance in the society it serves. If the forms of buildings and other elements of the environment are not expressed in a coherent visual language so that they may be absorbed and experienced at the deepest level, if they engage only the rational mind and not the emotions, an emotional vacuum must ensue. This vacuum can be easily filled — by inducing ourselves to feel what our minds tell us we ought to feel, as in the case of the conceptual observer mentioned earlier. The environment then arouses little more than sham feeling, while genuine feeling, which in a healthy organism has the task of guiding rational thought, is now unattached to anything around us; it hides in the most recondite regions of the human mind.

There can be no fusion between thought and feeling because they now operate on different levels. On the one hand emotions exist in isolation and in their own right generate new emotions which assume grotesque and unhealthy forms; on the other hand sham feeling is matched to the environment, to deeds and to thoughts, in an attempt to fill out the vacant space. The separation of thought from feeling produces sentimentality.

Sentimentality replaces real feeling, which grows from within, by an affectation imposed from without. It is a negation, or at best a dilution, of real feeling. And sentimentality was the backbone of Victorian life.

This short description of certain aspects of the nineteenth century, a period whose complexity and paradoxes baffle us still, cannot be comprehensive or even balanced. Nevertheless it will have served to focus attention on two of the essential features of the transition from nineteenth century to twentieth century art, architecture and design: the reaction against conceptualisation and false feeling. Not until these had been eliminated from visual experience could there emerge a new art and a new approach to the making of the human environment in which visual values — space, form, structure, mass, rhythm — served as vehicles of emotion. This continuing theme throughout the evolution of the twentieth century visual language is the subject of this book.

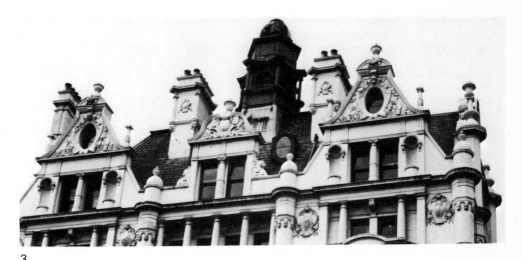

3

3 *Nineteenth century building, London. A composition — but of ideas rather than visual elements*

1 Arts and Crafts

WILLIAM MORRIS

In 1851, largely through the enthusiasm of the Prince Consort, an exhibition was organised in London to provide a forum for many nations to display the products of their arts and crafts and industry. The Great Exhibition was in many people's view a triumphant success, but a few were less laudatory.

The Crystal Palace, the building in which the exhibition was housed, was condemned by both Pugin and Ruskin. The most perceptive writer of his age on art and architecture, John Ruskin could say little more than that it was a cucumber frame. As the subsequent course of architecture was to prove, the Crystal Palace was a remarkable, forward-looking adventure in building, more in tune with our twentieth-century eyes and senses than with the objects it was designed to house. It was designed by a non-architect, Joseph Paxton, a gardener who had given a great deal of thought to the subject of more efficient structures for large greenhouses. No architect of the period could have thought up such an edifice for the simple reason that it was not considered architecture. There were no walls and no windows in the accepted sense, that is in the sense in which architects understood them. Was the enclosure made up of walls of glass or outsize windows? And where were the usual columns with their capitals and pedestals, where the cornices, mullions and transomes? Above all, what style was it supposed to be? It was all very confusing and certainly not architecture.

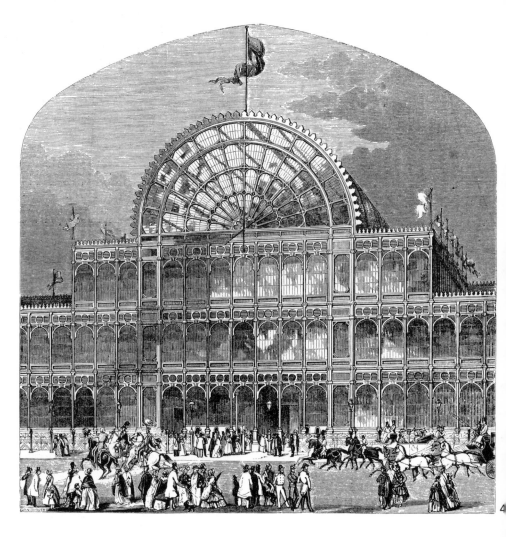

It is hard for us now to understand the difficulty of accepting such an entirely new concept. The Crystal Palace represented what architects of the period ought to have aimed at and what architects of earlier times had often achieved. It was a practical job, designed for the technology of the day, an easily-understood structure which Paxton saw no reason to mask, well-proportioned, and proclaiming its purpose — the housing of an exhibition of industrial design — by its form and materials. It antagonised the architectural profession because it was based on new concepts which could not be found in the textbooks of the time. By cutting across traditional ideas and making historical styles appear irrelevant, Paxton laid one of the foundation stones of modern architecture.

As for the exhibits inside the Crystal Palace, these allowed a group of artists and designers to take a comprehensive view of the products of the new machine age. William Morris was to become the most prominent and articulate of these artists. By his teaching and his example he summed up the feelings of all those who opposed the debasing effect of industrialisation on the human environment. Morris objected to the products of industry not on the grounds of bad taste but because he believed they coarsened human sensibilities and were therefore evil in their effect. He looked beyond the problem of art and design to the larger one of human fulfilment and the quality of society.

Morris explained the pretentiousness and deplorable taste of industrial artefacts, like those shown at the Exhibition, by the simple fact that they were produced by machine and not by hand. How different it had been in earlier ages when craftsmen, following their instincts in shaping useful objects from different materials, made work into a pleasurable activity. He came to the conclusion that art is 'the expression by man of his pleasure in labour' and only through work in this manner, Morris believed, could men regain their human dignity and achieve a commensurate quality of life.

He saw the products of machines, manned by workers in deplorable conditions, as quite outside the creative process, filling people's lives with trash and ugliness. 'As a condition of life, production by machinery is altogether an evil', he wrote. He saw the evil not only in the machine but in the whole system whose tool it was.

At the other end of the scale, it seemed to him thoroughly irrelevant for artists to paint pictures for a small aesthetic élite and he blamed as irresponsible their espousal of alien styles in painting, architecture and design, styles 'which only a very few

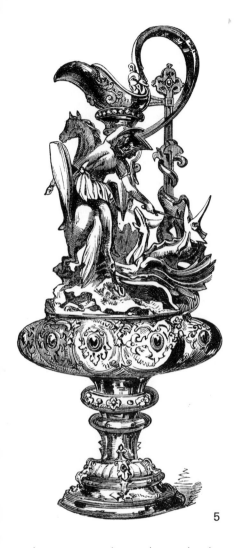

people even pretend to understand or be moved by'. 'What business have we with art,' he asked, 'unless all can share it?'

It is understandable that these convictions would lead Morris to Socialism. It is impossible to enumerate all the facets of his full life. He became an active member of the Socialist League, lectured at working men's clubs and wrote many pamphlets, and even songs, in support of his political and social ideals. He produced many designs for printed and woven fabrics, carpets, wallpapers, furniture, ceramic tiles and stained glass. He ran a private press which printed illustrated books, often with his own illustrations and decorations. He painted, he wrote poetry. When he died at the age of 62 his doctor said 'he died simply of being William Morris' i.e. of having done the work of ten men.

4 *Joseph Paxton, The Crystal Palace, 1851. The transept*

5 *Silver cup*

6 *Carpet design*

7 *Carved oak table. All these were exhibited in the Crystal Palace*

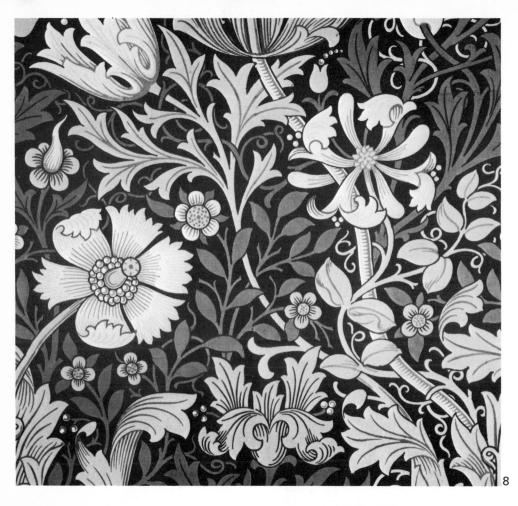

In 1861, at the age of 27, he set up a firm (Morris, Marshall, Faulkner & Co.) for the design of furniture, fabrics and wallpapers. The firm also undertook whole interior decorative schemes. It is largely through his work for this firm that Morris's name became famous. We only have to compare one of his designs with the usual commercial merchandise of the period to realise his great contribution. Most Victorian fabrics and wallpapers contained forms derived from earlier periods — just as Victorian architecture was derived from past styles — but these forms, assembled indiscriminately, were perverted through the insensitivity of designers no longer familiar with the visual language the forms implied. In Morris's work also we can detect influences from other eras and other lands — for instance, Italian Renaissance in his fabrics, Oriental in his carpets — but these were always absorbed and assimilated, so that all the parts of a design worked together in one pervading rhythm.

His work has an equilibrium entirely absent from that of so many of his contemporaries. Where other designs of the period appear insensitive to materials, methods and purpose, his stand out for their suitability; where others are overcrowded and overbearing with their meaningless scrolls and pseudo-organic forms, his are characterised by a relaxed relationship between forms and background, and above all by a flatness of the pattern.

William Morris was concerned with producing not merely better designs, but a better life. His work forms part of a much larger system of thought and sensibility. One feels that the dead, stagnant pretentiousness of Victorian art and design has been left behind and that there is a return to first principles. He sought always for simplicity and honesty.

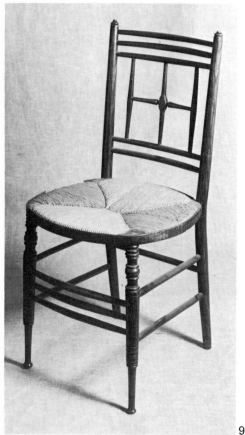

The furniture produced by his firm, but not designed by Morris, shows similar tendencies: a return to basic forms, a regard for honesty and simplicity. Chairs were based on existing cottage type chairs still in common use in Sussex. But there were also original designs, of all kinds of furniture, sometimes decorated with paintings of medieval derivation, and often very costly. This reflects the overriding contradiction in Morris's work; that whereas his aim was to produce goods which would improve the quality of life both of maker and user, throughout society, his hand-made goods were in fact too expensive for anyone except the very wealthy. He raged against being condemned to cater for 'the swinish luxury of the rich'.

In spite of what he often felt was a failure in achieving his ends, Morris's influence on other designers was considerable. They began to understand from him that art

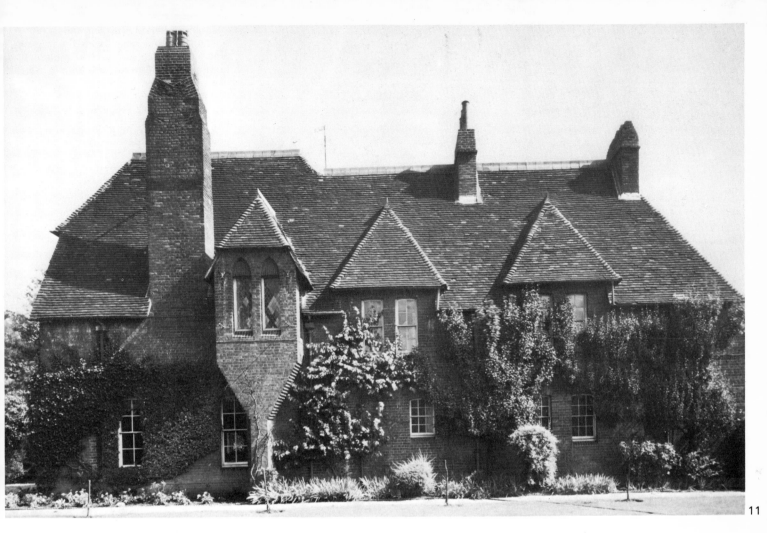

11

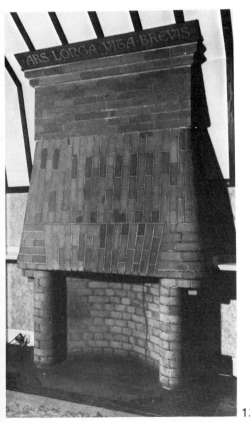

cannot be looked upon as an isolated pursuit of a few but as a phenomenon with social implications, that to look forward to a better art carries with it the expectation of a better society, and that if life is to have any meaning, work must be accompanied by pleasure. In his belief that a return to first principles, to simplicity, honesty and humanity, meant also a return to medieval forms and methods, Morris was very much of the nineteenth century, but his ideas and example opened other artists' eyes to the social involvement of design, as opposed to fine art. If in the following generation many artists were to forsake fine art for craft and design, thus initiating movements which were to lead to what we now know as industrial design, this was largely due to William Morris.

He wielded influence not only as a designer, manufacturer and theorist but also as a client, commissioning work for his firm from other artists. When he got married, in 1859, he asked his friend, Philip Webb, to design a house for him, and thereby extended his influence to another field, for that house has come to be recognised as a milestone in the evolution of modern architecture.

The Red House, so named because of its exposed brick walls, still suggests a hankering after the Middle Ages — witness its pointed arches and high-pitched roofs — but whereas other architects, in attempting to recall the medieval past, recreated an excess of Gothic decoration, Webb seized on the informal, asymmetrical grouping of medieval domestic architecture and the articulation of buildings according to function and convenience as still practised in rural areas. The Red House seems to follow the logic of Pugin's plea for functionalism which Pugin himself was incapable of translating into fact. Windows appear here where they are needed and not where the orders of architecture demand. Moreover they are highly differentiated by their form, again according to use. The building materials are left bare — against

8 *William Morris, fabric design*

9 *Sussex chair, about 1865. One of the products of Morris's firm*

10 *William Morris, wallpaper design*

11 *Philip Webb, The Red House, Bexleyheath, Kent, 1859*

12 *The Red House, fireplace*

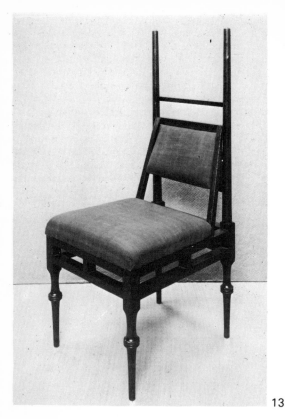

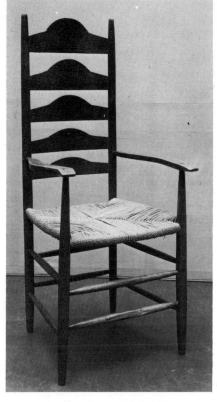

academic convention — and this is particularly noticeable inside the house where the fireplace — a stark functional form and in 1860 probably unique — has the subtly-varied brickwork as its sole decoration.

The Red House is not in any way a modern house, but it pointed the way to the architecture of the future by demonstrating the virtues of abandoning historicism — adherence to historical styles — and revealing the visual possibilities of basic forms.

Not least of Morris's achievements was the impetus he gave to the English Arts and Crafts Movement which exerted wide influence in Europe and America. During the last three decades of the nineteenth century there worked in England a large number of designers and artists who had broken away from the Victorian idiom and were producing work of considerable significance not only in its own right but also in relation to future developments. The English Arts and Crafts Movement was much admired and emulated in Europe where England's prestige in the fields of architecture and design had never stood higher.

Edward Godwin, in 1878, designed the White House in Chelsea for the painter James McNeill Whistler; an unusual house, asymmetrical, whimsical, with large white surfaces and a minimum of ornament, both inside and out. The interest of the elevation lies not in the arrangement of the scanty ornaments, but in the pattern of the windows, which is closely related to their function. Godwin's sideboard of 1867 and chair of 1885 look uniquely modern for their time.

Ernest Gimson, like Godwin, was both architect and designer. He concerned himself chiefly with the reinterpretation of vernacular forms but he also produced distinguished work of a more urbane character. Around the turn of the century he built a number of cottages based on traditional forms. He worked with a group of assistants and used no drawings, no doubt as an extremist gesture to stress his disregard for academic architecture and preference for the methods of traditional craftsmen.

Owen Jones was a designer who produced many patterns of a completely unrepresentational nature. As a designer of furniture he subscribed to the enlightened traditional design as pioneered by Morris. The natural grain of the wood, the subtle rhythm of the drawers and the clear-cut forms are the outstanding qualities of the dressing table shown here.

13

14

15

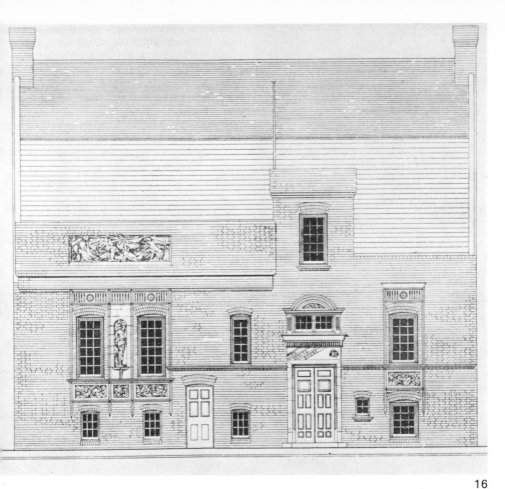

Arthur Heygate Mackmurdo was yet another architect-designer. He founded a guild, the Century Guild, and produced much of his own work within it. His furniture designs have an angular severity only rarely broken by flowing curves of unusual intensity. As a designer of patterns for wallpapers and fabrics, however, the restless, flowing character of his work far transcends his English context and it is possible to ascribe to him the origins of an international movement which forms the next stage in the evolution of art and design. Like many of his contemporaries he was much concerned with social questions and actually gave up his design practice to devote the last 40 years of his long life to writing.

13 *Edward Godwin, chair, 1885*

14 *Ernest Gimson, chair, 1888*

15 *Edward Godwin, sideboard, 1867*

16 *Edward Godwin, The White House, Chelsea, 1878. This is Godwin's original design*

17 *Owen Jones, dressing table*

18 *Arthur Heygate Mackmurdo, bureau, 1886*

16

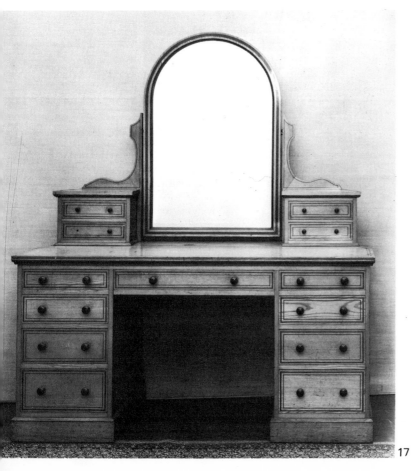

17

18

15

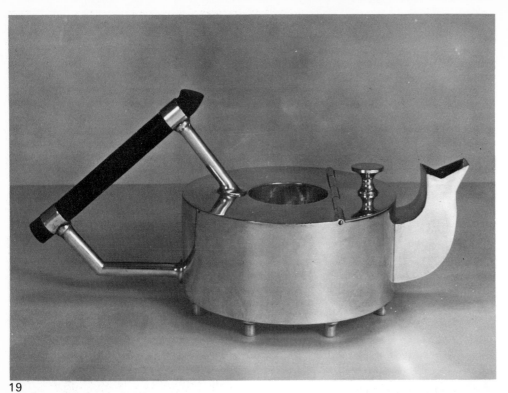

Some of the designs of Christopher Dresser are astonishingly modern even by twentieth century standards. His teapot of 1880 owes nothing to historical styles, everything to the designer's skill and sensitivity in composing abstract geometrical shapes which herald the machine age. The handle is one of the most direct and brutal expositions of function of its time; its form is a visual description of its use and the nature of the materials used. Elegance and style are most consciously, perhaps self-consciously, avoided. His designs are compositions of geometric shapes which pay heed to the requirements of function.

Charles Robert Ashbee was an architect and designer who, heeding Morris's call for a greater social commitment by artists and designers, founded a guild of craftsmen in the East End of London. He later transferred his workshops to Chipping Campden in Gloucestershire, perhaps motivated by romantic ideas of medieval working conditions in rural surroundings. Many fine designs flowed from his workshops, particularly silver and enamel work.

19

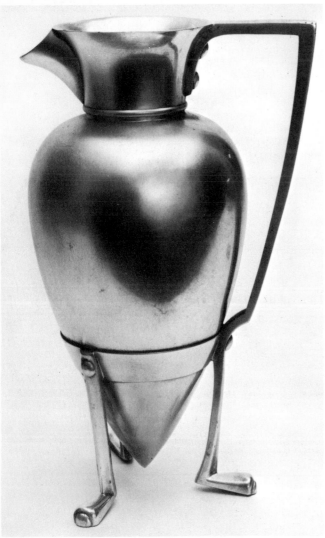

20

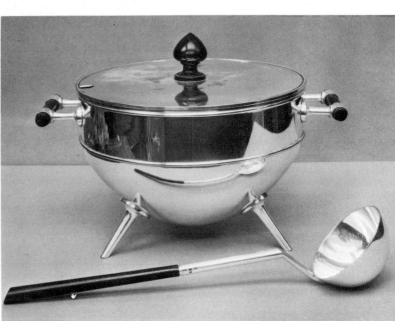

21

19 *Christopher Dresser, teapot, 1880*

20 *Christopher Dresser, decanter, 1879*

21 *Christopher Dresser, tureen and ladle, 1880*

22 *Charles Robert Ashbee, salt cellar and spoon, 1900*

23 *Charles Annesley Voysey, kitchen tools*

24 *Charles Annesley Voysey, design for a cushion cover*

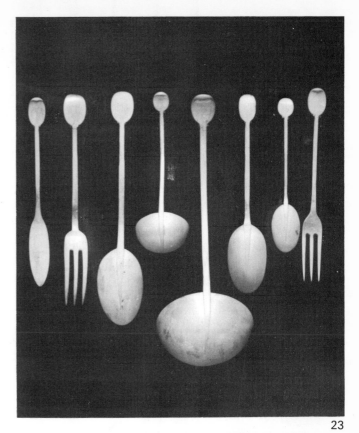

23

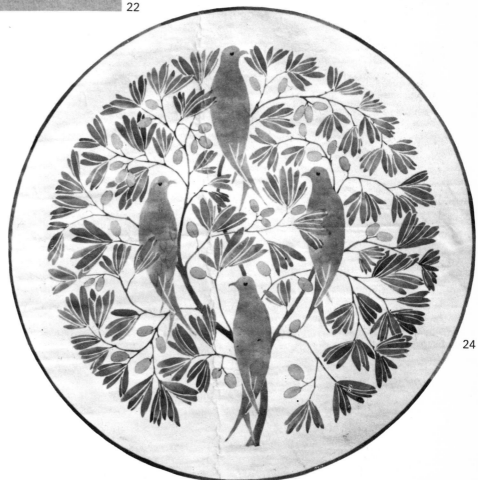

24

Charles F. Annesley Voysey was to become the most outstanding English architect-designer of his generation. It was through him that the principles of the Arts and Crafts Movement found their most perfect application and reached forward into the present era.

He designed fabrics of great charm and an often childish naivety. His use of colour was generally lighthearted; even Morris's designs, by comparison, look heavy. But there is a paradox in his work for he also declared that the chief use of pattern is to hide the ugliness of furniture. Patterns, he said, make bad furniture and modern life (i.e. Victorian life) bearable. Conversely a well-proportioned room and good furniture make patterns seem out of place. So we may interpret his celebrated patterns as attempts to hide the work of inferior designers. He asks designers not to follow existing trends and styles because they appear to be successful, but to look at everything natural and man-made, without copying, and using their God-given instincts and selectivity; then questions of style will have become irrelevant and sound pieces of design will emerge. He admits that such a process may lead to ugliness – think of Dresser's teapot – but at least there will be hope. His advice must have seemed irresponsible in 1893 when he offered it.

22

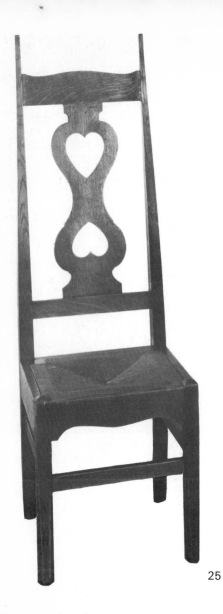

25

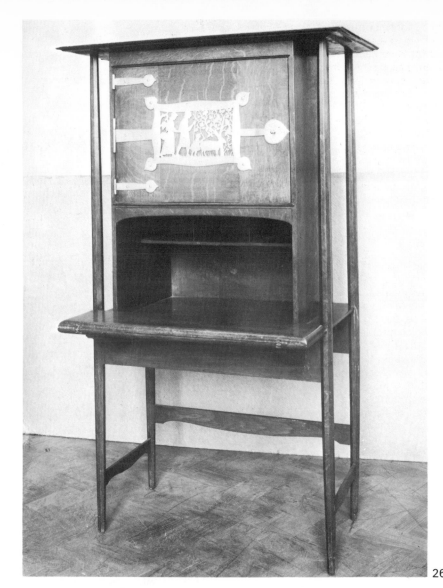

26

27

28

A sense of form is essential in all designing. This may strike us as a truism today but a sense of form is exactly what so much nineteenth century design lacked. The objects shown on page 11 have a great deal of decoration but no form. To trace the actual form underlying all the decoration would prove an impossible task. We should not find it; these are formless objects.

Progressive designers stripped objects of all unnecessary ornament and in so doing came face to face with the *problem* of form. Proportion and other relationships cannot be appreciated in an over-decorated object but a form such as Dresser's teapot stands or falls by its visual qualities. Voysey took this one stage further. In his work the purifying process of the Arts and Crafts Movement seems to have achieved maturity. He often indulged in a fanciful playing with form and on the whole there is a sophistication in his work which makes so many other contemporary designers look staid. For instance, the chair and desk are not merely simplified,

honest shapes but have a refined playfulness and wit resulting from the contrasts between the subtly shaped uprights and the heavy squat form of the desk, between the attenuated, unusually high back of the chair and the low seat. Even his designs for kitchen utensils have this wit which is never obtrusive and does not deflect from their use.

A similar principle applies to space. In a heavily patterned room the space may be obscured to the point where it can no longer be felt or understood. When patterns became flatter and when architects and designers even devised rooms without any pattern at all, people could look at rooms as *rooms* once more, that is to say, as volumes of space enclosed by walls. Until then these basic elements of the environment, form and space, could not even be discussed in a relevant manner. Modern ideas of form and space could not evolve until form and space had emerged in their purest state.

18

By leaving out all those obtrusive patterns Voysey was not doing anything unprecedented for in vernacular building, which in so many cases served him as a point of departure, bare walls were far from uncommon. But there was now another influence at work. The Victorian era was drawing to a close. It had lasted a long time and the desire for a certain measure of freedom had become apparent. The reaction against heavily decorated wallpapers, fabrics and furniture may be seen as a desire for liberation from the stuffiness of the Victorian era, a desire for a breath of fresh air.

The Orient seemed to offer an alternative, with its calm simple decorative schemes, not only in art but also in the design of interiors. The cloying, over-bearing, over-crowded Victorian interiors which allowed comparatively little freedom of movement, or a sense of space, gave way to simpler living areas in which people could escape from the ever-present past of historical ornaments, and move and live, think and feel, more freely. In this connection Whistler's importance should be recognised. In the White House, which Godwin designed for him, there were bare walls and just a few pieces of furniture.

In Voysey's interiors the absence of decoration no longer strikes one as an omission but as a spiritual release. It is also an invaluable means of clarifying space. As in his designs for furniture and other objects, so in his architecture he reaches well beyond the horizons of most contemporary progressive architects. He handles space with the same assurance and wit that we saw in his handling of form. The entrance hall of his own house, The Orchard, has a unique spatial clarity. The staircase injects a volume of clearly defined space, for it has no solid walls and we can see right through it, into the volume of the living room. The bare structure is expressed in a modern spirit. Although we shall have to go a long way yet to encounter the full modern consciousness of space, one can already begin to sense it in several of Voysey's interiors.

29

30

31

25 *Charles Annesley Voysey, chair, 1896*

26 *Charles Annesley Voysey, desk, 1895*

27, 28 *Space and pattern*

29 *Charles Annesley Voysey, The Orchard, Chorleywood, Hertfordshire, 1900. The hall*

30 *The Orchard, staircase*

31 *The Orchard, first floor landing*

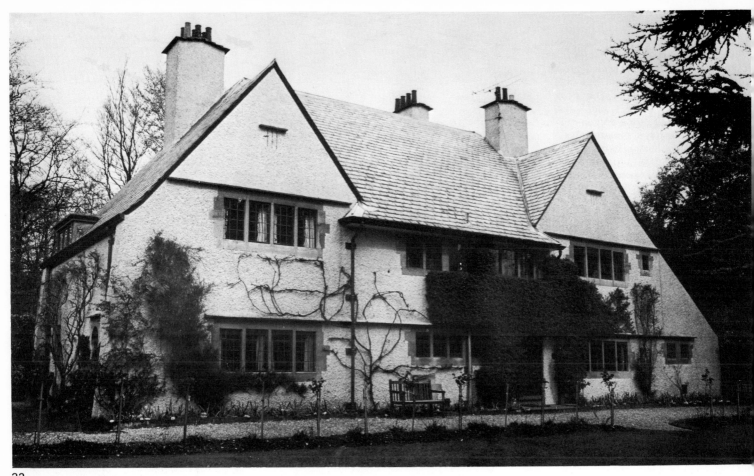

32

33

The outside of The Orchard is an asymmetrical composition of simple forms. The protective ledges above the windows and the projecting roof give a strong horizontal emphasis and visual order. A further functional touch is provided by the sloping buttresses in which the wall terminates on either side.

Similar buttresses can be seen in Perrycroft where some of them join up with the chimneys. The chimney tops, too, have a most decided twentieth-century character. Everywhere Voysey's regard for traditional forms is apparent, as is his ability to apply them to the new outlook and so make them modern.

Throughout the twenties and thirties, debased variations of Voysey's houses were scattered by the thousand throughout Great Britain. Voysey's designs were so subtly balanced that a visual sensitivity equal to his own would have been needed to adapt them. Later builders saw only their most obvious features without really understanding their inherent visual balance. It was as though the conceptual observer described in the introduction, had looked at Voysey's work and reinterpreted it. Such adapters did not understand the new visual language which owed little to classical architecture and had even left Arts and Crafts well behind.

32 *Charles Annesley Voysey, The Orchard, garden elevation*

33 *Charles Annesley Voysey, Perrycroft, Colwall, Herefordshire*

The Industrial Revolution had played havoc with the human environment but the pessimism which arose amongst artists during the last quarter of the nineteenth century was not due to that alone. To them the numbing of human sensibilities was of greater import. The material wealth now enjoyed by certain classes of society and their excessive and unashamed materialism; the sinister and cynical world of finance; the inhuman and mechanistic domain of technology which saw in human beings only operators of machinery; the singular concentration on the material aspects of life in a general sense; all these created, in the artists' eyes a stifling atmosphere in which the exercise of human sensibilities was no longer possible.

And behind it all stood the monster of positivism, scientific materialism, which provided the ethos of this world, since it required people to measure rather than to experience, to describe the surface rather than to sense the essence, to formulate more and more laws which inhibited the imaginative responses of the human psyche.

To exercise one's senses, to feel, became an irresistible artistic aspiration; anything could be forgiven, except lack of feeling. Artists tended to withdraw into their private worlds or, like Paul Gauguin, left Europe and its restrictive mental climate in order to feel again.

Even before this point had been reached a group of artists in England, the Pre-Raphaelite Brotherhood, seeking a way out of their stifling Victorian setting, proposed a fresh look at the condition of art. To them, as to William Morris, it seemed that the only solution lay in a return to the purer values of an earlier age, which alone would make possible a re-integration of thought and feeling.

This group of artists spurned the cosy, superficial paintings so fashionable at the time, paintings which dwelt on the outer, material aspect of things, and sought to establish an art in opposition to this materialistic view of the world. They drew mainly on the work of other artists before them who had relied less on an acute observation of nature than on the imaginative re-creation of their own inner worlds. William Blake had had such aims, as had later artists, even if they could not sustain their imaginative vision.

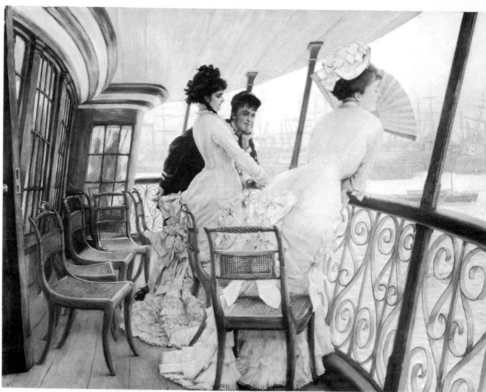

34

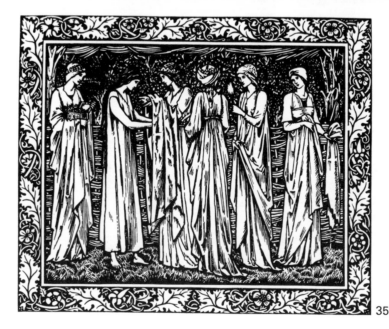

35

34 *James Tissot,* The Gallery of HMS Calcutta (Portsmouth), *1876. Exhibited in London, 1877. Tate Gallery, London*

35 *Edward Burne-Jones, illustration for the Kelmscott Chaucer, printed by William Morris' Kelmscott Press. Its tense, elongated figures which shun the materialism of the day reach back into the past and stress the inner meaning of the picture*

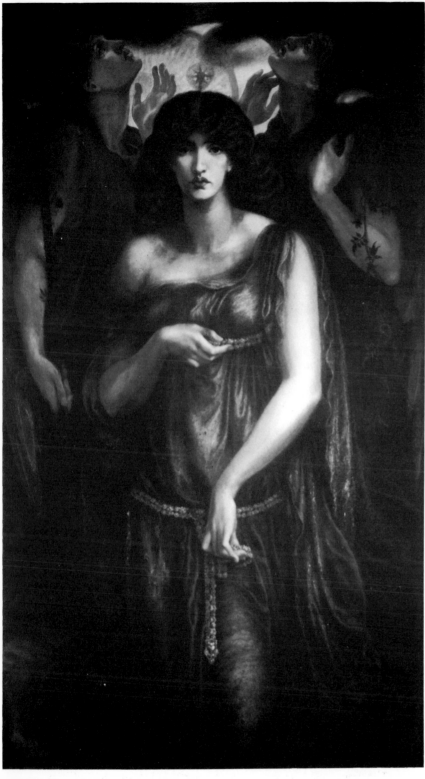

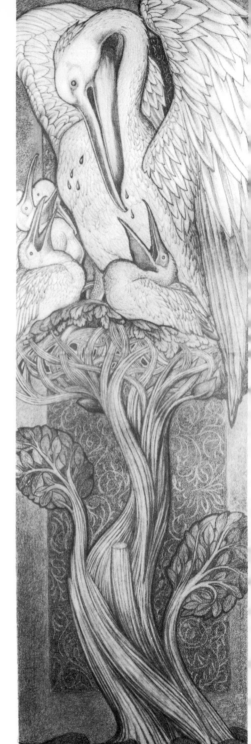

36 37

Dante Gabriel Rossetti was the most significant artist of the Pre-Raphaelite Brotherhood. In his work reality as such is less important than the poetic overtones of observable facts informed by feeling. The pictures Rossetti painted of numerous women were never just portraits, they always seemed to be charged with some hidden power, a mysterious unfathomable force. *Astarte Syriaca*, painted in 1877 which

Rossetti described as 'Venus Queen ere Aphrodite was' is an example of his mature style. William Morris' wife, Jane, served as the model for the picture but the artist transformed her appearance into a 'beauty with lurid and terrible royalty', while her 'two attendants . . . seem to testify to some dark, unholy power, the cruelty that is akin to lust.' These figures exist in a space which is no longer the three-dimensional space as

understood since the Renaissance, but the space of the imagination. They are symbols of a deeper significance, the outer manifestation of an inner spiritual reality.

A picture of 1881, *The Pelican*, by Edward Burne-Jones, a Pre-Raphaelite, could be taken as another pointer in the direction the new art was to take. Its taut, wavy lines and exaggeratedly twisted forms

give it a certain inner tension, which exceeds the importance of its subject matter.

These symbolic paintings foreshadow similar, later developments in other European countries, where the movement gathered momentum and became known as Symbolism. The new ideas were not by any means confined to the visual arts.

One may say in broad terms that the Symbolist poets, amongst whom we may count Mallarmé, Verlaine and Yeats, reacting to the staleness of nineteenth century materialism tried to bring about a reunion between the mysterious inner life of the individual and the world of reality, a union which they believed had existed in earlier periods. Stephane Mallarmé was the prophet of the movement; his ideas affected many poets, painters and musicians working at the time. His conviction that behind outward appearance there hides a greater reality a 'spiritual Universe', is central to his work. It is the poet who must supply the key to this world, through the mysterious power of words used in a manner which might by some be called illogical but which through their relationships suggest other relationships which factual language is unable to convey. Words may then be made to suggest more than they actually say and evoke a deeply-embedded mysterious language which can be understood through the senses. This new art, said Mallarmé, by looking beyond ordinary facts, could unlock the secret of Creation to Man. Instead of describing events, places, people, human behaviour, the Symbolist poets dwelled upon the symbolic meaning of words and the emotional overtones of their sounds, striving for psychic and sensuous effects rather than rational meaning. The ambiguity and obscurity of much of their work, the meanings deliberately left vague, were, the Symbolists maintained, a means of synthesising experience at various levels. Mallarmé summed up the new spirit when he declared that poetry is made with words, not ideas, and Flaubert concluded that a poem must be 'sustained by the internal force of its own style'.

These ideas had widespread repercussions. They imbued much of the art of the period with greater purpose in its search for spiritual meaning, and they led to intense discussions of the methods of art, all art. The concept of the *Gesamtkunstwerk* – the total work of art which embraces several forms of art within one pattern – had been discussed for some time. The idea was Richard Wagner's. He had coined the word to describe his own works in which poetry of heightened intensity, given musical form in a free vocal line, interacted with a richly coloured orchestral score to produce a dramatic, total, ultimate effect. Now the concept was applied loosely not only to opera but to any attempt to combine several arts in one enterprise. Magazines began to be concerned with a fusion of the arts, discussing in a single issue music, poetry, painting, architecture and furniture design. Abstract musical qualities were ascribed to the visual arts and to poetry; colour became a preoccupation of musicians. Arthur Rimbaud wrote a sonnet – *Voyelles* – whose subject is the relationship of colour and sound, and which begins with the words:

'Vowels: black A, white E, red I, green U, blue O,
Someday I shall name the birth from which you rise. . . .'

In painting Symbolism was represented by Paul Gauguin, Émile Bernard, Paul Sérusier, Odilon Redon, Maurice Denis and many other painters who joined in the movement of reaction to the factual interpretation of nature.

'It is well for young men to have a model', says Gauguin, 'but let them draw the curtain over it while they are painting. It is better to paint from memory, for thus your work will be your own; your sensation, your intelligence and your soul will triumph over the eye of the amateur.' Only the amateur copies nature, and the term would, by implication, include academicians and Impressionists alike. Cannot Impressionist paintings be confirmed by reference to factual reality? Such work is lifeless, for 'precision often destroys a dream, takes all the life out of a fable.' The true artist through his sensibility paints pictures in which all the accidental forms and colours of nature are harmonised into one design. In this process the artist must make judgements and relate objects to each other, changing them, as necessary, in the interest of a truth greater than naturalism. 'It is the eye of ignorance that assigns a fixed and unchangeable colour to every object.' Form and colour become relative to each other and to the content and intensity of the picture. In his artistic judgements the artist must be guided by his feelings, not by theory or convention. Colour and design must never be poured 'into the mould of a theory prepared in advance in your brain.'

It is typical of this period that like Gauguin many artists took to writing about their theories and work. The radical new ideas had to be justified, the old order attacked with words as well as pictures. Maurice Denis, too, stressed the importance of human feelings over mere facts: 'Art is nature seen through a temperament.' In all his writing Denis attempts to describe the relationship between nature and temperament, between fact and sensibility, between environment and man. In describing the artistic vision of nature, he maps out in one astonishing sentence the future course

38

36 *Dante Gabriel Rossetti,* Astarte Syriaca, *1877. Manchester City Art Galleries*

37 *Edward Burne-Jones,* The Pelican, *1881. William Morris Gallery, Walthamstow, London*

38 *Émile Bernard,* Breton Woman, *1886. Private collection. Even in a simple drawing like this Bernard attempts more than a record of factual truth, distorting and simplifying shapes to make them expressive, in this case, of the dignity and nobility of simple people*

of European painting: 'Remember that a picture before it is a war horse, a naked woman, or some anecdote, is essentially a flat surface covered with colours arranged in a certain order.' This is where art starts but we have lost our feeling for these basic qualities of art because we are too much concerned with the subject of the painting, the literary content represented by the forms and colours rather than with the forms and colours themselves. 'In all times of decadence the plastic arts fade into literary affectations and naturalistic negations.' Since we can no longer re-create human reactions, describe subjects in terms of human emotions, all we are left with is an art of imitation. Echoing Mallarmé and Rimbaud, Denis asserted that every human thought and emotion had an equivalent visual element, while Redon described Symbolist art as 'the visible in the service of the invisible'.

And this was as close as anyone could get to a succinct description of Symbolism.

Because Symbolism was concerned with the emotional effect of the visible rather than its factual reality (with visions rather than with vision), shape and colour were more important than verisimilitude. In reacting not only against academic art but against Impressionism, the new painting reintroduced the object as a whole, tangible, pictorial element. Visions did not consist of little Impressionist dots which broke up the contours of forms but of emotionally charged shapes, in visual relationships with each other. The indeterminate shapes of the Impressionists, broken up by light and shade, had to give way to clearly contrasted shapes, in a flat rendering and often contained by distinct outlines which made the shapes appear even flatter. Now colour could make an emotional effect within the composition. *Old Maids of Arles*, painted by Gauguin in 1888, is an example. It was no doubt inspired by a definite scene, something the artist actually saw, but in the process of being converted into a work of art it became a 'flat surface covered with colours in a certain order'. It makes more sense as a composition of shapes and colours which convey a certain emotional state than as a description of a real situation.

Since the shapes of a Symbolist painting referred more to the painting itself than to nature the outlines did not have to follow the natural contours of objects but were free to produce their own harmonious curvatures, in relation to each other and to the whole composition. Maurice Denis's painting *April*, 1892, is only remotely connected with reality, everything in the picture, particularly the white-clad figures, has a deeper significance. It is a truly

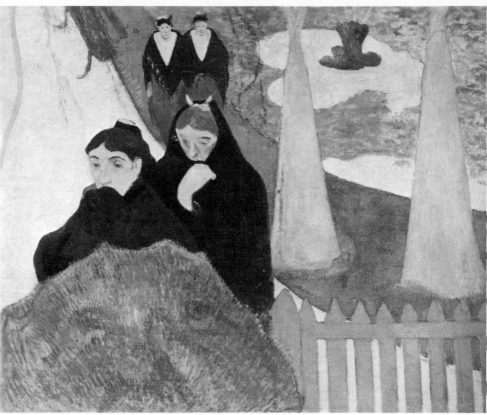

39

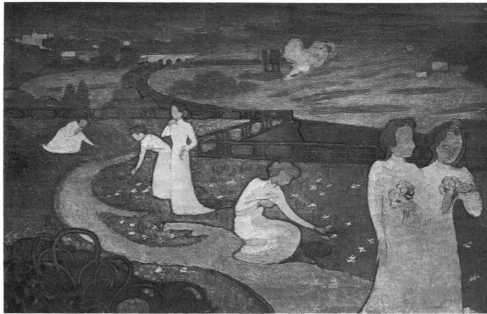

40

39 *Paul Gauguin*, Old Maids of Arles, *1888. Art Institute of Chicago*

40 *Maurice Denis*, April, *1892. Rijksmuseum Kröller-Müller, Otterlo*

41 *Paul Gaugin*, The Day of the God, *1894. Art Institute of Chicago*

42 *Georges Lacombe*, Bay at Carmaret, *1893. Private Collection*

43 *Detail of 42*

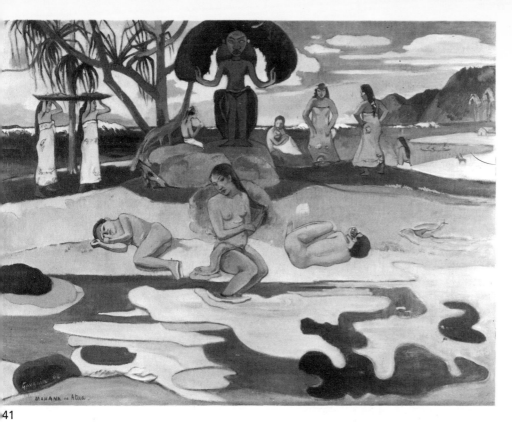

41

42

43

Symbolist picture, which expresses the gentle purity of spring. The shapes which in the real world would have been quite different from each other have been given a similar character. The figures reflect the shape of the path, of the plant in the foreground and the river in the background. Their outlines have become abstract elements which belong to the picture rather than to reality. Bernard referred to this as 'the significant distortion'. In Gauguin's *Day of the God,* 1894, the shapes are even more removed from the material world so that the greater reality of the scene may be revealed. In Georges Lacombe's drawing the trees have become formal elements in which shapes and spaces are considered in their own right. Lines exist in abstraction, seen as arabesques; they have been assigned a pictorial purpose in the composition.

In Symbolist art, then, visual values — shape, colour, mass, space, rhythm, and the composition in which they were all combined — came to the fore as vehicles of feeling. The effect of lines, shapes and colours on each other was exploited, building up here harmonies, there tensions, nostalgia, sensuousness, delicacy, refinement. In comparing an Impressionist painting with a painting by Gauguin it is immediately apparent that the artists' aims were different and that Gauguin had searched for something beyond a description of the world of nature.

This highlighting of pure visual values led to a greater interest in the phenomenon of visual experience which now began to be investigated, analysed, argued about by scientists as well as by artists. From Symbolism there began to develop the new art of the twentieth century.

An age whose most creative spirits were increasingly aware of the suffocating pressure of scientific materialism and the dead weight of inherited historical styles was clearly extremely susceptible to these new ideas. Young designers, more interested in the future than in the meaningless historicism of their predecessors, generated a new and original means of expression. Their ideas spread far and wide and embraced most elements of the human environment. In fact the creation of an overall integrated environment to meet the emotional as well as the practical needs of the time was one of the aims of the new movement. Because of its wide application we can speak of a New Art — Art Nouveau — a violent reaction against nineteenth-century historicism, and itself the first modern style.

Symbolist painting had to a certain extent established the conditions under which the new style was to evolve but other influences were also in evidence. It was as though designers, their ranks swelled by artists who were prepared to take a more active part in the shaping of the new environment, looked at nineteenth century design, including the Arts and Crafts movement, with new eyes — and the eyes were those of Symbolism.

Mackmurdo's design for his own book *Wren's City Churches,* published in 1883, is the first harbinger of the new style. In this design three flowers are impossibly intertwined with a banner bearing the main title. Two elongated cockerels flank the design. The three constituent elements — flowers, banner, cockerels — are combined in one overall design in which it is difficult to separate them visually. This title page, more than any other single piece of work produced at that time, points to the future and foreshadows the shape of things to come. Some even earlier work by Mackmurdo, strikingly unusual for its period, shows similar visual qualities.

It is true that Owen Jones had already spoken of his conviction that a slavishly faithful naturalism can only be harmful to design, and his own work and that of his fellow designers certainly affirmed this conviction. Nevertheless although they stylised natural shapes, achieving their 'modern' designs by a process of simplification, these still remained recognisable in naturalistic terms. They rarely attempted to arrange natural shapes in any but a natural manner, hardly changing from their natural state the relationships between different parts — stalk, leaves, flowers, buds. In Mackmurdo's work a different order of values obtains. Shapes are elongated, lines become tortuous and restless, sometimes even against the natural character of the subject. In fact the subject is difficult to pick out from the mass of lines and shapes moving in sympathy or in opposition. It is the movement, the flow, the rhythm of the design which we notice before anything else.

These important features of Mackmurdo's work differentiate it from other work of the period; they are also the chief features of the new style as it was to develop throughout Europe. Mackmurdo in seeking to impose a meaning on visual material at the expense of truth to nature had much in common with the Symbolists. Like them he allowed visual values to preponderate over factual ones.

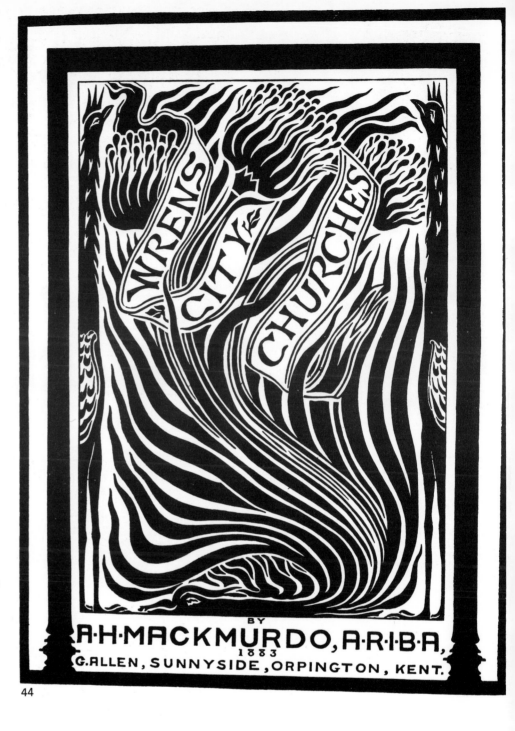

44

44 *Arthur Heygate Mackmurdo, title page, 1883*

45 *Arthur Heygate Mackmurdo, chair, 1882*

46 *Arthur Heygate Mackmurdo, fabric, design, 1884*

47 *Arthur Heygate Mackmurdo, fretwork decoration of chest of drawers, 1882*

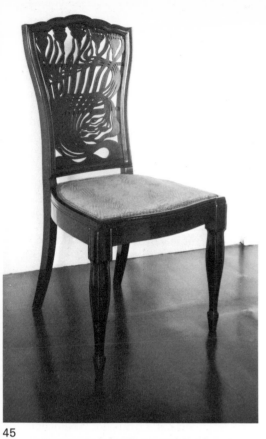

45

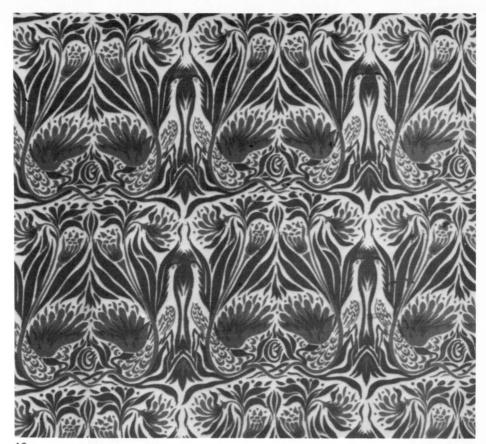

46

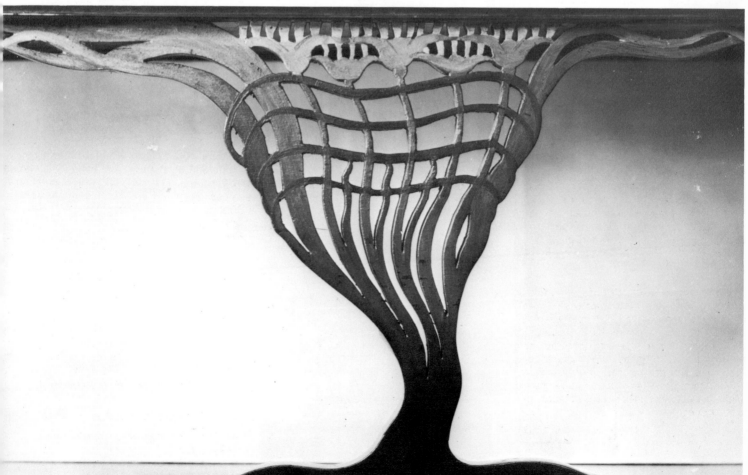

47

As Art Nouveau developed, features first introduced in Mackmurdo's designs became generally apparent.

The moving line, meandering, twisting, isolated or massed or in relationship to other lines, became the stock in trade of Art Nouveau designers, the favourite visual device which by the great was used with originality and sensitivity and by the second rate as a short cut to the modern look.

The main characteristic of Art Nouveau was its sinuous, elegant, restless line which carried the eye along in a variety of refined movements. This line, flowing and decorative as it was, was also charged with movement, emotion and tension. It was capable of decorating a solid form in the lightest, airiest manner, unifying the different parts into one whole. Similarly, several different objects could be drawn together by the strength and purposefulness of the style, making of furniture, fittings, wallpaper, fabrics a coherent, unified environment.

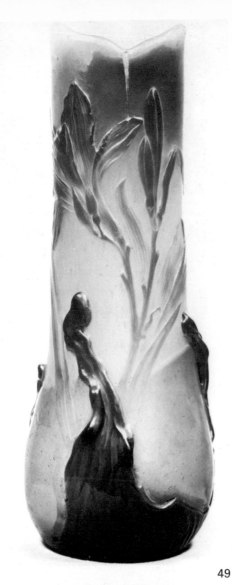

49

But if the sinuous, sophisticated line was the backbone of Art Nouveau, this does not mean that Art Nouveau was merely a form of decoration. Many designers were not only deeply conscious of the external appearance which made certain natural organisms — flowers for example — particularly suitable as decorative elements; they also analysed, both visually and verbally, their structural and their organic implications. This enabled them to join the concept of a plant as an efficient structure with the more traditional view that it was a harmonious and decorative object, and so to express through the same object the widely discussed twin ideals of utility and beauty.

Guimard's stations for the Paris Métro are a case in point. Gaillard's chair and van de Velde's hat and coat hook also have an organic quality.

Van de Velde, the most important theorist of Art Nouveau, believed that a designer should use ornament to structure the shapes he produces to such a degree that ornamentation and the form or the surfaces 'should appear so intimate that the ornament seems to have determined the form.' This is not merely an aesthetic whim, for he saw the whole purpose of ornament as an explanation of function. And since the ornament of an object should be related to form and function, and not be merely tasteful and decorative, imitations of natural shapes would impair the design and should be avoided.

Although not every adherent of Art Nouveau went as far as van de Velde and although there were various methods of interpretation, yet in the work of many different designers the decoration does indeed seem to have determined the form; often it is difficult to distinguish between form and decoration. And even where it can be recognised in its own right, decoration does not merely embellish, it emphasises and dramatises the structure.

48 *René Lalique, pendant, 1900*

49 *Emile Gallé, vase, 1900*

50 *Emile Gallé, firescreen in applied wood and marquetry, 1900*

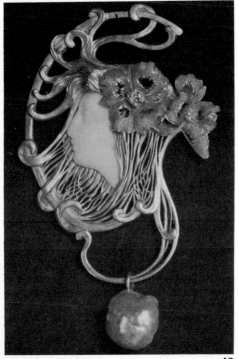

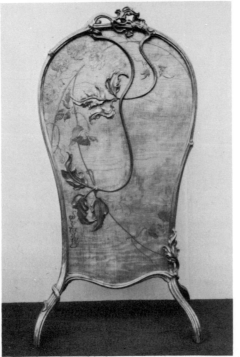

51 *Eugène Galliard, chair, 1900*

52 *Henri van de Velde, chair, 1899*

53 *Henri van de Velde, hat and coat hook, 1901*

54 *Hector Guimard, Métro station, Paris, 1899, lamp standard*

55 *Hector Guimard, Métro station, baluster*

48

50

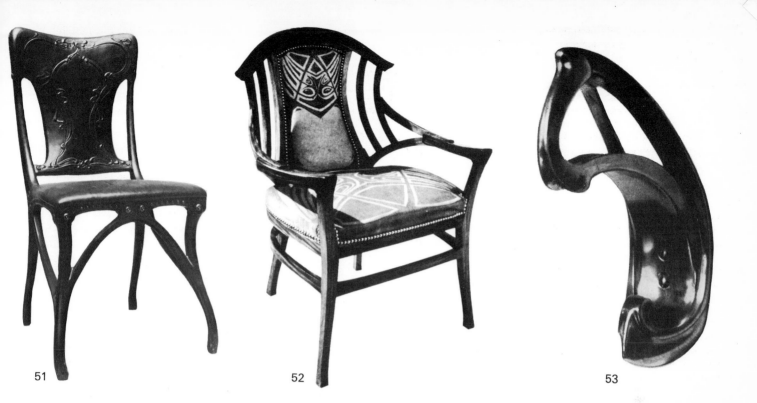

51

52

53

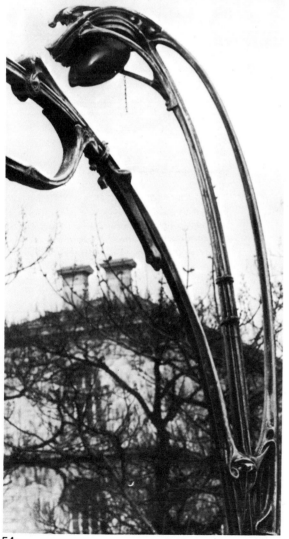

54

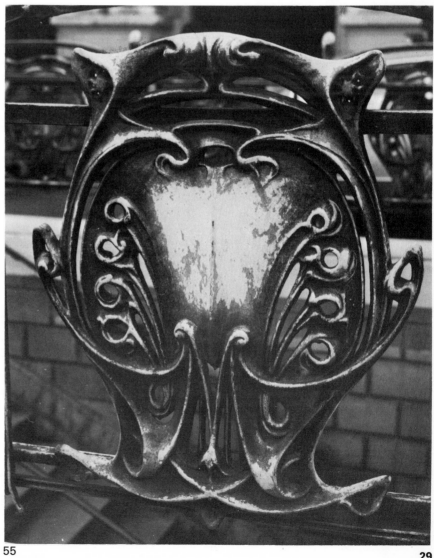

55

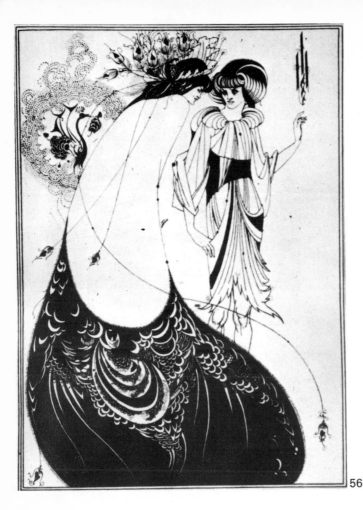

56

certain sensations, but this required tonal arrangement is not matched by natural appearance. Expression is thwarted by verisimilitude. But now, as he moves away from an exact description of nature, the artist can be freer with the tones he employs and use them as tools of expression.

Beardsley's straining after unusual effects which was common to all Art Nouveau allowed him to release tone from its naturalistic obligations. Because he did this in a particularly forceful and original way the whole problem of tonal balance and the expression achieved through it are brought to our notice. We realise that pictures — and other things too — require this element in their composition. The work of Beardsley and his contemporaries therefore could only lead to a broadening of human perception.

58

But Art Nouveau had other qualities, and initiated new departures and searches for visual experience, which make it important in the history and the development of the visual language of the new century. Women were often shown — whether in illustration or in three-dimensional decoration — as part and parcel of the flame-like, sinuous Art Nouveau world, their bodies and especially their long hair forming part of the sensuous rhythm, perhaps accentuated by floating veils and plants. All these elements are generally combined in one sweeping movement, and it is the resultant distortion which gives the bodies their powerful expression. When we add to this the unusual lack of pictorial depth, as for instance in the work of Aubrey Beardsley, where everything seems to take place in the same plane, and the equally unusual counterplay of black and white, it is understandable that such drawings are difficult to 'read'. The outlines of individual figures and objects are so distorted and so intimately interlinked as in the work of Mackmurdo that they cannot immediately be recognised. The pervading sensuous impression of Beardsley's drawings is produced by visual means — distortion, flatness, tonal counterplay, spatial counterplay — rather than by elements directly derived from nature, or by ornamental exuberance.

Even in a simple composition like the one shown above the lines have an ambiguous role; they may be read simply as lines, or as outlines of shapes which we are free to interpret in different combinations. If we fill in one or other of the spaces between the lines, to suggest definite interpretations, we are in fact changing the visual content of the composition. Each of the two shown here strikes us differently. The whole

57

composition seems to have undergone a change so that the effect on our perception and our emotions is quite new. One of the problems which confronts every artist is this; his expressive purpose may demand a certain tonal arrangement, a sequence of patches of tones which would give rise to

In this simple Art Nouveau vignette the tonal interplay is the most important element in the total effect. Like Beardsley's and Mackmurdo's designs it is difficult to understand in a rational sense. Through its ambiguous tonal effect it exercises the observer's powers of perception and not his powers of recognition.

A similar development towards pure visual qualities can be seen in three-dimensional Art Nouveau. Artists and designers who work in the round have problems similar to those of the artist working on a flat surface: the balance between solid forms and the spaces between them. Here too the problem is age-old although too little recognised by the outsider. In a traditional chair we may focus on the solid parts little realising how carefully the designer has had to work out the relationship between these and the empty space contained by them.

At this time of quest for the new and the unusual, designers, like artists, made many experiments in order to achieve novel effects. It is to be expected that a

30

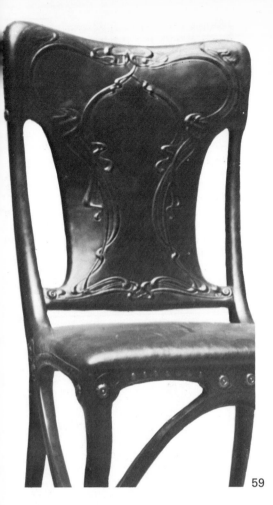

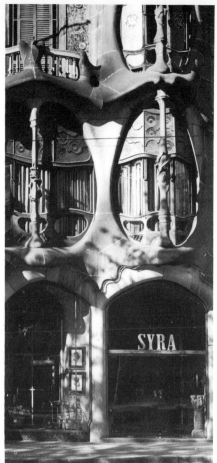

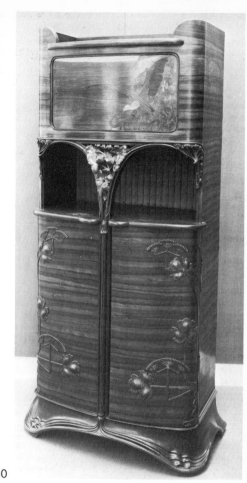

59

60

61

movement like Art Nouveau which sought to displace historical styles would try to upset existing relationships dictated by tradition. Art Nouveau succeeded in offering a new and different interpretation of whatever through tradition or usage one was conditioned to expect. Traditional ideas about the relationship between shapes and spaces were no longer accepted. Spaces, no longer considered as accidental volumes of air, left vacant by the far more important structural members, were recognised as elements in the design, free to assume unusual shapes but still related to the overall form. In Art Nouveau design one is often more aware of the open spaces than the solid forms. It often seems as though the openings had dictated the shapes of the solid structure round them and not the other way round. We can see it in the work of designers of widely divergent views and in such different objects as Majorelle's cabinet and Gaudí's Casa Batlló. But if we look at Lacombe's drawing once more we see in Symbolism the source of this new way of designing.

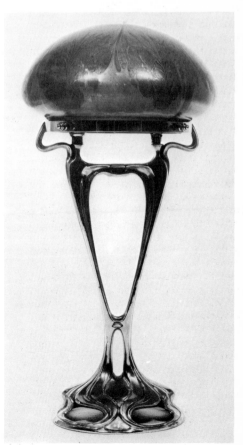

56 *Aubrey Beardsley,* The Peacock Skirt, *book illustration, 1894*

57 *Shape and tone*

58 *Vignette from* Ver Sacrum, *periodical of the arts, 1899*

59 *Detail of 51, a composition of shapes and spaces*

60 *Antoni Gaudí, Casa Battló, Barcelona, 1905*

61 *Louis Majorelle, cabinet, 1900*

62 *Loetz Witwe, glass and metal lamp, 1900*

62

Because Art Nouveau was an attack on the old, the backward-looking and the hidebound, it led to experiments with traditional materials which sought unusual and surprising effects. The opalescent, shimmering quality of Art Nouveau glass, whether by Tiffany or Loetz, is typical of this period. In many cases the designer has not wished to impose a definite, preconceived pattern on the glass but has allowed its free-flowing qualities to characterise the patterns. These flowing forms fitted perfectly into the Art Nouveau language of abstract, sinuous movement. Freed from the restraints of naturalism, craftsmen and designers could now follow up their own experiments and investigate the nature of their materials in a way which would have been impossible before the advent of the new style.

Iron and glass were the materials which came in for the most thorough reappraisal by Art Nouveau architects, and nowhere can this be seen to better effect than in the work of the Belgian architect, Victor Horta. His Maison du Peuple, built in 1896–9, has all the fluidity of the characteristic Art Nouveau line. The entrance has an exaggeratedly curved arch, which is nipped in at the base. The façade itself curves forward and back. The line of the windows of the first storey describes two wide sweeping arches connected by a short asymmetric dipping curve. This curve has in addition a functional significance; it draws our attention to the fact that it is part of the staircase which is also vertically differentiated from the rest of the facade. Friezes of decorative wrought iron provide decoration. Inside, in the auditorium, the

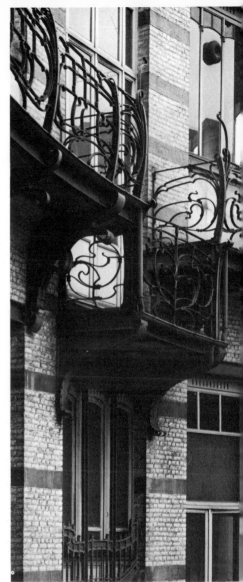

65

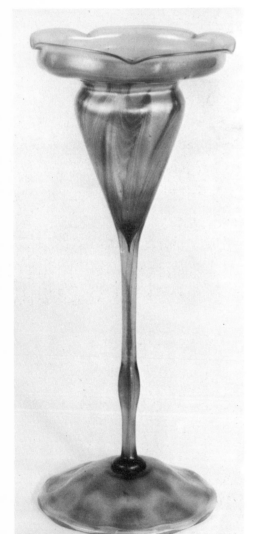

63

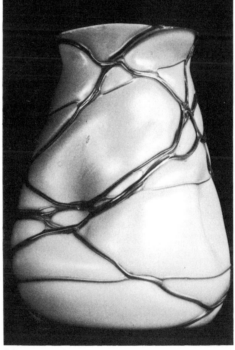

64

63 *Louis Comfort Tiffany, flower form vase, 1896*

64 *Loetz Witwe, vase, 1900*

65 *Victor Horta, Maison du Peuple, Brussels, 1896, balcony*

66 *Maison du Peuple, doorway*

67 *Maison du Peuple, general view*

68 *Maison du Peuple, detail of doorway. A search for unity of structural steel and decorative ironwork*

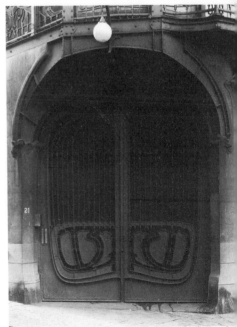

66

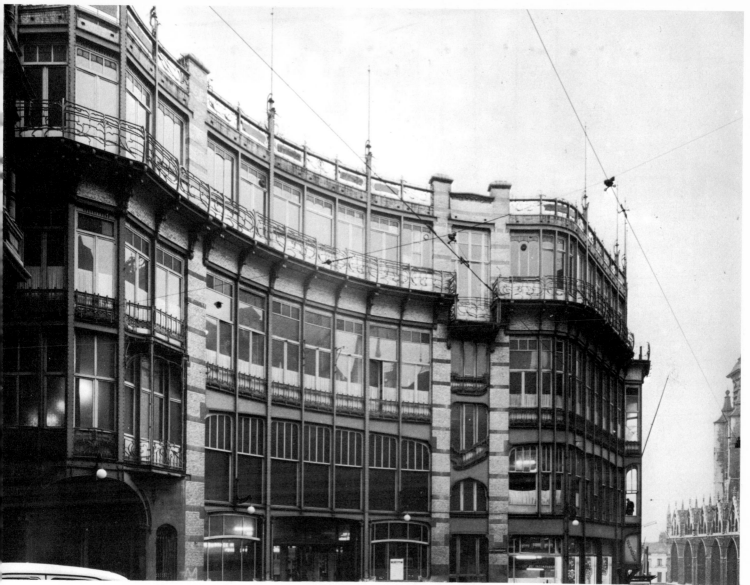

67

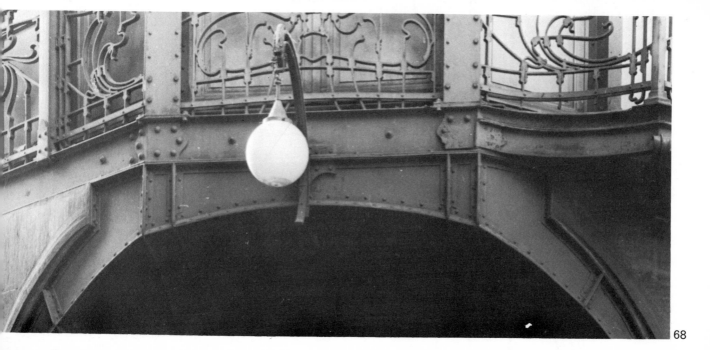

68

c

69

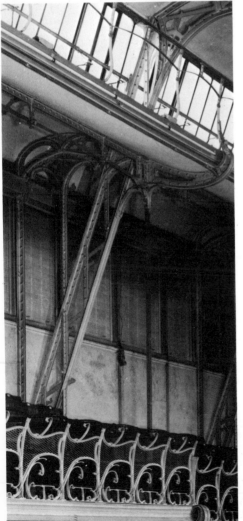

70

71

structural ironwork is exposed. We recognise on the ceiling structure the now familiar motif of the double curvature, and the roof line of the aisles connects with it in a harmonious structural movement. It is evident that Horta intended to make his iron structure part of the architectural language — by forming it into Art Nouveau curves.

An even more spectacular exposition of ironwork is given by the entrance hall and staircase of a house he designed in 1892 in Brussels. Here the structural function is made light of by graceful linear forms which appear to caress rather than to support the masonry. The hand rail and balustrade, the patterns on floor and walls, the curved stairs, all designed in the same playful spirit and in harmonious relation to each other, create a whole setting which comes close to the aim of Art Nouveau designers: a total environment in which all the components are fused into one Gesamtkunstwerk.

Art Nouveau belonged to the nineteenth century but the advances it effected towards a twentieth century visual language were widespread and basic. It challenged tradition in a completely unprecedented way and offered alternatives to traditional concepts. These may be grouped under three main headings.

1. By rejecting symmetry and imposing asymmetrical arrangements, the element of predictability was removed. When one half of an object reflects the other half, surprise and the unusual are reduced. Art Nouveau always strove for unusual effects and feelings and an opportunity to surprise. Asymmetry is a visual challenge not only to the observer but also to the creator, who, instead of following well worn tracks, must now learn to improvise. Against symmetry he must set unsymmetrical balance, a balance of unequal elements which taxes his powers of invention. The hostility of Art Nouveau to absolute symmetry prepared the way for an acceptance of wholly functional solutions to design problems. For example, a house or a piece of furniture may function less well in a symmetrical form than in a form dictated by requirement.

2. In opposition to the naturalistic ornaments of historical styles, Art Nouveau invented new forms which could not be interpreted in any naturalistic context. They had to be accepted in their own right and not on account of some factual allusion. Where in the past ornaments could be recognised as flowers, leaves, birds, scrolls, Art Nouveau ornaments were sinuous lines and billowing forms. The acceptance of ornaments therefore became a visual realisation, not a literary one.

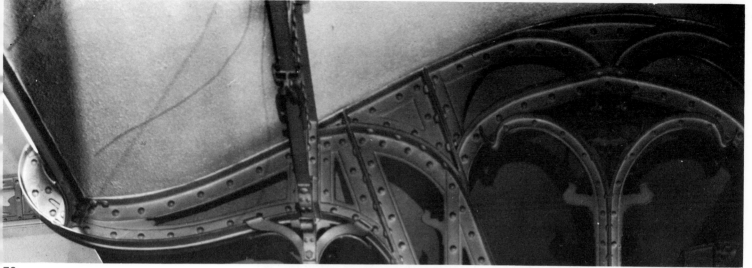

72

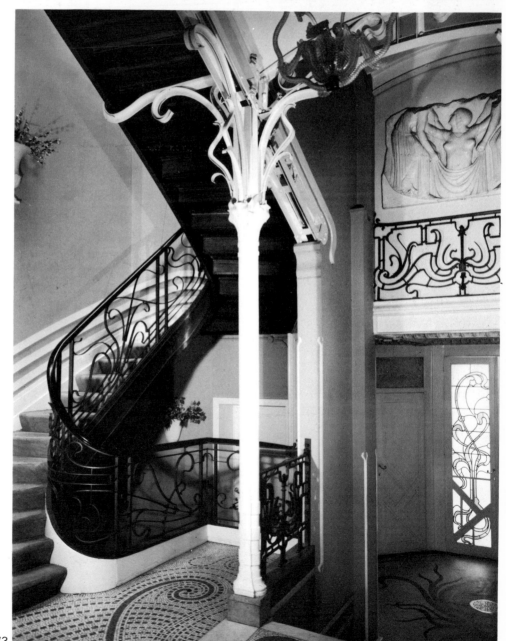

69 *Victor Horta, Maison du Peuple,*
auditorium

70 *Maison du Peuple, auditorium, balcony.*
Structure made decorative

71 *Maison du Peuple, auditorium, the pure*
geometry of the ceiling structure. The
contrast between these two different
treatments of structure is not always
resolved

72 *Maison du Peuple, auditorium, detail*
of structure above balcony. Even the rivets
have their place in the decorative scheme

73 *Victor Horta, entrance hall and*
staircase, Brussels, 1892

73

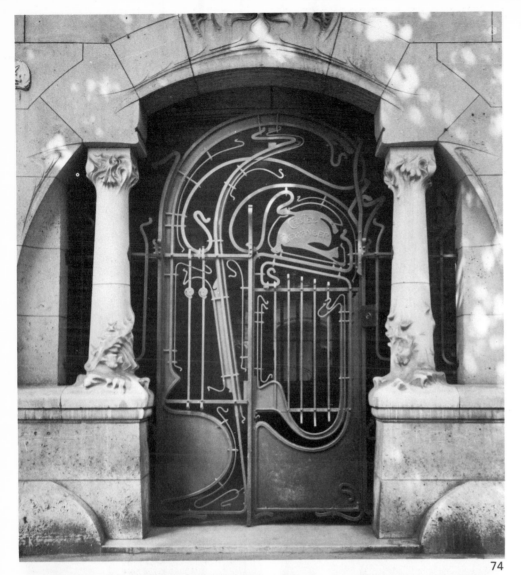

If we look at Guimard's decorative gate for a house, his Castel Béranger, the last two points become quite clear. There is nothing here that could be referred to nature; we must accept it as pieces of iron formed into certain shapes. Instead of static symmetry there is a dynamic visual relationship between the two large shapes at the bottom; one feels they might even fit together if we were to re-arrange them. Each of these shapes has an accompanying secondary shape with something of the character of the main shape. The oblique shape introduces an unexpected piquancy into a design which is further enriched by many whirls and straight lines. The effect is that of a piece of richly orchestrated music in which the main themes stand out boldly. Literal truth — recognisable form — is inapplicable to such work; visual truth — balance, relationship, tension — is all.

The adjacent stonework and the terracotta decoration inside the entrance take up the main themes of the gate. Each is allowed to develop these themes according to the character of its own material — note the elaboration of textures in the terracotta — and between them to add to the rich orchestration of the whole.

The Symbolists' call to concentrate on visual — or pictorial — means rather than on imitation of natural appearance seems to have been accepted. This can also be noticed in van de Velde's pictorial work. His tapestry *The Angels' Watch* has a recognisable subject but the tension lines which give it pictorial unity are even more prominent. In his *Plant Composition* subject matter is not nearly so clear. It shows greater concern for the essence of fruit than for its appearance. These developments within Art Nouveau greatly eased the drive to complete abstraction in the early years of the twentieth century.

3. The sinuous line of Art Nouveau eventually invaded the very structure of furniture and other objects. The chair, 1900, by Riemerschmid can be recognised as belonging to Art Nouveau, but its flowing lines are also structure lines. Van de Velde's lamp of 1906, shows how extreme this preoccupation with organic structure could become. It was in this extreme form that Art Nouveau cleared the path for later developments in industrial design.

74

75

74 *Hector Guimard, Castel Béranger, Paris, 1897. Entrance*

75 *Castel Béranger, wall decoration inside the entrance*

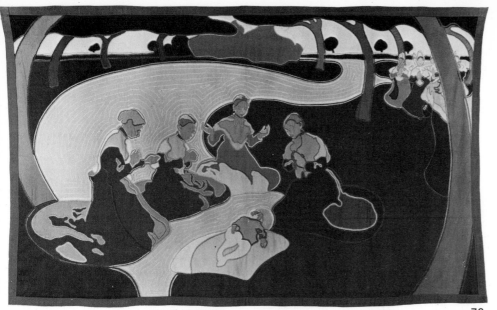

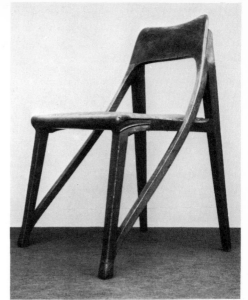

76

77

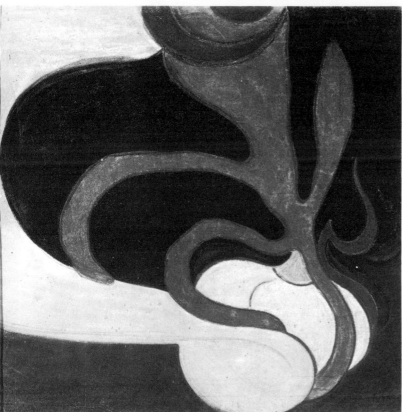

78

79

76 *Henri van de Velde,* The Angels' Watch, *1893, tapestry. Museum Bellerive, Zürich*

77 *Richard Riemerschmid, chair, 1900*

78 *Henri van de Velde,* Plant Composition, *1892. Rijksmuseum Kröller-Müller, Otterlo*

79 *Henri van de Velde, hanging lamp, 1906*

80

The movement away from the style-ridden academic architecture of the nineteenth century was not confined to Europe. The movement which developed in the United States was similar and parallel to its European counterpart and yet dissimilar in several important respects.

American architects, such as H. H. Richardson and Stanford White, used traditional New England materials — brick, clapboard, stone — to create buildings which suited the climatic conditions of the country, just as their European contemporaries did in their own vernacular. There were however differences between the two streams of development, and these not merely because of the different traditions of the two continents.

The nineteenth century concept of architectural style, that is to say the method of giving buildings an image derived from historic periods — Gothic, Renaissance, Baroque — was in American eyes a hangover not just from the past but also from colonialism. These styles had originated in Europe. English architects, particularly of the Neo-Gothic persuasion, were invited to America to design buildings. The École des Beaux Arts of Paris still wielded a good deal of influence. Even progressive American architects like Richardson and Sullivan had been trained there. A rebellion against stylistic building had for Americans far wider implications than the English reaction to historicism. Traditional architecture symbolised in America the

81

dependence of a colonial people upon the cultural values of its dominators. A young nation beginning to feel the strength of nationhood, to become conscious of its own vast size and enormous potential, looked upon the repudiation of European influences in architecture as one more act of breaking with the colonial past, as a demonstration of national pride. Almost from the outset, therefore, the new American architecture had all the vigour

and buoyancy of youth, with a predilection for massive, even extravagant effects. This was all to the good, for in America young architects were faced with a challenging task which even an enlightened traditional architecture was utterly incapable of coming to grips with: the design of tall office buildings. H. H. Richardson was one of the first to envisage such undertakings as new types of building and not just tall houses. The stonework of

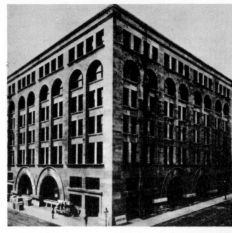

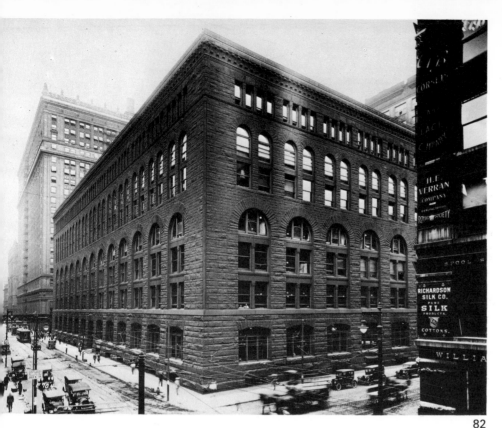

82

84

his Marshall Field Warehouse in Chicago, built in 1885, is still reminiscent of his dwelling houses but it has a massive scale and a rugged heroic air which may be compared to a nineteenth century railway viaduct or a Renaissance building. Like them, it is still a masonry building. Really tall constructions could not come into being until the modern lift and the steel frame had been perfected.

The problem solutions came in various tentative forms. It is clear that the intention to do more than just build mechanically efficient structures was present at an early stage. In 1890 John Root, one of the architects of the Chicago School, proposed that modern buildings should 'by their mass and proportion convey in some large elemental sense an idea of the great, stable conserving forces of modern civilisation . . .' He went on, 'So vital has the underlying structure of these buildings become that it must dictate absolutely the general departure of external forms; and so imperative are all the commercial and constructive demands that all architectural detail employed in expressing them must become modified by them.'

It was in Chicago, a brash, thriving commercial centre without respect for tradition, that the new techniques were developed on a large scale. The 'Chicago construction', as the new steel frame was called, made tall buildings possible, but at the same time it posed problems which like similar problems in Europe were linked

to 'truth' and 'honesty'. Should new elements be allowed to affect the outward appearance of buildings? Would it be honest to clothe a tall steel frame structure in stone, to simulate a stone building, when it was patently impossible to build to such heights in stone?

The style of building which developed in Chicago towards the end of the nineteenth century was distinctive. Of the architects who became known as the Chicago School the most important was Louis Sullivan. His early Walker warehouse of 1889 is still under Richardson's influence, as can be seen by a comparison with the Marshall Field warehouse, but by 1895 he had developed his own characteristic style. Sullivan was a profound architectural thinker and he produced a programme for architects to follow, a systematic approach to design which spells out what future architects and designers were to come to accept as normal practice.

80 *Stanford White, W. G. Low House, Bristol, Rhode Island, 1887*

81 *A. B. Mullet, State, War and Navy Department Building, Washington, 1871. A 'European' building*

82 *Henry Hobson Richardson, Marshall Field Warehouse, Chicago, 1885*

83 *Adler and Sullivan, Walker Warehouse, Chicago, 1888*

84 *Burnham and Root, Reliance Building, Chicago, 1890. A product of the Chicago School, featuring 'Chicago windows'*

Analysing the requirements of office buildings, he decides that they must include a basement for the mechanical services (heating, lighting, power, etc.); a first storey with a related second storey for banks, shops and so forth; a succession of office storeys; and finally a top storey for complementary services (water tanks, lift gear, etc.). In architectural terms this means a ground floor with the largest open spaces — 'liberal, expansive, sumptuous' — a first storey similar but somewhat more restricted; a series of office storeys, consisting of cells which all look alike 'because they are all alike'; and a top storey which should by its form proclaim its difference in function from the rest of the building, and at the same time provide a significant finishing off of the whole. This brief analysis on its own might well have produced an efficient building, but Sullivan went further and supplemented the material terms of reference by heeding 'the imperative voice of emotion'. In clear if romantic language he added to the bare functional details a statement of emotional qualifications for an office building. 'It must be tall, every inch of it tall. The force and power of altitude must be in it, the glory and pride of exaltation must be in it. It must be every inch a proud and soaring thing, rising in sheer exultation that from bottom to top it is a unit without a single dissenting line. . . .'

Perceiving similar emotional content in nature, he produces the final and most significant dictum. 'All things in nature have a shape, that is to say a form, an outward semblance, that tells us what they are, that distinguishes them from ourselves and from each other . . . It is the pervading law of all things organic and inorganic, of all things physical and metaphysical, of all things human and all things superhuman, of all true manifestations of the head, of the heart, of the soul, that the life is recognisable in its expression, that form ever follows function. This is the law.'

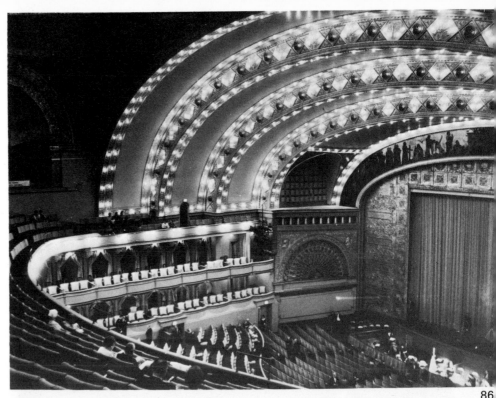

86

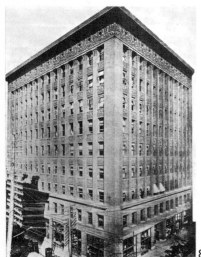

85

87

Once this 'law' is accepted the architectural solution is at hand, for there can be no doubt that each of the defined sections of the building must have its own special character, both in expression and in essence, and be related to the other sections as all parts of a living organism are related. The office building can now be seen not as an individual architectural problem, but as a new type of architecture with its own character. 'And thus the design of the tall office building takes its place with all other architectural types made when architecture . . . was a living art. Witness the Greek temple, the Gothic cathedral, the medieval fortress.'

The condition, the character, the methodology of modern architecture were stated for the first time in Sullivan's writing. And they were also expressed in their first physical form by Sullivan and his partner Adler.

The Wainwright Building is a new architectural type with its interrelated elements. The horizontal spandrels on which each storey rests are recessed to allow the upright piers to flow upwards into the crowning Art Nouveau attic. Absolute honesty is however still not achieved, for only every other pier is structural, i.e. load-bearing, even though they are all given the same form. The cohesion of the building did indeed make other buildings of the period look bitty, but a complete fusion of Sullivan's ideas was still short of realisation.

The Guaranty Building reintroduces the arch, abandoned in the Wainwright Building, but now each arch is matched by a round attic window so that a greater cohesion of the building results. These windows are foreshadowed in a smaller form on the Wainwright Building where they are much more arbitrary.

85 *Adler and Sullivan, Wainwright Building, St Louis, 1890*

86 *Louis Sullivan, Auditorium Building, Chicago, 1887. Sullivan's early essay in combining structure and decoration*

87 *Wainwright Building, detail of elevation*

88 *Wainwright Building, door jamb*

89 *Adler and Sullivan, Guaranty Building, Buffalo, 1895*

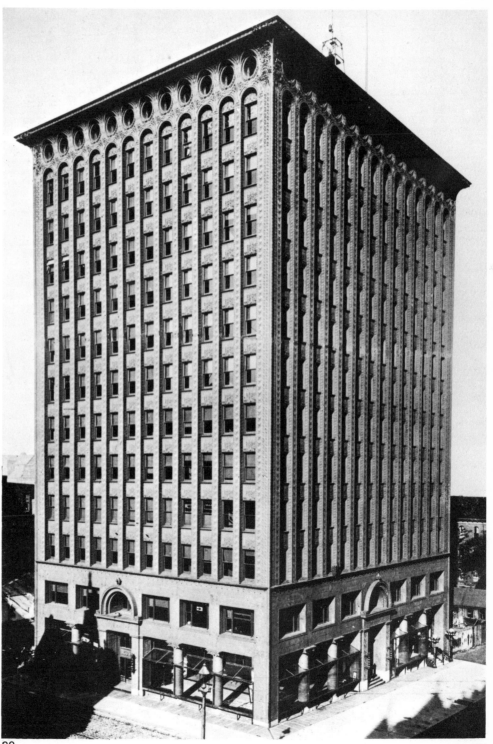

88 89 41

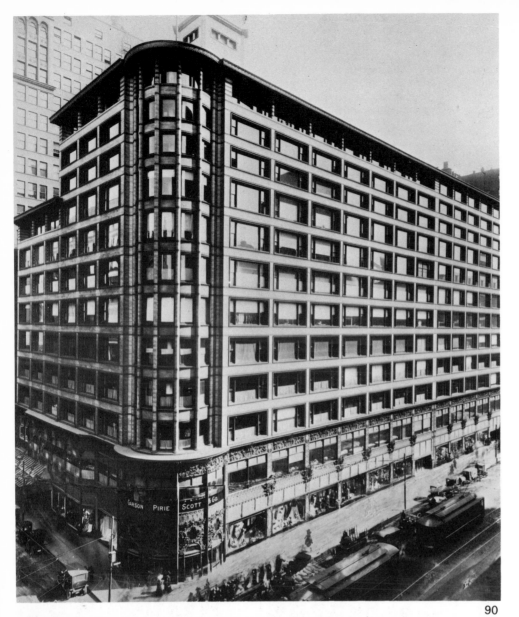

Sullivan in common with other contemporary architects used decoration not simply to embellish a building but also to emphasise the structural elements. In the Wainwright Building uprights and horizontals are not only clearly articulated, by recessing, but also distinguished by decoration. Sullivan was a prolific designer of architectural decoration and produced many different kinds for different purposes. Each example bears the mark of his strong personality.

The Carson Pirie Scott Store, designed in 1899, was Sullivan's fulfilment — and swan song. It was his last large building although he had another 18 years to live.

What has been called 'the world's busiest corner' has been given due attention by the tower-like structure at the corner with a strong vertical emphasis — a common device of nineteenth century architects — and a profusion of Art Nouveau decoration. The rest of the building however shows that form may indeed follow function. The structural grid is exposed and the wide windows fit between the structural members. Because it is a true expression of the steel cage structure the elevation is neutral — there is neither a horizontal nor a vertical emphasis.

Sullivan demonstrated by word and deed that the work of engineers may be put to architectural use, endowing the structures of the twentieth-century world with qualities which meet the emotional as well as the physical needs of human beings. In Sullivan's buildings the structural grid takes the place of traditional elements of classical architecture: column, capital, cornice, etc. Because this principle is a cornerstone of modern architecture Sullivan may be regarded as one of its pioneers.

90

90 *Louis Sullivan, Carson, Pirie Scott Department Store, Chicago, 1899*

91 *Carson, Pirie, Scott Department Store, 'Chicago windows', incorporating fixed and movable panes*

92 *Carson, Pirie and Scott Department Store, ornamental detail*

91

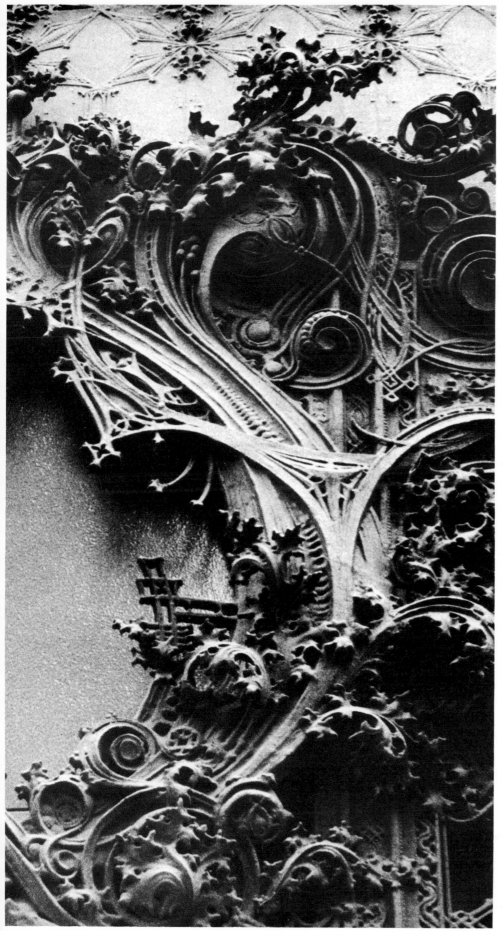

It was, however, Frank Lloyd Wright, Sullivan's pupil and follower, who outstripped his master in the scope of his work, in his influence on other architects and eventually on the evolution of modern architecture.

His Winslow house, built in 1893, already shows some of the traits it will share with several other houses built by Wright during the next 15 years or so: the projecting roof, the division of the elevation into two layers which gives the house a horizontal emphasis, and the incisive clarity of the detailing.

93

94

93 *Frank Lloyd Wright, Winslow House, River Forest, Illinois, 1893*

94 *Winslow House, detail. Clear-cut forms and decoration, the legacy of Sullivan*

92

95 *Froebel blocks*

96 *Detached Imperial Palace Villa of Katsura, Kyoto*

95

96

97

Amongst the earliest influences on Wright's creative life were the building blocks devised by the German educationist Friedrich Froebel. His mother introduced him to these educational toys when he was still a young child and there can be little doubt that this early experience moulded his development as an architect. At any rate, Frank Lloyd Wright himself understood, years later, the role which these revolutionary toys had played. They consisted of basic geometric shapes and it was intended that children, in composing them into larger structures, should thereby enlarge their experience of their environment.

Another influence upon his development was that of Oriental art and architecture. Wright was a collector of Oriental art, he possessed Japanese decorative screens and prints, Chinese vases and other objects. The Japanese house with its simple structure and decorative use of structural elements; its interior organisation of flexible, flowing spaces; its lack of a clear distinction between inside and outside space, and its close relationship with the natural environment – all these exerted a strong influence on him, an influence he would never acknowledge, in spite of the unmistakable evidence of his houses.

Wright's houses may be said to start with the hearth and grow outwards from this central point. The idea was not new. In Elizabethan houses, for instance, it was common for individual rooms to cluster round the central chimney stack, to ensure the best use of the available heat, and in America this plan had been incorporated in the vernacular methods of building. A still more characteristic element of American vernacular building was the porch, often given prominence not merely as an occasional shelter but as an outdoor living area. Both central hearth and extended porch are found in Frank Lloyd Wright's houses. The porch often becomes a cantilevered roof, sometimes a porte-cochère (a coach gate), and the forerunner of the car-port, jutting out from the house, visually emphasised by low, deep roof lines. The dominant character is the horizontal and this had for Wright a very profound meaning. Superficially it may be seen as indicating the sweeping vastness of the American scene, where, at least in the days of Wright's youth, the horizon could be recognised as the most characteristic feature. But there is a deeper meaning. We have it on record from Wright, speaking of one of his buildings, that horizontality is also an expression of man's aspirations: 'I see this extended horizontal line as the

true earth line of human life, indicative of freedom.'

To be free, yet earth-bound; to be human, yet a part of nature; to set down a man-made structure in the midst of rolling country, yet to make it part of the country and of nature – these were some of the seemingly contradictory aspirations which Frank Lloyd Wright resolved through the predominant horizontality of his architecture. Once we have considered them in these terms the ground plans of his houses begin to reveal more about his – perhaps unconscious – intentions. The elements of the plan which point away from the hearth in different directions express, like a symbolic cluster of roadsigns, the idea of democratic freedom. At the same time they are traditional elements whereby the house spreads into its immediate surroundings. Because Frank Lloyd Wright's early houses reflect so much of the character of the Mid-West country, they have come to be known as the prairie houses.

The unified character of the prairie houses is exemplified by the Ward Willits House. Elevation, plan and decoration have the same character; they are different aspects of the same large composition.

98

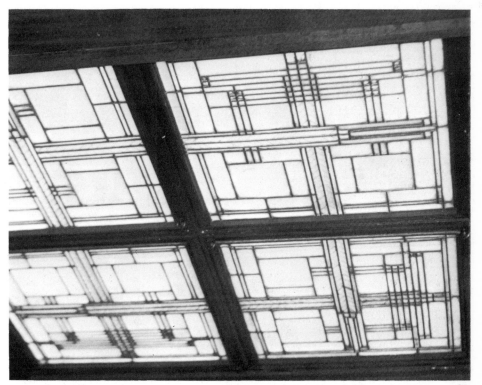

99

97 *Frank Lloyd Wright, Ward Willits House, Highland Park, Illinois, 1900*

98 *Ward Willits House, plans*

99 *Ward Willits House, skylight above stairwell*

45

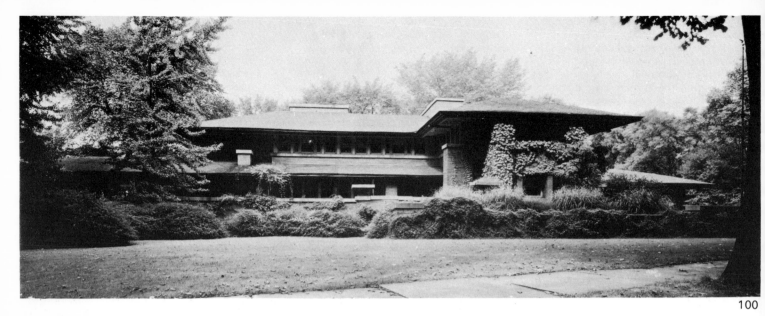

The Martin House seems to belong to the
landscape as though it had always been
there. Its interior spaces are varied, often
containing an element of surprise, low and
intimate.

In the Robie House, which is perhaps the
best example of this period, the chimney
is the highest point, the core of the house.
Descending from this topmost point, we
come first upon the high parts of the house
and then the single-storey wings, whose
walls project onto terraces which in turn
spread into the garden.

Seen from outside the house does not
shoot brusquely up from the ground, but
is always related to it. The meeting place of
house and earth is a crucial area and Wright
gives it a great deal of attention in order to
soften the impact of the man-made on
nature. The transition is effected by short
walls projecting from the house or by
stepping-out of walls or pillars.

Many technical innovations distinguish
Wright's houses from other American
houses of the early years of the century.
Their ribbon windows, built-in furniture,
concealed lighting, heart units (cores which
incorporate all the services of the house),
have become part of common practice in
architecture. Even more significant is the
varied spatial treatment of the interiors.
Living spaces are open and run into each
other, but they are articulated according to
their use — living, eating, cooking etc. — so
that relationships between the parts of a
house are easily grasped. Sometimes the
furniture itself is allotted a role in defining
the interior space. The high backs of the
dining chairs in the Robie House jointly
define the dining area, yet at the same time
leave it open. This new conception of
flowing space is further stressed by the
vertical organisation. Low ceilings,
particularly over the hearth area, stop

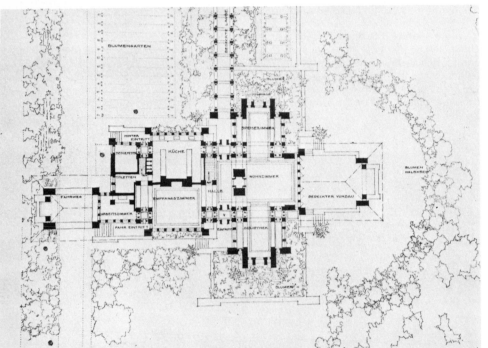

101

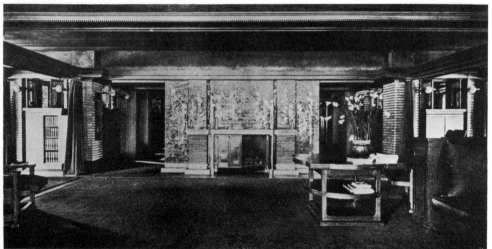

102

46

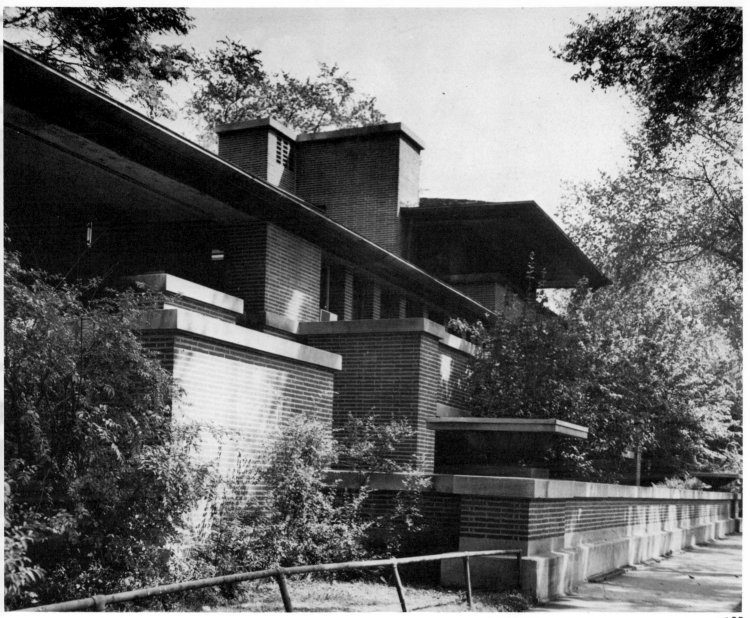

103

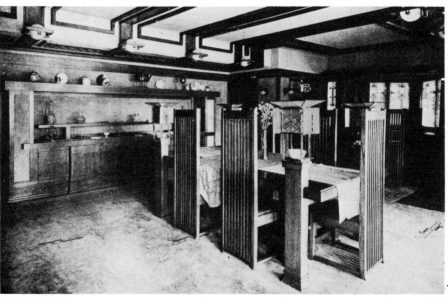

100 *Frank Lloyd Wright, Martin House, Buffalo, 1904*

101 *Martin House, plan. The garden is a part of the architectural scheme*

102 *Martin House, living room. The open plan with its central, free-standing chimney can be appreciated in this view as well as in the plan*

103 *Frank Lloyd Wright, Robie House, Chicago, 1909*

104 *Robie House, dining area*

104

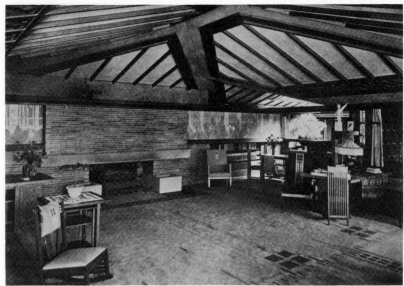

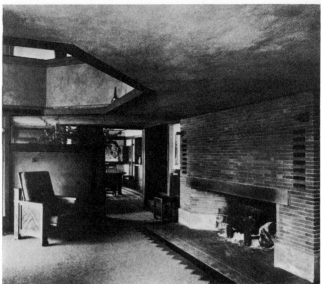

abruptly and allow the space to burst dramatically upwards to the ceiling which in the higher parts is also the underside of the roof. The sloping roof, seen from the inside, makes another link with Wright's origins, the anonymous, indigenous architecture of pioneering America where the roof structure is often left open to the living area. Windows are so placed as to dramatise still further many aspects of the flexible interior space. They are put in unexpected places, in corners where they cannot always be seen yet where they cast a light to make the unusual spatial experience even more powerful.

If the interior of a prairie house can be said to be a dramatisation of human functions, the exterior form is partly a reflection of this and partly a dramatisation of man's part in nature and of the very act of placing his shelter in the landscape.

The overhanging, sheltering roofs emphasise this permanent quality as they parallel the predominant line of the earth. The deep overhangs seem to reach out into the surroundings to scoop up portions of the natural world, or at least the space it contains, so as to establish a close relationship between architecture and nature. The landscaping of the garden is always related to the house, parts of it overlapping in the form of planting spaces left in walls, rooflines curving in to avoid nearby trees, rough outer walls intruding into the inside of the house. The new spatial articulation of the interior — true to the avowed principles of Wright's organic architecture — is mirrored outside where advancing and receding planes are balanced with volumes in complex compositions. In the Robie House space makes itself felt as an active element in the architectural composition. Spaces in Wright houses are never accidental gaps between masses of masonry; they are always recognised and used as balancing elements.

The achievement of Frank Lloyd Wright's early houses is very real in terms of the development of the Modern Movement. In an age of increasing mechanisation and technical sophistication, he restated and redefined basic eternal truths related to the functional and spiritual needs of the individual. He was not the first man to spotlight the functions of modern living, but he was probably the most articulate of his generation in giving them an architectural, and therefore spatial, expression.

His larger buildings of the early period are an extension of the spatial concepts of the smaller houses. The Unity Chapel built in 1906 has a subtle and highly complex articulation of space in all directions. The deep ceiling grid, the balconies, the open form of the staircase, all contribute to an articulation of space far in advance of anything Wright had achieved up to that time both in complexity and subtlety.

In his domestic interiors Wright had often used a horizontal band, like a narrow frieze, at the level of the top edge of the doors. In view of the complexity of the interior space he deemed it necessary to impose a visual order by graphic means and relate the doors to each other. He had also used lines to define the edges of planes.

He was now to develop a subtler use for these linear decorations. Instead of applying them to the edges of planes he let them cross over onto the adjoining plane. The break in direction and the angle between the two parts indicated and emphasised the spatial relationship between the two planes. He employed this device extensively in the Unity Temple, together with other ways of using the same kind of line. Everywhere the line seems to clarify the relationship between planes and consequently the space between them. For instance, the planes of the two re-entrant corners on the side of the pulpit are partly outlined and partly crossed by the lines. One line plunges into the doorway leading to the staircase, and in so doing explores the relationships between planes, solid forms and open spaces. The ceiling grid which holds the skylights is also outlined, and there are lines running up each well to make us aware of the depth of each cube of space. Some double lines are extended from the grid across the ceiling until they meet the windows, thus relating windows to skylights by means of a definition of the intervening planes in space. It is as though Wright had wanted to be sure that all the intricacies of the space he had created would be appreciated. In the process he produced what is probably the first modern example of a definition of architectural space.

105 *Frank Lloyd Wright, Coonley House, Riverside, Illinois, 1908*

106 *Frank Lloyd Wright, Roberts House, River Forest, Illinois, 1907*

107 *Frank Lloyd Wright, Unity Chapel, Oak Park, Illinois, 1906*

108 *Unity Chapel, detail*

109 *Unity Chapel, lamps*

107

108

109

4 The Periphery

CHARLES RENNIE MACKINTOSH

Art Nouveau may have received its first impetus in England, but in its fully developed form it found little favour there. Some of the products of the Arts and Crafts Movement at times assumed Art Nouveau forms, while Liberty's, the London store, took up the cause of Art Nouveau with merchandise of varied kinds and in particular fabrics, but on the whole the Arts and Crafts Movement rather than Art Nouveau remained the chief expression of modern English design. Arts and Crafts represented English tradition and traditionalism, and Art Nouveau was resisted as a foreign style.

Scotland did not follow England. In that country a group of young designers – later known as the Glasgow School – achieved a unique fusion of tradition with a Scottish adaptation of the new style. The group included the sisters, Margaret and Frances Macdonald, Herbert MacNair, and Charles Rennie Mackintosh, undoubtedly the leader and moving spirit. In Mackintosh's work nineteenth century architecture and design came as close as they could to the twentieth century without actually becoming part of it.

Mackintosh's work and ideas were derived from the Arts and Crafts movement. Like Voysey he believed in a common-sense rather than an academic approach to architecture, and in a revival of simple traditional forms in preference to stylistic ones. To Voysey this return to tradition meant a development of the English cottage style, whereas to the Scotsman, Mackintosh, it meant a revival of some aspects of Scottish baronial architecture, with its massive, functional squat and rounded forms and crisply cut stonework. There, to him, lay honesty in building.

From very early in his career Mackintosh was interested not only in architecture but also in various crafts and in these fields his work developed an entirely different quality from the dour baronial style. As a designer of decoration he created his own version of Art Nouveau, which was both unique and at the same time a highly suitable foil to the austerity of his architecture. The Studio magazine which reproduced work by Beardsley and other artists with Art Nouveau tendencies seems to have been the main source of Mackintosh's Art Nouveau development. It is difficult not to see a connection between the glass panel designed by Mackintosh in or just after 1896 and Beardsley's drawings like the one shown here. But even in so early a work, Mackintosh's individuality is obvious. Delicacy is never introduced at the cost of weakness and the robust strength of the design is evident in the emphatic uprights and horizontals. The whole design is most lucidly related to the frame. As Mackintosh grew in stature as an architect, so his decorative work became more structural in character.

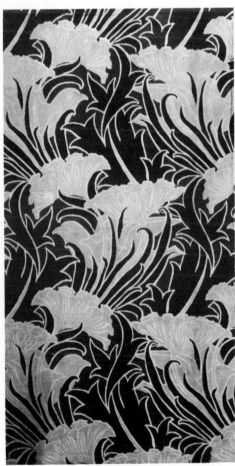

110

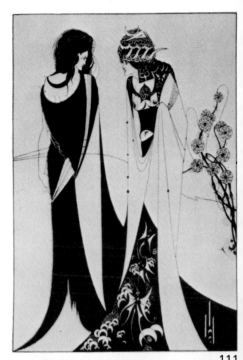

111

112

110 *Charles Annesley Voysey, fabric design, 1900. The influence of Art Nouveau*

111 *Aubrey Beardsley, John and Salome, 1894*

112 *Charles Rennie Mackintosh, glass panel, 1896*

As an architect Mackintosh's chief work was the Glasgow School of Art.

A first glance at the main façade gives us a somewhat ambiguous picture: large windows of a completely unadorned grid but with decorative iron work in front of them, flanking a central section which is at once austere and romantic. However these — and other — contradictions are resolved by the way in which they are woven into one grand design. The large windows seem to derive from the English functional tradition of engineers while the middle section has overtones of that stream in English architecture which stressed traditional methods as best suited to the expression of 'truth' and 'honesty'. This central section includes an office on the ground floor, next to the entrance, the director's office above and the director's studio on the highest floor. A small window is inserted in the baronial tower, rather like a gun port in a fortress, but the tower houses nothing more martial than the director's staircase to the studio above his office. In fact the design might seem rather selfconsciously demonstrative and declamatory, but those were the days when modern architects felt impelled to state their new aims boldly and even with exaggeration. Although the forms do hark back to a romantic past the usage and the context are modern — modern that is, and the point is worth making again, in nineteenth century terms.

Mackintosh's expression of the essence of the building is reinforced by his regard for the nature of materials. The forms he creates centre round the function of the building but they are also in harmony with the materials of which they are made. The centre section of the main façade, massive and clean-cut, is as much in sympathy as a baronial castle with the stone of which it is built. The metalwork, whether functional like the screens and gates or ornamental like the lamp fittings, is always in shapes derived from the character of the material. Ornaments are not introduced for their own sake; they arise from a functional need, stressing, often in an expansive way, the

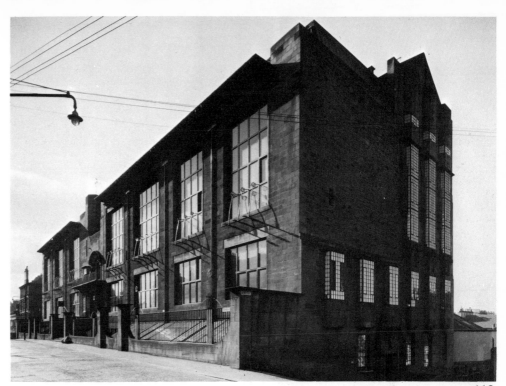

113

113 *Charles Rennie Mackintosh, Glasgow School of Art, 1896*

114 *Glasgow School of Art, main entrance*

114

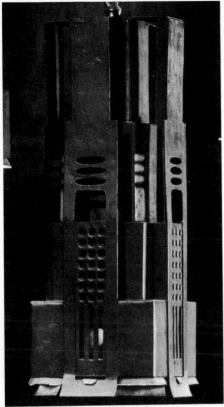

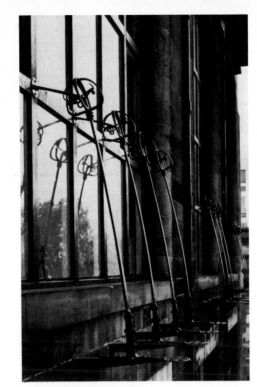

— 116

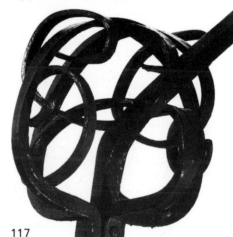

117

118

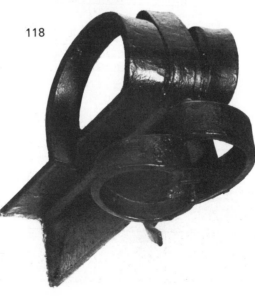

115

structural importance of a member. For example, the brackets on the front of the building provide rests for the window cleaner's ladders and at the same time give some bracing to the very large window grids. They also provide Mackintosh with an opportunity to indulge in wrought iron decorations at the angle of each support. These decorations relieve the austere parts of the façade and anticipate by many years future developments in sculpture. The ends of girders in one of the studios come in for similar decorative treatment. Instead of allowing the free ends to project Mackintosh asked the blacksmiths to forge the ends into shapes of his design. Wherever possible Mackintosh exploited functional needs as opportunities for visual enrichment.

The library was the last part of the school to be completed and shows Mackintosh's mature style. The beams carrying the gallery project beyond its width to the point where they meet the uprights. Here on either side of the main structural

115 *Glasgow School of Art, hanging lamp in the library, 1908*

116 *Glasgow School of Art, window brackets*

117 *Detail of window brackets*

118 *Girder end*

uprights Mackintosh introduces shorter wooden pillars to receive the twin beams. These shorter pillars are made narrower to mark their separateness. This again is typical of much of Mackintosh's work: structures are always expressed, even over-expressed. The decoration in the library is in the form of chamfering and carving, the former derived from traditional wagon work. As a demonstration of craft-quality — in contrast to mass-production — the carved ornaments on the aprons of the gallery are all of different designs, although of course conforming to a common character.

In spite of occasional curves and undulations the main impression of the library is one of squareness of a much more severe type than in the earlier part of the building. This tendency can be observed in other aspects of Mackintosh's work. If we look at the chair of 1897 and the one produced seven years later, or compare an earlier light fitting with the one of 1908 we shall notice an increasing preponderance of verticals and horizontals, while ornament becomes rarer, less arbitrary, and more closely related to the structure. This can also be confirmed by a comparison of the two side elevations of the School of Art, the east elevation built in 1899 and the west elevation, part of the library wing, completed in 1909. The east elevation, with its arched window, tower and curved roof, is very much in keeping with the front, but the west elevation speaks a different language, or at least uses a different accent. Visual relationships are here resolved by what can only be described as a new aesthetic, a more emphatic approach. The massed windows which light the very high library are unified with those of the floors above and below. The device is not altogether new and is anticipated — in a more traditional manner — on the front of the building to the left of the main entrance. What *is* new is not the use of large areas of glass (also anticipated by the large studio windows on the front and by many engineering structures) but the uncompromising quality they now possess. What on the east elevation may still be seen as a collection of bits and pieces is here resolved into one overriding pattern. The diverse elements which we noticed on the front elevation — baronial, Voysey-traditional, functional-traditional — and which there are still separated (although part of one overall design), are now brilliantly resolved into one fluent idiom. A comparison of the two entrance doors is equally enlightening. The tightly drawn Art Nouveau decoration above the door on the front has here given way to a larger, more massive decorative element with a decided rectilinear character. The main impression is of an overall massing together of what on the front and east elevations are still isolated features.

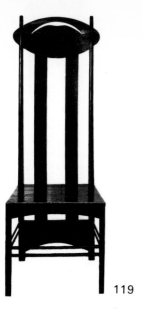

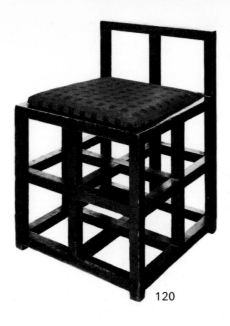

119

120

121 *Charles Rennie Mackintosh, Glasgow School of Art, east elevation*

122 *Glasgow School of Art, west elevation*

123 *Glasgow School of Art, the library*

124 *Glasgow School of Art, entrance, west elevation*

121

119 *Charles Rennie Mackintosh, dining chair, 1897*

120 *Charles Rennie Mackintosh, low-backed chair, 1904*

123

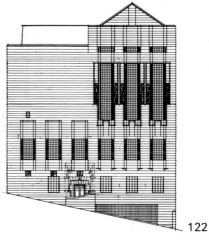

122

124

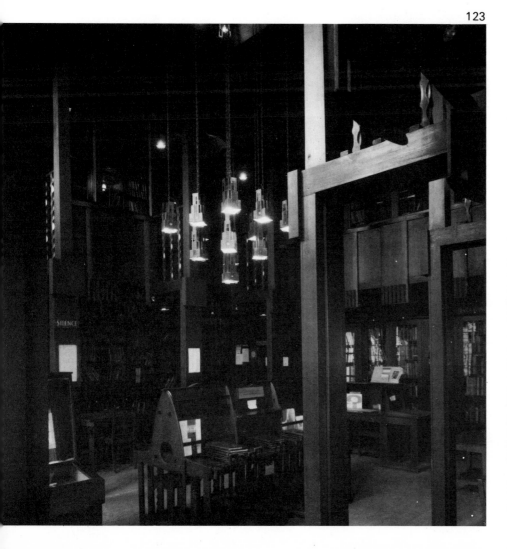

Round the corner, on the south elevation of the library wing, the window treatment is somewhat different. None of the windows projects beyond the plane of the wall; some are flush with the wall, some are inset, others repeat the form of the bay windows of the west elevation, their central panels flush and their sides cut into the wall. The window at the top is also of this type, but since the roof line follows its upper edge it appears as a shape almost detached from the building. The bay window motif, although applied differently, acts as a unifying element between the two sides of the library wing.

The windows are oddly proportioned. Some are very narrow and high, others are several times as wide as they are high, and others again come in between these two extremes. The large areas of windowless wall are another unusual feature of the south elevation.

If we examine the complete south elevation, these characteristics become even more apparent. As elsewhere, the forms are an expression of function. There is a sloping roof with a skylight which lights the room above the library, originally used for flower painting. The conservatory which is cantilevered from this level must have been a useful adjunct to the flower painting room. The different window sizes can also be justified by their function. It is reasonable, for example, to expect a store room or a cloak room to need smaller windows than studios or a library. One cannot, however, help feeling that the differences cannot be wholly justified. It is as if Mackintosh needed to stress the different window sizes rather as he stressed — or over-stressed — the forms of the

building and the joints of the timbers. Because this matter is of paramount importance not only in the development of Mackintosh's own work but also in the development of the Modern Movement itself, we must examine it in more detail.

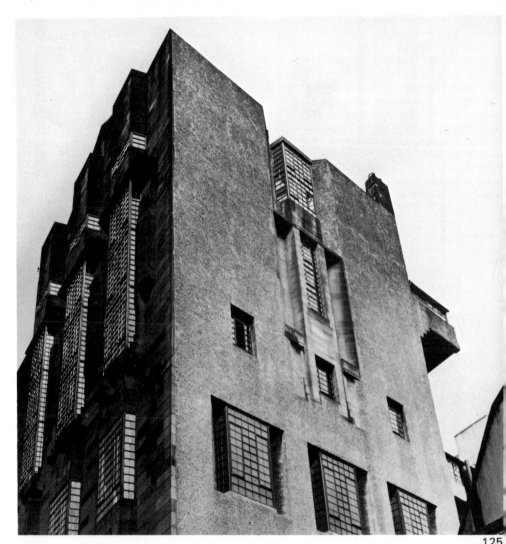

In the confrontation between honest and truthful architecture on the one hand and historicism on the other, the principle of allowing the plan of a building to determine the elevations occupied a central place. This meant quite simply that the outward appearance of a building should not belie its purpose and the disposition of spaces within it and that the windows should be arranged according to convenience and not according to a classical order. Such functional arrangements were usual in medieval buildings and rural houses and were taken up by progressive nineteenth-century architects, like Webb and Godwin. But honesty could not be left to chance, it had to be displayed. Architectural forms as well as the forms and positions of windows began to express more of their function than was strictly necessary.

Even when the position and sizes of windows are determined by convenience, an architect still has a considerable amount of freedom in their arrangement. Small differences in alignment can be eliminated or emphasised, proportions can be adjusted for visual rather than functional reasons. In an architecture which seeks to achieve honesty of function and of expression, ornament cannot be vital and consequently the architect may seize on the fenestration – the arrangement of windows – to give a building its outward character, its face. The fenestration of Webb's Red House and Godwin's White House is not purely functional but also has a visual element.

By now Art Nouveau had spread among younger architects and designers everywhere and the main characteristics of the style invaded architecture as they did every other field of design. Expression of function received a new visual emphasis. Architects like Victor Horta used the sinuous Art Nouveau line to express function and structure and to relate doors, windows, balconies and decoration. In the work of Mackintosh, by contrast, Scottish commonsense forbade any excessive tampering with the structure of a building and he drew on another aspect of Art Nouveau. In their urge to produce something revolutionary and startlingly modern, Art Nouveau designers had designed furniture in which the shapes and disposition of spaces and the relationships between them had become unusual, often extreme, and it was the same new approach to relationships between open and solid forms which produced the original and unusual fenestration of Mackintosh's buildings.

In this design for a country cottage of 1901, planned for an artist whose name we do not know, Mackintosh showed his talent for abstract architectural composition. Although the project is not sufficiently

125 *Glasgow School of Art, library wing, south-west corner*

126 *Glasgow School of Art, south elevation*

127, 128 *Different possibilities of functional fenestration*

129 *Charles Rennie Mackintosh, design for an artist's country cottage and studio, 1901, east elevation. University of Glasgow*

130 *Design for an artist's country cottage and studio, south elevation and plan*

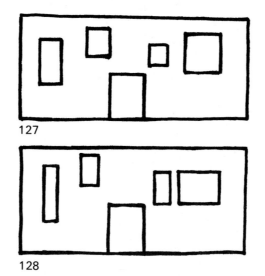

127

128

129

worked out to make it a practical undertaking, it gives an insight into his architectural thinking which might not be so evident in a completed work, modified by the client's tastes. The arrangement of rooms is simple and, as in all Mackintosh's work, suited to the pattern of life of the intended inhabitants. The outside is however most sophisticated. Apart from the strange roof line and the sloping walls the most unusual feature is the uneven distribution of the windows. Referring to the plan, we can see that these occur just where they are needed: the tall window between the chimneys is for the staircase; of the three small windows on the first floor, south elevation, the one on the extreme left belongs to the boxroom, the other two to the bedroom; and so on. But who can doubt that each window was placed with great circumspection and deliberation not only for functional reasons but also for original visual effect? The ones which border on the chimney stacks relate the stacks more closely to each other and to the house, making their positions less arbitrary. The south elevation has one very wide window divided into three at ground level, three small windows, like an echo, at first floor level, and a disproportionate blank area. The whole effect is novel, strange and arresting – and must have been more emphatically so at the date when the drawing was made – like all the best of Art Nouveau. Each aspect of the house is a carefully considered visual composition of striking originality, but the whole construction can still be justified as a practical one.

We have seen the whimsical arrangement of windows in Godwin's White House. Other architects, Norman Shaw for example, could also produce highly original elevations. It is however in Mackintosh's work that we see the application of this principle in an extreme form and, even more important, in abstraction and free from historical associations.

130

When in 1901 a German publisher set a competition for the design of a house it was won by the English architect/designer, Baillie Scott, with a comparatively traditional design. Mackintosh received only second prize but his entry was acclaimed by architects and designers throughout Europe and must have exerted considerable influence although the exact extent cannot of course be precisely measured. His basic creed of expressing externally the internal functioning of the house is again evident. The house is not one overall, unified structure but a series of articulated shapes, differentiated by function. For instance, the staircase is allowed its most logical form with a semi-circular landing and shown from the outside in unadorned and unconcealed starkness. The lady's room is oval — to give it a feminine character — and its window breaks through the plane of the wall to indicate the curved nature of the room behind it. Other windows and walls are curved — often for visual reasons — and add to the complexity of the house. The children's room can be seen as a shape of its own at second floor level, its abrupt wall giving the building its characteristic outline. It also indicates the extent of the lobby at ground level. Once again windows play an important part in the visual organisation. Cornices are as far as possible done away with and within the clearly outlined areas of the elevations the windows are placed with unfailing sureness. Elevations and individual features are drawn together by the relationships between the windows. The curved window of the lady's room is balanced by another round the corner, this one flat and inset into the wall. The drawing of the east elevation shows some of the more striking relationships. The two windows of the top floor are aligned and equal in size. The window on the adjacent wall to the right is related through horizontal alignment, the one below by symmetry. The former in turn is aligned vertically with the large window below, which is aligned with the one on the right and symmetrically related to the still lower window and to the door. The structure of the whole building is therefore brought together by the relationships between the windows. It will furthermore be noticed that the tall poplars and the round, unnamed trees correspond to the tall and squat elements and windows of the house. Landscape and architecture are drawn into unusually close harmony.

131

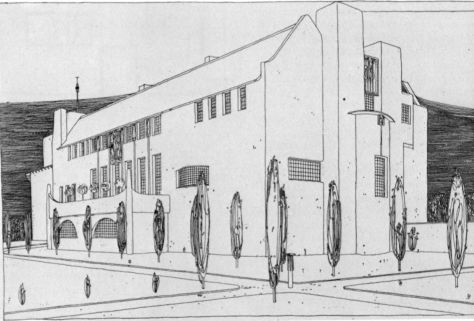

132

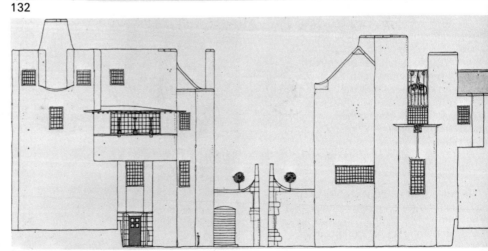

133

131 *Charles Rennie Mackintosh, house of an art lover, 1901, perspective from south-west*

132 *House of an art lover, perspective from north-west*

133 *House of an art lover, east and west elevations*

The designs which Mackintosh produced for the interior of the house show his characteristic tall, elegant, tense decorations. The tall structural and decorative elements of the music room are matched by the high-backed chairs grouped round a table. This group forms a near-enclosure, a space vaguely defined by the high chair backs within the larger space of the room. Mackintosh used this device again in the design for a tearoom in 1904, where similar high backed chairs create an enclosure round each table. It is reminiscent of the dining area in Frank Lloyd Wright's Robie House.

The competition house was never built and we have only Mackintosh's drawings to show how he intended the interior to be organised. It is the completed houses which give a better idea of Mackintosh as a designer. Hill House, built in 1902, features built-in furniture as part of the construction. The bedroom wardrobes — their decoration still recognisably Art Nouveau but less

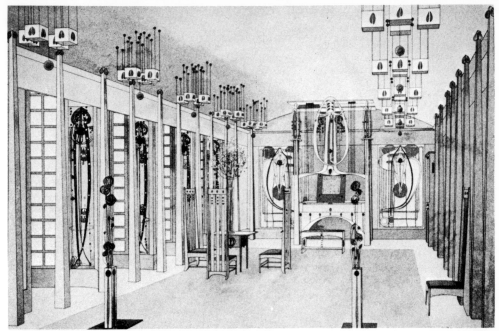

134

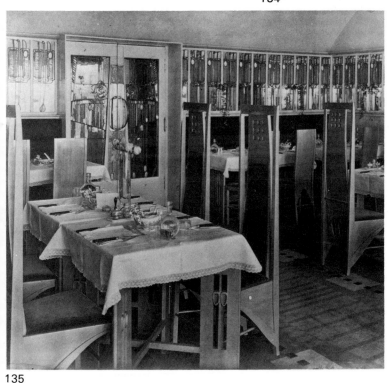

135

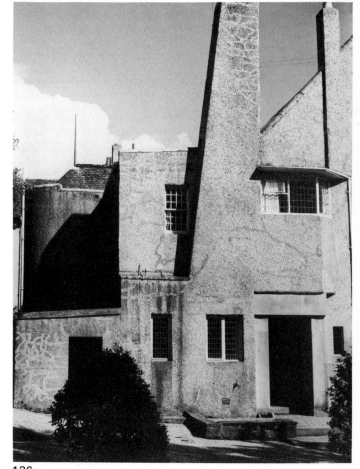

136

134 *Charles Rennie Mackintosh, house of an art lover, music room*

135 *Charles Rennie Mackintosh, Miss Cranston's Willow Tearooms, Glasgow, 1904. The Room de Luxe*

136 *Charles Rennie Mackintosh, Hill House, Helensborough, 1902*

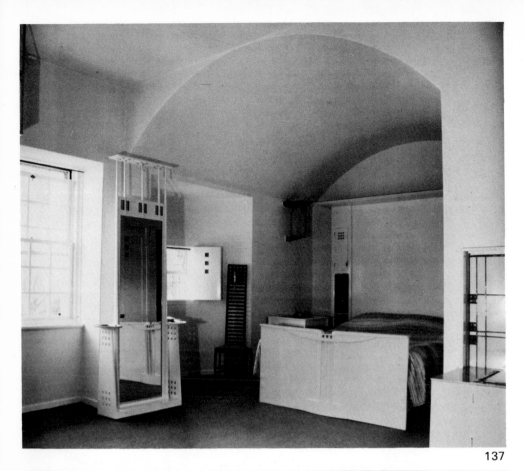

137

florid, more structural and tightly charged — are built into the structure and aligned at the top with windows, doors and lamp. The drawing room also has built-in furniture: a window seat, with magazine racks. A sub-space in the window recess is defined by the uprights of the construction. There is a clarity about this room which begins to show its modernity. A thin moulding unifies the ceiling line of the recess with the top edge of windows, doors, fireplace and fitments. The walls are painted green up to the moulding and above it dark, like the ceiling. This gives the effect of a uniform ceiling level and of one total space. Room and recess may be seen as one space, defined by the light green walls, and the upper part as another related space — a light space and a dark space. But another interpretation is possible. We may think of the room as a space whose extent is marked by the dark ceiling and — roughly — the carpet, while the window recess forms another related space, with a different function. The curtain which draws across just in front of the garden doors to shut out part of the recess when it is not wanted, for instance on dark winter nights, makes further spatial modulation possible.

Mackintosh occupies a unique position in the history of the Modern Movement. It is easy to see his derivation from his own Scottish background, the Arts and Crafts Movement and from Art Nouveau. He took what he needed from them and welded these disparate elements into a unique and strongly personal visual language. A comparison between one of his chairs and those of Godwin and Voysey establishes his descent quite clearly. A comparison of the bedstead he designed in 1900 and a contemporary French Art Nouveau bedstead highlights the essential difference between his work and European trends. Even his decoration is structural and taut, which gives it a forward-looking character.

On the one hand Mackintosh created buildings, objects and ideas which have a twentieth century character; on the other hand his traditionalism was more deeply entrenched than is often realised. It may be relevant to bear in mind that at about the time of the completion of Sullivan's Carson Pirie Scott Store in Chicago, Mackintosh in Glasgow was denying the advent of modern architecture. '. . . the eye is distressed at huge lofty tenements resting to all appearance on nothing more stable than plate-glass. . . . These two comparatively modern materials, iron and glass . . . will never worthily take the place of stone . . .' With this statement Mackintosh labelled himself a man of the nineteenth century.

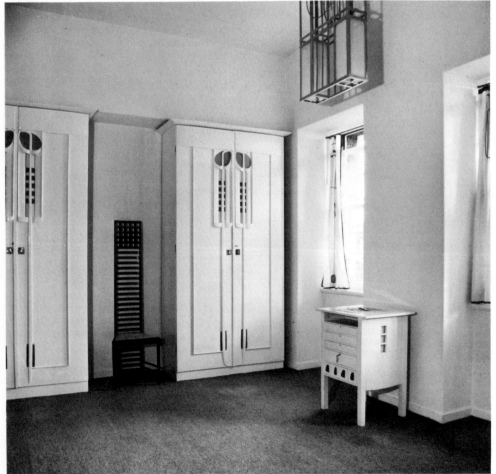

138

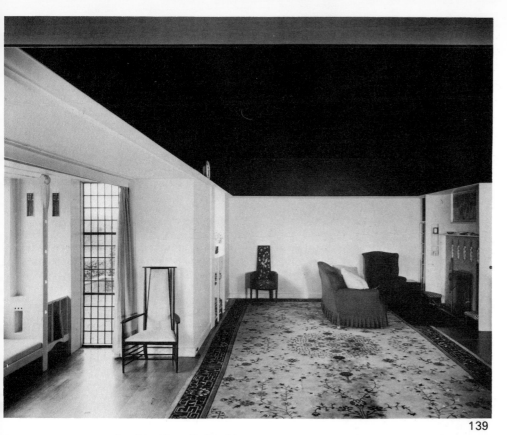

139

140

It may seem strange that Mackintosh should come from a town on the periphery of the European movement. It is even stranger that he should have found success and influence in another town situated at the farthest point of the same periphery.

141

137, 138 *Charles Rennie Mackintosh, Hill House, the bedroom*

139 *Hill House, the living room*

140 *Diagram of living room and different interpretations of space*

141 *Pérol Frères, bedstead, 1900*

142 *Charles Rennie Mackintosh, bed-end, 1900*

142

In Austria, and more particularly in Vienna, Art Nouveau arrived rather late. A group of young Viennese artists and designers, reacting, as artists and designers did elsewhere, against the historicism of so much in their environment, banded together to form an association which they named the Secession. In their work, and in the pages of their periodical *Ver Sacrum*, the ideals of Art Nouveau found full expression. Their social awareness was strong and they saw the integrating tendencies of the new art primarily as an effort for a better human environment and as a social challenge. In Vienna as elsewhere 'applied' art was given the full status of fine art.

Viennese Secessionist art and design were from the beginning different from the Art Nouveau of most of Europe. The sinuous line was certainly present, at least in the early days, but it lacked the intricacy, the sophistication and mystery of, for example, French Art Nouveau. Clarity was an outstanding quality of Viennese design and

even where a convolute line was used it always had a peculiarly clear and constructive character. The use of symbolic ornaments was rare in Vienna, where geometric shapes were often used as elements in decoration.

Josef Hoffmann's display cabinet has several discretely curved outlines which place it in the sphere of structured Art Nouveau – perhaps somewhere between Mackintosh and van de Velde. Notice the openings in the top through which a bouquet emerges. The picture frame, too, has the sober kind of Art Nouveau curvature. Even the wall and floor decorations – reminiscent of Mackintosh – have an unusual clarity about them. But this designer produced work with even more marked structural qualities.

The later drawing by Hoffmann shows a bed-sitting room. The patterns are for the most part simple and geometric and this common character running through the

different patterns results in a unification, an integration, so that the individual pieces add up to something larger than their joint sum. But there is even more to this design. The concept of the total interior as an object of design emerges with a modern clarity which is surprising at so early a date. This clarity stems from the fact that the individual items are drawn together by their articulation in space rather than by their common style of decoration.

Other Art Nouveau designers had created integrated schemes by means of the common character of the ornaments they applied to various individual pieces, but their use of spatial relationships was not of primary importance. In Hoffmann's design it is of the essence. The patterns themselves, because of their austerity, define the planes in which they lie. The rectilinear divisions of space at ninety degrees to each other – the most comprehensible of all space articulations – dominate this design. The pieces are relevant to each other in a

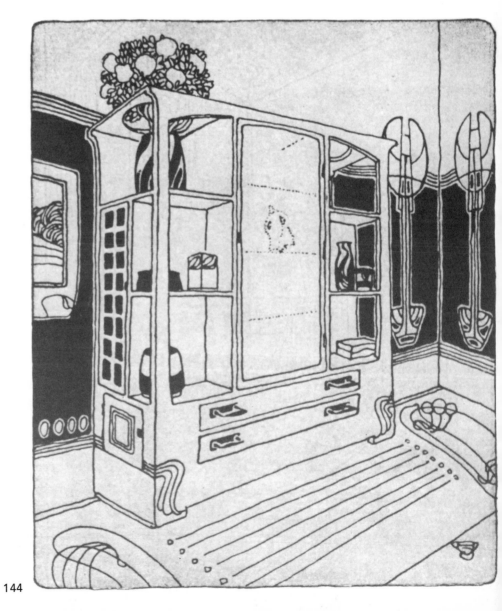

143 144

spatial sense and the total space is subtly subdivided by the curtain and the open screens which let us see the space beyond. Note how even the pattern of the tablecloth clarifies the relationship between its two planes, the one which lies on the table top and the one which hangs down. There is no doubt that this is no mere national variation of Art Nouveau, but an entirely new departure.

The chair which Hoffmann designed a few years later for his first large building shares some of the characteristics of the bed sitting room. As the later work of Mackintosh and van de Velde, it can no longer be described as Art Nouveau.

In the same year, 1898, Joseph Maria Olbrich designed a building to house Secession exhibitions and other functions. Its clear block-like articulation of geometric shapes establishes it at once as a near-relative of Hoffmann's design. The main theme is the contrast between cubic and spherical shapes — the cupola and the clipped box trees on either side of the entrance. The linking of an architectural

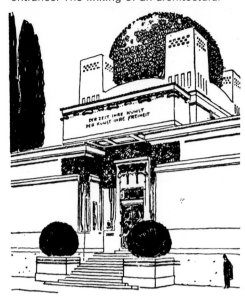

143 *Viennese Art Nouveau decorations, 1898*

144 *Josef Hoffmann, design for an interior with display cabinet, 1898*

145 *Josef Hoffmann, design for bed-sitting room, 1898*

146 *Josef Hoffmann, chair, 1903*

147 *Joseph Maria Olbrich, Secession building, Vienna, 1898*

147

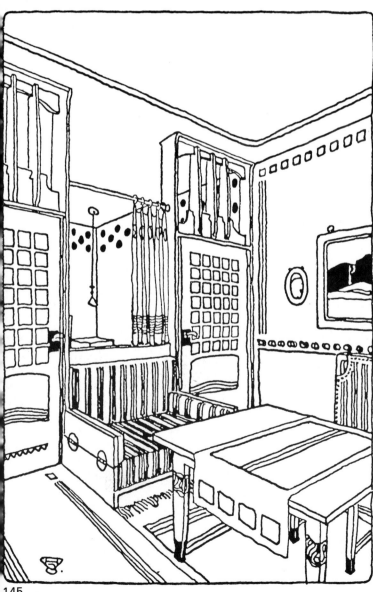

145

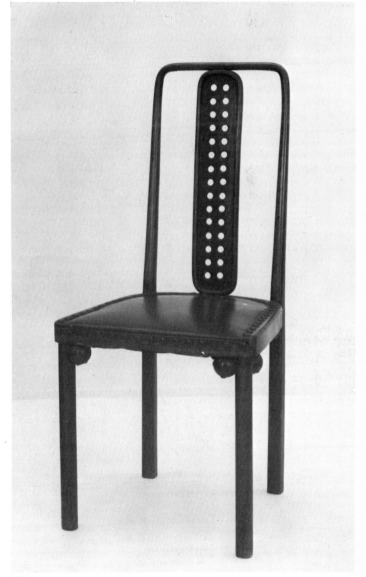

146

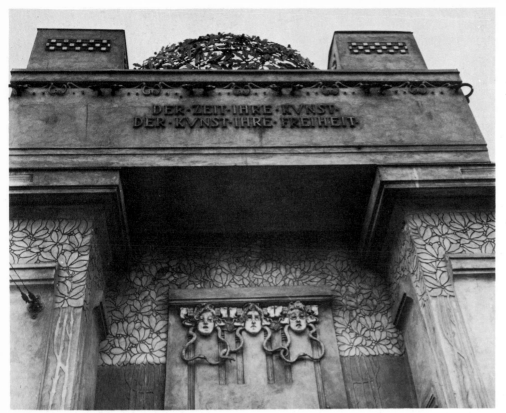

148

149

element with natural ones is common in other phases of late nineteenth century progressive architecture and can be seen as part of the desire to bring about a fusion of architecture and nature. We found it in Frank Lloyd Wright's work and in a different sense in the work of Charles Rennie Mackintosh.

Olbrich's geometrical architecture is still encumbered by masses of ornament: trees growing up on corners and filling friezes with their foliage, rows of mythological heads, many abstract geometrical patterns. The richness of the decoration is however never allowed to distort the actual architectural forms. A great part of the decoration is indeed geometrical too — squares and circles; and this tendency is even more noticeable in Olbrich's later work in Darmstadt.

148, 149 *Secession building, details*

150 *Josef Hoffmann, samovar, 1904*

151 *Josef Hoffmann, cutlery, 1904*

152 *Josef Hoffmann, desk, 1905*

153 *School of Kolo Moser, part of a coffee service, 1905*

It is difficult to explain why Vienna was out of step with much of Europe. Perhaps it was the result of Mackintosh's influence, at least in part. His designs first appeared in The Studio in 1897, the year before the rectilinear, structural style made itself evident in Vienna. It is in any case easy to understand why a designer of Mackintosh's character should meet with admiration and success among a group with the outlook of the Secession. In 1901 he was invited to exhibit at the Secession and in the following year he executed work for a Viennese client.

The Eighth Secessionist Exhibition, held in 1901, had an international flavour. Amongst the foreign designers represented were Henri van de Velde, C. R. Ashbee, C. R. Mackintosh and his wife Margaret Macdonald. The main theme of the exhibition was interior design, with whole rooms conceived as unified schemes. Ashbee's furniture was considered, by Viennese critics, square and ponderous, but they gave high praise to Mackintosh, and there can be little doubt that as a result and from that time on Mackintosh had considerable influence on Secessionist design.

The Secession was, however, soon to lose many of its most talented members. Olbrich was lured to Darmstadt to join the artists' colony assembled there by Grand Duke Ernst Ludwig. Soon after, in 1903, several prominent members of the

Secession — Hoffmann, Klimt and Moser — resigned over matters of policy and joined with other designers and artists to form the Wiener Werkstätte, the Vienna Workshop. The project was financed by Fritz Wärndorfer, a young banker with an insatiable enthusiasm for modern art and design, who had been one of the first benefactors of the Secession. In 1903, returning from a visit to London, where he had seen Ashbee's workshops, he discussed with some of the ex-Secessionists the idea of a workshop in Vienna. As a result the Wiener Werkstätte was established as an association of craftsmen somewhat along the lines of a guild. Although they marketed their wares as a body, each master craftsman signed his own work. Hoffmann soon dominated the Workshop. He designed a wide variety of objects: tableware, cutlery, jewellery, and of course furniture. Mackintosh's influence on Hoffmann can be seen in the way he relates ornament of Art Nouveau derivation to cube-like masses, but this relationship — and the nature of the ornaments and forms themselves — is more relaxed than in Mackintosh's work. It has little of Mackintosh's tenseness and capriciousness. Koloman Moser was also an outstanding designer in the Workshop, but few of the other members were distinguished. Most of them produced work which was merely modern, often fashionable in a distinctly Viennese sense, even pretty, but no more. In spite of repeated financial troubles the Workshop survived well into the 1930's.

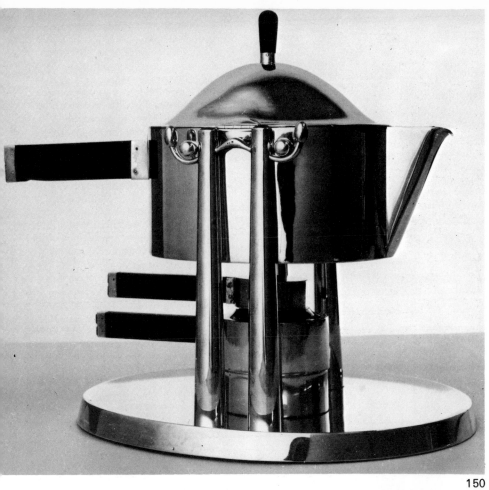

150

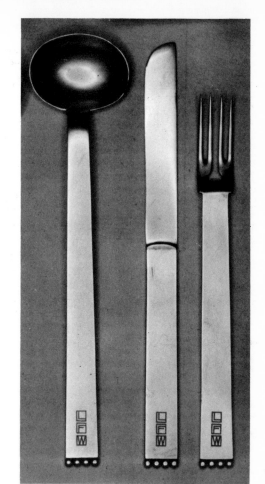

151

152

153

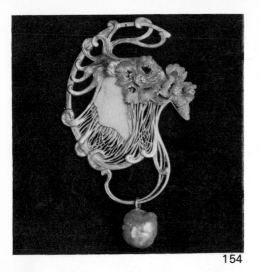

154

155

156

157

Die Haustür geht.
Sie kommt, sie kommt.
Und = da ist sie.
Hast du mich aber lange lauern lassen.
„Ich konnte doch nicht eher . . .
Oh, die Rose, die Rose."
Hut ab erst.
Stillgestanden!
Nicht gemuckst.
Kopf vorwärts beugt!
Und ich nestl' ihr
Die gelbe Rose ins schwarze Haar.
Ein letzter Sonnenschein
Fällt ins Zimmer
Über ihr reizend Gesicht.

(Aus „NEUE GEDICHTE".)

158

The structured character of Viennese design at the turn of the century could be observed not only in architecture, furniture, and interior design, but in other fields too. It was, as we have seen, the aim of Art Nouveau artists and designers to fuse several elements into one whole with a common character. The design of the printed page was also approached in this spirit. The design by the Belgian designer Lemmen owes its harmony to the related character of type and ornament. The difference between Lemmen's design and an average page design in *Ver Sacrum* is comparable with the difference between the work of Lalique and Hoffmann. The *Ver Sacrum* decoration is structural, in the sense that Hoffmann's and Mackintosh's decoration is structural. The different elements are drawn together not only because of their similar character but by their clearly articulated position on the page, and by their clear spatial relationships akin to those in Hoffmann's designs. The elements of decoration and type were not usually similar in *Ver Sacrum* pages, but they were held together by their composition, much as a painting is held together.

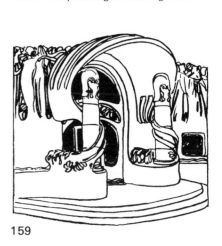

159

160

The position of shapes on a background, their relationship to each other and to the edge of the field on which they were placed, became the foremost criterion of design. In 1901 an article by A. Hölzel in *Ver Sacrum* discussed the perceptual effect of different arrangements and compositions. The shapes, as can be seen, are abstract, and the writer's only concern is with purely visual effect, balance and tension. This preoccupation with composition, the abstract structure of visual elements, rather than with the expressive quality of naturalistic representation can be seen as a logical development of the Symbolist standpoint. Hölzel's analysis of the balance between forms and the spaces between them seems to rationalise inherent qualities of much Art Nouveau work.

Four years before the *Ver Sacrum* article, in 1897, August Endell, a German architect, had written in similar terms about architecture. Discussing the impression a building might make, its emotional effect, he stressed not as earlier architects might have done the nature of ornaments and historical associations, but instead the effect of proportions and divisions of areas, such as windows.

Attention to structure, to proportion, to composition, came to take the place of the curvilinear unifying theme of Art Nouveau. Josef Hoffmann's Palais Stoclet in Brussels, which he designed for a Belgian industrialist, in 1905 must be seen in this context.

The rectilinear character is emphasised by narrow decorative bands which delineate the edges. As in Mackintosh's Glasgow School library the windows break into the roofline, but even more drastically, and there is no cornice. The hall with its

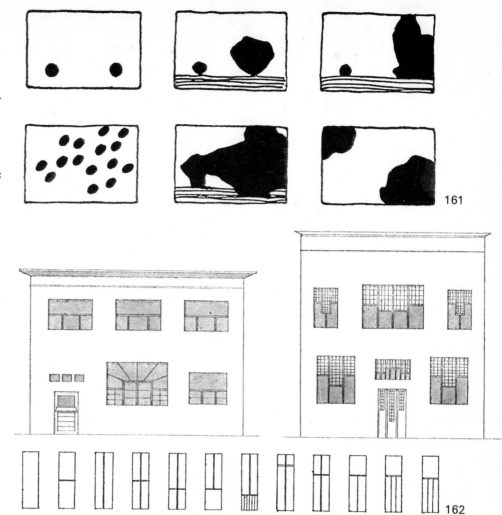

161

162

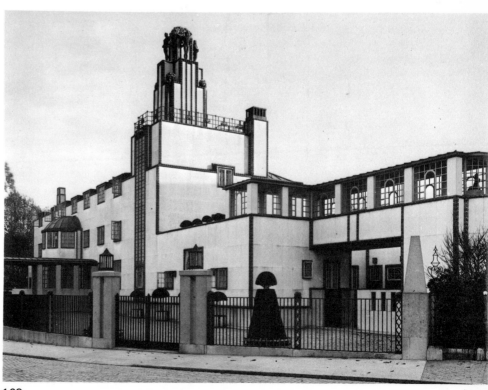

163

154 *René Lalique, pendant, 1900*

155 *Josef Hoffmann, buckle, 1905*

156 *Georges Lemmen, advertisement, 1897*

157 *Josef Hoffmann, buckle, 1908*

158 *Josef Brockmüller, typographic setting for a poem, 1901, from Ver Sacrum*

159 *Josef Hoffmann, design for an entrance, 1898*

160 *Josef Hoffmann, decorative panel above an entrance, 1902. Another example of the breakaway from Art Nouveau*

161 *Adolf Hölzel, diagrams of compositions, 1901*

162 *August Endell, diagrams of proportions of houses and windows, 1897*

163 *Josef Hoffmann, Palais Stoclet, Brussels, 1905*

E

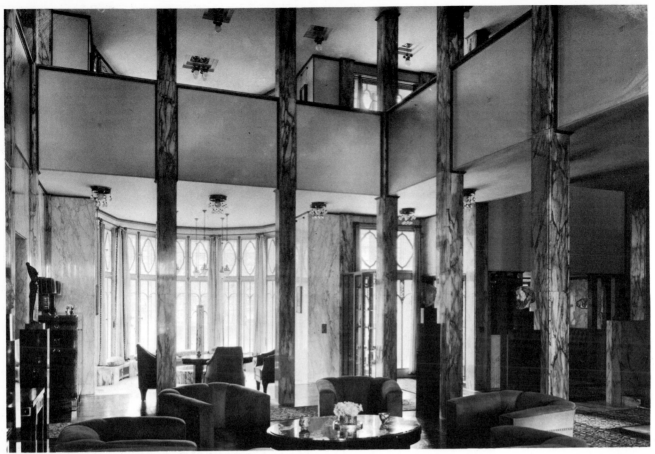

164

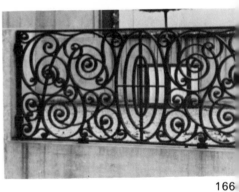

166

165 Palais Stoclet, the kitchen

166 Palais Stoclet, wrought iron fence. The
unity of the building is underlined by the
unity of patterns. The wrought iron fence
consists of two motifs: concentric ellipses
with their axes, and more informal spirals.
The geometric ellipses can be seen again in
the kitchen, the rambling spirals in the
frieze of the dining room

164 Palais Stoclet, the hall

165

gallery also recalls Mackintosh's library; it is important to remember that Hoffmann's building antedates Mackintosh's. The interior of the Palais Stoclet is characterised by a pervading air of luxury – called for in view of the client's status – and this has not been achieved by over-elaborate ornament, as it might have been in the past, but by a sensitive and varied articulation of space and the use of good materials.

Hoffmann achieved in this building a unity of structure, space and surface texture which comes as close as do some of Mackintosh's works to the idea of the Gesamtkunstwerk. This achievement is enhanced by furniture designed by the architect for this particular building and by remarkable mosaic murals created by Hoffmann's fellow Secessionist, Gustav Klimt.

Deriving from the lush neo-Baroque idiom of the late nineteenth century, Klimt had by the early 1900's evolved towards a personal Art Nouveau. Like most other Secessionists Klimt never lost his interest in decoration; in fact it was the fitting vehicle for his intoxicating art, and he developed it to an extreme degree and in a most personal way. The mosaic murals he designed for the Palais Stoclet consist largely of patterns confined to distinct areas and differentiated in character. Klimt therefore creates relationships between shapes through relationships between patterns. For instance, the pattern of the man's and the woman's cloaks are differentiated – the woman's being softer in character, the man's crisper – and it is this difference in character rather than tonal contrast which enables us to see – but only just – the woman's arm round the man's back and the articulation of the two bodies. In spite of their difference, however, the two patterns belong together and make one large shape against the completely different pattern of the background. This part of the mural is entitled *The Fulfilment* and its symbolic representation of male and female in union is given special point by the use of intermingling patterns rather than by academic drawing. The patterns themselves are noteworthy because they are clearly structured and often based on geometric shapes, in particular the circle, the square and the triangle. They are reminiscent of Olbrich, but it is also possible to see the influence of Mackintosh, who designed Wärndorfer's music room in 1902 and brought the possibilities of geometric patterns to Klimt's notice. The end panel of the mural in the Palais Stoclet is of special interest, because here subject matter has been completely eliminated in favour of pattern. The pattern itself is the subject matter, derived from the patterns seen in the other panels. This could be called an abstract picture – giving it a historical importance – or we could see it simply as a

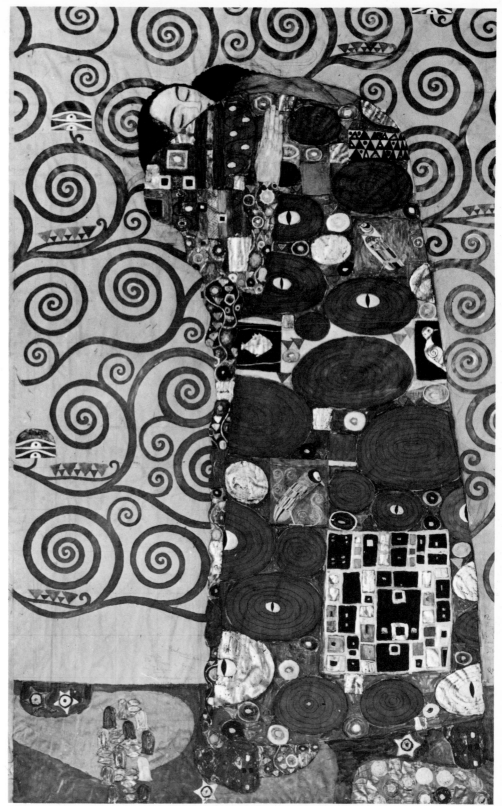

167

167 *Gustav Klimt,* The Fulfilment, *1905–1909, design for Stoclet mosaic. Museum of Applied Art, Vienna*

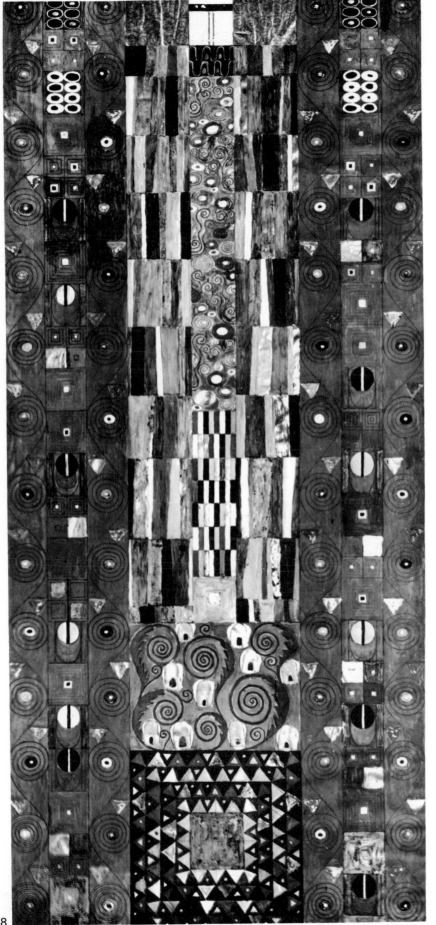

168

decorative panel. What is important is that in its clearly-structured, predominantly square character it follows the Viennese trend and therefore makes a fitting contribution to Hoffmann's building, complementing its architectural language in a pictorial sense. In a wider context it offers an early example of a new kind of pictorial composition in which precise geometrical shapes are arranged in abstract visual rhythms. Through their perceptual effect on each other they create a new sensation of pictorial depth, an ambiguous sensation which does not belie the flatness of the surface. This strange design has a distinct resemblance to much of de Stijl painting of ten or more years later in Holland and to certain forms of art of our own time.

The transition from Art Nouveau to a more rational and structural visual language can be traced in a different context through the work of Otto Wagner, another Viennese architect. The transition in his case is even more dramatic than in Hoffmann's, for his architectural origins were deeply embedded in historicism and he made the final break not in youth, like his pupils Hoffmann and Olbrich, but at the age of 55.

Wagner's early work, like Klimt's in another sphere, derives from the neo-Baroque at that time practised in so many parts of Europe; it also owes much to the Renaissance. His own house was modelled on an Italian Renaissance villa. In 1894, however, when he was appointed director of the School of Architecture at the Vienna Academy, Wagner reiterated Morris's axiom that nothing that is not useful can ever be beautiful. He spoke of the need for a 'naissance' rather than a 'renaissance' in architecture (a birth rather than a re-birth), and suggested that the future of architecture lay with a completely new style, as yet unknown. This statement must be appreciated in its historical context, for in the nineties it was still widely accepted that architects could do little more than re-arrange, in modern terms, the elements they had inherited. An article in The Studio of 1895 contains this revealing passage: 'The North country farmer who expressed his disgust of existing circumstances in the phrase, '' 'Tis as 'tis and can't be no tisserer,'' finding the language at his command unequal to his thought, boldly evolved new words. Today in architecture one may indeed evolve a new style in such a way; but originality in literature based on a disregard for grammar and the English language, equally with originality of design which neglects certain abiding laws, gains its object at the expense of all other qualities. The really original cannot be evolved from nothing out of nothing, but must needs rearrange old details with new expressions adapted to new requirements.'

At the time Wagner's pronouncement must have sounded like science fiction, especially since he went on to elaborate his ideas by prophesying the movable house and even the prefabricated house. He designed a museum which had no definite or ultimate form and could be enlarged over the years to provide new space for new works of art.

Yet to a certain extent a process in his own development can be likened to a similar one in the Arts and Crafts Movement: a stripping down of inessential ornaments in a search for form — and structure. When he designed his second home several features of the first reappear but in a clarified form. Historical ornaments are abandoned; new, rectilinear ones are invented which do not disturb the newly-found forms.

Opportunity on a grand scale came Wagner's way when the organisation and design of Vienna's new transport system was entrusted to him. His Karlsplatz station for the Vienna Stadtbahn (city railway) owes some of its ornament to Art Nouveau — the frieze below the roof and the iron grilles on the doors — but it is a functional shape, incorporating an iron grid and pioneering the use of corrugated metal sheets in architecture. The round roof covers the booking hall while the lower wings on either side lead down to the platforms.

His search for methods of combining iron and stonework into unified structures — parallel to that of Victor Horta — also resulted in an abandonment of traditional forms. In his early railway bridge the iron structure has been softened to make it architecturally acceptable. In his later design for a road bridge over the Danube Canal historical precedent has been

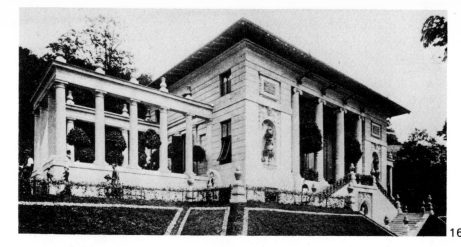

169

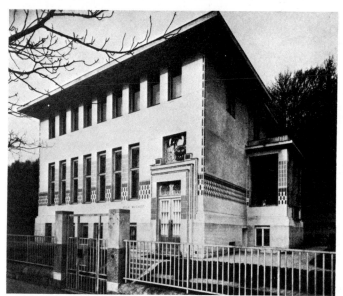

170

171

168 *Gustav Klimt, end panel from Stoclet mosaic. Museum of Applied Art, Vienna*

169 *Otto Wagner, Villa Wagner 1, Vienna, 1886*

170 *Otto Wagner, Villa Wagner 2, Vienna, 1912*

71 *Details of Villa Wagner 2*

72 *Otto Wagner, Karlsplatz station, Vienna, 1898*

172

69

abandoned and several features begin to
show the new spirit in architecture.
The great engineering structure is related
to four free-standing pylons which serve
as visual landmarks, their tiles visibly
riveted. The forms of the lamp standards
and the balustrade no longer show
traces of either historicism or Art Nouveau
and are in keeping with the engineering
structure. The simplicity of these elements
is matched by the design of the new
Stadtbahn station seen at the extreme left
of the picture. Equally important is the
attention which has been paid to the
separation of circulation on two levels –
along the bank of the Danube Canal and
over the bridge – and the steps which
connect the levels. This is a modern vision
of a modern city.

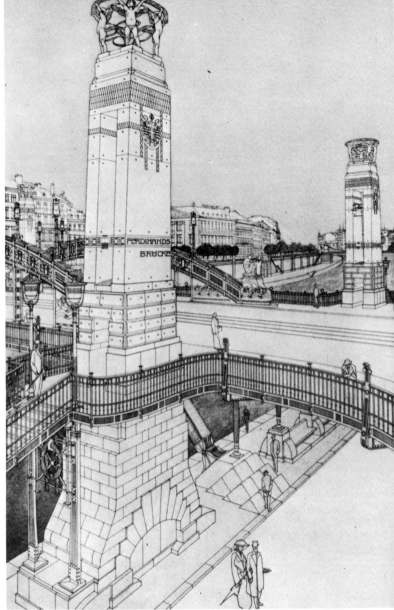

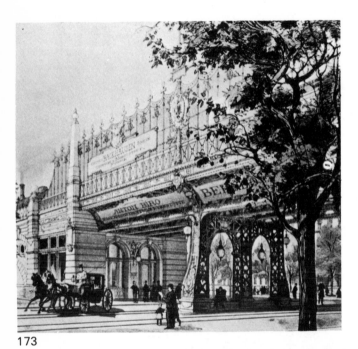

173

174

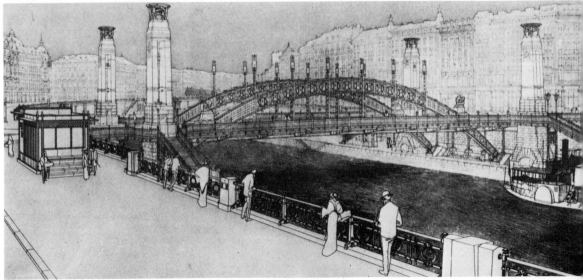

175

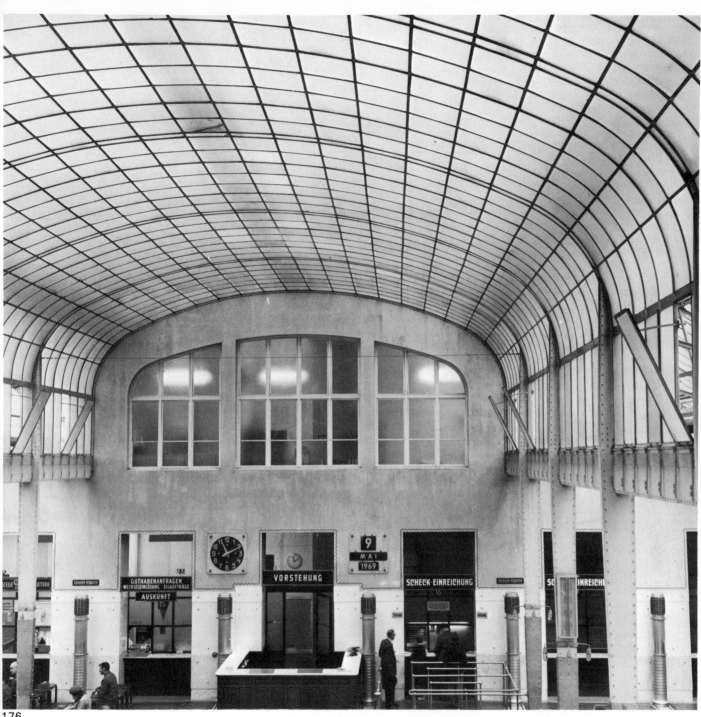

176

173 *Otto Wagner, early design for a viaduct*

174, 175 *Otto Wagner, design for a bridge (Ferdinandsbrücke), 1905. Glazed tiles on reinforced concrete pylons*

176 *Otto Wagner, Post Office Savings Bank, Vienna, 1905, main hall*

In the building for the Post Office Savings Bank which Wagner designed in 1905 he produced his most prophetic statement, a prospect of the architecture of the future, which he was never to equal in his subsequent work. The glass structure of the roof of the main hall is the most outstanding feature. The hall is wholly top-lit through the glass panels of the delicately-curved diaphanous roof, whose airy structure is partly supported from below and partly suspended from above. The upright supports, tapered to give an added sense of lightness, can be seen from the hall, but the rest of the structure is hidden from sight above the roof. The use of metal structures in all parts of the building is both true to engineering and visually imaginative. The structural brackets of the canopy over the main entrance, and the rivets, are an example of how forms and patterns natural to engineering have been given prominence. The motif of the rivet head has been allowed to encroach on areas where it was not structurally necessary: on the outside of the building where slabs of stone are fastened to the wall by this means, and even on the furniture which was in fact designed eight years later.

177

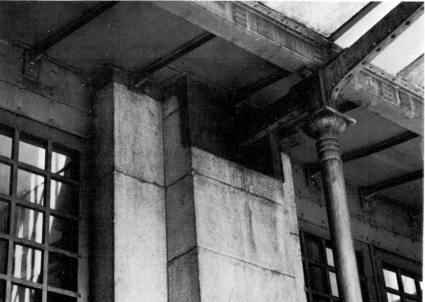

178

179

177 *Otto Wagner, Post Office Savings Bank, entrance*

178 *Post Office Savings Bank, detail of canopy over the entrance*

179 *Post Office Savings Bank, air conditioning outlets in main hall, made of aluminium*

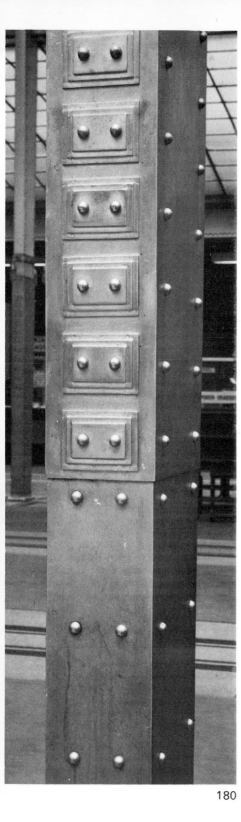

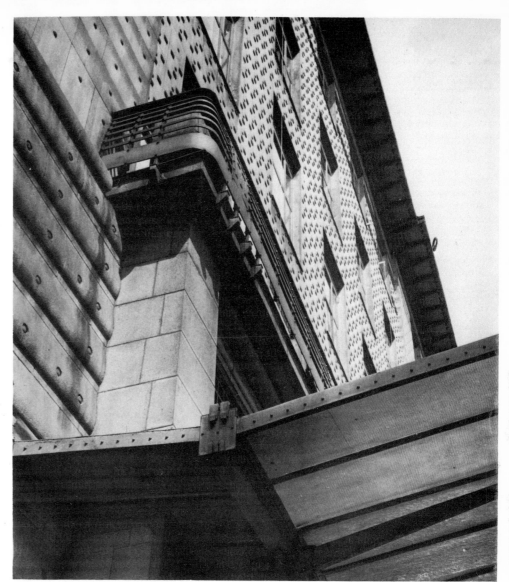

181

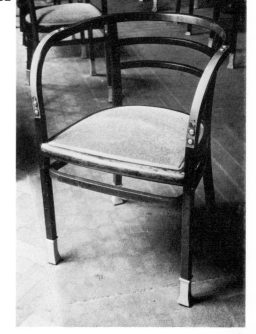

182

The rivet-like pattern is seen also in the interior, on pillars and walls. The outlets of the air-conditioning plant gave Wagner a great opportunity to display his interest in and acceptance of machine forms. The air louvres are separated by metal balls which serve a structural as well as a decorative purpose. The rings round the base are a repetition of a similar decoration found on the pillars of the canopy outside and which depends for its effect on the accuracy and regularity of its finish. It is minimal and reticent and better produced by machine than by hand. These qualities allow such ornaments to take their place alongside truly functional features without competing with them. At a first glance it is not always easy to decide which feature is functional and which is decorative. The boundaries between industrial design and sculpture here seem very blurred.

180

180 *Post Office Savings Bank, pillar in main hall, clad in aluminium*

181 *Post Office Savings Bank, exterior, canopy and balcony*

182 *Post Office Savings Bank, boardroom chair*

When Wagner became director of the School of Architecture at the Academy, the character of the school changed to such an extent that the Viennese justifiably referred to it as the 'Wagnerschule'. Little is known about Wagner's educational methods but students' work which has survived in the School's publications makes it possible to rate his achievement as high in this sphere as in his own architectural practice.

As might be expected, it was Wagner's principles rather than his actual working solutions which influenced his students' work. He believed fervently that form could only be a *result* and not a *starting point* of the creative process. In academic architecture the architect generally begins with a notion of the final form; but in Wagner's opinion form must not be aspired to for its own sake but always developed in relation to a specific problem or situation. Here his students could afford to be more logically consistent than their master. Wagner's ideas on the relativity of form — a kind of determinism — were emphasised by the School's lack of formal training in the orders of classical architecture and its concentration on practical problems. This tendency made the Wagnerschule unique throughout Europe and attracted many students from beyond the boundaries of the Austro-Hungarian Empire.

What emerges from works produced in the Wagnerschule is above all a confirmation of Wagner's belief that architecture will progress from historicism to a modern idiom in which simple planes, structural lines and materials will be the dominant features, made possible by the means which modern technology has put at the architect's disposal. One can sense too a social consciousness, again part of Wagner's philosophy, a desire to make art worthy of society. 'It is the purpose of the Wagnerschule,' wrote one of his students, to train in looking, perceiving, recognising human needs and solving artistically the task thus encountered. But it is not the intention through such studies to create a type, to seek a "modern style" '

This rejection of a modern style, that is to say a style in the accepted traditional sense but with a modern face, is of far-reaching importance. It had been the belief of many artists that a modern environment could be created simply by introducing new, modern forms, and we shall see that this belief persisted until well into the twentieth century. Wagner, however, recognised and taught that the question of form was no longer a matter of style but rather a question of solving problems in ways which will suggest their own forms. He maintained that a problem cannot be solved unless it is first recognised as such, and that solutions should not be merely a matter of expediency, but should correspond to the aspirations of modern man and to the individuality of the artist. There is no contradiction here for the artist can express his own aesthetic response to a problem by choosing from several possible solutions the one which seems to him most visually significant and most expressive of its social context. He may even through his sensitivity modify the solution while preserving its efficiency. Bearing in mind Wagner's theories about architecture, it seems natural that a member of his circle should write in 1909 that . . . 'the house (should) function, machine-like, as a flawlessly constructed apparatus . . .', thus anticipating by many years Le Corbusier's over-celebrated slogan, 'A house is a machine for living in.'

Indeed many of the School's designs seem to anticipate later developments in architecture. Roith's public baths of 1906 presage Bruno Taut's glass pavilion of 1914 and other later essays in this form. Benko's store of 1902 disposes of the façade by placing a large glass wall in front of the building. More important than the actual detailing of this design is its rendering, the execution of the drawing, which suggests that the architect had, at a time when such ideas were still far from current, fully appreciated the qualities of glass as a building material. The transparency of the building is its more salient architectural characteristic; we can

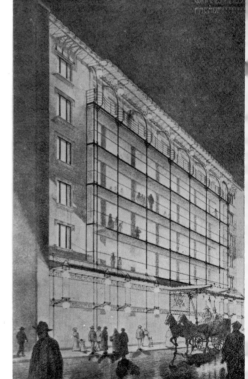

184

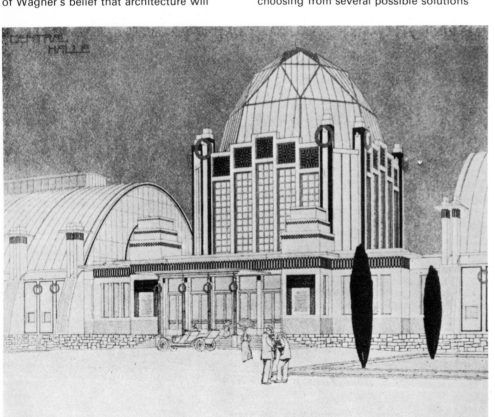

183

183 *Franz Roith, design for public baths, 1906*

184 *István Benko, design for a store, 1902. Designs produced in the Wagnerschule*

see right into it and people appear in a setting never envisaged before. The building also assumes a new function in the environment, as the source of visual excitement and light. The changing pattern of human beings visibly moving within the building replaces the static pattern of historical architecture.

The development of architecture does not depend solely on schemes which were actually carried out. It relies too on the theoretical writings of architects and on the unbuilt projects of visionaries. The thoughts and drawings of members of the Wagnerschule fall into the latter category, for although their buildings were never erected, the plans were published in several large volumes and were seen by progressive architects the world over. It is impossible to prove conclusively the indebtedness of later architects to the Wagnerschule or to the Viennese group of architects and designers as a whole, but there can be no doubt that many ideas which we now look on as modern were first tried out here in the early years of the century and that the speculations of Viennese designers did a great deal to bring about the application of modern ideas to the evolving modern architecture.

Wagner, whether judged by his own architectural work, by his writing, or by his influence on the next generation of architects, must be recognised as forming a bridge between the nineteenth century world of Art Nouveau and the machine aesthetic which became the chief characteristic of twentieth century architecture.

There was however in Vienna an architect who saw modern technology somewhat differently. Adolf Loos repeatedly expressed admiration for Otto Wagner, but his approach to the new environment is more complex, often ambiguous, and needs more detailed description.

In a much quoted passage from his famous essay, *Ornament and Crime*, Loos associated the need to decorate utilitarian objects with the primitive urge to draw erotic symbols on walls. In primitive peoples, or in children, this urge can be equated with art, but in civilised societies it is a sign of mental regression. Ornament, he argues, derives from such degeneration, and this leads him to the magisterial pronouncement: 'Evolution of culture is equivalent to the removal of ornament from utilitarian objects.' This was written in 1908. Two years later, as if to give concrete proof of the viability of the theory, he designed and built the Steiner House. It looks modern even today, as though it had been built many years later than 1910. There is nothing superfluous in the design. The curved roof at the front of the house

was Loos' method of circumventing building regulations which allowed only one storey to be visible from the side of the street.

Loos' fame in the history books rests largely on these two contributions: *Ornament and Crime* and the Steiner House. In fact they are both symptoms of something much more fundamental. His real contribution to the Modern Movement lies at a deeper level than the merely negative virtue of omitting ornaments.

Loos was a stonemason's son and this gave him a firm grasp of the craftsman's scope and of the mentality he brings to his work. 'One who has worked in stone all his life,' he writes, 'begins to think in stone and see in stone. He has a stone eye which transforms all things into stone, he has a stone hand which makes all things into stone. . . .' He resented any interference with this sensitivity, particularly from fine artists. He tells a parable of a saddler who has been making good saddles all his life and then, worried lest his goods are not thought modern any more, consults a 'professor' of the Secession. The professor pronounces against the saddler's goods but asks him to return next day. When he returns he is shown a pile of designs for saddles which the professor and his students have produced in the meantime. They are 'modern' saddles. The saddler, after looking at them for a long time, eventually exclaims: 'If I knew as little about leather, horses and riding as you, then I would have your imagination.'

As a young man Loos spent three years in America. This experience reinforced his views but gave them a different emphasis. What impressed him most was the unstuffy atmosphere of American life as he knew it — before the turn of the century — where almost anything could be done, unhindered by traditional inhibitions, so long as it was good, practical, economical, convenient. The Americans, he said, knew the secret of relaxing. American homes, such as those built by H. H. Richardson, compared favourably with those he had been used to in his native Austria. America was to him a truly modern country, where people dressed for comfort, where the plumbing was up to date and lavatories were equipped with water cisterns and washbasins. He became conscious — perhaps over-conscious — of the technological signs of civilisation and ashamed of his own background, where the gulf between peasants and townfolk was almost unbridgeable, where people messed up salt cellars by dipping their knives into them, and where 80 per cent of the country population did not use toilet paper. On his return to Vienna he started a magazine which he entitled *The Other. A journal for the introduction of Western Culture into Austria.* In this journal and elsewhere he wrote knowledgeably, perceptively, sensitively, wittily when the mood took him, and often extravagantly, on such subjects as clothes, the battle of the sexes (an advanced expression for 1898), the best way of cooking aubergines, opera, women, and of course town design and building in all its aspects.

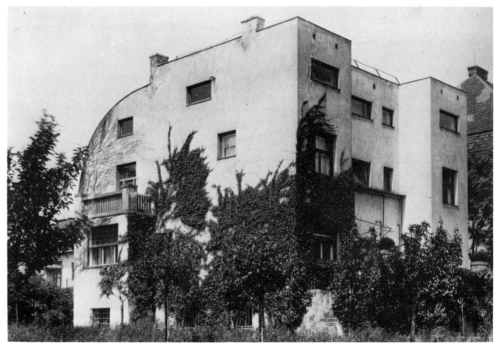

185

185 *Adolf Loos, Steiner House, Vienna, 1910*

Culture, to Loos, was more than a high regard for art or an adherence to certain aristocratic values; it comprised everything that human beings feel inclined or compelled to pursue. All that he thought and wrote were aspects of his experience of life and by his own standards he was a truly cultured man. It is necessary to approach his architecture though his views and writings, for architecture was to him simply the vehicle within which human beings live out their destinies, enjoy the benefits of music and aubergines and toilet paper, live harmoniously in relation to one another, understand their own and others' functioning in all its implications, learning to refine this functioning and so make life even better and richer. His view of human life, fully expressed in his architecture, led him to aim at and finally achieve an architectural structure in which human beings could come freely together and move freely apart and which made the most efficient and economical use of space.

Loos' admiration of America was only equalled by his adulation of England. To him the centre of civilisation lay in London. The English did everything right. Needless to say, they also had the best architects and designers. Why? Simply because their training methods were unlike those prevailing elsewhere, in Vienna for example, where students were tortured with worn-out concepts of art. In England examiners were drawn from practising artists, designers and architects and not from the ranks of academics. '. . . We can see that in England the school stands in the midst of life. Art and life complement each other peacefully. But with us it is art against life.'

What was it in Loos' view that made art oppose life in Vienna? Superficially it was ornament – not so much historical ornament as the kind indulged in by members of the Secession. Hence his essay *Ornament and Crime,* where a significant but little known passage occurs. 'The absence of ornament means shorter working hours and consequently higher wages. The Chinese carver works sixteen hours, the American worker eight. If I pay as much for a smooth box as for a decorated one, the difference in working time belongs to the worker. And if there were no ornament at all . . . a man would only have to work four hours instead of eight, for half the work done at present corresponds to ornamentation . . . Decorated plates are very dear, while the plain white china from which modern man likes to eat is cheap. One man accumulates savings, the other incurs debts. So it is with whole nations. Woe to the people that lags behind in cultural development! The English become richer and we poorer. . . .' The connection which Loos saw between economics and culture becomes clear, at

least in his context. Ornament which is somehow a part of cultural activities has more than the immediately apparent visual effects. 'As ornament is no longer organically linked with our culture' (Loos sets this out now as an axiom) 'it is no longer an expression of our culture. Ornament as created today . . . has no connection with the world as it is ordered. It is incapable of development. The artist always used to stand in the forefront of humanity. . . . But the modern ornamenter is a straggler, a pathological phenomenon. He rejects even his own products within three years. . . . Where will Olbrich's work be in ten years' time? Modern ornament has no forbears and no descendants, no past and no future. . . .'

The trouble, as Loos saw it, was not simply ornament but the unhealthy concern with 'applied art'. Why apply art to the products of craftsmen who know better than the artist how to shape their materials into sensible, workable objects? When artists and designers declare that they are seeking 'a style for the time', Loos states categorically: 'All those trades which have so far succeeded in keeping this superfluous phenomenon (applied art) at bay have reached the peak of their potential. Only the products of those trades represent the style of our time. They are so much in the style of our time that we – and this is the only criterion – do not even experience them as stylish. They are organic parts of our thinking and feeling. Our carriages, our glasses, our optical instruments, our sticks and umbrellas, our suitcases and leather goods, our silver cigarette cases and decorative goods, our jewellery and clothes are modern. They are modern because in those workshops no outsider has attempted to pose as leader.'

This was not strictly speaking true, for artists like van de Velde had produced magnificent jewellery, and the design and products of craftsmen were not always of a high standard. However one understands what Loos is trying to say, particularly when his views are transferred to architecture. There can be no modern architecture, he wrote, so long as we speak of applied art.

'Note the forms the countryman employs. They are the essence of the wisdom of our forefathers. But look for the reasons for the forms. If technical progress has made an improvement possible, use it. The threshing machine takes the place of the flail. . . . Don't think of the roof, but of rain and snow. . . . Be truthful. Nature knows only truth. She agrees with iron lattice bridges but rejects bridges with Gothic arches and towers and arrow slits. Fear not to be rebuked for being old-fashioned. Changes are permitted when they lead to an improvement, otherwise stick to the old.

Truth, be it hundreds of years old, has more to do with us than the lie which walks beside us.'

There is nothing essentially new in any of this. Much of it could have been said years earlier by Loos' counterparts in England. But there is one of Loos' statements which has a prophetic ring and seems to go beyond the ideas of the Art and Craft Movement. 'Don't think of the roof, but of rain and snow' means quite simply don't start with pre-existing solutions but look for the primary causes and then find your own original solution, unprejudiced by what has been done before. In spite of his insistence on functional efficiency Loos stressed the abstract qualities of architecture, summed up in this aphorismic passage:
'If we find a mound in a wood, six feet long by three feet wide, built up with a shovel in the shape of a pyramid, then we grow earnest, and something in us says "Someone lies buried here." This is architecture.'

Loos seems to have been the victim of his own confused terminology. He equates art with decoration. Art, as far as architecture is concerned, can only mean applied art, and this was to him anathema. On the other hand he wanted architecture to be considered in its own right, as an expression of its own problems and its own elements. That the composition of a building may also be considered an artistic exercise was more difficult to understand in the early years of the century than it is now. Art then meant pictures, figures, flowers and leaves, or a concern with form for its own sake. Loos wanted to free architecture of all non-architectural matter so that the functions, and the shapes and structures which serve these functions, might become a complete expression without help from the fine artist. Loos fought for pure architecture.

The Steiner House is a clear expression of pure architecture. It is composed of pure cubic masses. The windows are cleanly let into the wall without the usual mouldings and in some cases even without any glazing bars. The interior is equally rational. A large area serves both as living room and dining room. Settee and fireplace are topped by a common shelf. The window bar runs into the top bar of the panelled area. Within this strictly geometrical structure there is a considerable interplay of textures and patterns: upholstery, brick, wood, plaster.

186 *Adolf Loos, Steiner House, living room*

187 *Adolf Loos, shop interior, 1898*

188 *Adolf Loos, clock, 1902*

In this mass of seemingly contradictory ideas, it is not easy to pinpoint Loos' exact position. Perhaps he does not have one. Loos was not really opposed to ornament as such. He often speaks of his respect for ancient ornaments, but is resolutely hostile to the invention of new ones — in the 'spirit of the time'. Even so, it is impossible to define his attitude, for he himself sometimes invented ornaments when they seemed called for. In an early design for a shop interior, 1898, the display counters and other fitments with their large panes of glass were wholly rational but the light fittings were more ornamental than they needed to be. There was a reason for this: they were designed to hide the division of the shop by an exposed beam. Even so, his later work too showed that he was not wholly opposed to discreet ornament. There were friezes and cornices even where they were not required, ceilings were often coffered, recalling Renaissance palaces, and his anglophilia led him to install false beams as one sees them in English domestic architecture. His design for a clock has many stylistic, as well as functional, details.

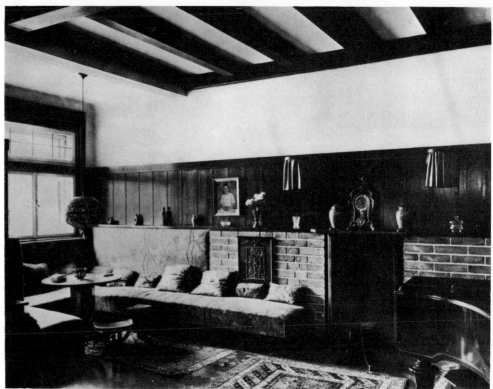

186

187

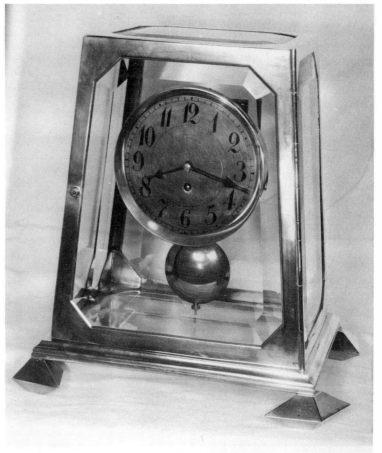

188

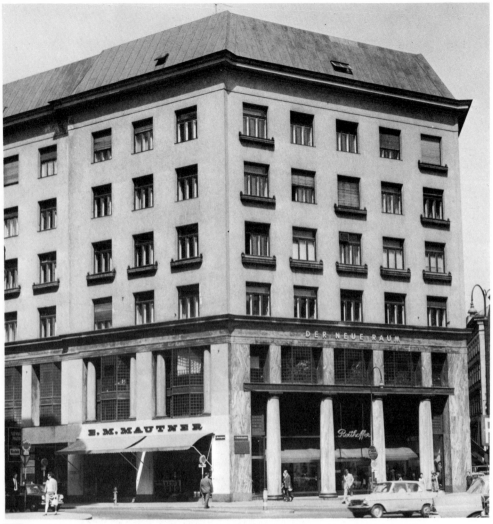

189

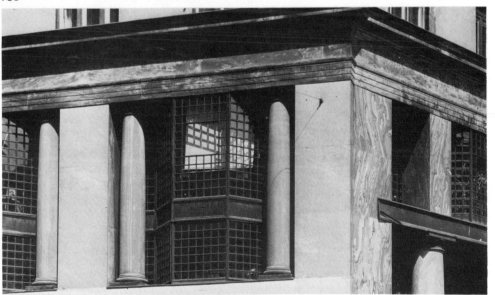

190

In the same year, 1910, Loos completed his building in the Michaelerplatz in Vienna. This looks less modern to us now because of its cornices, sloping roof and columns, but its new ideas caused a scandal at the time, work on it had to be temporarily stopped and Loos became quite ill in consequence. The crisply inset windows without mouldings are still used. The first floor windows, of the English bay type, recall Mackintosh's library. Loos chose them for psychological reasons. Each one of these windows extended from floor to ceiling. To the Viennese of 1910, Loos reasoned, flat windows of such dimensions might have looked unsafe, while a bay window, inset and its sides cutting back into the interior, would give a greater sense of security. To modern eyes the rear elevation of this building is the most impressive, with its large glazed and tiled areas and the exposed glazed lift shaft.

Loos' houses and buildings are always designed from within; that is to say the internal working governs the outer appearance. This quality can be clearly seen in the Michaelerplatz building. The difference in first floor levels follows the function of the floor, so that rooms where customers were received could be low-ceilinged and homely, while adjacent workrooms had to be light and airy and therefore higher. Loos made it a major concern to find the correct height for each room and from this seed grew his real contribution to modern architecture.

One normally assumes that the function of a building may be served by the size and shape of each room (in plan) and their disposition to each other. To Loos, however, their relative height was equally important. In 1901 he had adapted an apartment in which a small sitting area derived its intimate and cosy character from the low ceiling. We have seen similar arrangements in Frank Lloyd Wright's early houses and in some of Voysey's, both deriving from traditional and indigenous building methods. Loos developed this much further, for it allowed him additional articulation of open plan areas. In adapted apartments such methods led to a waste of volume, but in reconstructed, or better still newly built, houses he learned to use the saved volume – arising from the difference in ceiling levels – and so created a new concept of architectural planning.

189 *Adolf Loos, Michaelerplatz building, Vienna, 1910*

190 *Bay windows, detail of 189*

191 *Michaelerplatz building, lift shaft*

192 *Adolf Loos, Rufer House, Vienna, 1922, interior*

193 *Adolf Loos, apartment, 1901*

192

The Rufer House of 1922 is remarkable for a number of reasons. The central chimney stack acts as a load-bearing column so that some internal walls may be omitted and a completely open plan achieved. The picture shows the living area in the foreground. The steps on the right lead to the raised dining area which however shares the same ceiling level. The long stairs in the background lead to the first floor which consists of bedrooms and services. On the left the hall can be seen on a lower level and beyond that on a still lower level under the stairs is the cloakroom (not visible in this picture). There is therefore a vast open space whose articulated sub-divisions — we can no longer call them rooms — are fitted together three-dimensionally to make the maximum use of the available volume. The height of each subdivision is in keeping with the requirements of its function. The fenestration of the house fully expresses the freely planned interior

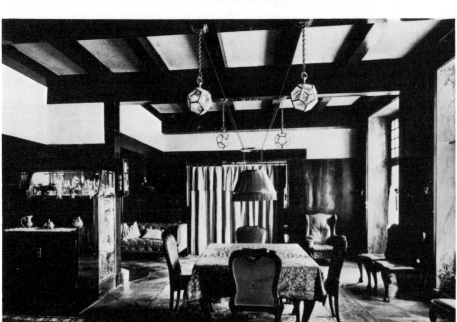

193

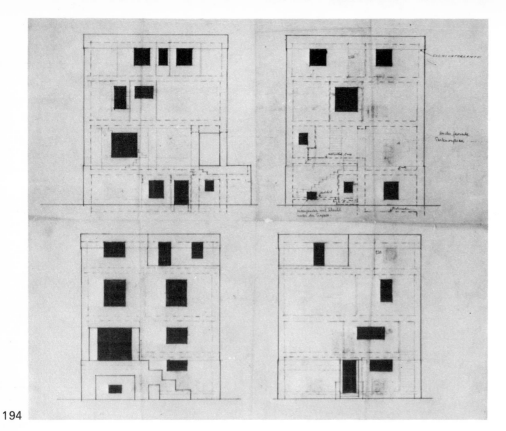

194

A design for a house which was unfortunately never built shows an even more economical use of the available interior volume, but here an open outside volume is related to it in a complex three-dimensional composition. This design was produced in 1923 for a villa on the Venice Lido. A photograph of a model shows its proposed form. The flat roof is a sun terrace and there is also a lower terrace. This secondary terrace is linked to the open plan living area within the house and related to the form of the house by a pergola-like structure. Functionally the terrace is part of the living area, visually it is part of the architectural composition. The sections through the house show that it is difficult to speak of different, separate storeys. They are better described as subdivisions, of irregular dimensions, of a large volume. We shall see that architects in other parts of Europe were dealing with similar problems at about the same time. It must be remembered that the solutions put forward by Loos do not stem primarily from any preoccupation with aesthetic matters but derive from his desire to produce conditions for what he considered a civilised life. In his discovery of new modern meanings through old methods he is comparable with Frank Lloyd Wright, but there are important differences between the two. Not only was Loos more self-effacing than Wright – denying art where the American affirmed it – but he had to design for different conditions. Where Frank Lloyd Wright could articulate his open plan homes horizontally by spreading outwards into the limitless American landscape, Loos, building in Europe on more restricted plots, used vertical articulation for similar ends. This explains the largely European flavour of Loos' work in spite of his considerable American sympathies.

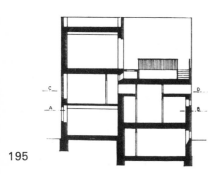

space. Loos' drawing shows the four walls of the house and explains how the windows are related to the structure (dotted lines). A close examination of each elevation shows a subtle visual order within the apparent chaos. We are reminded once more of Mackintosh, but Loos' design seems to have less in common with the capricious Art Nouveau compositions of Mackintosh than with rational planning. His house is all the same a visual composition and the art content which he so ardently denied to architecture is there for all to see.

195

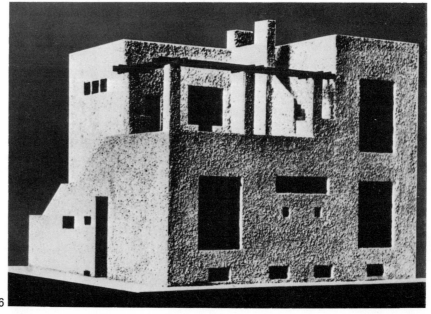

196

194 *Adolf Loos, Rufer House, elevations*

195 *Adolf Loos, Villa Moissi, 1923, sections*

196 *Villa Moissi, model*

The artist is not only concerned with *what* is there to be seen but also with *how* it is seen. The *how* of his vision is his attitude to his environment and to reality itself. So one could say that the *manner of seeing* is the true subject matter of every good painting.

A picture by an artist of the fourteenth century is not merely painted in a different technique. It gives a different view of the world from a picture painted in the nineteenth century. The two pictures describe not merely different scenes, different buildings and different costumes, but what amounts to different worlds and different views of reality. Even if his painting shows nothing more than a flower it yet reflects the artist's attitude to, and interpretation of, reality. It has been said, 'The artist does not paint what he sees, he sees what he paints.' Seeing, that is to say, visual perception, requires knowledge. The artist takes much of this knowledge from the mental climate in which he lives.

By the early years of the century the accumulated knowledge and the traditional values which had been in force for generations had been challenged, questioned and often rejected. The long-accepted picture of reality had begun to crack. People felt they were beginning to live in a different world. Artists, whose chief concern is the interpretation of reality, had sensed the changing outlook and they knew that a revolutionary new departure in art had become a necessity. But the artist's role as interpreter had been made infinitely more difficult by the fact that not only had reality become hard to define, but the very idea of reality had been put in doubt.

Under these conditions it is therefore to be expected that artists would be less unanimous in their approach to the physical world, than they had been so often in the past. There were some who attempted to interpret the world according to newer, more up-to-date principles, while others discovered hidden layers under the surface of a reality they had learned to mistrust, whilst still retaining links with a more or less traditional view of physical reality. They can broadly be described as realists. And there were those who found any adherence to concepts of traditional reality completely untenable and who were led through their own experience to a new, inner, spiritual reality which we may term abstract. These two revolutionary new departures were not always separate and

some artists stood astride them. We shall take a closer look at each in turn.

It may, of course, be said that the previous generation of artists, painters such as Gauguin and van Gogh, had already carried out a revolution. But yesterday's revolution is no answer to the problems of today, and yesterday's revolutionaries are viewed as today's establishment.

The young painters of the turn of the century certainly claimed their inheritance of Symbolism and other new directions. Denis had spoken approvingly of earlier, more primitive art forms and Gauguin had turned his back on Europe and embraced a kind of primitivism as more honest than post-Renaissance art, less tainted by materialism and more capable of

transmitting genuine feeling. In the younger painters this led to a more general admiration of non-European art, for instance African and Oceanic sculpture. What to earlier European artists might have seemed somewhat childish attempts at recreating reality could now be seen as expressions of feelings, and insights deeper than those of the rational mind. Although these artists did not copy the works of primitive artists they were nevertheless induced by their example to explore spheres other than those of factual reality — the world of feelings and instincts, of pure colour and shapes which answered only a pictorial, and not a representational, need; an art in which the painting, expressing the artist's insights, was a parallel to nature, not a description of it.

197

197 *André Derain,* Path through the Mountains, *1906. Hermitage, Leningrad*

F

The paintings shown here by Maurice de Vlaminck, André Derain, Georges Braque and Henri Matisse were all painted about 1906–7. They show the most important new departures of the new painting in France and go considerably beyond anything the older generation had achieved. Here pure colour, even further removed from the colours of nature than in the pictures of the Symbolists, administers a perceptual shock and floods the emotions; the free and uninhibited brushwork is even less related to nature and serves only the expression of feeling: it has become the artist's personal language.

Essentially there was little difference between the beliefs of the old and the new generations. Indeed, when Sérusier, who had been a member of the Pont-Aven group, came upon the new painters, he commented, 'Their idea is to paint their emotions . . . their explorations are intelligent and may turn out to be fruitful. It is the same idea we had . . . fifteen years ago.' So the new painting may be seen as a logical development of earlier ideas and experiments – though it must be recognised that many of the ideas had been discarded by the earlier artists, or not thought worth developing.

The idea of art as a re-creation of what the artist may have seen had been attacked by the Symbolists, nevertheless in their pictures there was still an adherence to retinal truth, a balance between their feelings and the actual world as their retinas received it. Now with the next generation the content of feelings became even more dominant. In their painting nature was little more than an excuse for producing 'a flat surface covered with colours arranged in a certain order'. Where in Symbolist painting forms may still have been, in places, indicated in their three-dimensionality, in the new painting there was no pretence of modelling. The Symbolists had distorted shapes and colours to make them fit into the scheme of the composition. The new painters felt free to distort them even further so that in the end individual shapes were almost indecipherable in terms of outward reality and had meaning only in the context of the composition. A painting was considered finished, so Matisse assures us, when the balance within the composition satisfied him, not, as of old, when sufficient ties with reality had been established. The young painters adopted unheard-of devices, went to unimaginable lengths, risking everything, even art itself, to achieve expression.

It was colour above all which acquired a new power. The coarsely painted canvases in which contrasting, pure colours could appear side by side, sometimes even squeezed straight onto the canvas from the tube lest they lose their power through the intervention of a brush, and the shock they administered to human perception earned the group the name 'les Fauves' (the wild beasts). Colour now completely free of any naturalistic requirements could be used in limitless ways – even in its own right for its perceptual effect. Art was never to be the same again. If Symbolism had freed the line, the Fauves had freed colour.

The violent colours and expressive forms of Vlaminck and Derain are more typical of Fauvism than the work of Braque and Matisse. Braque's painting, in spite of brushstrokes of disembodied pure colour, is already more restrained. Eventually he was to turn to other means of expression better suited to his character. Matisse was, of course the most important Fauve painter, but in spite of his wholehearted support of Fauvist principles, his paintings were always much calmer than those of his associates. It was this calm, reasoned assessment of visual problems which, in his personal exploration of the new painting, led him very close to an almost complete denial of subject matter.

'What I am after, above all, is expression . . Matisse wrote 'I am unable to distinguish between the feeling I have for life and my way of expressing it. . . . Expression to my way of thinking does not consist of the passion mirrored upon a human face or betrayed by a violent gesture. The whole arrangement of my picture is expressive. The place occupied by the figures or objects, the empty spaces around them, the proportions, everything plays a part. Composition is the art of arranging in a decorative manner the various elements at the painter's disposal for the expression of his feelings.' This is of course a modern version of Denis' definition of pictorial structure. Matisse goes on to speak of the clarity which a painting should have so that 'no matter at what distance you stand you will always be able to distinguish each figure clearly. . . . If in the picture there is order and clarity it means that this same order and clarity existed in the mind of the painter.' 'What I dream of is an art of balance, of purity and serenity . . . which might be . . . like an appeasing influence, like a mental soother, something like a good armchair in which to rest from physical fatigue.' The difference between Matisse and his fellow-Fauves is evident in this statement as well as in their paintings, for clarity and serenity are seldom found in the work of the other Fauves. His work is different too from that of his contemporaries in Germany.

198

198 *Maurice de Vlaminck, The Seine at Chatou, 1906. Private Collection*

199

200

201

202

199 *Raoul Dufy,* Hoardings at Trouville, *1906. Musée National d'Art Moderne, Paris*

200 *Georges Braque,* Landscape in Southern France, *1906. Private Collection*

201 *Henri Matisse,* La Coiffure, *1907. Staatsgalerie, Stuttgart*

202 *Henri Matisse,* The Bank, *1907. Kunstmuseum Basel*

Paintings which only a few years previously had seemed so bright and modern had in Germany as elsewhere gathered the greyness of museum pieces and the dust of academicism. Art Nouveau which had begun by creating, or attempting to create, homogeneous environments embodying a new spirit, had been largely discredited and had ended up as a trivial decorative style for the wealthy and fashionable. In 1900 the German artist, Ernst Ludwig Kirchner, visiting an exhibition of Art Nouveau in Munich, reflected on the disparity between art and life: '. . . indoors were hung these anaemic, bloodless, lifeless studio daubs. Outside was life, noisy and colourful, pulsating . . .' He began to think of arresting this life of movement '. . . in a few bold strokes . . . finding new forms. . . .' Looking back on the period he says, 'My goal was always to express emotion and experience with large and simple forms and clear colours.'

The similarity in outlook with that of the Fauves and particularly with the views expressed by Matisse is not surprising, but the movement which took root in Germany, Expressionism, is essentially very different from that of the Fauves in France, although both can be described as Expressionist. German art had for centuries displayed an earnestness and tension which even in minor artists went beyond mere visual description, while in great painters, like Grunewald, it took on extreme forms of tension, self-torture, often of mysticism and

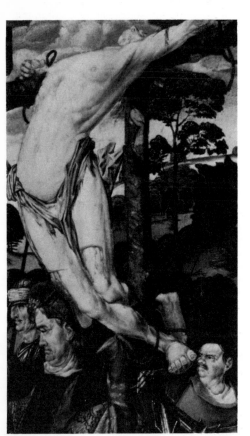

what has been called 'the animation of the inorganic' (that is the endowment of inanimate objects with emotive qualities for expressive purposes). In Germany then there has always been an Expressionist art, particularly during times of stress. One would therefore expect German artists to take very easily to the expression of their emotions at a time when expression was considered the whole purpose of art. The turn of the century saw German life once more under stress and this was reflected in contemporary art. There were political stresses, due to the recent unification of Germany as one nation; social stresses, resulting from the strict sense of morality of the German bourgeoisie — much stricter than the French — and also from the culturally repressive power of the authorities, which in turn caused a violent reaction among the younger artists; and there were spiritual stresses due to the pessimism arising from the disintegration of social and religious values which weighed heavily on the Nordic mind.

No one person had done more to analyse this state of mind and to propose a completely new creed, a new faith for the new age, than Friedrich Nietzsche. The philosophy, sweeping away everything bound to and by tradition, which Nietzsche put forward in a series of books published during the seventies and eighties of the last century, had such a deep effect on writers, artists and musicians that it succeeded in reshaping the whole of western consciousness; and nowhere more than in the German-speaking world.

Nietzsche's basic premise is that God is dead and Man must — in order to fill this terrible vacuum — take on responsibilities which in past ages were God's. Ordinary man, who differs from animals only in degree, could not step into God's shoes but Nietzsche asserted that there are men with extraordinary powers who might fill the empty place. This type of man — Superman — is certainly not what most people mean by it, and even less what the Nazis, in an attempt to justify their Fascism by philosophical proof, made of it nearly half a century after Nietzsche. He understood, by Superman, the man who has overcome his animal origin, who has sublimated his aggressive spirit, his will-to-power, in creative pursuits. He is the great artist, the great philosopher, the great statesman. The men who conquer *themselves* instead of conquering others will be the new gods. In the past man had sought meaning in life by referring all his thoughts and actions to a supernatural, divine agency, a point of reference outside earth-bound humanity. But once this relationship had been disturbed human life was stripped of meaning and, in consequence, of purpose. However Nietzsche points out that other qualities rise to compensate for this loss,

such as the very condition of existing without purpose, the state of being. If life has no meaning in the old, traditional or religious sense, and no purpose in the old moral sense, then each moment, instead of being justified in terms of meaning and purpose can be considered in its own right, and of equal importance with all other moments. State of being is the new meaning of life; religion is replaced by the doctrine that every moment is an eternity and every individual must become a god. But if the importance of the here and now takes precedence in Nietzsche's belief over the hereafter, the mental functioning of the Superman, the machinery of the new order, is of the greatest consequence. It does not, Nietzsche asserts, relate to intelligence. 'Behind your thoughts and feelings, my brother, stands a mighty commander, an unknown sage — he is called Self. He lives in your body, he is your body. There is more reason in your body than in your best wisdom . . .' The instincts and the senses will, in their developed form, raise man to the state of Superman, the great creator. 'I agree with the artists more than with all the philosophers up to now: they did not lose the great track where life advances, they were fond of the things of this world — they were fond of their senses.' Creation itself is to Nietzsche the apotheosis of the senses and the instincts, an irrational, trance-like state in which 'one hears — one does not seek; one takes — one does not ask who gives . . . Everything is in the highest degree involuntary but takes place as if in a tempest of freedom. . . .' But this near-divine power is not had for the asking. 'Who wishes to be creative must first blast and destroy accepted values.'

This was the clarion call to all artists, particularly those of Northern Europe. Edvard Munch, a Norwegian artist, may be thought of as the forefather of Expressionism. He was a dedicated admirer of Nietzsche, whose works seemed more clearly than anything else to set out the artistic task confronting him, as religion had done for artists of the past. Although a superficial assessment might classify him as an Art Nouveau painter — his pictures were in fact exhibited at *Art Nouveau*, Bing's shop in Paris, from which the whole movement took its name — his work had a directness and power which places him well beyond the world of Art Nouveau. In his painting *The Shriek*, 1893, the influence of Art Nouveau is obvious but the mood and tension conveyed are stronger than the stylistic details. Munch himself describes the inception of the painting in these words: 'The sun was setting; the sky turned blood-red and I felt a breath of wind. . . . Across the blue-black fjord and the town were tongues of blood and fire . . . My friends walked on; I remained behind, shaking with fear, feeling the great cry of nature.' Even without the figure in

203 *Master of Aachen*, Crucifixion, *16th century, detail. National Gallery, London*

204 *Edvard Munch*, The Shriek, *1893. National Gallery, Oslo*

204

merely a description of nature. In these ideas as in the free application of paint to canvas we may see a similarity between the Expressionists and the Fauves; but this is where the similarity ends.

The most important subject of Expressionist art was the human figure and in describing his approach to this subject Kirchner makes plain the difference between the two groups. '. . . I undertook the withdrawal of the self from itself and its dissolution within the other person's psyche for the sake of a more intense expression.' He often referred to this artistic passivity. 'It is the ability of so losing one's own individuality that one can make this contact with others. It takes immense effort to achieve this yet it is achieved without willing it, to some extent unconsciously without one's having anything to do with it. To create at this stage with whatever means – words or colours or sounds – is art. . . . And then the most powerful things are produced here because feeling is released from specific material limitations.'

Nietzsche's description of the mysterious, involuntary state which results in creation is identical with Kirchner's.

But beyond all this lay Kirchner's ultimate aim – and that of many other Expressionists: the search for and expression of the inner secret of nature. 'This great mystery which stands behind all events and things . . . can be seen or felt when we talk to a person or stand in a landscape or when flowers or objects suddenly speak to us . . . (A portrait) does not represent a single personality but a part of that spirituality or feeling which pervades the whole world.' These non-materialistic aims were beyond the scope of traditional post-Renaissance European art and the Expressionists looked to the purer methods of Gothic art and the art of non-European peoples still living in a more primitive stage of civilisation. Kirchner said, 'I find this art much purer, nobler and truer than the highly praised antique which has diluted all European art with its insipid aestheticism,' reflecting artistic opinion in just about every European country.

the foreground the flat, restless shapes of the landscape would have set a mood, expressed a feeling, rather than a scene. With the foreground figure, curving unnaturally but in sympathy with the composition of the painting so that it is seen as part of the rhythm and power of nature, the picture becomes a statement of an attitude to life.

Of course not every artist had Munch's intimate knowledge of Nietzsche's writings, indeed probably only a few had any direct knowledge at all, but even so Nietzsche's ideas through their widespread influence created a mental climate in which the already existing antipathy to established values soon took on a more decided and outspoken course. The roles of sensitivity and instinct gained in prominence at the expense of mere intelligence and the task of giving expression to them became

urgent. Kirchner was the most articulate of the German Expressionists and in him Expressionism had its most thoughtful exponent. He shared with Matisse and many other contemporary artists a conviction in the supremacy of pictorial values over factual ones. Because of the inspired, rhapsodic nature of his art he considered his drawings his purest works but even here the laws of art, and not those of nature, ruled. He wrote, 'Not only the lines and the forms defined by them but all the empty areas . . . (are) part of the picture. . . . The forms do not so much represent specific objects as such. They receive their specific meaning from their position, their size, and their relationship to each other on the surface of the page.' Kirchner therefore subscribed to the affirmation of the autonomy of the work of art, of artistic creation as the construction of a parallel world to nature and not

85

The earliest work by the artists who banded together in 1906 in Dresden under the name Die Brücke (The Bridge) derives partly from Art Nouveau – in spite of what Kirchner thought of it – as well as from the primitive sources mentioned.

They produced a great many woodcuts as this medium by its very nature lends itself to the crude, simple forms favoured by them. We can read Gauguin's example in this, not only in the choice of medium but also as a symbolic return to more honest and direct forms of experience. Eventually Fauvist influences led to a greater freedom and the uninhibited use of bright, blinding colours. Max Pechstein was more under the influence of French painting then his fellow-artists – he had been working in Paris – and his paintings were therefore less Germanic than those of his associates in Die Brücke and were more readily accepted by critics and public. Karl Schmidt-Rottluff's earliest paintings have an unmistakable flavour of van Gogh with their agitated short brushstrokes of thick bright colours but later, about 1910 his work developed into calmer, although still powerful, designs of flat contrasting colour areas. Kirchner's and Erich Heckel's painting of this period could also be compared to Fauvist painting.

When the group moved to Berlin in 1911 the painting of Die Brücke underwent a considerable change. It was only then that the truly Expressionist character began to manifest itself. Kirchner's and Heckel's

205

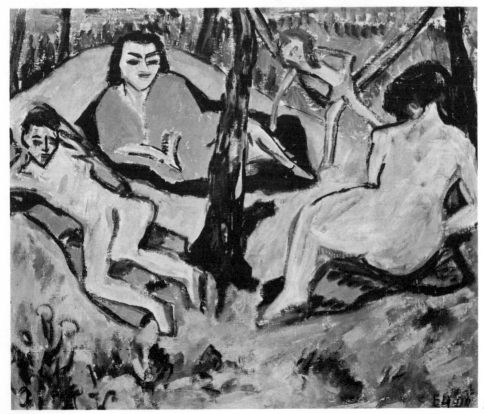

206

20

205 *Ernst Ludwig Kirchner,* Cabaret Dancer, *1908. Staatliche Kunsthalle, Karlsruhe*

206 *Erich Heckel,* Open Air Group, *1909. Private Collection*

207 *Max Pechstein,* Nelly. Portrait of a Negress, *1910. Private Collection*

painting in particular assumed a spiky, angular quality, while the colour became muted. The angst-ridden world of Expressionism emerges in these works, as also their search under the surface of visible things. Kirchner's *Five Women in the Street*, 1913, suggests both a mood and a realisation of the sleazier, shadier aspects of a great city: the lives of streetwalkers which are spent mostly on pavements in the nightly penumbra between pools of electric light. They have a statuesque quality somewhat like that of early Gothic grouped sculptures and the distortion of their bodies gives this picture a tension and a sense of a deeper reality — again like its medieval precursors — beyond anything which could be contained in a description of factual reality or even the Fauves' rendering of sensations. The figures in Heckel's *Two Men at a Table*, 1912, have a tense relationship with each other which, like those of Kirchner's figures, we cannot explain in rational terms. The symbols on the walls add further layers to this mysterious reality. One senses that these artists are trying to uncover regions of the human psyche which are not accessible to probing through rational processes.

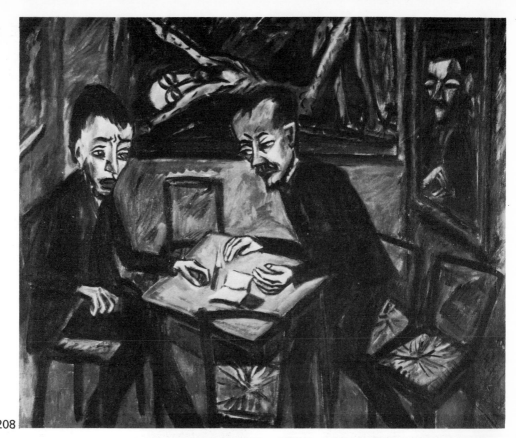

208

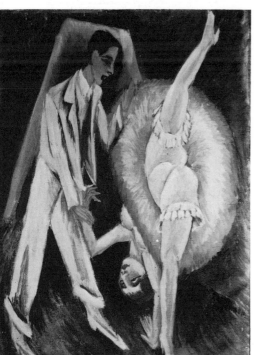

209

208 *Erich Heckel,* Two Men at a Table, *1912, Kunsthalle, Hamburg*

209 *Ernst Ludwig Kirchner,* Dancing Couple, *1912. Collection Claus Gebhard*

210 *Ernst Ludwig Kirchner,* Five Women in the Street, *1913. Wallraf Richarz Museum, Cologne*

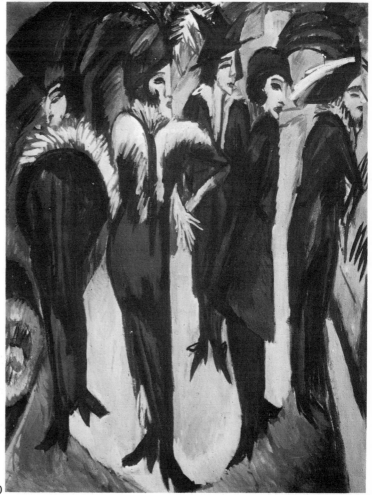

210

211

213

212

211 *Hans Schmidt-Rottluff,* Head, *1914,*
woodcut

212 *Hans Schmidt-Rottluff,* Head, *1917,*
sculpture. Tate Gallery, London

213 *Hans Schmidt-Rottluff,* Two Women,
1912. Tate Gallery, London

214 *Erich Heckel,* Walkers by the Lake,
1911. Folkwang Museum, Essen

215 *Ludwig Meidner,* Burning City, *1913.*
Morton D. May Collection, St Louis

214

The Expressionist visual language which challenged traditional aesthetics enabled these artists to approach the 'inner secrets' of life and of nature which they sensed. Everything was brought to the service of expression; expression of feelings, of insights, of states of being. Never by traditional standards subtle, their work nevertheless surpassed in sheer expressive power and psychological insight anything attempted elsewhere at the time and made the work of so many Fauves look merely charming and decorative.

It was the Expressionist artists' purpose to reveal the soul of man, to man, and so to describe his true nature. They therefore examined man's contact with man, and with the cosmos, at those points where this contact was at its maximum, where it could be experienced in its purest intensity. In order to achieve this, the artist sought a state of grace, even a state of ecstasy, often culminating in apocalyptic visions such as

Meidner's *Burning City*, 1913, which presages the two European holocausts.

Sensitivity must be at fever pitch to obtain such insights. In such a state it is the unconscious which effectively takes command, that part of the mind which has no sense of morals, ethics, beauty and the usual materialist order as decreed by bourgeois society. These notions were not altogether new but they had acquired a topical interest as they had been analysed only recently in the writings of Sigmund Freud. Morals and moral education had to most artists become an outdated commodity anyway because they stood in the way of the thoroughgoing exploration of the condition of man which they desired. Our moral education, they seem to reason, teaches us to distinguish between good and evil and to shun the latter. We are therefore selective in our approach to our environment; the artist's scope is narrowed down to an area mapped out for

him by authority. But to the modern artist everything has a value in the world or in the cosmos: the smallest detail has become a world, as in Nietzsche's philosophy each moment is an eternity, a point of entry to nature's mysterious inner workings. Once the old moral order is removed the artist has achieved *real* freedom, he can look at everything for its own sake and without preconditioning which may disguise the truth. As in Kirchner's painting, prostitutes can now be treated in a way which is consistent with the medieval artist's rendering of saints.

The existing bourgeois order was therefore felt to stand in the way of artistic aspirations. Modern man's soul could not be bared under the materialistic order. Therefore, for man to achieve his true vocation nothing less than a new society was required. No art movement had stronger social implications than Expressionism.

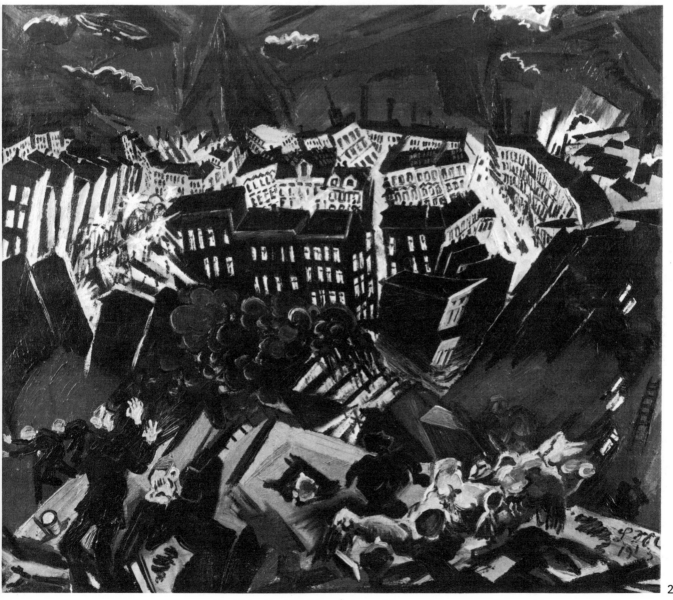

215

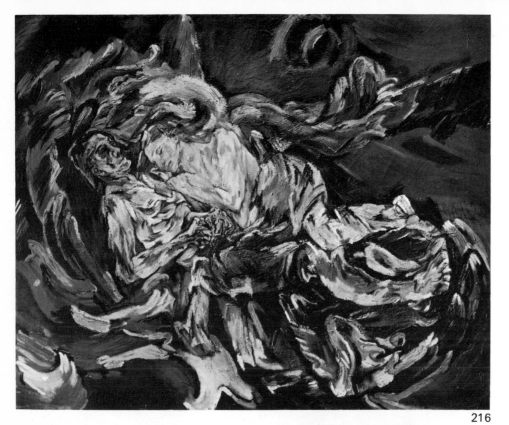

216

Expressionism was largely related to the German-speaking part of Europe and this included Austria. The Austrian contribution lay almost wholly in the work of Oskar Kokoschka and Egon Schiele both of whom had connections with the Vienna Workshop. Kokoschka's poster for the first public performance of his own play is one of the first Expressionist achievements in this medium. In his painting a strange trance-like quality expresses itself through the sombre, other-worldly colour, the nervous brushwork and the distortion of forms, which could be interpreted alternatively as chaos, nightmare, transcendence or a visionary portrayal of the doom-laden nature of man. In his most important painting of this period *The Whirlpool,* 1914, he depicts himself with Alma Mahler, who was his mistress at the time, riding in the eddy of an apocalyptic storm.

Egon Schiele was a pupil of Klimt with whom he shared many traits, such as a natural, brilliant draughtsmanship and an absorbing interest in sexuality. But whereas Klimt with his sensuous charm and his suave eroticism is still an extension of the nineteenth century, Schiele belongs without a doubt to the present century: the two men standing on either side of the watershed. Schiele's portraits probe the psychology of his sitters in a way Klimt's never do. There is not normally any salaciousness in Schiele's nudes, some of them little more than children, who display their sex purified of all 'naughtiness' or civilised pretence. This is sex in the Freudian sense, physical nudity being accompanied by psychological nakedness. The people in Schiele's paintings and drawings exhibit the frightening nakedness of the modern psyche. His work has all the fear and despair peculiar to this period, and to Expressionist art, in all media.

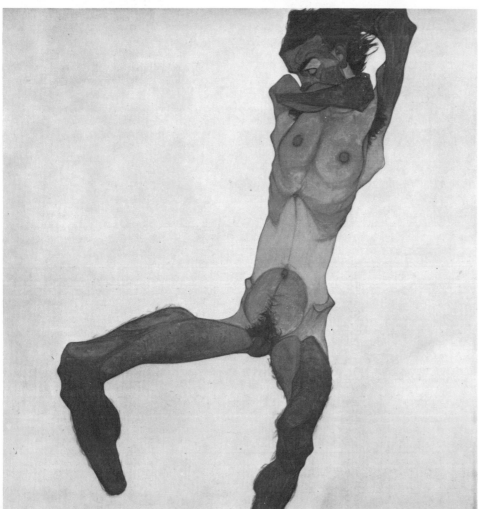

216 *Oskar Kokoschka,* The Whirlpool, *1914. Kunstmuseum Basel*

217 *Egon Schiele,* Male Nude, *Collection Rudolf Leopold, Vienna*

218 *August Macke,* Three Girls in a Landscape. *Private Collection*

219 *Paul Klee,* Carpet of Memory, *1914. Paul Klee Foundation, Bern*

217

Although Expressionism is not always an easy concept to grasp we can yet recognise in the work of different artists, say Schmidt-Rottluff, Meidner and Kokoschka, qualities which enable us to place them within the Expressionist movement. But there was another, smaller group which, although still Expressionist in aim, does not fit quite so easily into the mainstream. This group, *Der Blaue Reiter* (The Blue Rider), was formed in 1911, in Munich, rather later than *Die Brücke,* and counted amongst its members Wassily Kandinsky, Paul Klee, Franz Marc and August Macke. Here a more poetic, gentle, thoughtful and lyrical art developed in contrast to the abrasive, attacking, tortured art of other Expressionist artists. These men were not only artists but also theorists and philosophers; they wrote some of the most important documents of twentieth century art. For their first exhibition Kandinsky proposed this typically Expressionist definition of the content of the work of art: 'the communication of what is secret by means of a secret'. Soon both he and Klee were illuminating such theories by visual evidence. Klee's *Carpet of Memory,* 1914, is full of poetic and portentous signs, and the observer is left to ponder their mysterious message which defies rational comprehension. It was in this group where the expression of pure feeling was carried to its natural conclusion: the denial of traditional subject matter, pictorial abstraction, non-objective art. We can describe this development as a new direction of Expressionism. If an Expressionist artist sought to uncover the irrational and often unethical forces residing behind civilised social behaviour he was in fact rejecting materialism. In Kandinsky's art we find implicit not merely a rejection of materialism but of the material world itself.

The ideas which circulated in the early years of the twentieth century attacked the traditional, optimistic view of the material world. That matter is only a form of energy and not an absolute substance had been widely accepted, together with the resultant view of physical reality as transitory. Artists faced, in addition, the more practical problem of having to enlarge their ideas of space by those of time and motion which, however, proved to be beyond the compass of the visual language which had been in use since the Renaissance. News of the splitting of the atom made a deep impression on Kandinsky, he felt as though the whole of reality had collapsed and there was nothing to lean on. Reality as apprehended by the human senses could now no longer be taken for granted. As doubts about the nature of reality grew into a conviction that reality, as it had been understood in the past, was illusory and a construct of the human mind, its abandonment in art was

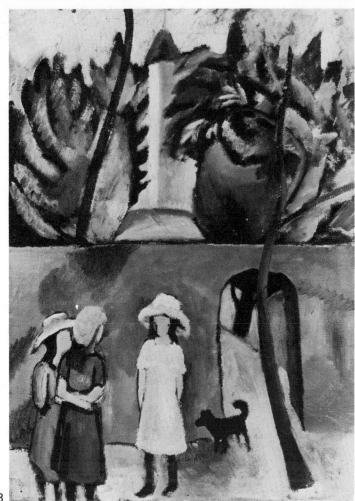

218

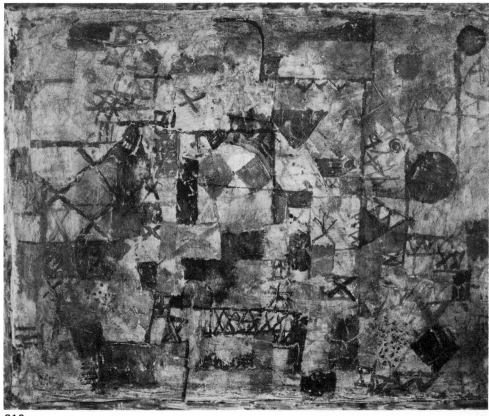

219

not difficult to contemplate. Abstraction in art is the search for an alternative reality, to take the place of the lost one.

Because the need for an alternative reality became irresistible we can speak of a drive to abstraction. It was no isolated phenomenon; several artists strove towards it simultaneously, in Germany, France, Holland and Russia, and, as so often happens, achieved it round about the same time.

It is difficult to decide who painted the first abstract picture. Because Kandinsky's development towards abstraction appeared to be the most consistent and logical, and because he was, in addition, a man of considerable intellectual power who exerted great influence on other painters, not least through his writing, he is usually credited with this achievement. Whether he was first or not his background had fitted him for his exploration of the expressive power of pure abstraction. In Russia, which he left as a young man, folk art and the art of the icon with its medieval conventions were still a powerful and formative force. To a Russian therefore the reality of the Renaissance is not necessarily the only reality, nor are the pictorial devices of the Renaissance — perspective, light and shade — the only means of describing reality. The traditional European view of reality was not, therefore, as deeply embedded in Kandinsky's cultural background as it was in that of the other artists of Western Europe.

A further pointer in the direction of abstraction was Kandinsky's sensitivity to colour. Each colour had for him a definite emotional content. His writing is interspersed with long references to the individual character and the emotional and spiritual meaning of colours, which he soon learned to use for these qualities rather than for their factual accuracy. When as a young man in Russia he first entered a peasant house with its painted interior he had a sensation of entering a picture, of moving about inside a painting. Such sensations tend to erode the division between the inner and the outer world, between imagination and reality. Kandinsky's early paintings are akin to those of the Expressionists. Soon however the emotional content begins to dominate in a way which clearly anticipates his later development.

The colours seem to burst the very forms which contain them as feelings overcome objectivity. Patches of colour freed from the task of describing recognisable objects assume a life of their own. It is as though the soul of the picture wanted to break free of its body. *Houses in Murnau with Women,* 1909, is an example of this period of Kandinsky's development. It was done from

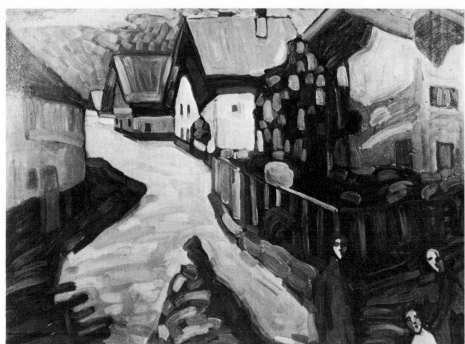
220

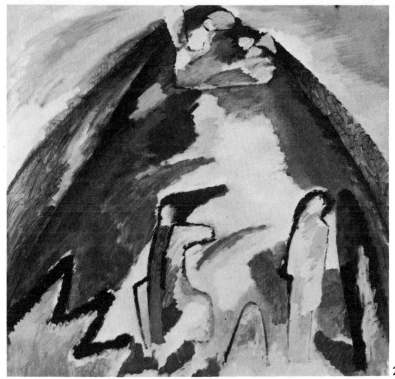
221

memory rather than from nature and this was wholly in keeping with the artist's desire to reveal the rich life of the spirit and of the imagination rather than the physical world. The painting has left representation far behind. Concrete objects are still recognisable: houses, fields, a tree, people, but the colours and forms of the picture make sense only when considered outside traditional reality. They are to be looked at in their own right — as forms and colours — even before we decipher the factual content of the picture. They attempt to convey the reality of feelings rather than the reality of objects.

At this stage in Kandinsky's life an event occurred to speed his journey towards complete abstraction. Entering his studio one evening in the dying light of the day he noticed a painting leaning against the wall, a painting of overpowering beauty which he could not remember having seen before. It seemed to radiate a beauty like a heavenly light. In his wonderment he suddenly realised that it was one of his

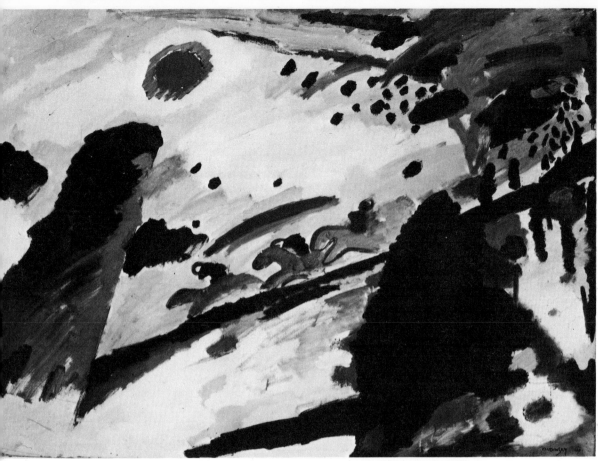

222

223

own paintings — standing on its side. Because he had not recognised the objects in the picture, the forms and colours had acted simply as forms and colours in their own right and not as descriptive devices; they had become temporarily abstract. The road to the world of the spirit led through abstraction. The spiritual beauty of the picture, as he saw it in this brief instant, lay in the abstract content and was destroyed when the picture was turned back into its usual upright position. Kandinsky realised then that he must find a way of painting pictures 'without subjects', pictures in which purely visual elements would convey emotions and sensations. He made several attempts and did in fact produce a watercolour without a recognisable subject — the first abstract picture — but his mind had outstripped his eye. It was to be another three years before he succeeded in painting abstract compositions that began to satisfy him.

In the years following his great discovery, Kandinsky continued to paint pictures which relied increasingly on the disposition of coloured masses and less on subject matter. *Mountain,* 1909, could be described as near abstract. The shapes and lines seem to convey a 'real' situation but we cannot be sure of its exact content and in our uncertainty we are forced to draw on our imagination. But although literal content was slowly being discarded, it was still a functional element in these pictures. For instance the literal content of *Romantic Landscape*, 1911, the part we can recognise as 'real', although slight in appearance still has a crucial part to play.

In spite of its apparent looseness, this is a tightly controlled picture. The most important lines strive towards an area near the right hand edge. Other lines vaguely support them in this tendency. The area of their confluence is also the most exciting part of the picture for it is here that the dark dots, thinly scattered elsewhere, have become densest. The dots, by drawing the eye in the direction of greatest density, reinforce the movement of the lines. This combined movement is given added impetus by the two large brown shapes which also point in the same direction but in a lurching, less defined movement. The whole composition, therefore, in spite of several balancing lines, moves visually to the right. The artist now uses the factual element to balance his composition. The three riders, seen in the centre, move — now in the realistic sense — to the left. We therefore experience the picture at two different but simultaneous levels: recognisable reality and visual abstraction; actual, physical movement as expressed by the three riders, and implied visual movement as expressed by the urgency of the abstract shapes, lines and dots, the two levels holding each other in balance.

220 *Wassily Kandinsky,* Houses in Murnau with Women, *1909. Collection Mrs Nina Kandinsky*

221 *Wassily Kandinsky,* Mountain, *1909. Städtische Galerie, Munich*

222 *Wassily Kandinsky,* Romantic Landscape, *1911. Städtische Galerie, Munich*

223 *Analysis of* Romantic Landscape

93

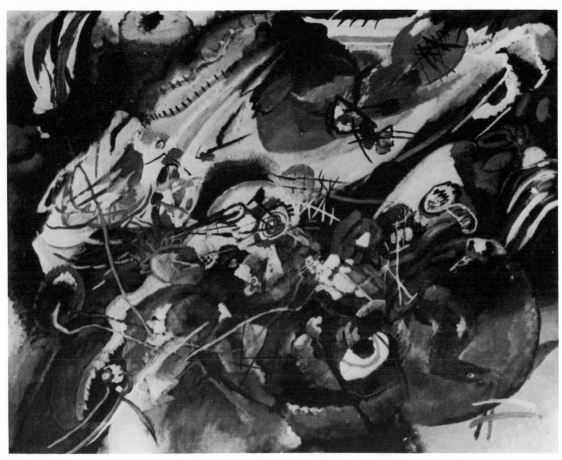

224

From here it is but a short step to a complete abandonment of subject matter. *Composition VII*, 1913, is one of the finest examples of this early period of abstract painting. In spite of its apparent random qualities, on examination it again turns out to be a controlled picture. Many closely-knit but diversified forms build up to a richly textured event of cataclysmic force even more universal than Meidner's and Kokoschka's compositions. An incredible variety of forms and colours articulate with each other, react to each other, support or oppose each other, link in visual movements which are related to other visual movements. The richly emotional effect of such a picture has perhaps more of the nature of music than of traditional painting. The late-Romantic music of Gustav Mahler and Arnold Schoenberg with its highly coloured orchestration and intense feeling, music which has clear Expressionist tendencies, forms an obvious parallel.

Although the ideas of Expressionism were first formulated in connection with painting and the characteristics of the movement were first recognised here, similar movements had taken place in other spheres. This parallelism was eased and confirmed by the great number of artists who were active in several fields at the same time, applying their underlying urges to different media. For instance, Kokoschka and Kandinsky wrote plays in which

language was used expressionistically, that is to say as the forms and colours of an Expressionist painting, in bare constructions which have apparently blunt meanings but nevertheless intimate, deeper levels of feeling. Paul Klee wrote poetry. Arnold Schoenberg, the composer, painted and actually exhibited with the Blaue Reiter. The list is endless, and takes in not only artists of first rank but also the lesser ones. Albert Paris Gütersloh, a painter and friend of Schiele who had studied for a while under Denis in Paris, wrote several novels. Alfred Kubin, who was associated with the Blaue Reiter, wrote a novel, *Die Andere Seite,* (The Other Side) which describes a dream-like stream of consciousness. Georg Heym, the poet, whose poem *Umbra Vitae* was illustrated by Kirchner, bemoaned the fact that he could not paint.

This dual activity of many artists of the time did not by itself cause the fertilisation of all artistic media with Expressionist ideas, but it is indicative of the general mental climate in which all creative artists tried to keep abreast of each other. Expressionism was not a coherent visual style, like Cubism, it was fed by *ideas* as much as by visual experience, so that it spread more easily to other fields, not primarily visual. The writer Frank Wedekind created in *Lulu* a dramatic character to signify the universal concept of femininity: a being driven by a sexuality which is, like

that of Schiele's women, completely apart from the conventional moral values as understood by civilised society but which yet leaves the soul more innocent than those whom society normally considers virtuous.

Music also acquired Expressionist characteristics. In his String Quartet No. 2, 1907, Arnold Schoenberg abandons tonality. In a setting of two poems by Stefan George in which the poet seeks a state of peace in a sea of uncertainty, he experiences depths of human anguish no musician before has ever plumbed, and, like the artists of the period, rejects the traditional concept of harmony for the sake of greater expressiveness. In this setting the human voice no longer implores, it is the soul which now speaks, and sometimes screams in a way no civilised music could have accepted before. Stage design under the influence of Expressionism was stripped of naturalistic trappings, props were made to look unnatural in order to provide an adequate setting for the under-the-surface meaning of the new plays. Sometimes the stage was almost bare to give even greater prominence to the inner life of the characters. These characters, in new plays, were often de-personalised and simply named 'The Man' or 'The Woman' to make their emotions and problems universally applicable. Film sets, like stage sets, were deliberately made to look painted rather

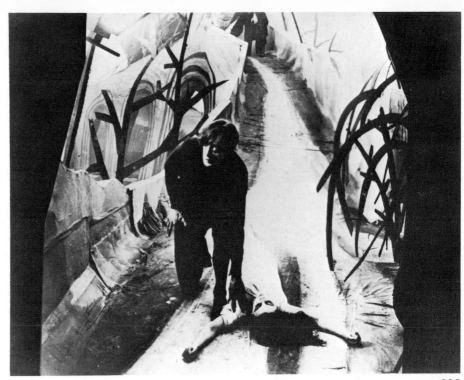

225

226

man real, and they were distorted to suit the meaning of the picture.

In all these spheres Expressionism was the accepted new vehicle of artistic creation. It enabled artists to explore depths of human sensations and experience, to search for a new meaning in a life which threatened to become meaningless, to define man's position in nature, in keeping with the spiritual crisis of the time, and to communicate these explorations.

Expressionism therefore made one of the most vital contributions to the development of all modern art forms. Our present-day literature, drama, music, cinema, etc. are unthinkable without the Expressionist contribution. Neither as we shall see is it possible to contemplate the history of modern architecture without the Expressionist element in it.

224 *Wassily Kandinsky,* Study for Composition VII, *1913. Collection Felix Klee, Bern*

225 *Oskar Kokoschka, theatre poster*

226 The Cabinet of Dr Caligari, *a still from the film, director Robert Wiene, 1919*

227 The Cabinet of Dr Caligari, *design for a set. In film sets such as these, Expressionist art almost achieved a physical reality: in this case the reality of an insane mind*

227

The Symbolist-Fauvist line of development had been the most serious and violent attack upon tradition. But it had an inherent weakness in that it was based on a heightened experience of such intensity as could not be maintained indefinitely. Also strong colours soon lose their power to shock. From about 1908 onwards the Fauves began to retreat from their more extreme positions, their colours became more muted and thoughtful and their vision seemed to focus more on the structure of the world they saw than on the excitement of pure colours. Derain's painting of 1910 shows how far he had withdrawn from the wild days of 1906.

Even before this time other artists had begun to approach their environment in a more considered manner and to pay attention to the structure of the visual world. This was in fact another important new departure, parallel to Fauvism. It derived from Paul Cézanne whose analysis of visual experience was at least as far-reaching as the discoveries made by the Symbolist painters.

His work is probably the most difficult of all modern painters to discuss, for in it the relationships between the visible world, human perception and the work of art are more fully realised and integrated than in the work of any other contemporary artist. Although the study of nature was to him the beginning of all art he admits: 'nature reveals herself to me in very complex forms'. The analysis and clarification of these complex forms is the core of his work.

That the structure of every object was of vital concern to him is clear from many statements contained in his letters. Two years before his death and after a life full of the most agonising visual analysis he wrote to Émile Bernard: '. . . treat nature by the cylinder, the sphere, the cone, everything in proper perspective . . .' But although he saw the basic forms in nature he was also aware of the relationships between them, their harmonies and tensions, which were as much part of his total vision as the individual shapes. The human senses may receive many

different impressions of the same object which must all be accommodated in one vision – as they were signally not in academic or Impressionist art – and this inevitably leads to conflicts, and consequently distortions, in representation. Furthermore all these – and more – conflicting elements had to be subjected in Cézanne's work to the discipline of art so that they could make their appearance on the flat canvas without contradicting its flatness. He understood and spoke of the dynamic, changeable nature of these complex relationships.

In seeking the underlying structure of nature – the absolute rather than the superficial – Cézanne neglected accidental appearances and atmospheric effects and defined the clear planes of the structure of objects. These planes which in nature are at angles to each other are often flattened out in the plane of the picture. Tonal contrasts are often reduced in intensity and in area. Pictorial depth is achieved by patches of colour which vibrate against each other and so seem to advance or recede. Towards the end of his life Cézanne's landscapes had become a mass of often disconnected small planes which synthesise the different aspects of his perception of nature, objectively observed.

Cézanne conducted a life-long, painstaking artistic analysis of the infinitely subtle and expansive interplay between appearance, structure, space, perception and expression to which only a close study of his actual work – and not descriptions of it – can give adequate testimony.

228 *André Derain,* Montreuil sur Mer, *1910. National Gallery, Prague*

229 *Paul Cézanne,* Card Players, *1892. Courtauld Collection, London*

230 *Detail of 229*

231 *Paul Cézanne,* Jardin des Lauves, *1904. Phillips Collection, Washington*

228

229

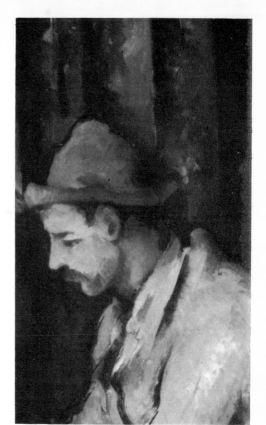

230

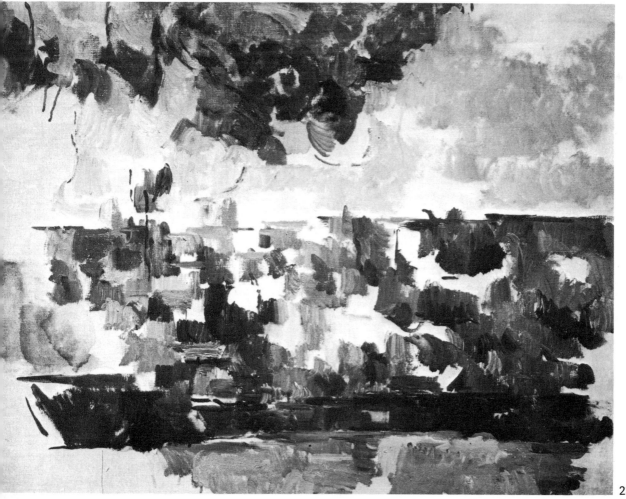

231

There was hardly a painter in the first half of the twentieth century who did not owe something to the work of Paul Cézanne but his most immediate effect was on two young painters in Paris, Pablo Picasso and Georges Braque, who carried his ideas into the twentieth century 'like two climbers roped together'. Their new art which seemed to their contemporaries to contain so much that was meaningless and chaotic can now be seen to possess its own logic and method. Because it gives a deep insight into the growth of artistic ideas we shall study it in some detail.

Although both Picasso and Braque were jointly involved in developing a new visual language, the initial impetus was no doubt Picasso's. He had come from his native Spain and settled in Paris in 1904. At that time his paintings described the reality of life as it was experienced by the less fortunate members of society: a poor housewife in a hovel, a Jewish beggar, members of a travelling circus. About 1906 a certain monumental quality enters his painting, an apparent desire to give his

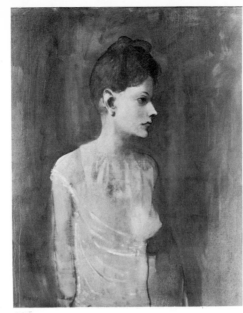

232

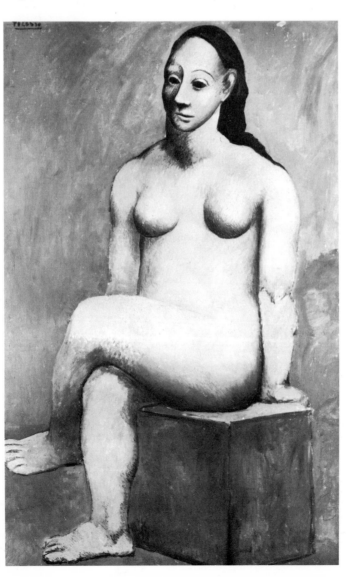

233

figures more substance and with it more dignity. This trend is already evident in *Seated Nude,* 1906. The shapes are simplified, the heavy masses of trunk and limbs establish a sculpturesque sense of the human body. It was however *Les Demoiselles d'Avignon,* 1907, which marked significantly the real turning point in his work.

From Picasso's preliminary sketch for this picture, we may infer that it was intended to be a fairly straightforward composition. The scene is a brothel, a familiar subject in late nineteenth-century painting. But although Picasso's original plan for the picture had its roots in the last century, its flowering certainly belongs to the present one. During the process of executing the painting, something caused Picasso to change both composition and manner, and therefore the meaning, of the whole picture.

The rendering of the drapery, the orange curtain on the left, the blue curtain on the right, the table cloth and the wraps of the women, suggest a rather crude adaptation of Cézanne's manner of treating such subjects: a shallow modelling which does not convey the full three-dimensionality of the real world. The distance between figure and background is also narrowed to a shallow space. The lines where figures and background meet are backed up by a tonal contrast, but the figures do not thrust forward nor the background recede; they both remain in more or less the same plane, approximating to the plane of the canvas. The modelling of forms in painting which has been customary since the days of the Renaissance is noticeably absent. Renaissance modelling relied on a fixed light source to show the surface form from its lightest to its darkest facets, but since in Picasso's picture there is no modelling there is also no consistent light since this is no longer required. The painting thus abandons all claims to be a representation of traditional visual reality. Not only is the fixed light source eliminated, the observer's fixed viewpoint is likewise dispensed with. The face on the extreme left shows the nose and mouth in profile, but the eye from the front. The table in the foreground is seen from a high viewpoint and the rest of the picture from normal eye level. The seated figure on the right is seen from the back, but the face from the front. Two main characteristics seem to emerge: 1. the picture is largely flat or near flat and at no point subjected to perspective or consistent light and shade, and 2. the picture is composed of different impressions obtained from different viewpoints.

The faces of the two figures on the right are derived from those of African carvings. We have already noted the impact of primitive art on the Fauves and the

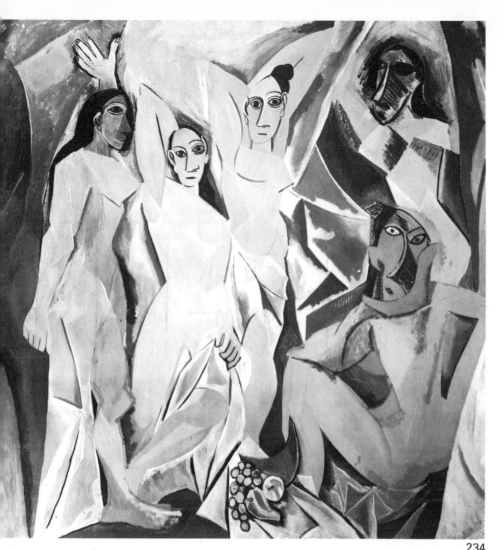

234

Expressionists. In the case of Picasso the effect was even more fundamental.

The masks and carvings of indigenous cultures are not renderings of natural forms; they have a functional rather than an illusionist purpose. They express searchings for the inexplicable aspects of life and death and the mental states to which these probings give rise. Perhaps at this time European artists saw such works as *real* art because they were products of a culture in which reality and imagination still went hand in hand, as did reason and emotion; in which belief and action had not yet suffered separation into the often opposed areas of religion and science. If such works of art can be looked on as functional objects which help individuals to establish an overall grasp of reality, then the appearance of such mask-like faces in Western art will be seen as symbolic. In *Les Demoiselles d'Avignon* the validity of other cultures is hinted at. Here is a challenge and an alternative not only to the Renaissance concept of man but also to the Renaissance view of reality. And so we can discern in this amazing picture which Picasso painted in 1907, barely a year after Cézanne's death, most of the future developments of twentieth century art.

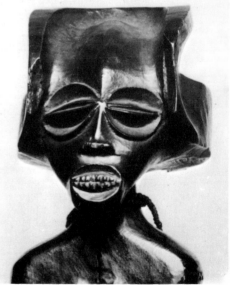

235

232 *Pablo Picasso,* Woman in a Chemise, *1905. Tate Gallery, London*

233 *Pablo Picasso,* Seated Nude, *1906. National Gallery, Prague*

234 *Pablo Picasso,* Les Demoiselles d'Avignon, *1907. Museum of Modern Art, New York*

235 *Head, French Congo. British Museum, London*

236 *Pablo Picasso, sketch for* Les Demoiselles d'Avignon. *Kunstmuseum Basel*

236

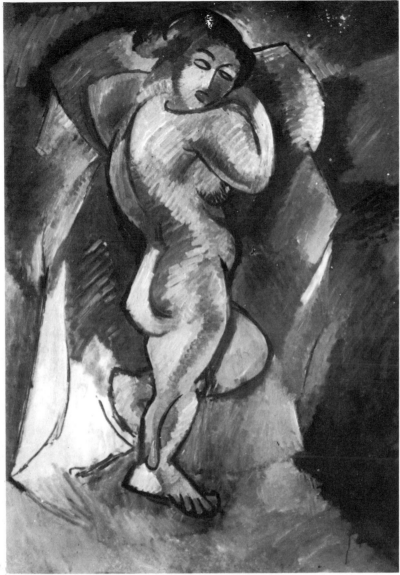

237

Braque's landscape *Houses at L'Estaque*, 1908, is an example of these early Cubist experiments. The photograph was taken the following year and seems to be from a slightly different viewpoint, but even so it helps to demonstrate the transformation which Braque wrought. In the photograph the houses and trees recede into the distance and a traditional painter would have acknowledged this recession by allowing the houses to diminish in size towards the horizon, according to linear perspective. He would have made the trees paler in colour and bluer as they approached the horizon, according to aerial perspective. In Braque's painting the horizon is eliminated and houses and trees are piled up to the top edge of the picture. They hardly vary in size at all. What Braque did was simply to turn upwards the receding plane, on which houses and trees stood, until it more or less coincided with the plane of the picture. He demonstrated his earlier verbal statement, but in much bolder form: a picture is not nature, it is flat, as Denis had declared. Braque could not have arrived at his visual statement without the pictorial means he found in Cézanne's paintings.

We have seen how in the landscapes of his maturity Cézanne had evolved his own method of translating the three-dimensionality of nature into the two dimensions of a painting. Braque uses a developed form of Cézanne's method throughout *Houses at L'Estaque*. Planes which in nature meet at angles lie in the same plane in Braque's picture or articulate only at the edge by means of a brief reference to tonal contrast. He uses a dense tone only where he wishes to emphasise a contrast. For instance, the tonal contrast (and the spatial differentiation) between the large tree in the foreground and the rest of the landscape is indicated only on the underside of the branches, while the bole of the tree itself is similar in tone to the background. The picture now makes sense as a flat composition; the objects described in terms of their constituent planes can be related pictorially on a flat surface. The artist can deal with them there; he can build them up into compositions which re-create his original response. He has found a language.

The significance of *Les Demoiselles d'Avignon* was not lost on Braque. He had been introduced to Picasso by the poet Apollinaire. Up to that time he had been one of the Fauves, but had recently begun to work on lines which suggested a more considered approach, with more than a trace of influence from Cézanne. Then he chanced on Picasso's revolutionary picture. He must have been the only person in the world to grasp Picasso's as yet only half-formed intentions, for even the artist's close friends were completely bewildered by it. Soon after seeing the picture in Picasso's studio, Braque painted *Grand Nu*, 1908, which shows how much Picasso's vision had jolted him into new realisations.

The figure in Braque's painting is closely related to the background which is both shallow and ambiguous. The figure too is distorted on account of multiple viewpoints; for instance the buttocks have been twisted into view when in actuality they should be hidden on the far side of the figure. Braque is reported to have said: 'I could not portray a woman in all her natural loveliness. I have not the skill. No one has. I must therefore create a new sort of beauty, the beauty that appears to me in terms of volume, line, mass, weight, and through that beauty interpret my subjective impression . . . I want to show the absolute and not merely the factual woman.' He did not wish to imitate nature but to re-create his personal responses to nature. This could, he believed, be achieved by stating the abstract qualities of nature which elicited his response. Notice the echoes of Symbolism.

What was to follow was an analysis of the abstract aspects of nature and also of the states of mind which they produced. Because the new visual language through which this analysis was made used straight-edged planes as the basic element it came to be known as *Cubism*. And because it dealt, initially, with analysis the early period is referred to as *Analytic Cubism*.

237 *Georges Braque,* Grand nu, *1908. Private Collection*

238 *L'Estaque, photograph by Daniel-Henri Kahnweiler, 1909*

239 *Braque's projection of the landscape onto the plane of the picture*

240 *Georges Braque,* Houses at L'Estaque, *1909. Kunstmuseum Bern*

241 *Paul Cézanne,* The Grounds of Chateau Noir, *1902, detail. National Gallery, London*

238

239

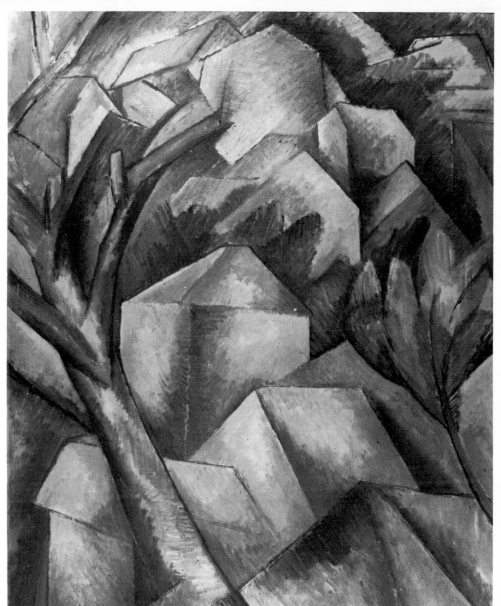

240

241

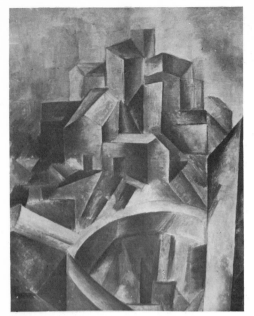

242

Pitcher and Violin, 1909–10, by Braque, goes considerably further. The table top is upright. Background and foreground have approached each other and lie more or less in the same plane. The painting of the pitcher demonstrates the new technique for round objects. For instance, the neck is broken up into three planes which are tonally similar. Like the planes describing the houses in the landscape, these planes lie in the same picture plane. The only difference is that whereas the houses had flat planes to start with the pitcher had not. The round form of the pitcher has been analysed so that its component parts can be fitted into the new flat visual language. In this painting visual analysis already begins to destroy the normal appearance of objects. The abstract quality of the planes is gaining the upper hand and the planes leave the objects. One feels that the planes of the violin occupied the artist's mind and eye as much *in their own right* as in their role of violin parts. He arranged them as he needed them in his composition, even if in the process they had to leave the normal confines of the object to which they belonged. The form, the contours of the violin have been broken in the interest of the picture.

This picture is also an object lesson in the use of the new visual language to convey emotions and the painter's reactions to the visible world. A traditional painter could control the emotional content of a picture by changing the direction of the light which illuminated the objects portrayed or by changing its quality from a soft diffused light to a strong, hard light, with correspondingly dark shadows. Neither of these devices fitted into the Cubist visual language, devoid of a fixed light source. Therefore Braque increased the tonal contrast *within each plane* and not

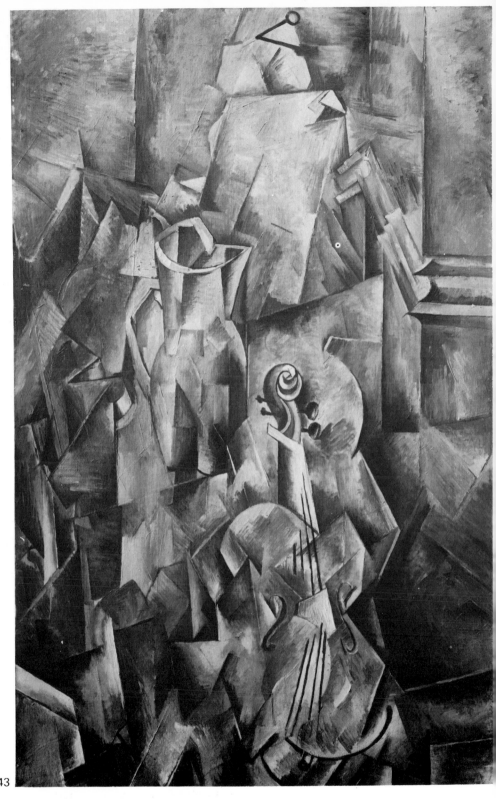

243

between different planes. The effect is a strange translucency, as though the objects have acquired an inner light. The poetry of the picture depends largely on this device, and embraces form as well as space. The world of factual reality has been left far behind. As a witty reminder of the realistic art which Cubism eschews, Braque has painted a nail, complete with its shadow, at the top of the picture.

Although Picasso and Braque had travelled very far within the short span of three years and were looked upon as revolutionaries, it was never their intention to break with realism. Picasso said that Cubism was just another style. This would seem to suggest that certain traditional values might still be embedded in Cubist art. The comparison of a Cubist painting with a traditional one of a similar subject may tell us more about this.

Rembrandt's *Portrait of the Painter in Old Age* was probably painted as a likeness, but there is no way of telling how good a likeness it was. We can see an old man looking at us, and by virtue of the manner in which he is introduced and described we can sense at least some of the human qualities he may have possessed. We are also made aware of a physical situation: the man is placed in an undefined space; the light strikes his forehead and left cheek and, less directly, his clasped hands at the bottom of the picture. Between these illuminated parts there is a mysterious dark area in which the folds of his garment can be vaguely recognised, largely as a result of the many reflected lights. We are also aware of the sensuous presence of the picture itself. The brushwork has a strong pattern of its own, culminating here and there in exuberant crescendos of thickly piled-up opaque paint, and in other places withdrawing into mysteriously silent, glowing depths.

If Rembrandt is looked upon as one of the great masters of all time it is not because he could render the appearance of things with greater accuracy than other artists, any more than a great photographer is one who produces the sharpest pictures. On the contrary, in his own day Rembrandt was often criticised for being more concerned with the play of light and shade than with producing a good likeness. In the same way Shakespeare might have been accused of paying more attention to poetry than to historic fact. Rembrandt's fame rests on the skill with which he used his personal visual language and on the quality of his visual poetry. What were the basic elements of that visual language? A short answer is: light playing on forms in terms of paint. Going into a little more detail, it could be described in the following words.

Light, often localised in certain areas yet distributed over the total area, is modified in strength and colour in the interest of the picture's tonal balance and not necessarily as found in nature. Forms are sometimes bathed in light; sometimes only partly exposed to it; sometimes placed in a muted half-light. They are also organised into a balanced whole, a composition. The paint varies in texture and body from thick impasto to thin glazes. The way in which these elements are combined determines the quality of a painting, in which the eye

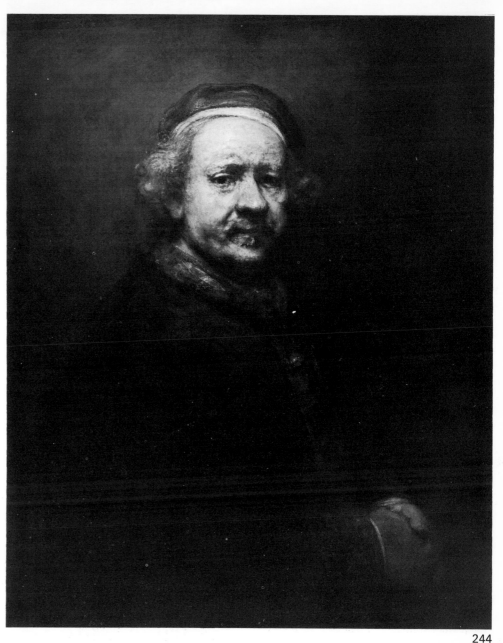

244

is made to wander over a continuously changing surface: forms receding and advancing, emerging from deep shadows only to escape again into the dark; pools of light, sometimes graduated by gentle stages up and down the scale of light values, at other times sharply, almost noisily, clashing with hard-edged intense shadows, changing not only from light to dark, but also from cool to warm; and all this expressed — not merely decorated — by the artist's handwriting, his spontaneous brushwork which is related to every element in the picture as well as to its medium, paint.

The elements of Rembrandt's language may even have made visual accuracy difficult to achieve. Deep shadows may break up the form of an object, coarse paint may rob it of detail. But the subject so depicted, expressed through Rembrandt's poetry, is

242 *Pablo Picasso,* The Reservoir, *1909. Private Collection. Picasso's contribution to the development of Cubism, but at this stage not as advanced as Braque's work*

243 *Georges Braque,* Violin and Pitcher, *1910. Kunstmuseum Basel*

244 *Rembrandt van Rijn,* Portrait of the Painter in Old Age, *1669. National Gallery, London*

transfused by a reality of its own, the reality of Rembrandt's vision. When we look at a painting like this we must try to understand it in its own visual terms, in its own poetry. It is only in this way that we may be allowed a glimpse into Rembrandt's world and of his vision of the condition of man.

Many people, perhaps most people, when the elements of visual language are pointed out to them, admit that they have never before looked at a picture in this way. So long as a building or a letter or the face of a friend can be recognised they have never really considered the articulations and proportions of the building, the shape of letters, the pattern of light and shade on the face. This is quite normal and is connected with the nature of our perception.

When we perceive an object, for instance a chair, from different angles and in different lighting conditions we receive a very wide variety of impressions. These may be so different from each other that in a purely visual sense they may have little in common. Yet the human brain is able to link these different and sometimes unlikely visual images. It was a vital part of the evolution of man as a thinking animal that his brain developed a mechanism which scans each image for relevant clues, sifting out the variety of visual information it receives and extracting from each impression only what helps it to recognise a meaning or an object in it. It is not often realised how subtle and involved a mechanism the human brain requires to enable it to 'see' an object, such as a chair, from an unusual angle, for instance a violently foreshortened view, which the brain may never have recorded before. Neither is it realised that in relating such an image to what it 'knows' of a chair the brain concentrates on only a small part of the visual information it receives. By such procedures it is able to equate widely different images of the same object. We give each of these images the name of 'chair', we can see only the 'chairness' of each and not its complete visual character.

This mechanism which enables us to take the first steps towards forming concepts, to ordering our world and acquiring the power of abstract thought, filters out the 'useful' bits of our perception and allows the rest — the greater part — to be discarded. The result is that vast quantities of perceptual information are thrown away unused or are suppressed. Abstract thought has been bought at a high price. The more we have learned to think in concepts the thinner has grown the stream of our perception. And it is precisely in the suppressed, unused area of our perception that we must look for the raw material of visual language and poetry.

When we look at a painting we may

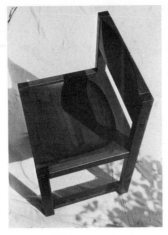 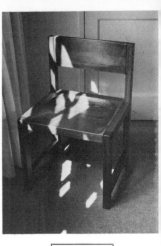

chair chair chair

perceive certain arrangements of coloured shapes and lines which, according to our 'educated' perception, we read as 'house', 'tree', 'man', that is, things. At the same time we ignore most of the non-thing qualities in the picture, qualities which may be nearer the artist's purpose. If we are incapable of penetrating a painting beyond the conceptual stage, and do not experience its inner structure, we shall, especially in the case of a modern painting, fail to wring any rhyme or reason from it.

Rembrandt's painting has a great deal in common with Picasso's *Portrait of Daniel-Henri Kahnweiler,* 1910. Both consist of dark and light areas, subdivided into smaller areas, in a balanced composition. Face and hands are in similar, conspicuous positions, but whereas in Rembrandt's painting the main shape may be interpreted as 'man sitting' and left at that, without thought of its artistic essence, the Cubist painting cannot be approached in this way. Here many non-thing qualities stand out and at times almost crowd out everything else. They ask to be considered.

A traditional painting relies for its effect chiefly on perspective and chiaroscuro (light and shade). Perspective assumes a stationary observer contemplating the world from his own immovable viewpoint. Chiaroscuro, similarly assumes a static source of light. These assumptions were discarded by the Cubists. In their reality passing impressions did not count and an observer could not be confined to one place, nor were the vagaries of accidental lighting acceptable.

Abandoning perspective and chiaroscuro brought its problems. In a traditional picture perspective makes the planes of all the forms relevant to each other. It also provides a structure for the composition. Chiaroscuro helps to render form; it also creates depth. The loss of these qualities —

related planes, structure, form, depth — might be expected to rob the new painting of all coherence; a new method was needed to replace the old.

This new method is demonstrated in Picasso's painting. a. Objects are broken up into planes which articulate not in terms of perspective but as divisions of the picture area while the edges of the planes form a rhythm which also lends structure to the composition. b. Tone is used to give the planes a spatial articulation, but in such a manner that they can still be read as more or less flat patterns. c. Additional depth is provided by the overlapping of shapes, an indescribable ambiguous depth which seems at the same time to be flat. This is in Cubist terms the ideal way of constructing depth in a painting for spatial ambiguity is the hallmark of Cubism. It is often impossible to tell whether a plane comes forward or recedes, whether it is part of the abstract element of the painting or is to be seen as a part of the subject matter. Depth which is at the same time flat seems to fit into this scheme.

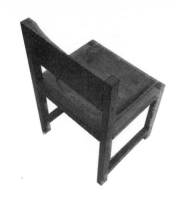

245

chair

a

b

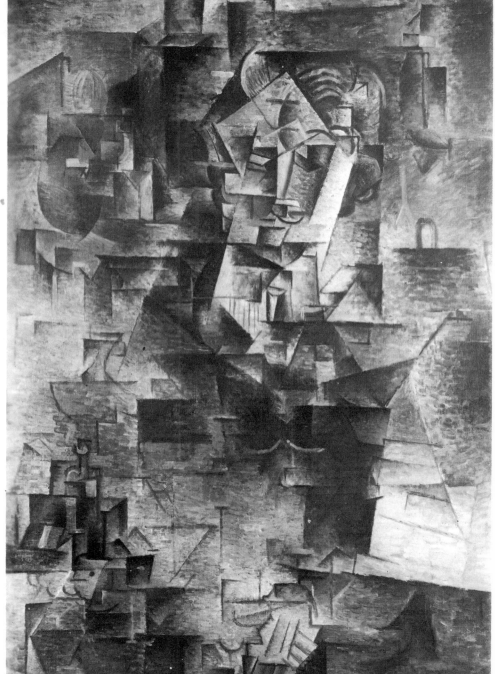

247

c

246

245 *Percepts and concept*

246 *Some aspects of Cubist visual language*

247 *Pablo Picasso,* Portrait of Daniel-Henri Kahnweiler, *1910. Art Institute of Chicago*

105

If we look once more at Picasso's painting we shall see how these new methods are employed. The painting consists of a closely knit arrangement of planes, in places combined into larger areas. Background, foreground and middle distance are not easily distinguishable. We can read distance into parts of the picture but the flatness soon reasserts itself. The most interesting quality of the painting is its varying density and rhythm. Letting our eyes roam over the picture we experience a progressive lessening of density, starting at the top with sombre, heavily articulated planes and gradually arriving at a flatter area where planes are barely distinguished on the flat ground. In the bottom left-hand corner we meet contrasted planes once more but they are smaller and more playful than those at the top. The central mass has a broader, calmer rhythm. Comparing other areas of the painting, we find that the fragmentation of the surface into small planes is not at all arbitrary but helps, amongst other things, to express the intensity of a given area.

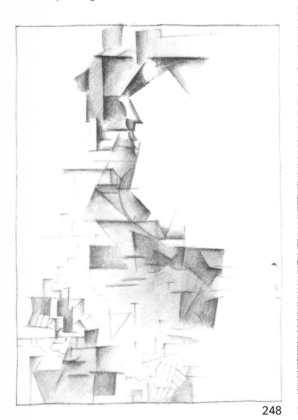

248

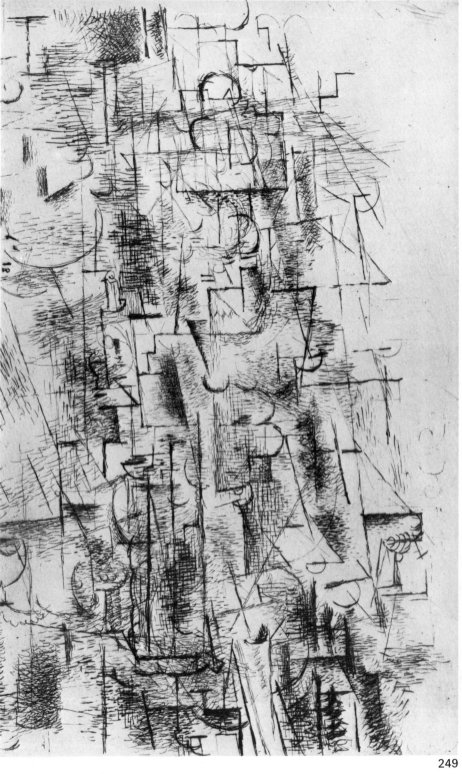

249

So Picasso's painting is not really as revolutionary as it may at first have appeared. It clings on the whole to traditional values but translates them into a modern visual language which makes it possible to portray a new reality never experienced before, a reality of ambiguous space and mysterious depth.

106

248 *Analysis of* Portrait of Daniel-Henri Kahnweiler

249 *Georges Braque,* Still Life, *1911,* etching

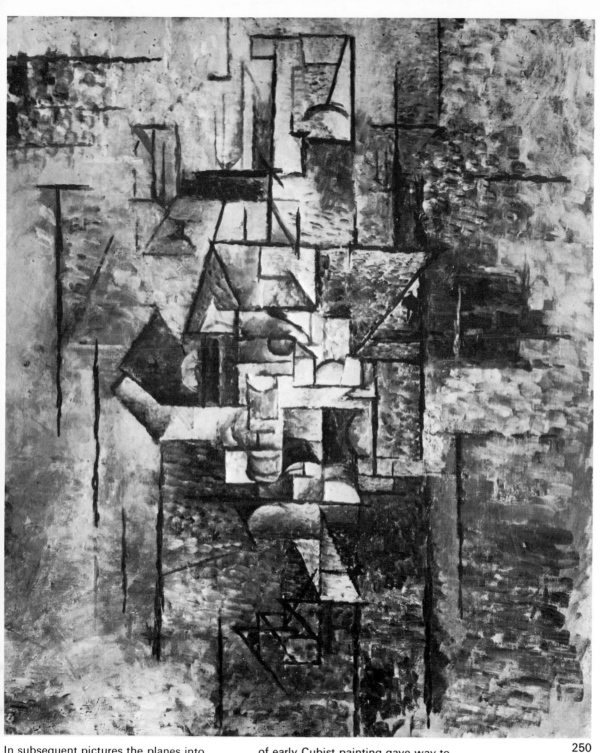

250

In subsequent pictures the planes into which objects were broken up became even more pronounced. We have noticed already that planes, originally invented in order to describe objects, tend to leave the objects to which they belong. Looking at Braque's *Still Life*, 1911, it is obvious that the artist's interest in the planes, as planes, exceeded his concern for the subject matter of the picture, so much so that even though it has a title it is hard to recognise anything at all. As Cubism developed, conventional subject matter was increasingly neglected, and replaced by spatial implications. The shallow space of early Cubist painting gave way to relationships between planes at once flat and spatial. This ambiguity of spatial articulation was wholly intentional; a more clear cut articulation of space would have meant a return to the old methods and the abandonment of the flatness of the picture plane. These paintings must be considered as paintings of *space*, or, more precisely, pictorial analyses of new experiences of space. Their effect resembles that of architecture, upon the development of which they were to exert considerable influence.

250 *Pablo Picasso,* Torero Playing a Guitar, *1911. National Gallery, Prague. Like Braque's etching this painting deals with planes and space*

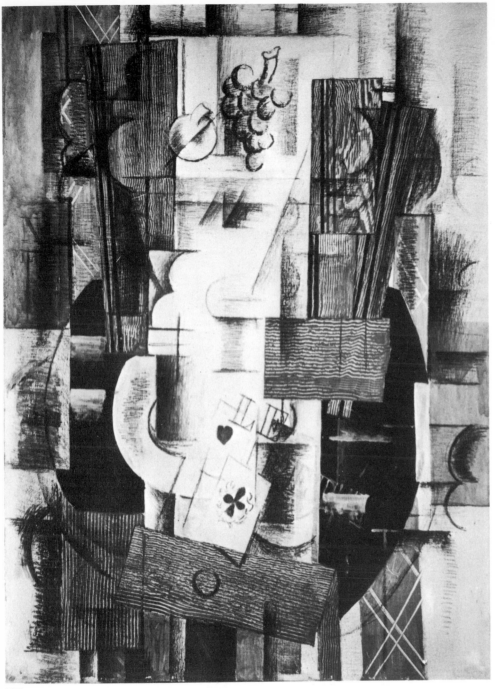

251

A crisis had now been reached. It was always the intention of Cubist painters to express their reactions to the visible world and in this sense their aims can be said to have been realist. The logic of their own visual development was, however, taking them further and further away from realism. They continued to retain a slender hold on reality by including in their increasingly unrecognisable paintings fragments of certain objects as clues to recognition: a bottle top, the curved outline of a musical instrument, a button from a man's coat. These fragments were now augmented by graphic symbols: letters, often of an evocative nature, portions of words taken from signs, labels or sheet music. Incorporated in compositions, these symbols stand in contrast to the more formal content as representative of a reality which had re-entered the Cubist structure.

In 1912 Braque treated an area of a painting with woodgraining of the type normally practised by housepainters. This example of a further aid to recognition was soon followed by Picasso's pasting to one of his paintings a piece of oilcloth with a basket weave pattern printed on it. In this painting, *Still life with Chair Caning*, 1912, the pattern suggests a chair, it does not describe it; it is both a part of the composition and a symbol for something larger than itself. The letters JOU, part of a newspaper heading, likewise do duty for the complete newspaper. Both these realistic incursions have an evocative value and perhaps relate to a certain occasion when the artist saw them in a café. They are in a very intimate relationship with the other objects in the picture — oyster, pipe, glass, lemon — largely through overlapping. Braque used pieces of woodgrained wallpaper to indicate the surface texture of a cupboard in a still life painting. Soon both Braque and Picasso were using pasted papers — collage — quite freely as part of the Cubist visual language. In so doing they brought back a certain measure of realism — or reality — into the near-abstract realm of Cubism, replacing by such means the use of illusionistic devices such as perspective and chiaroscuro which had long since been abandoned.

As a logical extension of these developments Picasso produced a number of three-dimensional collage works: Cubist sculpture. These works were never more than marginal in the evolution of Cubism but as we shall see they were to prove of fundamental importance in a different context.

251 *Georges Braque*, The Ace of Clubs, *1912. Musée National d'Art Moderne, Paris. An example of wood-graining technique*

252 *Pablo Picasso*, Still Life with Chair Caning, *1912. Collection Pablo Picasso*

253 *Pablo Picasso*, Guitar, *1912, sculpture with sheet metal and wire. Private Collection*

254 *Georges Braque*, Glass, Bottle and Pipe, *1913, pasted paper. Collection Lady Hulton*

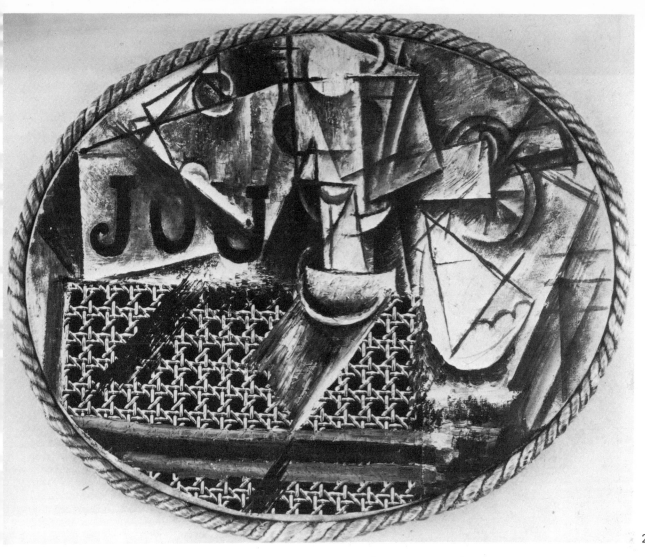

252

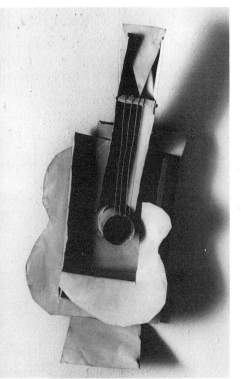

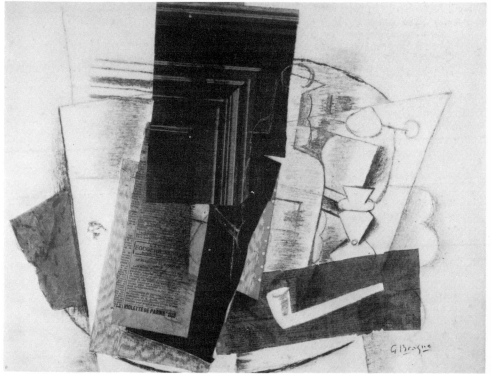

253

254

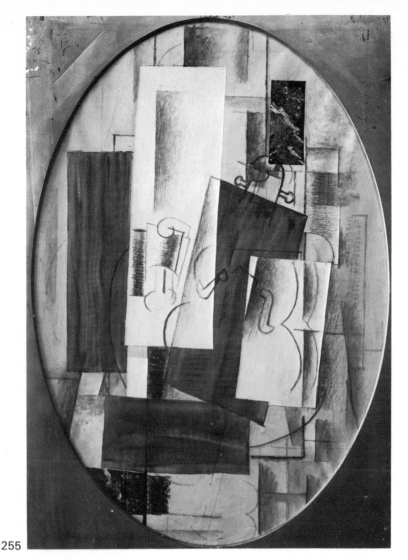

255

Cubism now entered its last phase. Cubist language had been established and what now exercised artists was largely its development and the composition of its elements into significant relationships. This phase therefore is known as *Synthetic Cubism.*

Braque's *Café Bar*, 1919, is rich in textures and spatial ambiguity. Some of the surfaces are textured due to an addition of sand to the paint, others have been scraped over with a comb. Edges are briefly referred to in a manner which recalls Cézanne. Some objects — for instance the fruit, dish and pipe in the middle, and the foot of the table at the bottom — are no longer splintered into planes as in earlier Cubist paintings but can be seen as whole objects. But there are planes in this picture which have no function beyond their compositional role. Between these two extremes there are clues to other objects: a stringed musical instrument, a newspaper, a sheet of music. The textural and spatial richness of this painting seems to indicate a return to more traditional, painterly values which find their culmination in the lyrical still lifes Braque was to paint in the 1920's of which *Still Life with Brown Jug,* 1925, is an example.

Picasso and Braque were the initiators and pioneers of Cubism but they were soon joined by other artists who employed Cubist methods in varying degree. The most important of these second-wave Cubists was Juan Gris, a Spaniard like Picasso. He employed the usual devices of late Cubism: overlapping planes, shallow

Pasted papers were not used simply to illustrate another aspect of the meaning of a picture, they also worked as flat planes in their own right, like the planes of the earlier Cubist paintings. And just as those planes eventually broke out of the objects from which they derived and destroyed their contours, so the planes of pasted paper also spread beyond the natural confines of the objects they described. As the pasted papers assumed importance in their own right the contours of objects were often indicated by lines, so that there was now an overlap of objective vision and abstract composition within the same pictorial space. The picture now clearly existed on two different levels simultaneously. In the past artists had succeeded in combining these different aspects of visual experience, objectivity and abstraction, although they became blurred in the process. Analytical Cubism had separated them. Now they had been brought together once more; they co-existed again in the same picture plane, each with its own integrity, but amid ambiguity and tension. These qualities had come to be accepted as essential in twentieth century art.

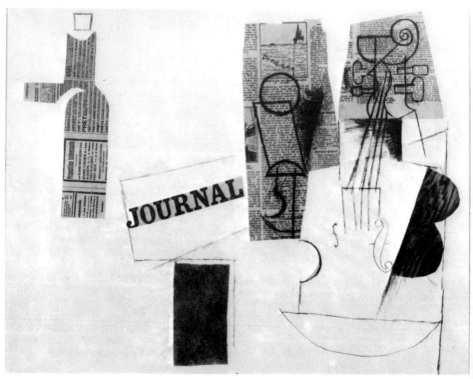

256

110

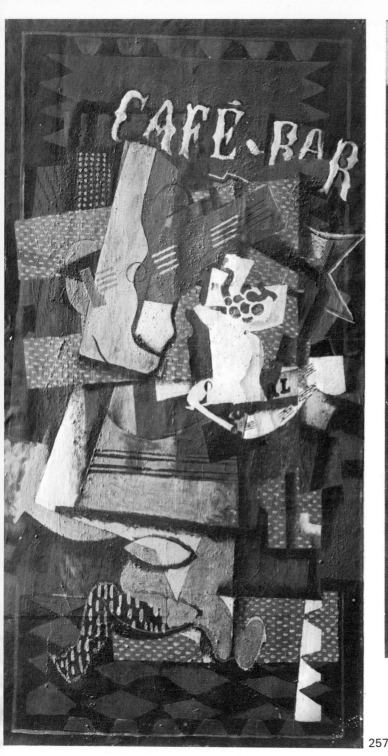

257

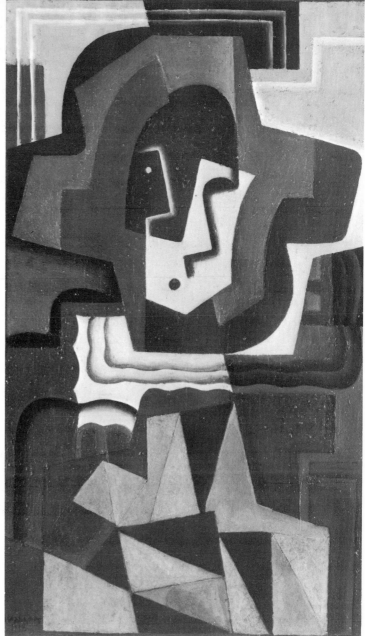

258

ambiguous articulations, lines backed up by strips of tone so that they might be interpreted as outlines of indeterminate shapes, closely interlocking shapes and spaces. But he used these pictorial means in a most individual and lyrical manner, creating spatial poems of great purity and refinement. *Harlequin*, 1918, is such a visual poem.

255 *Georges Braque,* Glass and Violin, *1913–1914, Kunstmuseum Basel. A great variety of spatial and textural interest; pasted paper, wood graining and other textures in oil paint, charcoal drawing*

256 *Pablo Picasso,* Bottle, Glass and Violin, *1912–1913, collage. Nationalmuseum, Stockholm*

257 *Georges Braque,* Café Bar, *1919. Kunstmuseum Basel*

258 *Juan Gris,* Harlequin, *1918. Private Collection*

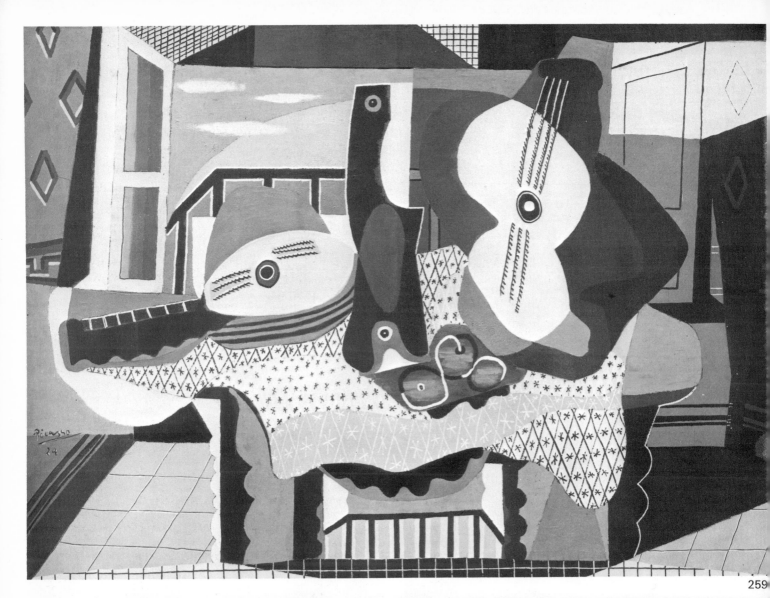

259

260

Picasso's still life *Mandolin and Guitar,*
1924, is considerably more dramatic. The
definition of objects is no longer left to
superimposed lines but depends rather on
the manner in which the shapes themselves
interact. They are tightly interlocked,
overlapped, counterchanged, defining here
contours, there shadows, in an amazingly
homogeneous composition. The shapes are
distorted to suit the composition and the
mood of the picture. Realistic details are
wholly suggested by abstract shapes. Like
all the best of Cubist and later twentieth
century art, the essence of this picture
hovers between two levels of reality.

The Three Dancers, 1925, by Picasso
marks the ultimate extent of Cubism. The
visual devices are similar to those in other
Cubist pictures but the content is of a more
violent and intense nature and is more
dramatically portrayed.

As soon as we begin to interpret this
picture on the most obvious level we
realise the impossibility of a factual
interpretation. The artist evidently intends
us to recognise the subject matter of the
title but he also supplies clues which
extend this meaning. Is the face of the
violently contorted figure on the left a
grimace or a skull? Is there another face
behind the head of the right-hand figure?
Or could the artist have intended the dark
profile to signify an evil spirit? Why is the
left-hand figure so contorted while the
right-hand one is so stiff? Whatever we
may think about these and many other
aspects of the picture we may be sure that
it is not merely a picture of three dancing
figures. The real content can be
apprehended only through the visual
elements, its Cubist language: the distorted
shapes, the jagged edges, the violent
colour contrasts. Yet in spite of their
disparity these elements are related to each
other in one overall composition in which
their disparity is resolved. The shapes fit
together in a tight pattern which is
interwoven with visual rhymes: the eye and
breast of the left-hand figure and the eye
of the central figure; the raised foot at the
extreme left of the picture and the hands
in the top right-hand corner; and so on.
The strongly contrasting planes of colour
not only underline the strong emotions of
the picture as such. They also give rise to a
sensation of Cubist space which is itself
intense and tragic. But even though the
pictorial language is distinctly Cubist, the
pictorial content — with its violence and
gloom — is closer to Expressionism. Cubist
Expressionism would be an apt designation
of this picture which would also indicate
that the two great movements in European
painting had joined forces.

261

259 *Pablo Picasso,* Mandolin and Guitar,
1924. Solomon R. Guggenheim Museum,
New York

260 *Georges Braque,* Still Life with Brown
Jug, *1925. Private Collection*

261 *Pablo Picasso,* The Three Dancers,
1925. Tate Gallery, London

H

By the turn of the century engineers had erected buildings and other structures in steel and reinforced concrete which amply demonstrated the capacity of these new materials to assume new forms, but architects responded very slowly to this challenge. Although the new technological means were used in building they were rarely given architectural expression. Most architects saw in the new materials and techniques little more than aids to even better reconstruction of old styles. For instance Selfridge's store in London was built in 1907. It has a steel frame but this is denied by its classical exterior. Even a great technological innovator like Hennebique, one of the pioneers of reinforced concrete, built a house in Paris in which the new material had little bearing on the architectural form.

It was in the work of Auguste Perret, in France, that reinforced concrete first achieved architectural status. The building which he erected in the Rue Franklin in Paris in 1902 was the first demonstration of the architectural use of reinforced concrete.

Parisian houses are normally built back to back with a light shaft, which is demanded by law, between them. When an old building is pulled down and the back of the building beyond exposed, the U-like form of the building can be clearly seen. It may be that such an occasion gave Perret his idea for the structure of his house. It may have struck him how much more characteristic of the building the back was, compared to the futile ornamental elaborations normally indulged in by the architects of the period. In their attempts to 'break up' the façade of their buildings, to give them formal variety and interest, they encrusted them with often unusable curved balconies and balusters, recessed windows and a cornucopia of classical garlands and romantic turrets. But on looking at the back of a building the young Perret may have realised that here was the raw material for a much more fruitful pursuit, namely the modulation of the outer wall of the building according to requirements, by giving these requirements their visual value. Whatever the cause may have been it was the back and not the front which became the significant part of the building, no matter what tradition decreed, and that was the part which he turned towards the street. By this seemingly irrational action he took a long step into the twentieth century: upsetting stereotyped attitudes, breaking down the traditional distinction between front and back and expressing the derivation of the ultimate form of a building from its use.

Looking at the building today its revolutionary, even visionary character is not at once apparent. But even at a first look, the very large area of glass of Perret's house stands out in a row of heavily ornamented contemporary buildings. This was made possible by the use of reinforced concrete and Perret took every advantage of it. Closer to the building, from the street level, we notice the extremely wide span across the centre of the ground floor which made a very large shop window a possibility. Also attracting our attention are the two entrances with their cantilevers on which several floors are partly projected over the pavement. Everywhere the structure of the building is clearly stated: the concrete structural framework is stressed while the parts in between are decorated with coloured tiles. The central recess – the old lightshaft – is the most significant feature. The interior space formed by it has become a part of the building. The balconies which are completely related to the articulated walls form an intermediate layer between the solid building and the space it contains. This indeed is the death blow to the idea of the façade which can be viewed – and admired – from one view point. To obtain a satisfactory idea of this building it is necessary to see it from many different view points, to walk past it and to experience the changing relationships of planes to each other in space. Although Perret started from bylaws, the function of the building, and the use of a new material, he succeeded in creating a new spatial concept of building.

This is amply confirmed by the interior where load-bearing pillars allow the arrangement of walls, relieved of their structural role, to model the available space to the functional and spatial requirements.

The Ponthieu Garage, also in Paris, is a later work by Perret (1906). Again the structure is honestly stated on the outside. Inside the combination of open floors, concrete pillars and glass roof make the whole building one homogeneous form. In both examples illustrated here a strong feeling for symmetry is still apparent. This has nothing at all to do with Perret's innovations and often inhibited a full realisation of the new principles. For

262

instance the two symmetrical entrances to the house in Rue Franklin serve two different purposes: one is the entrance to the hall and staircase serving the flats above, the other is the shop door. Two different functions have been disguised by the use of a classical device, derived from the principles of classical architecture. Perret was still in part a hostage to tradition.

Tony Garnier produced a plan for a modern city in 1904. It was never used but he made several additions to it until 1917. It relied for its architectural expression on reinforced

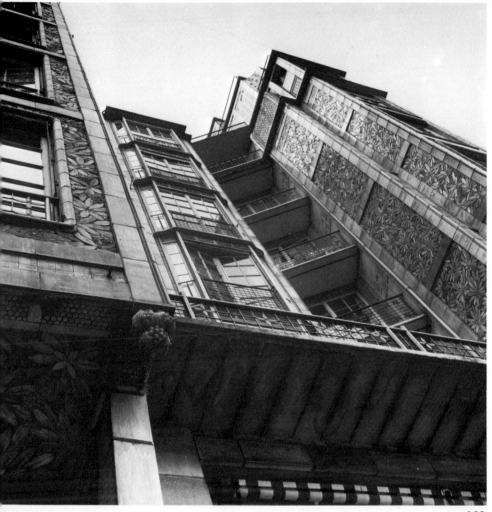

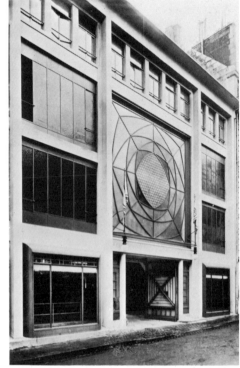

263

264

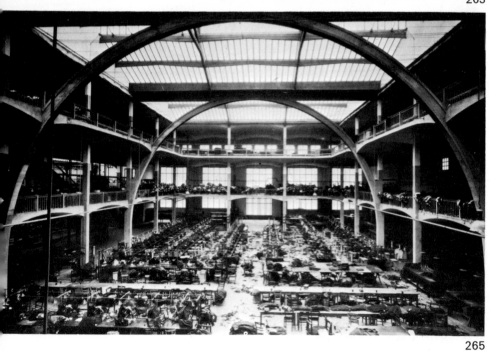

265

262, 263 *Auguste Perret, house in the Rue Franklin, Paris, 1902*

264 *Auguste Perret, garage in the Rue Ponthieu, Paris, 1906*

265 *Auguste Perret, clothing factory, Paris, 1913. A later and more adventurous use of reinforced concrete. The sections of the floors show their structural stress*

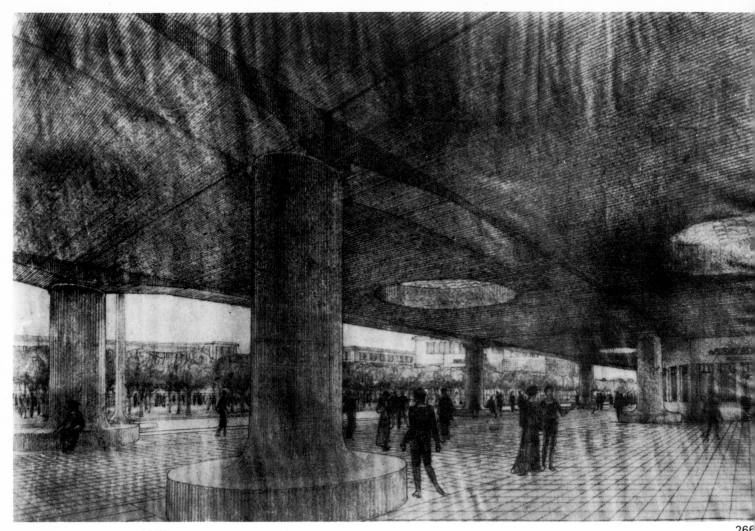

266

concrete. The design for the concourse may be one of the later additions. It shows a great understanding of the plasticity of the new material and an acceptance of structural forms — for instance the beams which are similar to those of Perret's factory — as architectural elements.

Structural steel also came in for consideration in an architectural context. In the building for Le Parisien Libéré one is no longer sure whether one is looking at a work of architecture or of engineering. The exposed, raised steel frame with its rivets certainly belongs to engineering, but the curvatures of the structural members still have an air of Art Nouveau about them, however remote, and this is confirmed by the more decidedly Art Nouveau curvatures of the entrance.

But even more significant developments in functional design and the use of modern materials were taking place elsewhere, again not entirely free from ingrained traditional attitudes. Developments in English architecture and design towards the end of the nineteenth century had not gone unnoticed in the rest of Europe. In Germany, in particular,

267

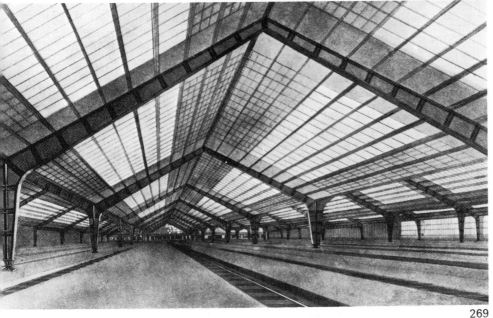

266 *Tony Garnier, design for a covered concourse, 1904–1917*

267 *Tony Garnier, design for a public building. Both these designs are for reinforced concrete*

268 *Georges Chédanne, newspaper building,* Le Parisien Libéré, *Paris, 1903*

269 *Design for Stuttgart railway station, 1914, from the Werkbund year book*

admiration for English achievements was widespread amongst architects, designers and industrialists. Industrial design, or at least what is now meant by this term, had not yet arrived, but even so, German industrialists, afraid of being left behind in the quality and design of industrially produced goods, urged their government to take action.

In 1896 Hermann Muthesius, a senior civil servant and architect, was despatched to London for the sole purpose of studying and reporting on English architecture and design. He spent seven fruitful years in England. The immediate result of his stay was a three-volume study of English architecture, *Das Englische Haus,* but more far-reaching were the lectures and writings in which he stated his conviction that art and industry need not be mutually exclusive. An association of German designers, craftsmen, architects and industrialists was formed in 1907 under the name of Deutscher Werkbund. The record of its achievements in the form of a series of year books includes not only photographs of ships, motorcars, fabrics, electric utensils and buildings, but also essays on such topics as the design of streets and civic spaces and of postage stamps. Since it was the chief purpose of the Werkbund to bring artist and manufacturer into closer collaboration — for their mutual benefit — arguments about the role of the artist in the quickly changing conditions of the new century were common. The central argument concerned the problem of standardisation. Although craftsmen may make individual pieces with minor, or not so minor, variations, industry cannot work in this way. While Morris and his followers in the Arts and Crafts Movement had looked for a solution in honestly hand-made utensils which could not, because of their high cost, find a way into the mass market, members of the Werkbund tackled the far more difficult task of reconciling the apparently antagonistic concepts of individuality (the artist) and standardisation (industry). In Muthesius' view the modern artist should emulate his classical precursor and like him work to a set of rules. Van de Velde passionately opposed this view. The battles which were fought within the Werkbund were concerned not only with aesthetic principles but also with matters of cultural and social significance. The fundamental problem was to decide how a society should make use of its artistic talent for its own enrichment.

While these arguments were going on, several events pointed to where a beginning might be made. In 1907 Peter Behrens was appointed design coordinator to the electrical firm AEG. He was put in charge of the design of industrial buildings erected for the company and also of their products and publicity material. The profession of

270

271

industrial designer was born with his
appointment. Behrens' most monumental
contribution was the turbine factory of
1909, in which large areas of glass were
inserted between exposed structural
members. Even more important perhaps
was his work as product designer. In some
of his domestic appliances the derivation
from Arts and Crafts and Art Nouveau is
still in evidence – note the hammered
finish of the heater, the decoration of the
electric kettle. Nevertheless Behrens
transformed the over-wrought, encrusted
objects he inherited into modern objects
which do on the whole match their
modern function.

His work in the industrial field is more
significant. The street lamps he designed
are visually significant objects which do
not conceal their machine derivation. They
can be accepted as shapes in their own
right, machine-produced machines, and no
longer pieces of historical decoration
which try to conceal their function.
Behrens related the basic shapes and
proportions of the utensils to their purpose
and their methods of production. Their
clean shapes and outlines express not only
the new scientific spirit but also the new
machine processes in which free, irregular
curvatures are best avoided. We can see
here the first assured steps in the direction
of what the next generation was to term
the Machine Aesthetic: the visual language
of a society no longer overawed by the
machine or depressed by its future
implications.

Behrens' importance, however, lies as much

272

in the fact that he was teacher to three of
the most influential form-givers of the
modern world: Walter Gropius, Ludwig
Mies van der Rohe, and Le Corbusier.

The Werkbund Exhibition of 1914 was a
demonstration of German progress in
architecture and design. Bruno Taut's glass
pavilion, one of the exhibits, an original
and influential structure, gave a most

advanced idea of the potentialities of glass
in building. Glass also played a major
part in the Model Factory designed by
Walter Gropius with his partner, Adolf
Meyer.

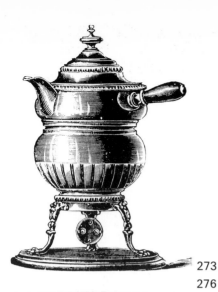

273

276

270 *Ernst Neumann, design for a motor car, 1914*

271 *Richard Riemerschmid, design for a tea service, 1913, both from the Werkbund year book*

272 *Peter Behrens, AEG Turbine factory, Berlin, 1909*

273 *Electric kettle, produced by AEG, late nineteenth century*

274 *Peter Behrens, electric kettle, 1910. Structured Art Nouveau*

275 *Peter Behrens, electric heater, 1910*

276 *Peter Behrens, hanging street lamp, 1907*

277 *Peter Behrens, electric fan, 1909*

278 *Bruno Taut, glass pavilion, Cologne, 1914*

274

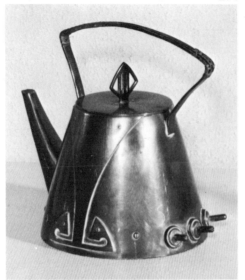

275

278

277

The office block of the factory is clearly the boldest gesture of modern architecture up to that time. The most striking feature is the pair of glass-sheathed staircases flanking the front elevation. The curved glass walls run back on either side of the building and along the whole length of the inner, courtyard elevation. The glass wall which envelops the building on a little more than three sides allows the inside offices, corridors, and staircases to be seen from outside. Viewed from the courtyard the old idea of a façade ceases to have any meaning. Since the glass wall rises several feet in front of the brickwork one cannot be sure which plane is to be accepted as the plane of the façade. And since in any case the glass wall does not offer a serious visual barrier the idea of the traditional façade is still further confused.

Like so many pioneer works, this Model Factory design is still largely couched in the language from which it is trying to escape: the symmetry of classical architecture is much in evidence, as indeed it was in the most advanced architecture of that period, for instance Behrens' Turbine factory and Taut's glass pavilion. The inclusion of a new building material — glass — on such a vast scale produced visual discrepancies. The glass envelope, although a brilliant innovation, does not always fit easily into the neo-classical composition of the building.

Buildings which breathed a modern spirit had, however, already been built before the Werkbund Exhibition of 1914, buildings which, each in its own way, challenged tradition-bound concepts. Gropius had built his Fagus factory in 1911. Here a new form of construction using internal supports made it possible to wrap the building in a skin of glass with the merest external evidence of a load-bearing structure. The omission of load-bearing corners — astonishing at the time — gave the building a lightness and grace unusual for an industrial building.

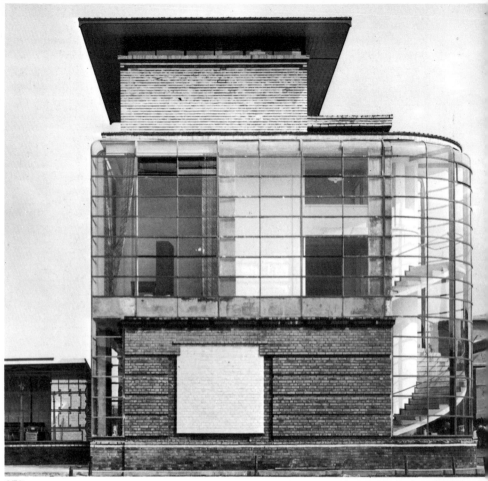

279

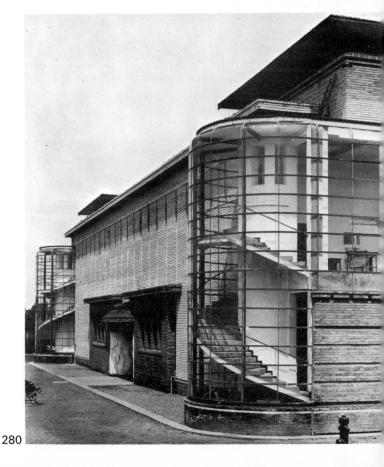

280

279 Walter Gropius, Model Factory, Cologne, 1914, side elevation

280 Model Factory, front elevation

120

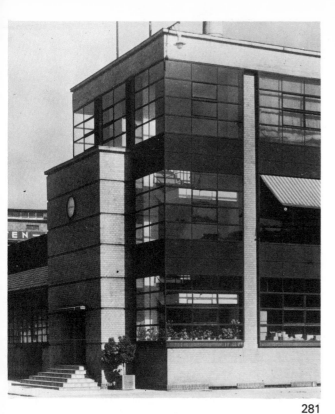

281

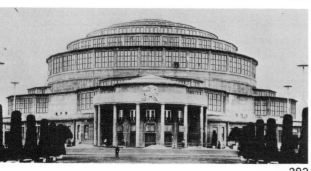

282

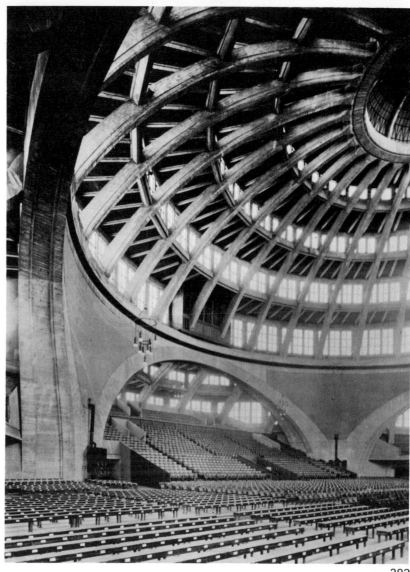

283

Max Berg's Centennial Hall at Breslau built in 1913 provided a demonstration of how reinforced concrete could be used for both structural efficiency and dramatic effect. This latter quality hardly resulted from a strict interpretation of function — none of these buildings can be said to be purely functional — and belongs properly to the field of artistic expression, in this case Expressionism. Quite apart from any direct influence which might have existed, the general climate generated by Expressionism in art opened the way to a more profound exploration of the expressive possibilities of architectural forms and their effect on the emotions.

The Deutsche Werkbund had ensured that industrial subjects were no longer thought by architects to be outside their province. Until then it had been mostly engineers who built water towers, factories and warehouses. When the architects took over some of this work from engineers they looked for architectural as well as engineering solutions to the problems posed by these projects and there were no architectural precedents for such buildings. Although the convention of clothing modern buildings, that is buildings related to modern functions, in historical styles was by now thoroughly discredited, historical precedent could yet be referred to in another way. If churches expresssed the spirit of Christianity, the house of a burgher his social standing, then factories and other industrial buildings must express the spirit of industry, of progress, of work. These buildings could discharge this function best by expressing their purpose and their structure in architectural terms and in such a manner that they could be seen as monuments to industry and progress.

We have seen that a trend to greater expressiveness had already entered architecture; we need only think of Mackintosh and Horta. But the new generation of German architects carried expressiveness in architecture to new heights. They took advantage of the opportunities offered by the new technology to make even more unusual and emotionally charged statements in architectural form. Their buildings (as well as their unrealised designs) not only provided new ideas for the efficient use of new materials, but also expressed their functions and human reactions to these functions.

281 *Walter Gropius, Fagus factory, Alfeld, 1911*

282 *Max Berg, Centennial Hall, Breslau, 1913*

283 *Centennial Hall, interior*

Poelzig's drawing for a water mill which dates from 1908 shows an early attempt not only to design a building expressive of its function but also to introduce something deeper, a certain stark grandeur. There is no decoration, apart from the semi-circular windows which are not wholly relevant to the functioning of the building. However, when Poelzig designed — and this time actually built — a chemical factory at Luban in 1911 these same windows found a practical purpose wholly related to the building's function. The dramatic, stepped-back roofline of the factory and the connecting bridge wring the maximum expression from the industrial elements. The strange relationship between walls and windows (reminiscent of Mackintosh), particularly of the side elevation, give the building a monumental quality. In the same year Poelzig designed a water tower incorporating an exhibition area on the ground floor and a restaurant on the first floor. Here can be found the same characteristics: a dramatisation of engineering structures and a setting for human activities consisting of nothing but engineering structures. Poelzig also designed other buildings, apart from those for industry, and there his brand of Expressionism found freer reign. He designed film sets which exude the

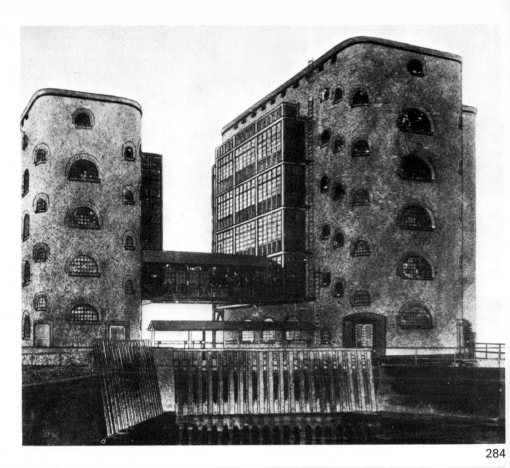

284

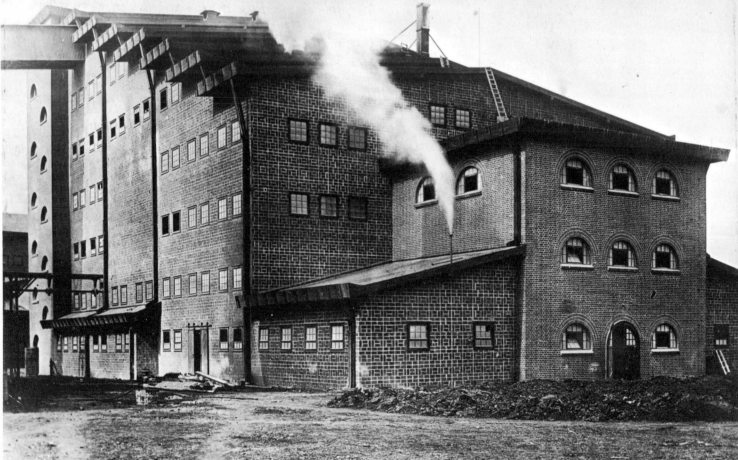

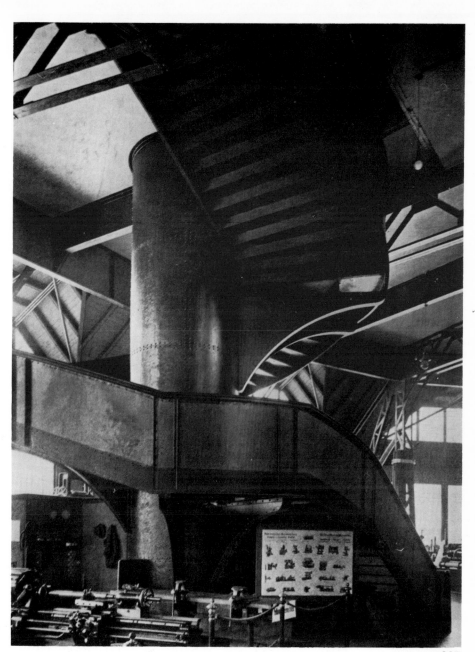

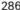
286

288

287

284 *Hans Poelzig, design for a water mill, 1908*

285 *Hans Poelzig, chemical factory, Luban, 1911*

286 *Chemical factory, Luban, side elevation*

287 *Hans Poelzig, water tower, Posen, 1911. Exhibition area with staircase*

288 *Hans Poelzig, film set for* Der Golem, *director Paul Wegener, 1920*

ssence of Expressionism. His set for *Der Golem* and the interior of the water tower have their Expressionism in common.

xpressionism was a live force in industrial rchitecture, many of whose forms can only e explained by a reference to it. But for he purest examples of Expressionist rchitecture we must look outside industry to the many buildings and projects where crude shapes and masses, comparable to Expressionist painting and sculpture, and even Expressionist film sets, appeal to our emotions.

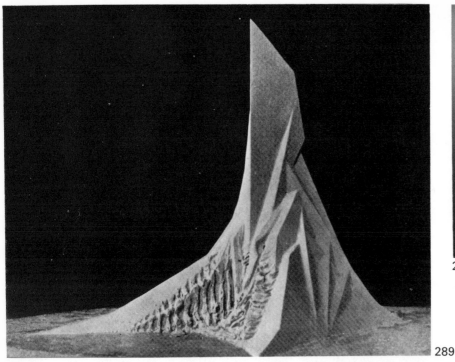

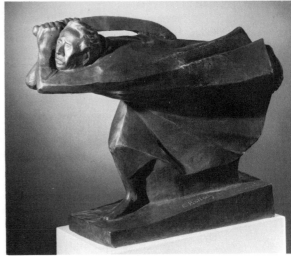

Wassili and Hans Luckhardt's *Form Fantasy* has no definite application but explores the possibilities of architectural form in an Expressionist context. It is a particularly pure form of Expressionist architecture and was no doubt influenced by Expressionist sculpture.

Hermann Finsterlin's Expressionist and Utopian projects – all of them unrealised – derive, as so much else in the Modern Movement, from his early attempts to find the basic forms of architecture, the forms normally overlaid by inessentials, the forms which may be combined in different compositions to make buildings expressive. Soon these basic elements melt into each other to produce varied overall forms more like sculpture than architecture. They constitute an attempt to create forms and internal spaces which would fill men with a daily sense of wonder and to which they could respond at deeper levels of awareness than in the case of traditional architecture. This architecture which would be 'close to nature and to the soul of man' would, by virtue of its organic structure, enrich life beyond the limitations of traditional architecture. Like Expressionist art, Finsterlin's designs, which must have seemed incoherent and formless to many of his contemporaries, attempt to state organic wholes in which the parts are intimately connected, as in a natural organism, that is to say not only through their forms but through the logic of their interrelated functions. Finsterlin's projected House of God is a monument to the spirit of man, to replace the cathedral, as in Nietzsche's philosophy man had replaced God. The driving force behind this pure form of Expressionist architecture was fired by the desire to find not only an envelope for man's physical functions but also a home for man's spirit. A concern for man's place in the cosmos is the underlying urge implied in Expressionist architecture and distinguishes it from other contemporary schools of architecture.

289

291

289 *Wassili and Hans Luckhardt,* Form Fantasy, *1919*

290 *Ernst Barlach,* The Avenger, *1914. Tate Gallery, London*

291 *Hermann Finsterlin, composition with building blocks, 1916*

292 *Hermann Finsterlin, House of God, 1918*

292

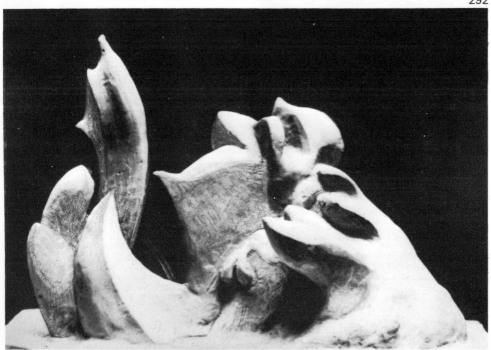

Even more important than Finsterlin's designs and ideas are those of Rudolf Steiner, not least because they actually led to completed — or nearly completed — buildings. In 1913 he designed and built the Goetheaneum, a large building mostly in wood, as the centre of the Anthroposophical Society, an offshoot of the Theosophical Society, a near-religious sect which aimed at the communion of man's spirit with the cosmos. Here Goethe's and Nietzsche's ideas were to be united. Ten years after its completion it was burned to the ground and Steiner designed another building to be erected on the same site in reinforced concrete. This second building was not completed until 1928, three years after Steiner's death.

Steiner's architecture can be described as architecture of the soul. He said, 'Architecture stands on earth in a central position. "A spiritual being" on one hand, inspiring mankind; on the other a solid structure of brick or concrete serving a sensible earthly purpose.' He believed, like Finsterlin, that a building should be like an organism, with its own inner life, to inspire the life of the individual. This inner life could be generated by giving the building a plastic quality. 'A wall is not merely a wall, it is living, just like a living organism that allows elevations and depressions to grow out of itself . . . inside our building we shall find *one* plastic form, a continuous relief sculpture on the capitals, plinths, architraves. They grow out of the wall and the wall is their basis, their soil, without which they could not exist.'

This unitary, monolithic structure but with a plastic, dynamic quality is achieved by dispensing with flat, perpendicular walls and articulating them as they might be in a natural organism, free from right angles. Its clear-cut, even brutal, forms, devoid of ornament, but enriched by the pattern of the shuttering into which the wet concrete was poured, is one of the most potent examples of Expressionist architecture. As in Expressionist art every detail is fraught with meaning and adds materially to the spiritual message of the total building. It was intended to appeal to and reveal the spirit of man as the cathedral had appealed to the spirit of man, but in a different sense.

We can detect these pervading ideas in the work of many architects active in Northern Europe at that time, in particular in industrial projects.

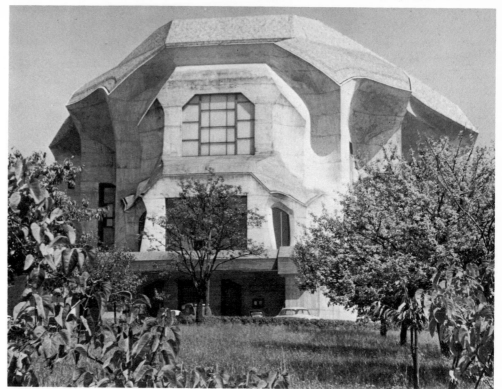

293

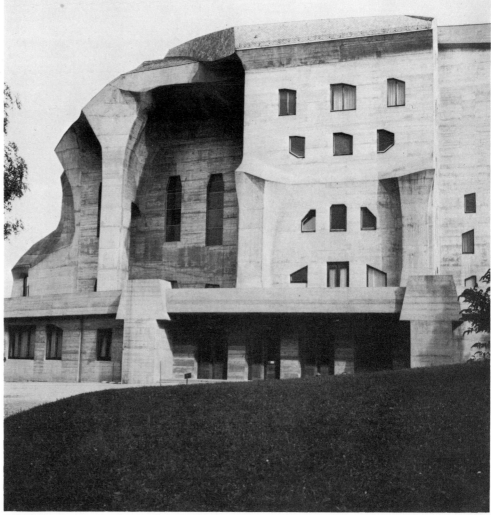

293 *Rudolf Steiner, Goetheaneum II, Dornach, 1925*

294 *Goetheaneum II, corner detail*

294

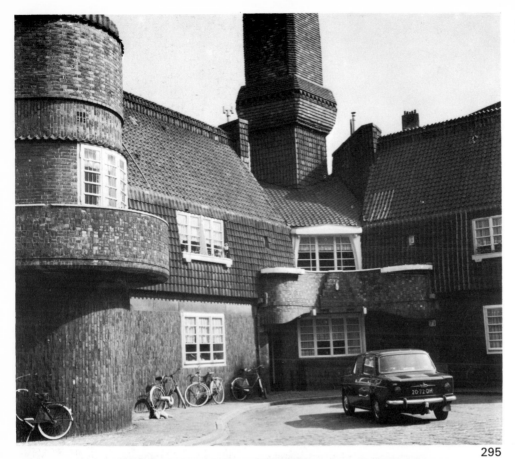

295

296

The housing development in Amsterdam which the Dutch architect Michel de Klerk designed in 1917 uses an Expressionist vocabulary of forms for functional purposes. The development included not only residential apartments but also the services which a community requires, such as a Post Office, a school, etc. These different functions were expressed on the outside of the building, often in quite dramatic forms. Even windows and doors became expressive in a dramatic way which appealed to human emotions and perception.

295 *Michel de Klerk, housing development, Amsterdam. 1917*

296 *Housing development, Amsterdam, entrance to individual housing*

297 *Housing development, Amsterdam, detail*

298 *Erich Mendelsohn, Einstein Tower, Potsdam, 1920*

299 *Einstein Tower, detail showing plasticity of form*

300 *Erich Mendelsohn, factory, Luckenwalde, 1921*

301 *Erich Mendelsohn, sketches for an industrial building and a hall*

297

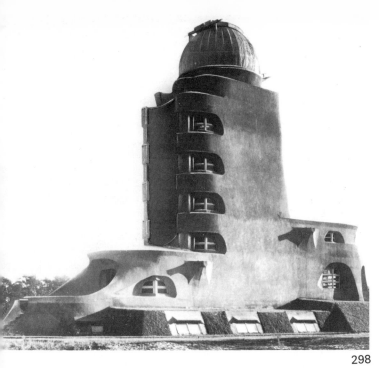

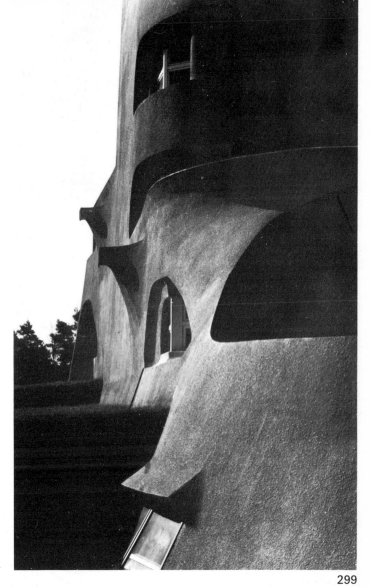

298

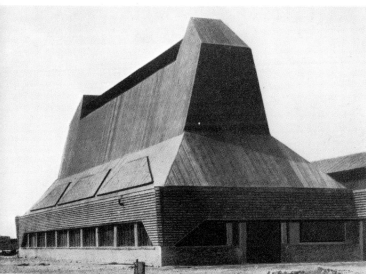

300

299

Mendelsohn's architecture is also of
the Expressionist school — although it must
be added that no architect of the time was
aware of being an Expressionist, the term
being applied many years later, in
retrospect. His Einstein Tower, more of a
monument than a building and
demonstrating the technical difficulties of
translating dream architecture into fact, is
the most obvious of Mendelsohn's
Expressionist buildings. But his numerous
industrial projects contain Expressionist
elements which are easily appreciated. His
factory at Luckenwalde although consisting
of clearly defined planes is also Expressionist.
His famous drawings show the plasticity of
form which entered his creative thought
from the very outset, and expressed the
motive as well as the organic aspect of the
function of the building.

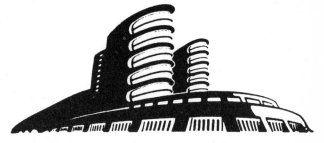

301

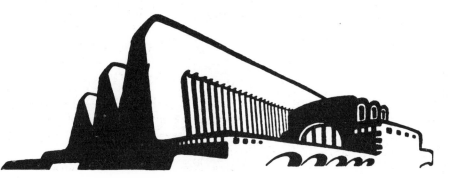

During the years immediately preceding and following the First World War, there existed conditions which allowed architects and designers to feel their way towards a new attitude to the human environment. Although every step was accompanied by a great deal of argument and polemical writing, the main advances came from practical experience in using new materials and from the need to build for new purposes. At the same time functional considerations were not the only guidelines for there was in all the work of architects and designers an attempt to handle masses and spaces in such a way as to imbue the purpose and structure of a building with spiritual and emotional meaning.

The great architects and designers of the period saw a quality in the machine which would enhance rather than impair the dignity of modern life and would emulate the greatness of past ages. The English architect and designer, William Richard Lethaby, declared in 1905: 'The impressive dignity, the beauty, the perfect fitness and the style of a modern express locomotive is incomparably finer than the best work of the best architect today.' And Gropius in 1913: 'The grain silos of Canada and South America, the coal bunkers of the leading railroads, and the newest work halls of the North American industrial trusts can bear comparison, in their overwhelming and monumental power, with the buildings of ancient Egypt.'

Some of the industrial forms of Gropius' Fagus factory, built in 1911, preceded his statement and they show clearly his faith in the spiritual as well as aesthetic potential of such forms, even though they are still somewhat at odds with the purely architectural elements. In his diesel locomotive of 1913, Gropius again manifests this new attitude to the machine, which has more than an element of Expressionism. The designer, having completely absorbed its functions, is able to express the organic character of the machine. Even in a later work of Bruno Taut, such as his design for the Tribune Tower in Chicago, we can detect in spite of its functional appearance a striving after expression. For Bruno Taut the purpose of glass in building was not only functional but also had a spiritual meaning and would, he thought, influence the emotions and the outlook on life of the inhabitants. The inscription on the glass pavilion of 1914 reads: 'Coloured glass destroys hate'. In one form or another Expressionism could be found in most progressive European architecture of the first quarter of this century, even when the external appearance seemed to be wholly derived from realisations of function.

302 *Bruno Taut, design for Chicago Tribune Building, 1922*

303 *Walter Gropius, diesel locomotive, 1913*

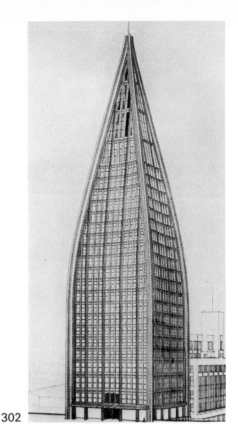

302

303

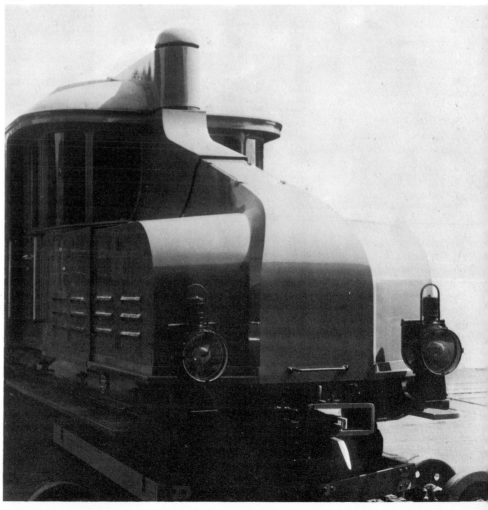

In the countries of Western Europe, where the processes of industrialisation forced architects to take machines and mechanical processes — as distinct from handicraft processes — into consideration, new and radical attitudes were gaining ground in the face of academic orthodoxy. The machine was in course of being fully accepted and given environmental status. These new approaches to designing, however, were part of a very much larger process which incorporated other elements as well: a desire, for example to, make the newly developing world of industry a valid part of existing culture, and also a concern with economic viability. The growing concern with such matters was also, no doubt, due to the fact that the majority of industrial installations were not up to the visual standard of such prototypes as those mentioned by Lethaby and Gropius, and to a very understandable wish to bring the new monsters under control.

Although these conditions were common to the industrial countries of Europe, there was one notable exception: Italy. Raw materials, particularly coal and ores, are not plentiful in that country and the suddenness and speed of the industrialisation process elsewhere was therefore ruled out. By the beginning of the twentieth century industrialisation had only recently become a feature to be reckoned with. It came into conflict with the bedrock of timeless Italian life in which the dynamics of modern industrial society, precise and topical, expressed by steam and steel, had no place. The gap of centuries during which cultural life and social evolution had stood still in Italy made the intrusion of technology more noticeable than elsewhere. The contrast between old and new, a universal talking point everywhere in Europe, was nowhere more acute than in Italy. It is against this background that we must consider the events, statements and manifestoes which surround the Futurist Movement.

The Foundation Manifesto of the Futurist Movement, written in French by F. T. Marinetti, was issued in 1909. It proclaims the advent of a new element in life — speed — and a veneration of the source of this element — the machine. The underlying reason for the manifesto was an acute dissatisfaction with the old ideas which in Italy had an air of eternity. It came to a head one night when Marinetti and his friends, all of them in their twenties and impatient at the stagnation around them,

took to their cars and raced through the streets of Milan. The manifesto opens with a description of this race.

'. . . The wild sweep of madness whipped us out of ourselves and chased us through streets as rugged and deep as torrent beds. Here and there a sick light in a window taught us to mistrust the fallible mathematics of our eyes.
I cried, the scent, the scent alone is enough to guide these beasts.
And we like young lions, pursued death with its black belt dotted with pallid crosses . . . Nothing this wish to die but a desire to be freed at last from the load of our courage.
And we sped on, flattening watchdogs on doorsteps, curling them up under our flying tyres like collars under the flat-iron. Domesticated death came up with me at every corner. . . . Let's just give ourselves up to the unknown, not out of desperation, for sure, but to plumb the deep wells of the Absurd.'

One is confronted, not for the first time in the century, by a combination of death wish and rich man's ennui, but there are two accompanying features even more alarming than the central theme: these are the ruthlessness which glories in the infliction of death on others if it serves to further one's own pleasure, and the subservience to the main occurrence of everything connected with this mad night ride, for example the streets and houses of the town. Speed is not experienced merely as a new factor in modern life; on the contrary, life is seen wholly in terms of speed and the sensations arising from it. What elsewhere in Europe was considered to be a new dimension of modern life which had to be taken into account in the organisation of society had for Marinetti and his followers become a fetish to which everything must be sacrificed. Isolated from the other elements of life, the machine worship of the Futurists, like an accelerating but freewheeling engine, gathered speed and momentum in Italy in a way that it could not elsewhere. Away from the soot and sweat of the Industrial Revolution it was easier to endow the machine with romantic attributes. It was this isolation which allowed Marinetti to proclaim: 'We declare that the splendour of the world has been enriched by a new beauty — the beauty of speed. A racing car, its bonnet draped with exhaust pipes like firebreathing serpents — a roaring racing car, rattling along like a machine gun, is more beautiful than the

winged victory of Samothrace.' Unlike the 'perfect fitness' of Lethaby's locomotive and 'the monumental power' of Gropius' American buildings, Marinetti's simile strikes a sinister note.

Futurist experience is usually of mass movement ('we will sing of the stirring of great crowds . . .') in which the individual is submerged in a vast current, powerless to stem its physical force or psychological effect. The only people who are allowed individual experience are the engineers, the wielders of the new power ('We will hymn the man at the steering wheel . . .') and the highest form of idolatry and ill-concealed envy goes to those ' . . . who enjoy . . . a life of power between walls of iron and crystal; they have furniture of steel . . . They are free at last from the examples of fragility and softness offered by wood and fabrics . . .' They are to be the new high priests wielding absolute power, ' . . . synthesised in control-panels bristling with levers and gleaming commutators'. This is surely the pivot of the whole Futurist argument. Speed and the mechanical power which supports it are not sought after as additions to contemporary life but as means of controlling the whole of modern society, 'the great crowds'. The subsequent connection between Futurism and Fascism is a logical development.

Marinetti's ideas attracted many artists in different fields. Particularly young artists who suffered the frustrations of being ignored by their tradition-bound, bourgeois-dominated society welcomed the social involvement which Futurism offered. Futurism announced the break-up of the old social order and of traditional patterns of thought and feeling. It attacked bourgeois order and hypocrisy and even old-fashioned logic as the main obstacles to true creativity. The wilful disorder of Futurist works and methods constituted the main attack on the establishment. Their worship of machines and of their hard geometry, in contrast to the soft degeneracy of bourgeois life, their love of speed and the sensations associated with it, and their belief in the violent use and total involvement of all the senses led them to see war, with its heightened experience as the ultimate in Futurist action. But there were also notable Futurist achievements and members of the movement initiated many revolutionary explorations of human experience.

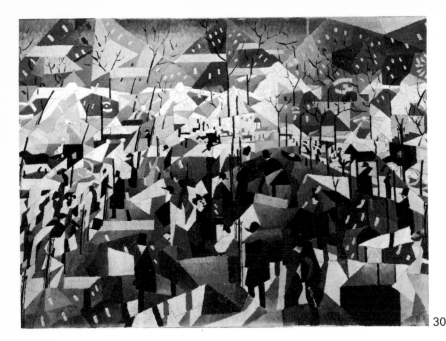

304

305

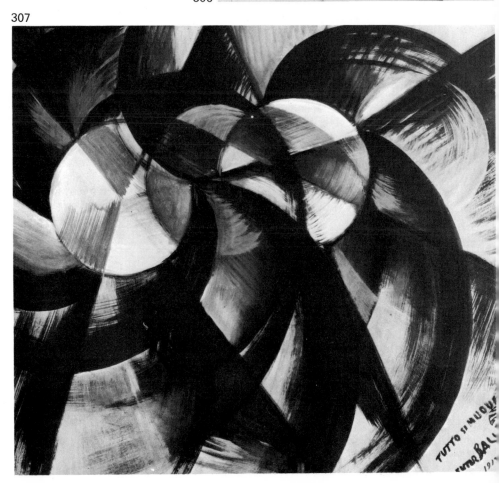

306

307

But in the main Futurism was a *verbal* idea. Futurist painters had to find the means to translate it into visual terms, a different process altogether from, for instance, Cubism and Fauvism which moved entirely in the visual field. Futurist artists, searching for a suitable vehicle for their aspirations availed themselves of the researches of other artists, particularly the Cubists, although they developed these methods in their own way.

The influence of Cubism is apparent in most Futurist painting but nowhere more than in the painting of Gino Severini. He had stronger ties with Cubist Paris – where he lived and worked – than with Futurist Italy and his paintings rely heavily on the Cubist idiom. *The Boulevard*, 1910, has areas of varying density rather like Cubist paintings, for instance Picasso's portrait of Daniel-Henri Kahnweiler, but they are more organised so that we experience an impression of simultaneous movement. The shapes and upright lines seem to ebb and flow over the whole picture area, each portion at its own speed.

The Rhythm of the Violinist, 1912, by Giacomo Balla is noteworthy for its unusual shape. The technique is derived from Impressionism, the imagery of movement is directly influenced by the high-speed photography pioneered thirty years earlier by Marey in France and Muybridge in England, for purposes of analysis. However Balla tried to render the sensation of movement rather than to analyse it.
Both *The Boulevard* and *The Rhythm of the Violinist* have tame and genteel subjects which do not, as yet, measure up to the stridency of the Futurist manifestoes. *Abstract Speed-wake of a Speeding Car*, 1913, and *Everything Moves,* of the same year, which is even more abstract are more

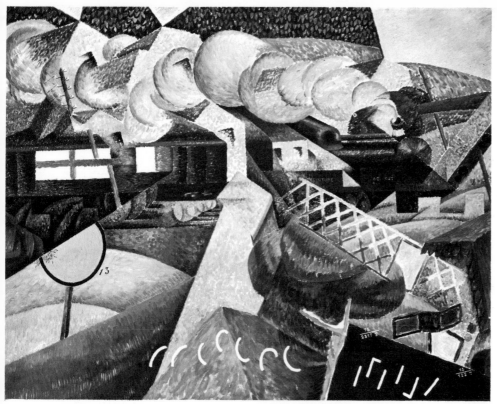

original conceptions of movement. Severini's *Red Cross Train*, 1914, also marks an advance in the represention of movement. It is through works like these that Futurism began to exert an influence on other artists and designers.

Of all the Futurists Umberto Boccioni was the most successful in combining physical sensation with metaphysical experience. His vision of the modern world of movement and speed and simultaneous happenings was more complex than that of his fellow Futurists, of whom he alone understood the emotional implications of the new machine age.

His painting, *Brawl in the Milan Galleria*, 1910, shows the method he was employing at the time to portray simultaneous movement by a rhythmic grouping of the figures. The method is not in any way original and derives from Renaissance painting. Botticelli's *The Miracles of San Zenobius* is an example of this kind of dynamic composition in which figures have been so grouped as to give an impression of an overall movement in which they all take part. Severini's *The Boulevard* also harks back to it.

308

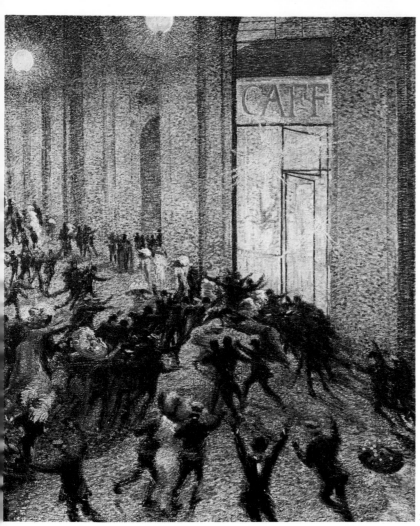

309

310

304 *Gino Severini*, The Boulevard, *1910. Collection Mr and Mrs Eric Estorick, London*

305 *Giacomo Balla*, Rhythm of the Violinist, *1912. Collection Mr and Mrs Eric Estorick, London*

306 *Giacomo Balla*, Abstract Speed-wake of a Speeding Car, *1913. Tate Gallery, London*

307 *Giacomo Balla*, Everything Moves, *1913. Collection Graziano Laurini, Milan*

308 *Gino Severini*, Red Cross Train, *1914. Solomon R. Guggenheim Museum, New York*

309 *Umberto Boccioni*, Brawl in the Milan Galleria, *1910. Collection Dr Emilio Jesi, Milan*

310 *Sandro Botticelli*, The Miracles of San Zenobius, *detail. National Gallery, London*

131

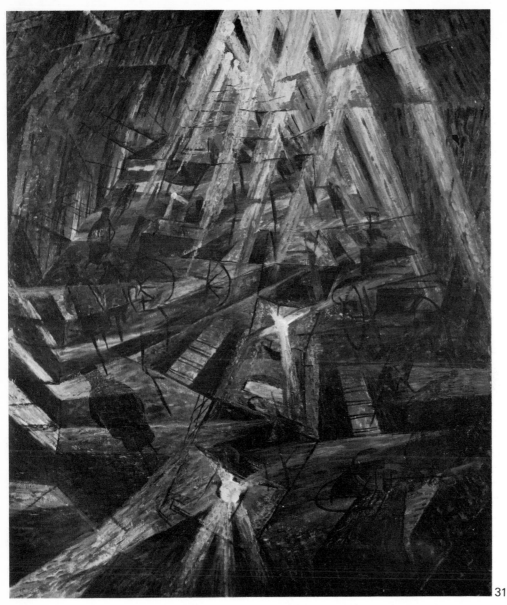

results from leaving home and being propelled towards strange places, and many other emotions combine here to form a complex modern state of mind. Boccioni attempted to render this. The whole series is entitled *States of Mind*. The picture entitled *The Farewells* explores the emotional state of parting. On the left couples are giving each other a last, hurried embrace; on the right the travellers have been absorbed by a maelstrom which draws them into the distance. The locomotive is shown in two views which also express different emotional attitudes: a romantic version at the top, aglow with heat and breathing steam; and lower down, in the centre of the picture, a vision of an impersonal technological monster, quite indifferent to the human element, its hard, geometrical forms drawn with precision. The numbers painted on the side of the cab are derived from Cubism but here they have something sinister about them and their purpose is obviously to underline the cold indifference of the machine: a prophetic vision.

The painting entitled *Those Who Go* shows the travellers speeding along, their faces and the urban forms of the landscape they traverse interpenetrating each other and both being in turn distorted by the lines of movement which permeate the whole picture. In *Those Who Stay* the people who saw the travellers off are returning, emotionally weary, to their monotonous urban streets which are indicated by the row of houses and the silhouettes of roofs at the top of the picture. The relationship between people and environment is static — in opposition to the breathlessly dynamic relationship in *Those Who Go* — the houses send long lines down to intermingle with the figures. The uprights with their slight curvatures at the bottom edge give the picture a melancholy quality.

311

In his painting *Forces of a Street*, 1911, Boccioni produces a poetic vision of modern life: a busy thoroughfare with lights and people brought into a structural relationship. Movement is here achieved not by stroboscopic techniques derived from photography but through a pattern derived from actual phenomena.

The curved line of lights above the street and the shafts of lights emanating from them make a visual tunnel through which people move. The lights streaming from the houses create a competing element which yet helps the general movement towards the focal point at the top of the picture. The rhythm of horizontal lines quickens towards this point. The figures of the people walking along the street are tilted so that their joint directions also indicate movements towards the same area. It is thus through visual rather than factual means that movement — the central theme of Futurist art — is achieved. The two lights

in the foreground — perhaps the headlights of passing cars — radiate shafts of light as though they had been seen through a camera or a wet windscreen. This is most certainly a picture of urban life in the twentieth century; the emotional content and the technical means are in harmony. It could not have been painted at any other time in history.

In the same year Boccioni produced a series of three paintings which analysed further the emotions of modern life. The subject matter is taken from a highly significant and symbolic place in the modern urban environment and the cause of many tensions associated with modern living: the railway station. It is here where technology seems to touch a sensitive area of man's psyche — at least it did in the days before the First World War. Anxiety associated with catching the train, fear of being parted from friends and lovers, excitement of travelling, uncertainty which

311 *Umberto Boccioni*, Forces of a Street, *1911. Collection Dr Paul Hänggi, Basel*

312 *Umberto Boccioni*, The Farewells, *1911. Private Collection, New York*

313 *Umberto Boccioni*, Those Who Go, *1911. Private Collection, New York*

314 *Umberto Boccioni*, Those Who Stay, *1911. Private Collection, New York*

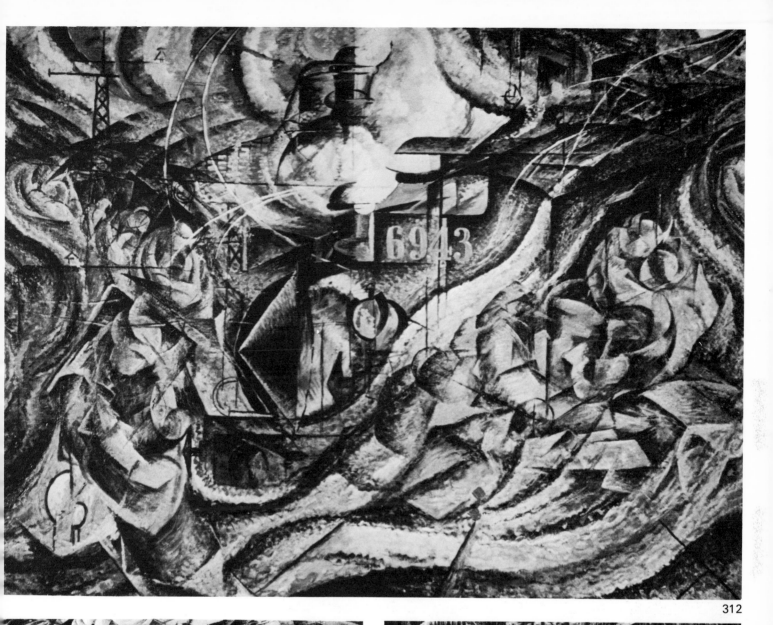

312

313

314

The intermingling of moving forms as seen in these paintings, particularly *Those Who Go,* was Boccioni's chief area of research, and his main contribution to modern art. Forms are related to each other through movement. They are also related to the space through which they move. The correspondence with new scientific theories of the period is evident.

His sculpture *Muscular Dynamism or Unique Forms of Continuity in Space,* 1913, attempts to show the relationship between moving form and space. The man does not simply move, the movement has become a dimension of his body. As form traverses space its movement becomes a part of it and transforms it. The volume of space which the moving form has displaced enters into a relationship with it and makes it different from other similar forms which have not been subjected to movement. It has become a unique form. In this sculpture previous positions of the moving body are made partly visible and are left trailing. The sculpture makes us aware of the relationships which exist between a moving body and the space surrounding it through which it moves. This relationship is shown to be quite different from that which exists between a body at rest and the space which surrounds it.

315

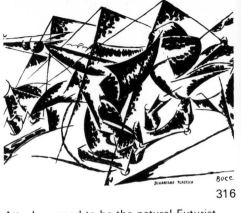

316

Attack seemed to be the natural Futurist method of interesting the public in their ideas. Marinetti's Futurist poetry was intended to be recited to audiences (recital, public demonstration, was their chief outlet; even their manifestoes were recited) accompanied by exaggerated gestures and grimaces and strident intonation. It also attacked traditional ideas on syntax and the use of words, for in Marinetti's poetry words were set free from their traditional role (Parole in Libertá) and used in pairs of nouns to suggest free associations rather than their usual meanings, a Futurist application of Symbolist ideas. Because this poetry depended on the manner of its delivery as much as on its content Marinetti devised different typographic settings of great originality to retain something of the flavour and effect of the oral delivery. The abandonment of the orthodox role of printing type developed, in Marinetti's hands, into a flexible and varied medium of expression which influenced later poetry.

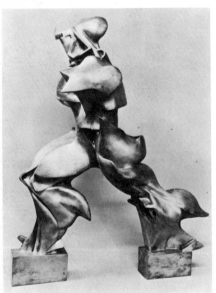

317

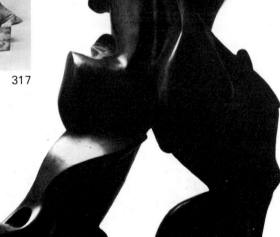

318

315 *Detail of 313*

316 *Umberto Boccioni,* Plastic Dynamism, Horse and Houses, *1914, drawing. Collection Mr and Mrs Eric Estorick, London. Interpenetration of forms*

317 *Umberto Boccioni,* Muscular Dynamism or Unique Forms of Continuity in Space. *1913, sculpture*

318 *Detail of 317*

319 *F. T. Marinetti, typographic setting for a poem*

320 *Carlo Carrá,* Exploding Shell, *1914. Collection Mr and Mrs Eric Estorick. London. A parallel to Marinetti's poetry*

321 *F. T. Marinetti,* In the evening, lying on her bed, she read again the letter from her artilleryman at the front, *1915*

322 *F. T. Marinetti,* Tumultuous Assembly, *1915*

terriiBLE SOLEEIL FÉROOCE

SENtimental

	sur les jeunes ex-	
	plorateurs trompés	
	par leurs femmes	
aveu-	maîtresses	aveu-
glant	solennité d'un cocu	glé
de	sur la ligne de l'é-	de
larmes	quateur	larmes
		rouges 319

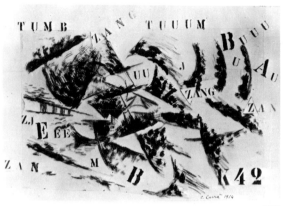

320

The two compositions shown here date from 1915, shortly after Italy's entry into the First World War. Letters are here completely divorced from their function as components of written language. They are considered for their visual appearance and dynamic effect. This development is important not only in its own context but also in its initiation of a new pictorial use of other objects separated from their usual purpose.

Speed and movement although breathtakingly exciting at first make stale subjects when pursued indefinitely. Beyond a certain point there seems to be no possibility of further development. Futurist artists like Balla gradually developed new means of expression but had no new ideas to contribute to the growth of the Modern Movement. When Boccioni died, in an accident in 1916, he was no longer a Futurist painter and Futurism itself, in spite of later attempts to revive it, was dead. It had lasted about four years.

However Futurism brought the implications of speed and of the machine into the consciousness of later artists, designers and architects. It did a great deal to help to crystallise the new attitude to the machine which was forming throughout Europe: a new element in life in the twentieth century, and not an extortionate god. One of the most important communicators of Futurist ideas was the architect, Antonio Sant'Elia.

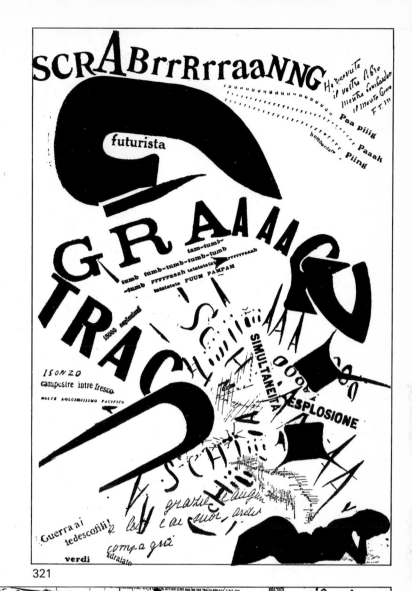

322 321

The visionary character of Sant'Elia's work is evident in his drawings, but for a full understanding of his aims we must turn to his writing, the statement of 1914 which accompanied an exhibition of his designs. Like writers of other Futurist manifestoes issued in the preceding years, Sant'Elia rejects historical styles in architecture and suggests their replacement by modern design processes. The tone of his statement is however calmer and more reasonable than that of most Futurist writing. Modern architecture must '. . . raise the new-built structure . . . gleaning every benefit of science and technology, settling nobly every demand of our habits and our spirits, rejecting everything that is heavy, grotesque and unsympathetic (tradition, style, aesthetics, proportion), establishing new forms, new lines, new reasons for existence solely out of the special conditions of modern living and its projection as aesthetic value in our sensibilities. Such an architecture cannot be subject to any law of historical continuity. It must be as new as our state of mind is new . . . Calculations of the resistance of materials, the use of reinforced concrete and iron exclude architecture as understood in the classical and traditional sense . . .' Most members of the Werkbund and the Wagnerschule would have agreed with this, for the rules of classical architecture had begun to be eroded by the need for new materials and methods to fulfil new functions and equally by the need to render these functions comprehensible to the modern mind and the emotions. But Sant'Elia in his vision of the future environment went well beyond anything contemplated or imagined by his contemporaries.

'We must invent and rebuild our modern city like an immense and tumultuous ship-yard, active, mobile and everywhere dynamic, and the modern building like a gigantic machine. Lifts must no longer hide away like solitary worms in the stairwells, but the stairs, now useless, must be abolished and the lifts must swarm up the façades like serpents of glass and iron. The house of cement, iron and glass, without carved or painted ornament, rich only in the inherent beauty of its lines and modelling, extraordinarily brutish in its mechanical simplicity, as big as need dictates, and not merely as zoning rules permit, must rise from the brink of a tumultuous abyss: the street which itself will no longer lie like a doormat at the level of the thresholds, but plunge storeys deep into the earth, gathering up the traffic of the metropolis connected for necessary transfers to metal cat-walks and high-speed conveyor belts . . . we can best attain that . . . by digging out our streets and piazzas, by raising the level of the city, by re-ordering the earth's crust and reducing it to be the servant of our every need and our every fancy.'

Some of the imagery is still reminiscent of Marinetti ('. . . lifts . . . like serpents of glass and iron') but the aims are humane as they rarely are in Marinetti. Sant'Elia's complete break with the past is Futurist in spirit, but he still speaks of façades as a classical architect might. In his rejection of ornament he takes up a position somewhat similar to that of Loos — although more superficial. In linking a building to the concept of a machine he echoes the Wagnerschule and anticipates Le Corbusier's more famous statement of 1923 as well as establishing himself as one of the spiritual progenitors of the de Stijl movement of which we shall hear a great deal later. His faith in machinery is romantic and unrealistic enough never to envisage a breakdown of lifts, which allows him to dispense with staircases. On the other hand he never stresses unduly the intrinsic beauty of machines, in the way that Marinetti does. On the contrary, '. . . architecture is not, for all that, an arid combination of practicality and utility, but remains art, that is, synthesis and expression.' Houses built of gleaming modern materials 'like giant machines', even 'brutish', with 'lifts swarming up their façades' must still be subject to the ancient discipline of synthesis and expression, that is composition. He concludes his statement by affirming that '. . . just as the ancients drew their inspiration in art from the elements of the natural world so we — materially and spiritually artificial — must find our inspiration in the new mechanical world we have created, of which architecture must be the fairest expression, the fullest synthesis, the most effective artistic integration.'

Sant'Elia's drawings fully support his literary statement. One can imagine that his designs for industrial buildings such as power stations and hangars would have been understood and approved by Poelzig and fellow members of the Werkbund with their Expressionist leanings. These designs rely for their visual effect on a dramatisation of the functions of the building through structural features rather than on structural necessities. They stand or fall as expressive compositions by the 'inherent beauty of (their) lines'. Apartment blocks are generally stepped back towards the top, the different storeys connected by bridges with free-standing lift towers. Where two such buildings meet back to back the gap between them (which is caused by the stepwise arrangement of apartments) is used as a tunnel for transport. Lines of communication never cross at the same level. Everything is visually related and physically connected to everything else. This is indeed the vision of the city as a machine — an organism entirely derived from the faculties of the human mind and constructed to serve human needs.

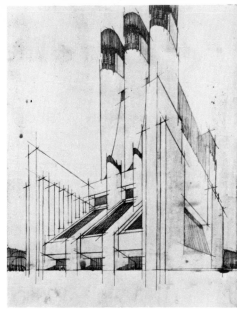

323

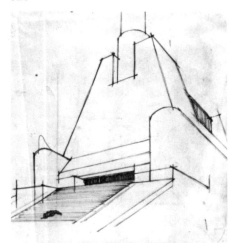

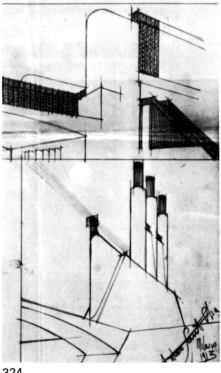

324

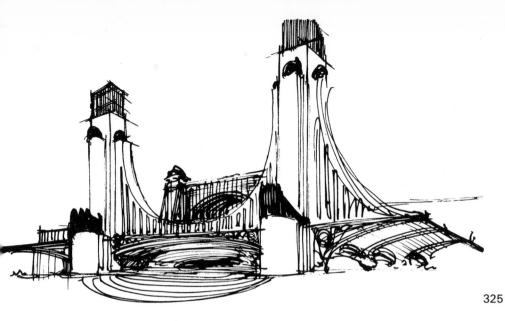

325

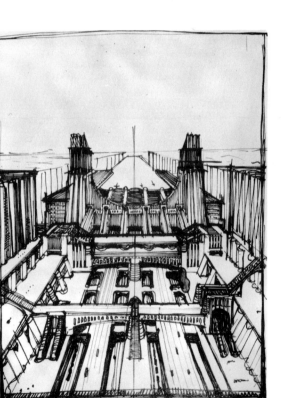

326

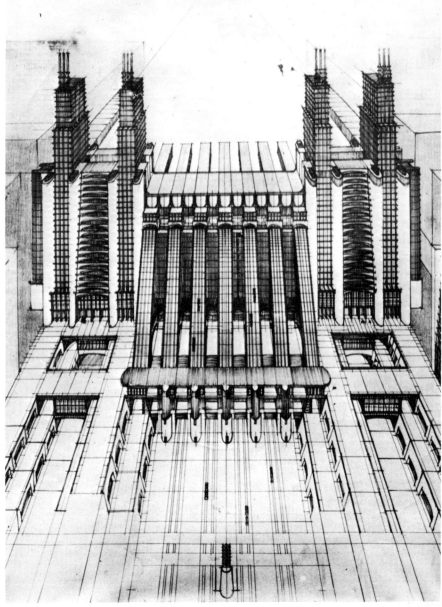

327

325 *Antonio Sant'Elia, study for bridges, 1912, Museo Civico, Como. An early study with distinct overtones of the Vienna School gradually grows into a grandiose poetic visualisation of the modern city.*

326 *Antonio Sant'Elia, airport and railway station, 1912. Museo Civico, Como. Lifts and cable cars on three street levels*

327 *Antonio Sant'Elia, study for airport and railway station, 1914. Museo Civico, Como*

323 *Antonio Sant'Elia, study for a building, 1914. Collection Sant'Elia family, Como*

324 *Antonio Sant'Elia, architectonic studies, 1913. Collection Sant'Elia family, Como.*

137

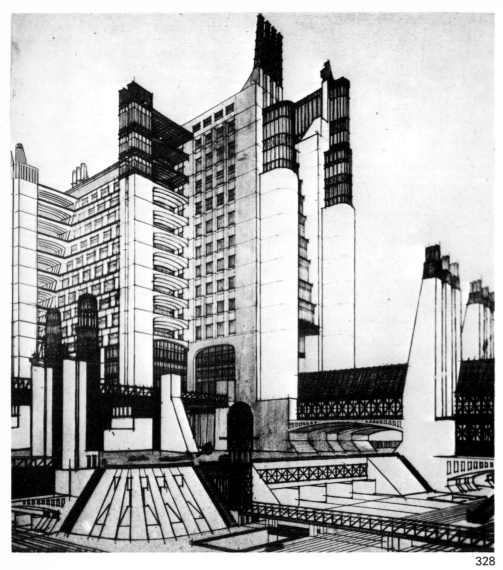

328

PADIGLIONE PER CONCERTI

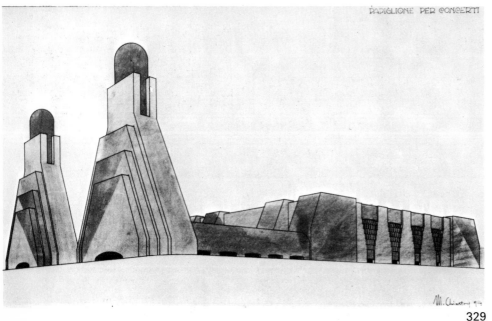

329

Mario Chiattone was an associate of Sant'Elia. His work also has its Expressionist characteristics, as exemplified by his Concert Hall. In general his work is more down to earth and moves at a lower pitch. His visualisation of the modern city has none of the homogeneity and poetic concentration of Sant'Elia. But because of their down-to-earth qualities his structures look as though they could almost have been built at the time. His radio station of 1918 is no longer Futurist.

The buildings and structures Sant'Elia proposes look startingly modern. Where, one may well ask, do they come from? Were they invented in all their originality out of nothingness, were they the product of a visual and structural imagination set in motion by the urgency of a manifesto? No individual can create in a vacuum. He must always build on what precedes him, however much he may wish to disown the past. Sant'Elia's startling drawings of towns of the future are not nearly so startling when viewed against the work of some of his predecessors and his contemporaries, for instance the Wagnerschule already referred to in this context and Wagner himself. Comparing Sant'Elia's drawing which includes a bridge with Wagner's drawing of a similar subject a more than superficial similarity may be detected. The separation of different streams of traffic and, the organisation of movement are common to both. Wagner's monoliths, the visual markers of the bridge, have been retained but under a functional guise. The theme of the monoliths has been taken up by the buildings themselves. This change is symptomatic. In Wagner's world the monument still had a place in its own right. In Sant'Elia's the monument had been abolished as useless and the quality of monumentality had been assumed by functional objects: the bridge, the ventilation shaft, the tall building, these are all new monuments: they have become expressive. This Expressionist principle took on great importance in all twentieth-century design and design theory. Poelzig and other Expressionist architects must therefore also be looked upon as the forefathers of Sant'Elia's visionary designs. Adolf Loos, too, had designed, in 1910, a building with stepped back upper storeys, and a similar building had actually been built by Henri Sauvage in Paris. The rear elevation of Loos' house in the Michaelerplatz with its stark, glass-sheathed lift shaft also had something in common with Sant'Elia's ideas. Mackintosh's design for a school in Glasgow, even more than the executed building, appears to contain the germ of several forms we find in the modern city of Sant'Elia.

Sant'Elia's drawings are not blueprints to be followed by a builder and converted into reality. They are not based on research

328 *Antonio Sant'Elia, study for The New City, 1914. Museo Civico, Como*

329 *Mario Chiattone, study for a concert hall, 1914. Istituto di Storia dell'Arte, University of Pisa*

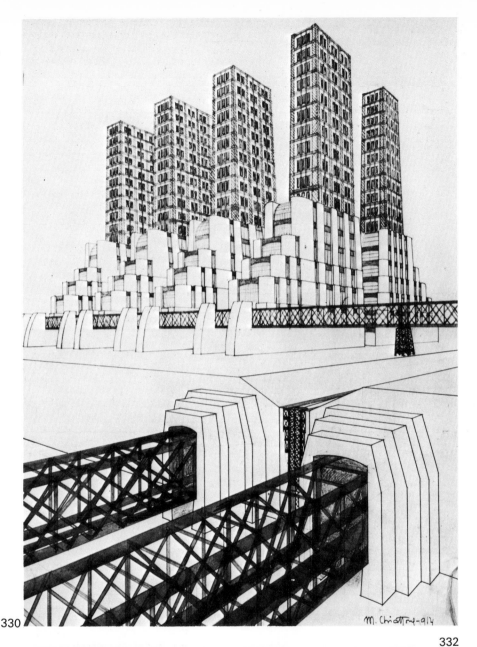

330

into structural strength or practicality — hence their daring. For instance, the vibrations from passing traffic through tunnels between buildings would make the buildings rather uncomfortable to live and work in. But these designs, for all their lack of specific practical application, are statements of a visionary faith. All great architecture needs this visionary quality if it is to be anything more than mere building. Sant'Elia's place in the history of architecture does not rest on an appraisal of his buildings, for none of these schemes was ever realised. His influence consisted in the aspirations and vision contained in his hundreds of drawings which have fired the imagination of successive generations of architects right down to our own day. There is little in even the most advanced schemes for towns of the future being prepared now that cannot be traced back to Antonio Sant'Elia in 1913 or 1914. When he was killed in the First World War at the age of twenty-six he was already a prophet.

331

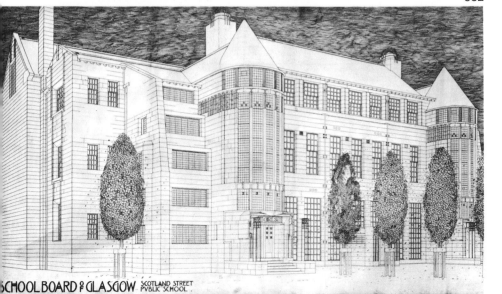

332

330 *Mario Chiattone, bridge and study of volumes, 1914. Istituto di Storia dell' Arte, University of Pisa*

331 *Mario Chiattone, radio station, 1918. Collection Bernasconi*

332 *Charles Rennie Mackintosh, Scotland Street School, Glasgow, 1904. University of Glasgow, Mackintosh Collection*

The machine, mass-produced machine-made objects, and technology made a deep impression on the new art of our century. Many artists and designers examined this area and their own attitudes to it. Morris ran away from it, the Futurists glorified it, Le Corbusier as we shall see found poetry in it. Does this exhaust all possible attitudes to the machine?

Lethaby and Gropius had recognised a certain nobility in industrial forms although they had to refer to older art forms to identify the emotions they evoked. But what would happen if we took an industrial product, or even a machine, isolated it from its usual context and entered into a direct relationship with it; and showing no concern with art, we sought out the source of its effect on us?

This is what Marcel Duchamp investigated in a series of startling works. A bottle rack which has no unusual qualities and can be bought in a shop becomes a work of art not because an artist has painted a picture of it but because an artist has chosen it, isolated it and exhibited it.

Kandinsky's tilted picture had become unrecognisable and in the process given up its poetic content. Likewise a urinal lying on its back can change its meaning and its effect on our emotions.

Art, poetry, call it what we will, lies not in the object but in the attitude we bring to it. Anything can become art if we see it in a certain way. The often quite meaningless objects which surround us, machine parts, waste products, everything can be seen in this way, either in isolation or in new and surprising combinations, founded on our new interpretations. Does this mean that art has been turned into life or, since this kind of art is no longer subject to the usual art process (a process which has not been disclaimed even by the most revolutionary and iconoclastic movements), is this new art not art at all but anti-art?

When Duchamp isolated ordinary objects and displayed them so that we saw them in a new way, discerning meanings and overtones we had not suspected before, he attempted to disclose their magic and their inner meaning. This is not so dissimilar from the pursuits of other artists, for instance Paul Klee, but the usual artistic process has been replaced by shock tactics.

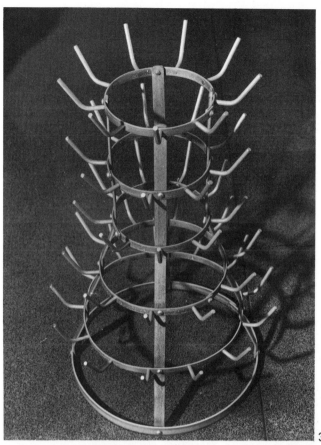
333

334
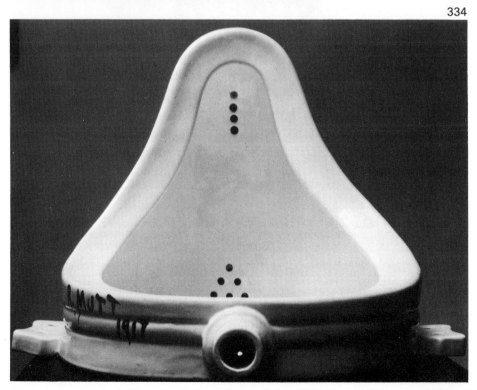

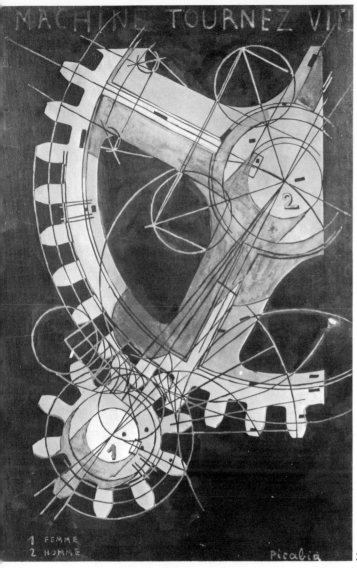

335

Francis Picabia was another artist with aims very similar to those of Duchamp. His pictures, often based on engineering drawings with writing added, portray machines as working organisms, mechanical beings, with their own inner lives and even sexual functions. In *Machine Tournez Vite*, 1916, the two cogs are numbered as we might expect in an engineering drawing. The key reads, laconically, '1 woman, 2 man'. Of course pictures like this are highly ambiguous and hardly capable of rational explanation. On the one hand the hard precision of the forms, the impersonal drawing with its construction lines, the mechanical projection of the shadows which gives the whole picture a disquieting air; on the other hand the delicate engagement of the cogs which may intimate a relationship which is not entirely mechanical. Is this a symbolic representation of human actions and relationships, are we machines? Or is it a huge joke? Is it black humour which incorporates both fear and the laughter which rises above it? And, once again, is it art?

Duchamp, a Frenchman, and Picabia, a Cuban, were living in New York during the war years. They were now joined by an American artist, Man Ray, to form the nucleus of a new movement. When in 1919 Picabia came to Switzerland he found there a group of artists who had been working in a similar anti-art direction for some years, independently of the New York group, with somewhat different origins, beliefs and methods.

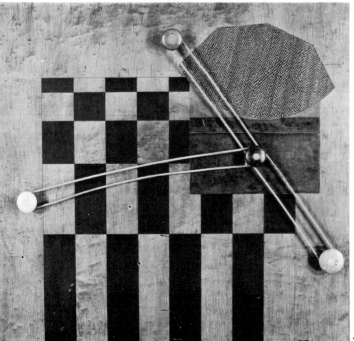

336

333 *Marcel Duchamp*, Bottle Rack, *1914, reconstruction. Galleria Schwarz, Milan*

334 *Marcel Duchamp*, Fountain, *1917, reconstruction. Galleria Schwarz, Milan*

335 *Francis Picabia,* Machine Tournez Vite, *1916. Galleria Schwarz, Milan*

336 *Man Ray,* Board Walk, *1917. Private Collection*

A group of artists of various nationalities, surrounded by the pointless bloodshed of the First World War, had initiated the movement in about 1916. It was not only their disenchantment with the state of society but with the whole of Western culture which set them on their way of opposition and their expression of disgust with the whole fabric of rational behaviour. With their aggressive buffoonery they set out to expose the worthlessness of so-called civilised values and of the money-bound social order which could, under cover of apparently rational behaviour, commit or condone irrational excesses. Viewing the war as organised mass murder they repudiated the concept of art as a sign of civilisation. Destruction, rather than reformation, seemed the only possible action to take. By ridiculing art they attempted to bring the society which had given rise to it into disrepute. By producing seemingly illogical relationships between objects, and by the use of techniques which were irreconcilable with orthodox art theory, they represented and revealed the underlying irrationality of civilised society, that is to say bourgeois society. The movement became known as Dada.

In a Dadaist work anything was possible, anything could be fitted into a picture because there was no theory of art, no definite intention. The more illogical an object or a person looked in a given situation, the better Dadaist ends were served; the more disruptive the better. But as we look at these 'pictures' hidden and quite unintentional meanings seem to emerge, meanings which would have eluded us in a more logical composition.

Hans Richter, one of the first members of the Zürich group, tells us that this experience of chance meanings grew out of Dada's 'total repudiation of art'. He says, 'Our feeling of freedom from rules, precepts, money and critical praise, a freedom for which we paid the price of an excessive distaste and contempt for the public, was a major stimulus. The freedom . . . brought us closer to the source of all art, the voice within ourselves. The absence of any ulterior motive enabled us to listen to the voice of the "unknown" — and to draw knowledge from the realm of the unknown.' This meant amongst other things that the concept of chance, so uncomfortable to most people because it cannot be fitted neatly into any rational system of thought, had to be accepted as a source of inspiration. 'Chance, in the form of more or less free association, began to play a part in our conversations. Coincidences of sound or form were the occasion of wide leaps that revealed connections between the most apparently unconnected ideas.' 'Chance appeared to us as a magical procedure by which one could transcend the barriers of conscious

337

338

339

volition, and by which the inner eye and ear became more acute so that new sequences of thoughts and experiences made their appearance. For us, chance was the unconscious mind that Freud had discovered in 1900.' This initially destructive movement, this anti-art, therefore led to new methods of exploring the human mind.

Drawings produced for no apparent purpose, and designs which in their construction defied all reason, were the chief vehicles of Dada. Hans Arp's automatic drawings have no subject matter; the artist simply obeyed the promptings of the unconscious. His *Collage with squares arranged according to the laws of chance*, 1917, shows another aspect of his work. The pieces of paper were dropped on a piece of cardboard and pasted down where they fell. His more conscious works were based on unpremeditated essays like these.

As Dada spread to other parts of Europe it drew into its fold a number of other artists who gave it an added impetus. Amongst them were Max Ernst and Kurt Schwitters. Ernst's *Little Machine*, 1919, is based on objects found in a catalogue; note in particular the tap on the left. They are assembled as if to form a machine, not, however, a machine which could be said to work in a mechanical sense. Ernst tells us how the pages of a printed catalogue fire his imagination '. . . that its very absurdity provokes in me a sudden intensification of my faculties of sight – a hallucinatory succession of contradictory images . . . superimposed upon each other with the persistence and rapidity characteristic of amorous memories and visions of somnolence. . . . They transform the banal pages of advertisement into dramas which reveal my most secret desires.' But, as in Picabia's work, there is also an element of buffoonery present.

From the assembly of cut-out pictures of objects it was only a short step to the assembly of the actual objects. Such 'pictures' may have mocked art – they also established a new process of art and extended the area from which the artist may draw his raw material.

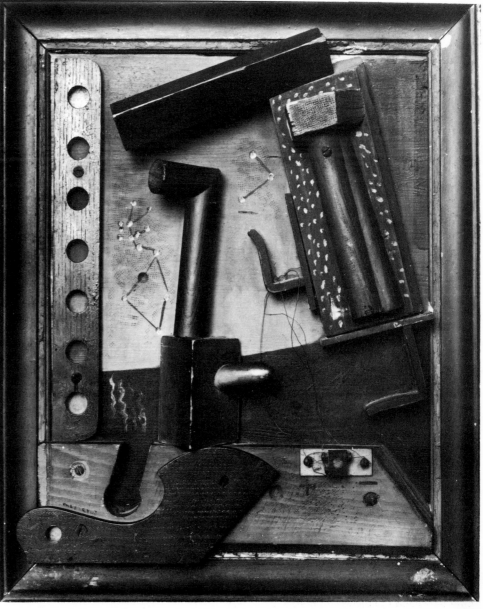

337 *Hans Arp,* Automatic Drawing, *1917. Private Collection*

338 *Hans Arp,* According to the Laws of Chance, *1917, collage. Collection P. G. Bruguiere, Issy-les-Moulineaux, France*

339 *Hans Arp,* Forest, *1916. Collection Sir Roland Penrose, London*

340 *Max Ernst,* Little Machine constructed by Minimax Dadamax in Person, *1919. Collection Peggy Guggenheim, Venice*

341 *Max Ernst,* Fruit of a Long Experience, *1919. Private Collection*

Schwitters made many assemblages of ordinary objects he had found, from tram tickets to wire mesh. The aims are similar. The effect on us is different from that of each one of these objects in its normal context. They have become magical objects. Raoul Hausmann produced collages of pictures cut out of magazines and newspapers, in chance associations.

Dada was not confined to the visual arts — or anti-arts. It had, as several other twentieth century European art movements, connections with cabaret in which Dada poetry played an important part. One of the chief forms of Dada poetry was the phonetic poem, of rhythms and sounds but no words: Mallarmé's ideas carried to extremes. These poems were often set in a special way. Hugo Ball's poem *Karawane*, 1917, is set so that the type reinforces the sound and a sound picture of the poem emerges.

There are obvious connections between Dada and Futurism. Marinetti's stricture, 'Every day we must spit on the altar of art' must have had the approval of all Dadaists. Furthermore Marinetti and other Futurists had developed means of expression which suited the Dadaists, such as the free use of type as a graphic element rather than for its verbal message. The typography of Dada poetry is Futurist-inspired and other Dadaists took readily to this free use of type in their magazines and other publications. They made use of a bewildering variety of printing types which helped to obscure the factual meaning of words, combined with visual material from many different sources. Photomontage was born. Many new ways of combining pictorial material with printing types were discovered by the Dadaist process of letting chance and the subconscious take over, unrestrained by conscious rules.

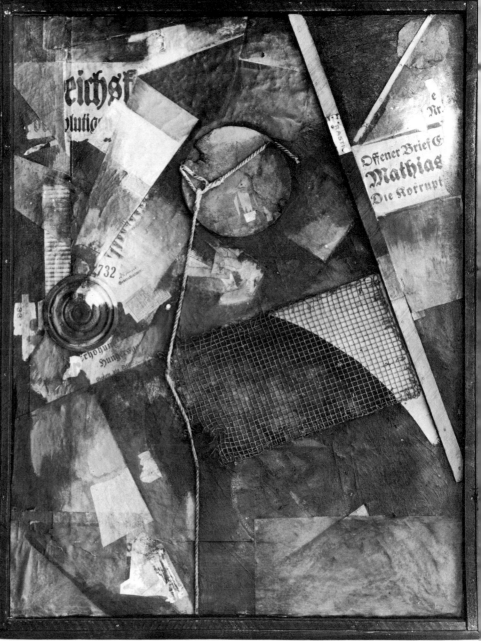

342

342 *Kurt Schwitters,* The Star Picture, *1920. Kunstsammlung Nordrhein-Westfalen, Düsseldorf. Social comment is thinly disguised. Certain words — hunger, bloody, corruption — are partly obliterated but still sufficiently legible to add yet another evocative element to the composition*

343 *Hugo Ball,* Karawane, *1917*

344 *Ardengo Soffici,* At the Station Buffet, *1914. A Futurist composition*

345 *Raoul Hausmann,* Dada *(periodical), cover design, 1919*

346 *Francis Picabia,* Dadaist Composition, *1920*

KARAWANE

jolifanto bambla ô falli bambla

grossiga m'pfa habla horem

égiga goramen

higo bloiko russula huju

hollaka hollala

anlogo bung

blago bung

blago bung

bosso fataka

ü üü ü

schampa wulla wussa ólobo

hej tatta gôrem

eschige zunbada

wulubu ssubudu uluw ssubudu

tumba ba- umf

kusagauma

ba - umf

343

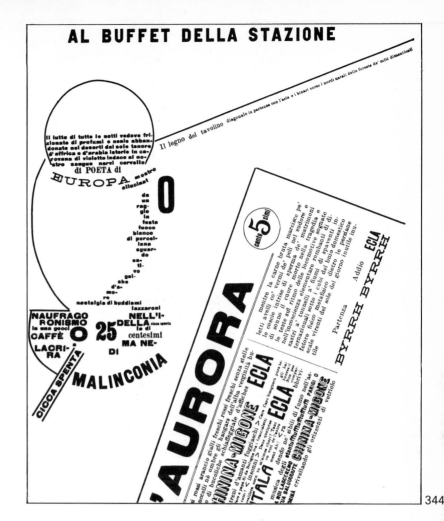

AL BUFFET DELLA STAZIONE

344

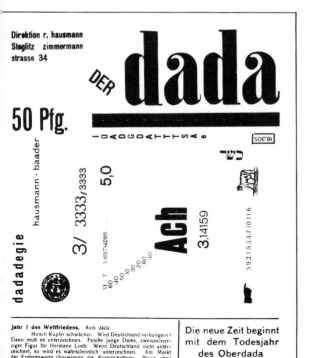

345

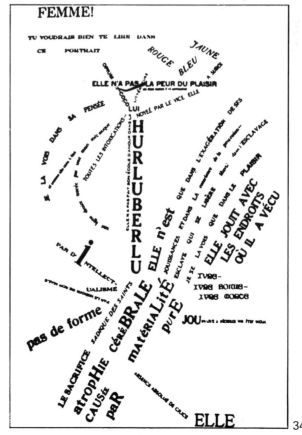

FEMME!

346

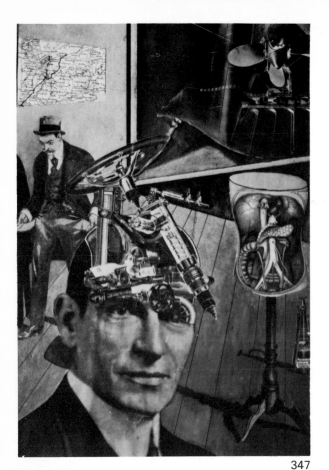

347

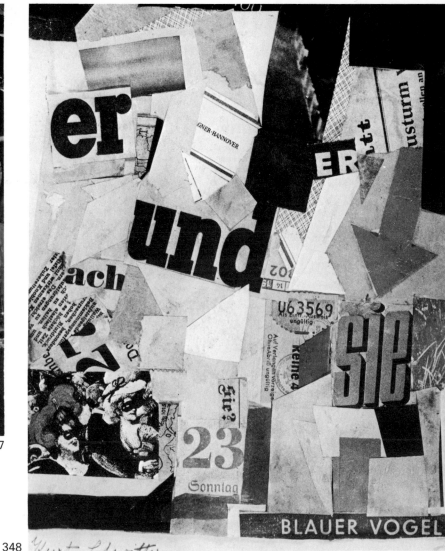

348

The chance combination of unrelated objects, as pursued by the Dadaists, gave rise to yet another pictorial technique: the photogram, photography without a camera. It was discovered by Man Ray about 1922. It consists simply of placing objects on a piece of light-sensitive paper and controlling the amount, and sometimes the direction, of light to which it is exposed. Double exposure with the ensuing transparent effect is also possible. The result is often dream-like and evocative.

Some of the technical discoveries of Dada were taken up by other artists and designers, as we shall see. Dada also infused a new ingredient into our attitude to machines and to technology. But the chief contribution of Dada was the emancipation of the unconscious, in a general sense. To quote Richter once again: 'The realisation that reason and anti-reason, sense and nonsense, design and chance, consciousness and unconsciousness, belong together as necessary parts of a whole – this was the central message of Dada.' A message whose importance was underlined by the eagerness with which it was absorbed into the general consciousness, so that today our experience of the environment would, but for its Dada content, be totally different.

349

347 *Raoul Hausmann,* Tatlin at Home, *1920, photomontage. Moderna Museet, Stockholm*

348 *Kurt Schwitters,* Russian Cabaret, *1922, collage. Private Collection*

349 *Man Ray, photogram, 1923. Private Collection*

350 *Kurt Schwitters and Theo van Doesburg, poster for a Dada function, 1923*

351 *Kurt Schwitters and Theo van Doesburg, page from* The Scarecrow, *a fairy tale, 1925*

352 *John Heartfieïd,* Arena (*periodical*), *cover design, 1927*

353 *John Heartfield,* Back to a Free Economy, *1927, political poster. Two examples of later applications of Dadaist techniques, rānging from a sense of jazzy excitement to deep political commitment*

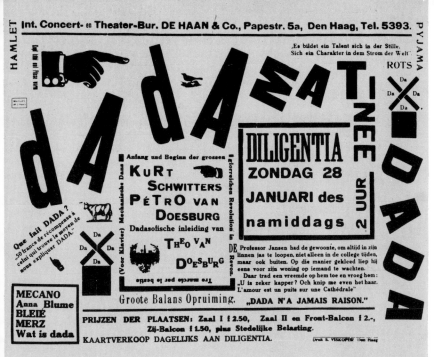

To a Futurist the machine was beautiful for the simple reason that it was a machine, and an object of worship worthy of twentieth century man. New materials and techniques, especially if related to speed, were similarly venerated. There is no doubt that the Futurist Movement had a powerful effect on the development of early twentieth century art and architecture which, helped by this onslaught from Italy, was able to formulate a purpose with less difficulty than it could otherwise have done.

Artists outside the Futurist Movement also assimilated the machine in their work but they did not follow the Futurists into their wild love affair with the machine, they concentrated on its civilising and humanising qualities. Although they too saw in the machine a symbol of a new civilisation and like the Futurists created a machine aesthetic, they did not go as far as a machine mythology. One of these artists was Fernand Léger. His early work seems to owe a great deal to Cubism, but it can also be seen as parallel to, rather than deriving from, Cubism. In *The Wedding*, 1911, the Cubist idiom is evident, but so are certain techniques not unlike those employed by Futurist painters. Aspects of events taking place simultaneously are shown in a kaleidoscopic vision, and several forms appear in a rhythmic repetition suggestive of visual movement. Gradually Léger's paintings break right away from subject matter and become more abstract, even though titles – *Staircase, Still Life* – are still attached to them. By 1913 completely abstract paintings appear in a series which bears the title *Contrasts of Forms*. Curved surfaces are built up in relation to each other and contrasted, as a group, with flat shapes and rectilinear outlines. Although Léger's art was to undergo subsequent changes, these paintings of 1913 already show the basic structure of much of his later work – excited, largely curved shapes displayed against an impassive arrangement of horizontal and vertical elements.

The war of 1914 gave Léger's art a new direction. He recalled, 'During those four years I was abruptly thrust into a reality which was both blinding and new . . . Suddenly and without any break I found myself on a level with the whole of the French people; my new companions in the Engineer Corps were miners, navvies, workers in metal and wood. Among them I discovered the French people. At the

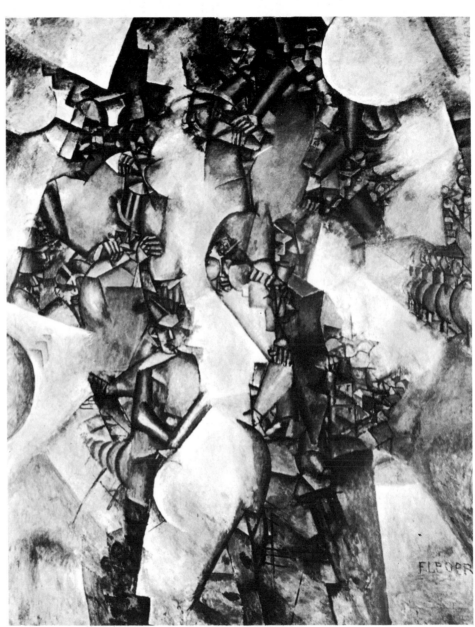

354

same time I was dazzled by the breech of a 75 millimetre gun which was standing uncovered in the sunlight, the magic of light on white metal. This was enough to make me forget the abstract art of 1912–13.' From then on the world of the common man and the objects produced by technology were to be the subject of his activities.

354 *Fernand Léger*, The Wedding, *1911. Musée National d'Art Moderne, Paris*

355 *Fernand Léger*, Contrasts of Forms, *1913. Philadelphia Museum of Art, Arensberg Collection*

356 *Fernand Léger*, The Game of Cards, *1917. Rijksmuseum Kröller-Müller, Otterlo*

357 *Fernand Léger*, Study for The Game of Cards, *1919. Staatsgalerie Stuttgart. Not really a study for 356 but a later elaboration of a part of the 1917 painting*

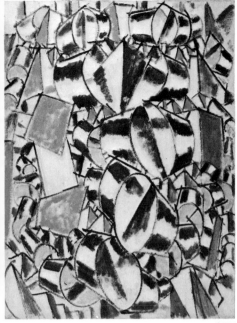

355

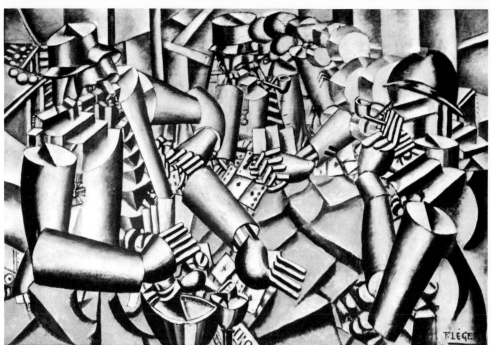

356

The problems entailed by such subject matter were not new, at least in their most obvious aspect. Artists had addressed themselves to the industrial environment before, but so long as they employed traditional means of representation they could do no more than render the most superficial features of the impact of technology: streets with motorcars, landscapes with factories. Such factual descriptions of modern life had no place for the new emotions which the influx of technology had aroused. Léger never attempted to render the actual forms of motorcars and other machines. 'I have used the machine as others have used the nude or the still life,' he said. 'I was never interested in copying the machine. I invented images of machines . . .' All-embracing images, that is, of the new industrial environment, as well as of the new feelings it inspired.

The abstract curved and flat forms which Léger had used in his pre-war compositions were now applied to more realistic purposes. In *The Game of Cards*, 1917, the card players and their environment are part of the same structure; man has become part of the new environment of precise, technological forms. In Léger's later works the curved surfaces have a distinct, iridescent quality, derived no doubt from the gleaming surfaces of industrial objects. 'Take an aluminium saucepan. Let shafts of light play upon it from different angles — penetrating and transforming it. Present it on the screen in a close-up . . . The public need never even know that this fairy-like effect of light in many forms, that so delights it, is nothing but an aluminium saucepan.' This was written as a commentary to his film *Ballet Mécanique* made in 1924, but it applies with equal

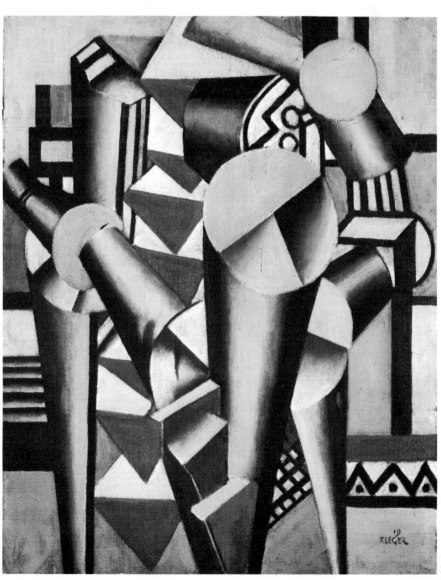

357

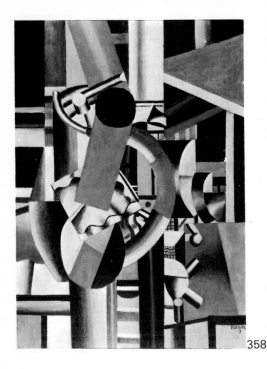

358

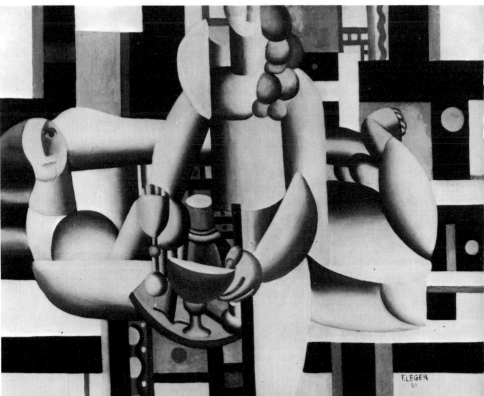

359

360

force to his painting, in that it embodies a
new machine aesthetic based on the
poetry of machine forms and machine-
produced forms. The origin of the forms
contained in *Still Life,* 1919, is by no
means clear, and this composition must be
accepted as a poetic reinterpretation of
industrial objects in a wider context.
The City, 1919, describes the excitement
of modern city life, without fixing on any
definite objects. We can recognise sections
of familiar objects, steel structures,
hoardings, letters, stairs, railings, but the
greater part of the painting consists of
crudely coloured forms and lines which
create an effect of simultaneous happenings
and of the resulting excitement.
The bits we can recognise are merely there
as pointers, to direct our perception towards
definite subjects, but the impact of the
composition lies in the juxtaposition of
shapes and lines in their own right. Léger
wrote, 'It is my opinion that plastic beauty
in general is totally independent of
sentimental, descriptive and imitative
qualities.' A picture must therefore be built
up from purely visual elements and values
derived from the environment. And these
visual elements and values must be
composed in a painting as the elements of
architecture are composed in a building.

Even in his most exciting paintings, Léger
never allows excitement, speed and
turbulence to get out of hand, as the
Futurists frequently did. There is always a
strong structure of uprights and verticals,
foreshadowed in his work of 1913, to hold
the moving elements in a firm compositional
grip. *Two Women and Still Life,* 1920, is a
good example of this principle. Even *The
Pilot,* 1920, with its movement and
excitement is controlled in this way.

150

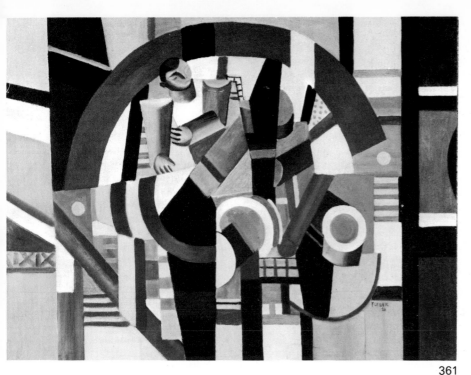

361

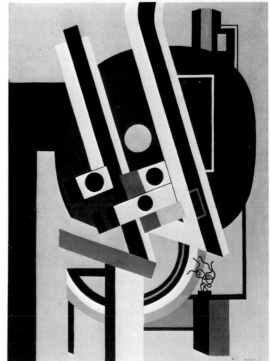

363

362

Man is fitted into his new environment, he is not oppressed by it; the new technological environment has a benign face. It is stark and undecorated, with many fragmented patterns superimposed and creating a kaleidoscopic hubbub of excitement, but although at times discordant the tensions between the fragments of patterns are always resolved in the total composition. By the early twenties the human figures had lost some of their more mechanical qualities, yet they remained unindividualistic and anonymous, in keeping with their environment free from 'sentimental, descriptive or imitative qualities'.

In Léger's painting real and abstract shapes hold each other in balance. But at times Léger concentrates on the abstract parts and isolates them, as in his *Study* of 1919. *Composition*, 1925, is a painting which expresses his purely compositional, abstract interest, but machine forms are never far away.

We can see in these paintings an affirmative attitude to the new industrial environment, with its cities full of lights, traffic, machines, movement: a faith in the machine civilisation. It marks the culmination of a long process which brought modern consciousness into harmony with the physical conditions of the twentieth century. It must be emphasised once again that, in spite of some superficial resemblances, Léger was not a Futurist. To him what mattered was human emotion and dignity in relation to the machine, and man's position in the modern world, not the machine itself.

358 *Fernand Léger,* Still Life, *1919, Collection Mrs Ayala Zacks, Toronto*

359 *Fernand Léger,* The City, *1919. Philadelphia Museum of Art*

360 *Fernand Léger,* Two Women and Still Life, *1920. Van-der-Heyt Museum, Wuppertal*

361 *Fernand Léger,* The Pilot, *1920. Private Collection*

362 *Fernand Léger,* The Breakfast, *1921. Private Collection*

363 *Fernand Léger,* Composition (Definitive Version), *1925. Solomon R. Guggenheim Museum, New York*

Léger did not see the problems facing the modern artist as essentially new. He said, 'It can be held that a machine or manufactured object can be beautiful when the relationships of the lines which define the volumes are balanced in an order equivalent to those of earlier architecture. We are not therefore facing a phenomenon which can properly be said to be new. It is quite simply one incident in architecture like others before.' This may be said to apply to Léger's painting as much as to the new architecture. But even if the principles of composition in his painting are not new, the content is — and in this Léger was more truly a painter of the twentieth century than were the Cubists. New too is the element of simultaneity, the many incidents which attract our attention at the same time and so give an idea of reality in terms of modern perception. The technique is similar to that used by a film director to describe the many parallel events of real life. It is therefore understandable that Léger should be attracted by the moving picture to investigate further the problems of simultaneity. The film *Ballet Mécanique* referred to above, made in 1924, explores many ideas first stated in Léger's paintings, but now space is replaced by time. For instance, the repetitive shapes which so often set up a rhythm in his paintings are translated into movements repeated in time. Details are observed in close-up and in motion. Portions of objects and incidents, which might be considered insignificant, are thereby given a new meaning. Many of Léger's experiments have influenced film makers right into the second half of the century.

If Léger's painting can be described as a purification of Cubism, another even more intense form of purification evolved during the same period and was in some ways parallel to Léger's development: Purism. Its two originators were Amédée Ozenfant and Charles Édouard Jeanneret, who were brought together by Auguste Perret in 1918. They believed that Cubism had dissipated its energies, was no longer a driving force, and had become suave and decorative. The hit-or-miss methods of Cubism, they said, no longer satisfied the needs of a scientific and technological epoch. It seemed to them that a new purified form of Cubism was required, Cubism purged of its wilder and more romantic aspects, refined and controlled by classical discipline. This discipline was not only of a pictorial but also of a philosophical nature.

To the Purists, man was simply an organism, a machine, which had been subjected to the process of natural selection. His state of perfection and high degree of physical and mental organisation were the result of an evolutionary movement which strengthens efficient organisms. Man-made things, such as buildings, tools and machines, could be described as extensions of man's functioning as an organism, and only those objects which had reached a comparable state of perfection and efficiency to that of man himself would fit into his world. The most efficient artefacts followed man's own development, for they were subject to the same laws. The artist was a special kind of organism, similar in essence to the others but more sentient and receptive. His works

also were machines, but, unlike those produced by other men, the artist's machines were for the investigation and communication of feeling.

The Purists' subject matter consisted of objects which had already gone through a long and successful period of evolution and had attained — or nearly so — maximum efficiency: for example, bottles, tumblers and other vessels, and musical instruments. The visual poetry which illuminated Purist painting derived wholly from commonplace man-made objects, but the poetic quality of their art did not — as so often in the art of the past — arise from the representation of individual objects. It grew out of the interaction of different shapes and objects, as in the art of Léger.

Léger said that when Renaissance artists began to paint their mistresses because they were beautiful, art was betrayed. They became mere imitators of nature instead of inventors of new forms, as their predecessors had been. Denis had referred to this as 'naturalistic negation'. Only by inventing new forms, Léger maintained, can an artist produce art. The Purists shared this belief. The immediate pleasure derived from a work of art, for instance an Impressionist painting, is only a superficial aspect of art, they said. The optical sensation aroused by a painting is more far-reaching and has a more lasting and profound effect. A painting, the Purists believed, should therefore attempt to arouse sensations and to order them, investigate them and balance them. This is yet another instance of a new application of Symbolist principles.

364 *Amédée Ozenfant,* Still life with Glass of Red Wine, *1921. Kunstmuseum Basel*

365 *Charles Édouard Jeanneret (Le Corbusier),* Still Life with Guitar and Lantern, *1920, Kunstmuseum Basel*

366 *Analysis of 365*

367 *Le Corbusier,* Violin, Glass and Bottles, *1925. Galerie Beyeler, Basel*

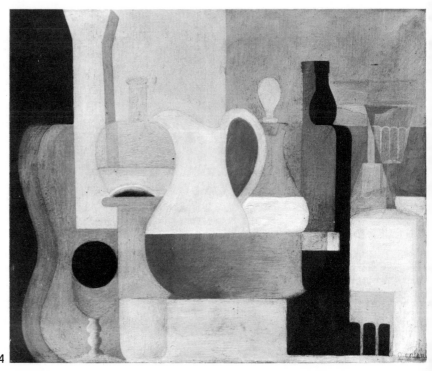

364

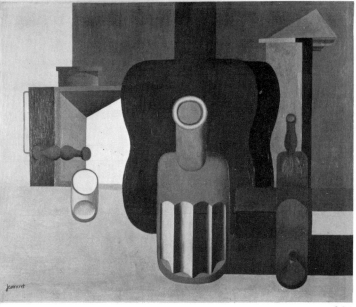

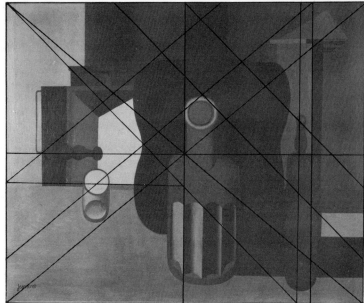

365

366

This balance of sensations they achieved by combining geometrical and free forms, fitting them harmoniously together or arranging them in visual counterpoint, their positions and proportions related to each other, and to the edge of the picture, by a precise geometrical structure. They often employed the Golden Section. Close-fitting forms with common contours make distinction between form and space uncertain and may even make these concepts interchangeable. Closely-grouped transparent, overlapping forms may lose their individual contours, and therefore their identities, while the overlapped area, or volume, may be assigned to either form. The Purists therefore not only arranged coloured forms in compositions but they planned also the effect of these forms on our perception of space. The result was a sensation of pictorial space — the crucial quality of all painting — which was both precise *and* ambiguous, mathematical *and* poetical.

In Purist painting the universal and the permanent take precedence over the incidental, as they had in Léger's work. Although the individual forms are free from emotional attachments, they produce, like those of a Greek temple, a poetry which speaks of equilibrium, of peace and often of nobility.

In 1920 the Purists published a series of articles on architecture in the magazine *l'Esprit Nouveau* over their joint nom-de-plume, Le Corbusier-Saugnier. The first half stood for Jeanneret, while Ozenfant had taken his mother's name for the occasion. When the articles were reprinted, with certain modifications, in book form in 1923, only Le Corbusier was named as the author. He continued to work under this name. The book, *Vers une architecture* (*Towards a New Architecture* in its English translation),

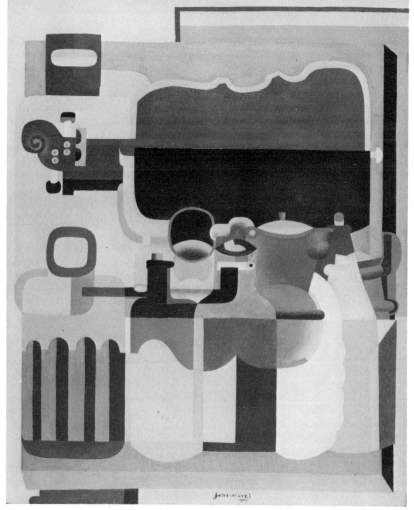

367

achieved world fame as one of the most important manifestoes of the Modern Movement and helped to establish Le Corbusier, together with his architecture, as the most formidable force in this field.

Vers une architecture is a strange book. The various essays of which it is composed do not always contribute to a continuous argument, and the writing is often exclamatory and rhetorical rather than — as one might expect — reasoned and analytical, which gives it Futurist overtones. Nevertheless the book puts into proper perspective some of the most influential ideas current in the last stages of the evolution of the Modern Movement.

Throughout the book examples of the works of engineers (grain elevators, steamers, motorcars, planes, viaducts) are interspersed with examples of architecture, particularly views and details of the Parthenon which Le Corbusier admired above all other works of architecture of all ages. In his linking of engineering with classical architecture one senses in Le Corbusier a search for continuity, a desire to bring modern machine civilisation into line with the best of western culture and to justify in human terms what has been resisted as an intrusion into human values.

A picture entitled 'Delage. Front Wheel Brake', which has a more than passing resemblance to Léger's *Composition*, 1925, is captioned: 'This precision, this cleanness in execution go further back than our reborn mechanical sense. Phidias felt in this way: the entablature of the Parthenon is a witness. So did the Egyptians when they polished the pyramids. This at a time when Euclid and Pythagoras dictated to their contemporaries.' Léger said much the same thing when he stated that the modern problem was really an old one in modern dress.

At the beginning of *Vers une architecture* Le Corbusier states his position boldly. 'The engineer, inspired by the law of economy and governed by mathematical calculation, puts us in accord with universal law. He achieves harmony.' Architecture by contrast is unequal to the demands of the new age. 'Architecture is stifled by custom.
'The "styles" are a lie.
'Style is a unity of principle animating all the work of an epoch, the result of a state of mind which has its own special character.'
This definition rules out historicising architecture, or any architecture which does not look to the future with the same eagerness as engineering. Engineering reasoning must therefore be applied to architecture.
'The airplane is the product of close selection.
'The lesson of the airplane lies in the logic which governed the statement of the problem and its realisation.
'The problem of the house has not yet been stated. . . .
'The house is a machine for living in.'

368

3

370

3

372

373

368 *Paestum, 600–550 B.C.*

369 *Voisin, Sports Torpedo, 1921*

370 *Steel construction*

371 *The Pantheon, A.D. 120*

372 *Delage, front wheel brake*

373 *The Propylea*

All the above appear in Vers une architecture

The idea of the machine as an analogy for organisation and for organisms, even the human organism, is not new. Eighteenth century philosophers had described Man in mechanical terms. Hogarth had compared the mechanism of a clock to the human body. Writers on architecture in the next century had compared buildings with functional things like ships, indicating the visual beauty which results from honest engineering design, that is the recognition of mechanical rather than artistic principles. Prosper Mérimée said that architects were doing the equivalent of 'designing steam boats on the models of antique galleys' and Viollet-le-Duc, the French architect who pioneered the use of iron in architecture, remarked that engineers do not build ships or locomotives in historical styles but instead 'obey blindly the new principles given to them and produce works which possess their own character. . . .' He intended this as a reminder to architects who employed traditional forms without much regard for contemporary needs. Such writers still had certain ideas on style, that is to say their final forms were at least partially preconceived. Le Corbusier took this idea to its logical conclusion, isolated it as an abstract concept and applied it to architecture as a problem-solving activity in which the final form *emerged as the solution* of a problem clearly stated, a procedure which had been hinted at by Otto Wagner.

The 'machine for living in' is elaborated further in Le Corbusier's book. 'If we eliminate from our hearts and minds all dead concepts in regard to the house, and look at the question from the critical and objective point of view, we shall arrive at the 'house-machine', the mass-production house, healthy (and morally so too) and beautiful in the same way that working tools and instruments which accompany our existence are beautiful.' Léger is on the whole in agreement with this when he writes, 'Architecture must take its place in nature without being too obvious. The idea of an object with startling qualities should be confined to the spectacle and public holidays, being no more than temporary in quality. With an architectural work the exact opposite holds. Here the quality is permanent, conceived in such a way as not to be specific to any period, trend or expression, but simply useful and beautiful through its geometric order most appropriate to the site and inherent requirements.'

In spite of all the praise for engineering, it is recognised as patently not enough on its own for the creation of a new environment. The purpose of construction is *to make things hold together*; of architecture *to move us*. Architectural emotion exists when the work rings within us in tune with a universe whose laws we obey, recognise and respect. . . . Architecture is a matter of harmonies, it is a pure creation of the spirit.' So architecture is engineering (construction) plus something else which raises it to the level of art, perhaps in the same way as an assortment of ordinary objects is converted into a work of art in a Purist painting. As in Purist painting, the universal laws of nature are invoked.

The idea of simple geometric shapes as ideal architectural forms is not peculiar to the modern world; it goes back to the eighteenth century French rationalists who used words very similar to Le Corbusier's. Now however it has a Purist significance as well. In Purist art clear, precise forms were considered the most appropriate to express the feelings associated with a machine civilisation. The standardisation of mass-produced objects had their counterpart in the standardisation of the basic forms of art. When Purist theory was applied to architecture it was logical that such precise and uncomplicated forms should commend themselves as possible standardised elements in a machine-based architecture. Geometric forms therefore acquired a functional as well as a visual significance and justification.

We may well ask how the work of engineers, which by Le Corbusier's testimony is as harmonious as the great works of classical antiquity, could be raised to an even higher level. Perhaps Le Corbusier merely implied that engineers, looking at fundamental problems with modern eyes, create harmonious solutions. If architects are to produce works of art in the spirit of their time they must proceed in a similar way. Wagner, who on one hand pointed to engineers as true men of their age and on the other relegated them to a subsidiary role, seems to have had a similarly ambiguous attitude.

When Le Corbusier defines the way in which architecture affects — or should affect — people, the definition could with a few minor modifications be applied to Purist painting. '. . . architecture which is a matter of plastic emotion . . . should use those elements which are capable of affecting our senses, and of rewarding the desire of our eyes, and should dispose them in such a way that the sight of them affects us immediately by their delicacy or their brutality, their riot or their serenity, their indifference or their interest; these elements are plastic elements, forms which our eyes see clearly and which our mind can measure. These forms (sphere, cube, cylinder, horizontal, vertical, oblique etc.) work physiologically upon our senses and excite them. Being moved, we are able to get beyond the cruder sensations; certain relationships are thus born which work upon our perception and put us into a state of satisfaction (in consonance with the laws of the universe which govern us and to which all our acts are subjected), in which man can employ fully his gifts of memory, of analysis, of reasoning and of creation.'

This leads Le Corbusier to formulate the maxim, 'Architecture is the masterly, correct and magnificent play of masses brought together in light.' Although function is always implied in his philosophy, in the last analysis it does not rate as high as poetry. 'The business of architecture is to establish emotional relationships by means of raw materials.' How such relationships may be illuminated by geometry is demonstrated by a series of visual analyses of buildings, including his own, which recall the geometrical composition of his Purist paintings. Describing the formation of a culture as 'the flowering of the effort to select', he goes on to say, 'Selection means rejection, pruning, cleansing; the clear and naked emergence of the Essential.' There is a distinct echo of Loos, confirmed by the subsequent passage: 'From the primitiveness of the Early Christian chapel, we pass to Notre Dame of Paris, the Invalides, the Place de la Concorde. Feeling has been clarified and refined, mere decoration set aside and proportion and scale attained, an advance has been made; we have passed from the elementary satisfactions (decoration) to the higher satisfactions (mathematics) . . . Decoration is of a sensorial and elementary order, as is colour, and is suited to simple races, peasants and savages. Harmony and proportion incite the intellectual faculties and arrest the man of culture. The peasant loves ornament and decorates his walls. The civilised man wears a well-cut suit and is the owner of easel pictures and books.'

As early as 1915 Le Corbusier had produced an idea for houses, using a reinforced concrete structure which would allow an architect to apply the (non-load-bearing) walls according to need. In the Domino House his intention was to show how technology could be used to free the architect from the constraints of traditional building methods and allow the construction of varied environments, using only one

374

basic skeleton. The Citrohan House, designed in 1920, was yet another project for mass-production houses. It was developed in several varieties, on stilts and as maisonettes. A completely furnished version was shown at the Exposition des Arts Décoratifs in Paris, in 1925. The name comes from Citroën: 'that is to say, a house like a motorcar, carried out like an omnibus or a ship's cabin'. The aim is to provide a truly modern house with garage, central heating, modern services and a sun terrace, 'a house as serviceable as a typewriter', by modern methods including reinforced concrete and expanded metal.

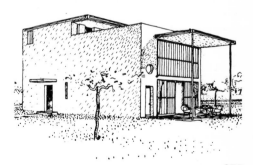

375

374 *The Domino House, 1915*

375 *The Citrohan House, 1920*

376

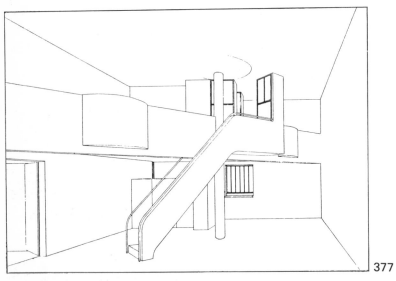

377

378

During the following years he produced many ideas ranging from designs for whole cities to mass-produced workers' houses. The houses he designed for a development at Pessac, Bordeaux, owe much of their form to Le Corbusier's experience of Purism.

It is however in the individually designed houses of this period that Le Corbusier expresses his ideas most clearly. The house at Garches has a simple, calm façade. The interior is more complex and in plan certain Purist forms and methods of composition are apparent. Le Corbusier never ceased to be a Purist. Although much can be justified on functional grounds, the 'machine for living in' is, as Wagner had maintained, predominantly aesthetic.

Reinforced concrete makes functional needs easier to satisfy; furthermore, it makes possible the introduction of higher standards of comfort. For instance, wide windows admit more light; windows which stretch across the full width of the room eliminate dark walls. Yet there is little doubt that the Purist interest comes before the functionalist interest in Le Corbusier's mind, although it is often difficult to make a distinction. Can the long strip window of the house at Garches be wholly justified on grounds of function, or is it an element in the composition? Le Corbusier had spoken of reinforced concrete in connection with realising forms – as well as functions – and it therefore became part of the grammar which enables an architect to produce architecture according to the Corbusian definition: visual poetry. Such modern technological means as reinforced concrete make it possible for the architect to establish visual relationships between the parts of a building with greater freedom, and to express them with greater clarity. If we still cling to the idea that modern architecture consists in expressing the whole function of a building honestly, Le Corbusier's projects teach us to modify this idea. The architect, as an artist, must select those functional elements which are significant in the composition, those which give him the raw material for his visual poetry. He must select as a painter selects

376 *Le Corbusier, town plan 1922*

377 *Le Corbusier and Pierre Jeanneret, mass-produced workers' houses, 1924, interior*

378 *Le Corbusier, housing at Pessac, Bordeaux, 1925*

379 *Le Corbusier, house at Garches, 1927*

380 *Detail of 379. Applied Purism*

381 *Le Corbusier's analysis of the composition of the front of the house, reminiscent of the strict geometry of his Purist paintings*

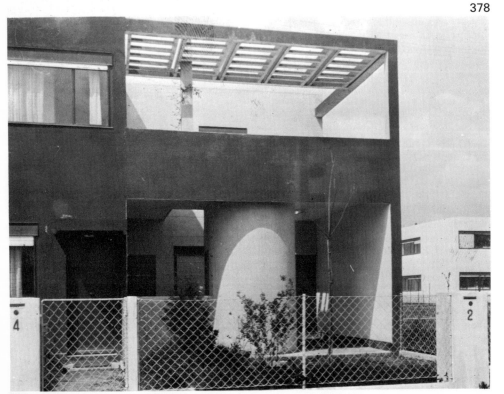

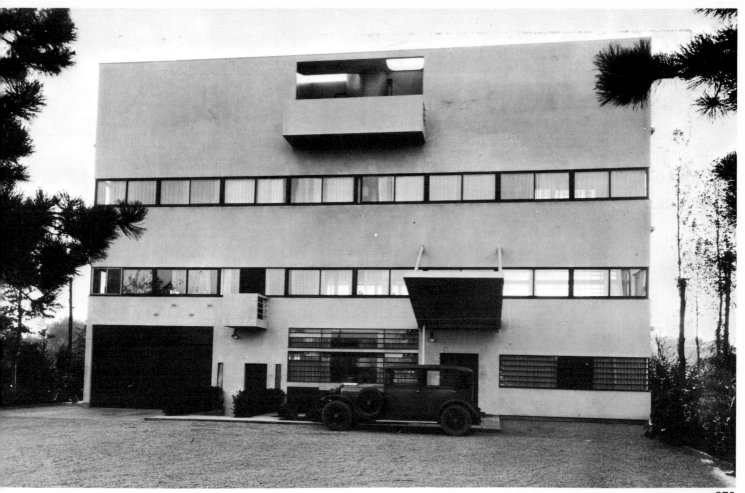

379

380

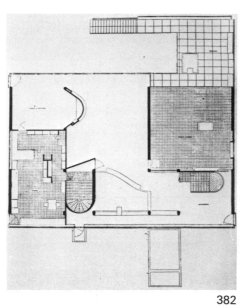

382

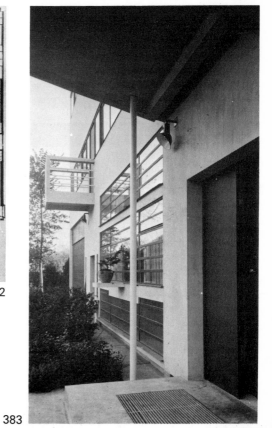

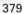

382 *House at Garches, plan, first floor*

383 *House at Garches, view from under the canopy over the entrance*

381

383

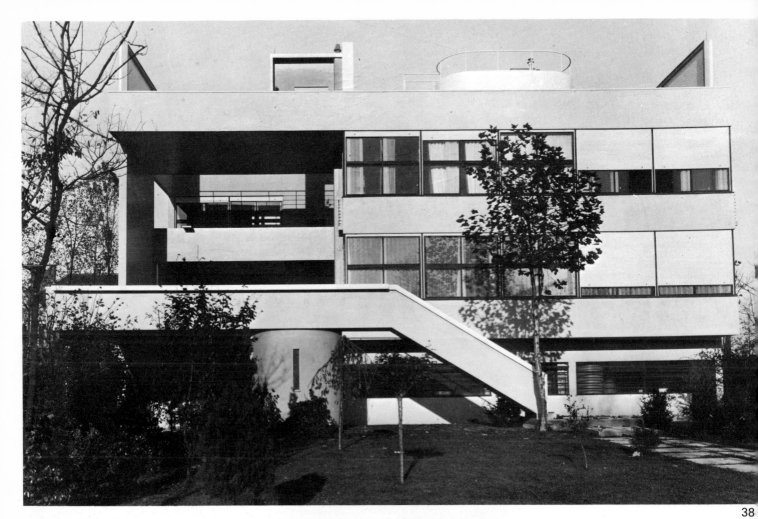

38

385

386

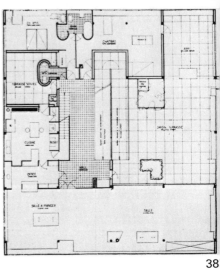

38

384 *House at Garches, rear elevation*

385 *Le Corbusier's analysis of the composition of the rear of the house*

386 *Detail of open-air sitting area*

387 *Le Corbusier, Villa Savoie, Poissy, 1929, plan*

388 *Villa Savoie, section*

389–391 *Villa Savoie, exterior views. Eac one an extension of Purist theory*

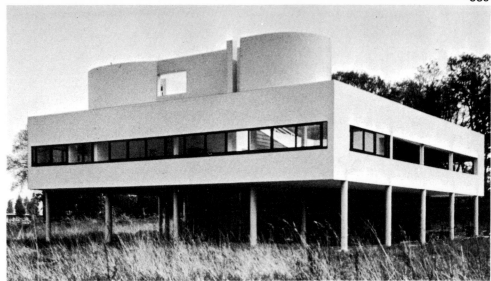

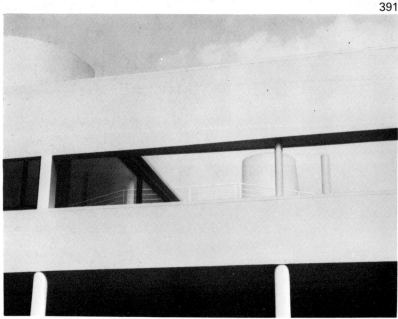

from the available data, as a poet selects from the words and sounds suggested by a situation.

The Villa Savoie, 1929, is the first complete fusion of Le Corbusier's architectural ideas in a realised house. It comes nearer to being a living-machine than any of his earlier houses and nearer to being what he understood by architecture: a poetic play of forms. It is probably also the first house whose form was influenced by the motorcar — apart from the provision of a garage — for the curvature of one of the sides of the ground plan approximates to the turning circle of a car. This allows the car to be taken to the entrance where the passengers may alight under cover provided by the projecting upper floor. The car may then complete the loop to regain the drive to the gate house. A ramp as well as a spiral staircase lead to the upper floor. There a large sitting room is separated by a sliding pane of plate glass from the inner open air court, virtually an outdoor sitting room, with its table and flower bed. Next to the kitchen is an outdoor dining area, and on the top floor a sun terrace protected by wind breaks.

Seen from a distance the house appears to float, balanced delicately on its stilts, for the recessed ground floor, which is partly painted dark and partly clad in glass, is almost invisible as a means of support. The long continuous windows which pierce the four walls allow complete views of the surrounding country (today sadly spoiled by adjacent buildings) but they are also an important element in the architectural composition. Everywhere one is surprised, and moved, by the unexpected play of forms, particularly where the staircase and windbreaks are involved. They are quite clearly Purist forms. The staircase which traverses several floors extends the idea of interpenetration of volumes — so often essayed in Purist painting — to the realm of architecture. The mathematical form of the staircase can be seen from several positions and levels, for instance from outside the house in front of the entrance hall and from the inner court, through the huge windows which seem to have been designed as much for the convenience of the inhabitants (admitting light: function) as of observers (visual clarity: architecture).

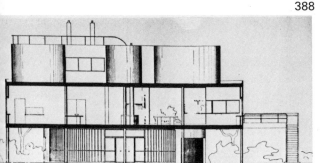

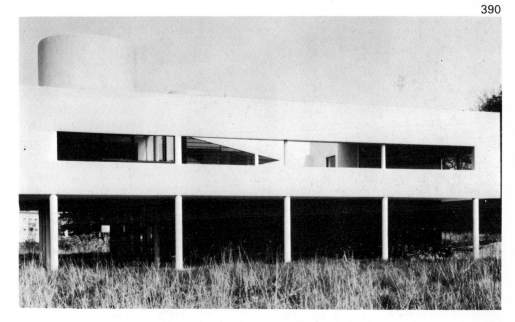

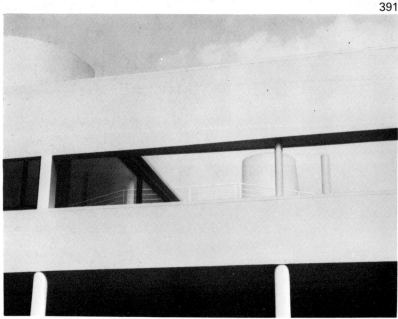

159

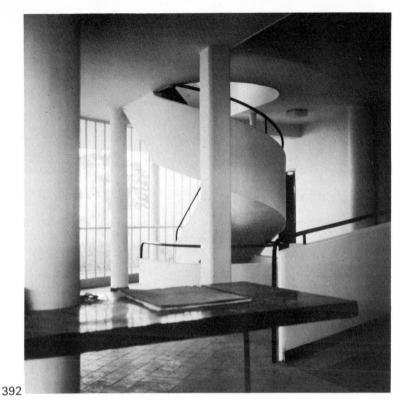

The transparency of articulated volumes gives a sensation of space which is at once clear and mysterious: architectural poetry. The nearest to the poetry of Le Corbusier's *architectural* space is the poetry of the *pictorial* space in his Purist paintings. In fact, the Villa Savoie is Le Corbusier's most perfect realisation of a three-dimensional, habitable Purist composition.

The curved glass wall of the entrance hall might have been straight, but then it would not have expressed the movement of the motorcar, the complement of the house in modern living. This curved glass skin is a gesture expressing the modernity of living and in particular the movement associated with it. The Futurists would surely have given such a gesture their wholehearted approval.

392

392 *Villa Savoie, entrance hall*

393 *Villa Savoie, roof top with windbreaks*

393

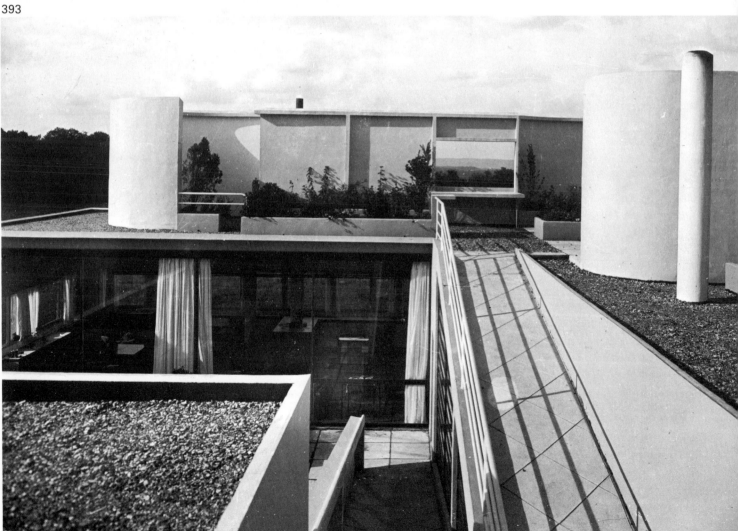

While Kandinsky evolved his own form of abstraction in Germany other developments towards similar goals were taking place elsewhere. Piet Mondrian, in Holland, sought like Kandinsky to induce nature to reveal its essence, but he was inspired by different motives.

The differences between the Russian and the Dutch temperaments are self-evident. On the one hand a tendency to extreme emotionalism, to being overwhelmed by intense suffering or joy; on the other hand a tendency to a realistic, level-headed outlook on life and a reluctance to give vent to hysteria or violent feeling. The swirling arabesque in Kandinsky's art, reflecting every nuance of emotion and excitement, has its counterpart in Mondrian's straight line: calm, reasonable, classical, rejecting all ephemeral pressures. When Kandinsky turned away from a disintegrating reality and found his way to abstraction, he was seeking echoes of his own psychical state. Mondrian's journey to abstraction had different causes. 'Gradually I became aware that Cubism did not accept the logical consequences of its own discoveries; it was not developing abstraction towards the ultimate goal, *the expression of pure reality*.' This simple statement made by Mondrian near the end of his life sums up his striving. He did not search for abstract symbols of his own emotional life but for another reality, purified of all traditional encumbrances and imperfections, innocent of individual whims and of universal validity. Because of its universality this new, pure reality would embrace all individuals, linking them to their environment and ultimately to the universal.

Like Kandinsky Mondrian had a high regard for the ideas of theosophy. He also shared this interest with the Dutch philosopher M. H. J. Schoenmaekers who was to exert a powerful influence on the young painter. The two men met frequently to discuss philosophy and the problems of belief. Looking for a permanent basis in the midst of change Schoenmaekers put forward the view that the structure of the world 'functions with absolute regularity' and can be expressed by 'plastic mathematics'. Ideas relating to the union and balance of the vertical (male) and the horizontal (female) were also encompassed by Schoenmaekers' mystical philosophy. In Mondrian's development as an artist these ideas came to assume a most important formative role. Like Schoenmaekers he

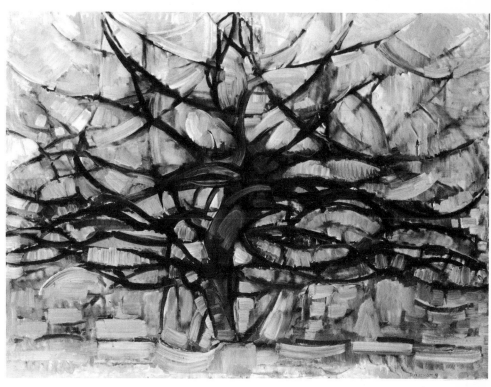

394

grew more concerned with the structure and rhythm of the spiritual world than with the appearance of the physical world. His paintings made between 1909 and 1913 show the direction of this development. The earlier paintings of this period have a resemblance to Expressionism or to van Gogh. Soon, however, Mondrian began to refine the essential lines of the forms which made up his subjects. This distillation of physical reality to a harmonious structure of lines culminated in compositions of predominantly vertical and horizontal masses. This expressed not only Schoenmaekers' philosophy but also Mondrian's own need to order and balance the apparently chaotic phenomena of nature. Through a sifting and ordering of impressions the writhing, tortured vision of his earlier painting is transformed into an image of balanced calm. Where Kandinsky intensified the emotional content of his pictures, Mondrian cooled it down. In this series of pictures naturalistic details gradually disappear while structure becomes ever more pronounced until eventually no trace is left of the objects which may have contributed to the final result. Instead of the naturalistic interest of traditional paintings, these pictures rely on visual qualities and values: harmonious relationships, rhythms and movement.

394 *Piet Mondrian*, The Grey Tree, *1912. Haags Gemeentemuseum, The Hague*

L

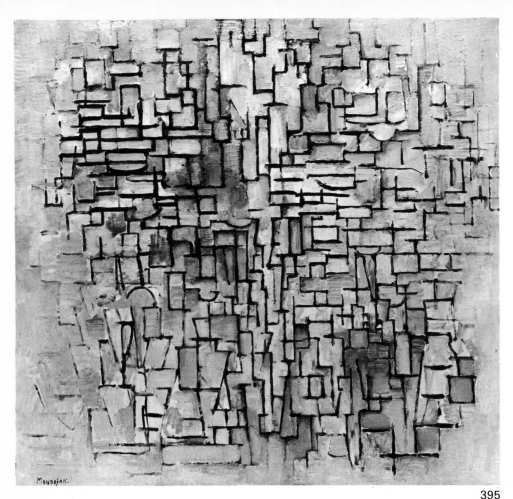

395

396

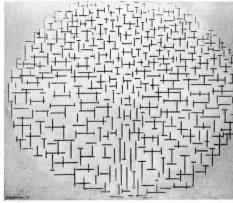

397

There is a similarity between the grid-like structure of Mondrian's work of this period and the gradation of different densities of many Cubist paintings. Indeed, areas of contrasting density and transitions from one to the other are even more important in Mondrian's work than in that of the Cubists. *Composition 7*, 1913, depends for its effect on the relationship between areas of tight, narrow patterns with those of a broader, more open treatment. The horizontals and verticals balance not only in a structural sense but also in their implied movements. An analysis of *Composition 7* shows that certain areas have a preponderance of vertical lines, others of horizontals, both reinforced by the closeness of lines in those areas. The horizontal-dominated masses pull against the vertical-dominated masses and the two contrasted visual movements are held in balance.

This manner of ordering visual impressions was exploited by Mondrian during 1914–15 in a series of paintings with the title *Pier and Ocean* in which the rhythm of the sea is balanced by that of the pier. As the lines expressing these rhythms were set free from their structural context the two-way stress became clearer. The picture shown here, which is one of the series, expresses the rhythm of the sea as an essential and permanent quality and not as it might have

been shown in a traditional painting, with successive waves frozen into one instant of time.

In spite of the serenity and precision of these pictures, Mondrian now reached an impasse. His pictures, even though they were by now completely abstract, still depended to a greater or lesser extent on natural phenomena. He came to the conclusion that visualisations of concrete situations – the sea, landscape, plants, people, still life objects – could never completely shed the individual properties of the originals.

He found it impossible to purge his paintings of all attributes of natural forms and to arrive at a universal vision and experience, balance and harmony. 'The emotion of beauty is always obstructed by the appearance of the object,' he wrote, 'therefore the object must be eliminated from the picture.' Perhaps by the word 'appearance' he meant the inner appearance in his own mind of an object or even a faint afterglow of an object in which the picture had originated. 'The emotion of beauty' he believed, could be fully felt only if the starting point of a painting, and not merely its final form, was wholly outside the world of natural appearances. Mondrian therefore turned to an even more profound form of abstraction in which

structure and rhythm became simply qualities of a picture; they were no longer extracted from what he had observed in nature. In such visual rhythms it is the spaces between the lines and not the lines themselves which determine the character of the rhythm.

395 *Piet Mondrian*, Composition 7, *1913. Solomon R. Guggenheim Museum, New York*

396 *Analysis of* Composition 7

397 *Piet Mondrian*, Pier and Ocean, *1915. Rijksmuseum Kröller-Müller, Otterlo*

398 *Spatial rhythm*

399 *Piet Mondrian*, Composition, *1916. Solomon R. Guggenheim Museum, New York*

A band like this expresses a rhythm.

We may emphasise a different aspect of the same rhythm by changing the rendering from lines to spaces.

It is also possible to use a mixed technique of both lines and spaces, which enriches the rhythm, especially when colours are introduced. This version of the original

rhythmic band expresses several aspects of the same rhythm all at once. Lines, spaces, depth of tone and intensity of colour, and the relationships of all these, play a part in the complex, overall rhythm.

Since such a rhythmic sequence does not refer to anything in the visible world but must be treated in its own right, it can be brought together with other rhythms even if such structures do not exist in reality.

398

They may be allowed to cross over so that new, even more complex, rhythms emerge which no longer function from side to side but now cover a whole area. This is what we see in Mondrian's next stage of development.
In *Composition 1916*, as in *Pier and Ocean*, the bands of rhythm run at right angles to each other. Several lines have

been thickened to establish a dominant rhythm while the rest of the rhythmic structure fades away at the sides. The coloured shapes relate the uprights to the horizontals and also add a rhythm of their own, a balancing rhythm without emphasis in either direction. Because the warm colours advance while the cool colours recede we experience a rhythmic sensation of space.

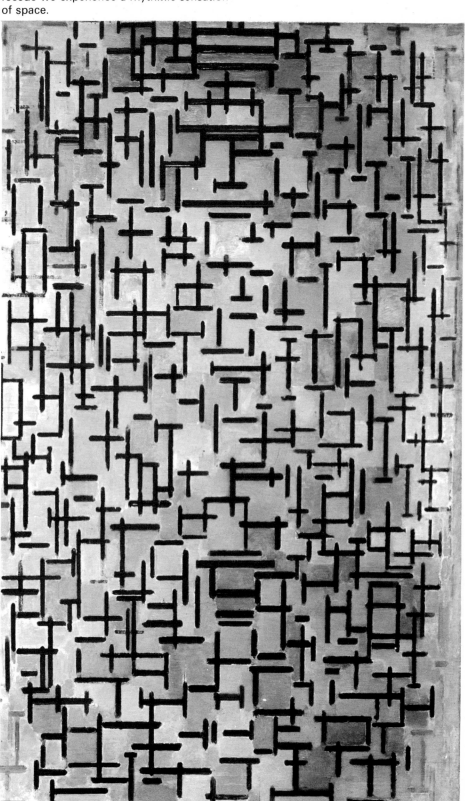

399

From 1916 onwards coloured squares and rectangles as well as lines became the means by which Mondrian represented the inner rhythm and structure of nature. Gradually the lines grew smaller, as in *Composition in Blue B,* 1917, and eventually disappeared altogether, while the shapes became larger, approaching each other and assuming a reality of their own. In *Composition No. 3 with Colour Planes,* 1917, only the relationships between the shapes remains. The universal validity of this picture is reinforced by the disposition of some of the shapes which appear to be bisected by the edge of the picture. These shapes may be imagined to continue outside the picture area which therefore shows only a part of something much bigger than itself: the continuous rhythm of life itself. Pure reality has been achieved.

When, in the development of Mondrian's painting, the shapes became too large he found it necessary to divide them, introducing lines once more. These lines were now quite straight and geometrical; they had nothing to do with natural phenomena. They reassert the importance of structure which had been largely lost during the period when Mondrian was investigating rhythmic relationships.

We have seen that in pictures such as *Composition 1916* two sets of rhythms are intermingled. The resultant, rich, complex rhythm spreads over the whole area and can be considered the subject of the picture. Such a picture cannot be 'seen' as a result of piecemeal visual exploration, it can make sense only if the whole is assimilated simultaneously. But simultaneous perception is impossible to achieve through an act of the will; it can be achieved only if, instead letting our eyes roam over the surface of the picture, taking in each element in turn, we extend our vision by an involuntary process, taking in the overall, complex subject at one glance. Looking at such a picture is therefore an education for our perception.

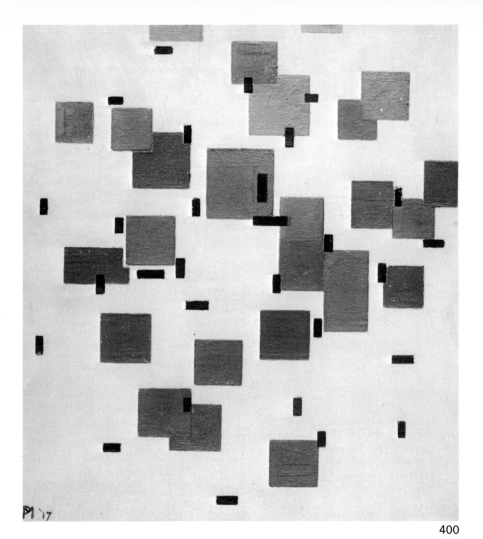

400

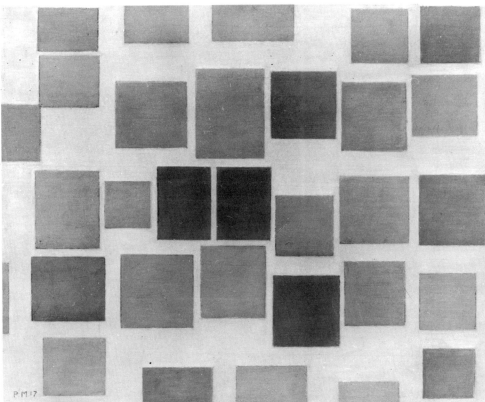

400 *Piet Mondrian,* Composition in Blue B, *1917. Rijksmuseum Kröller-Müller, Otterlo*

401 *Piet Mondrian,* Composition No. 3 with Colour Planes, *1917. Haags Gemeentemuseum, The Hague*

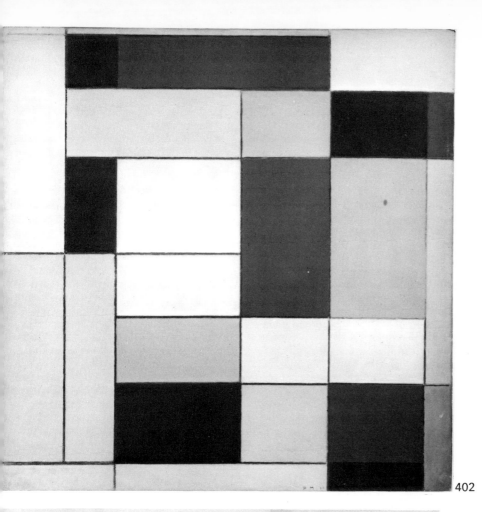

402

For *Composition 1921* an even more
sensitive perception is needed. There are
still two basic sets of rhythms, at right
angles to each other, but there are fewer
divisions, so that each sequence, even each
space, becomes more vital and has a
greater effect on the balance of the
picture. The lines of the earlier *Composition
1916* make a mass appeal and to miss one
or two or even more makes little difference.
But in a composition such as the one of
1921 the framework is something like a
close-up of a small part of the overall
pattern of *Composition 1916*. Each element
now matters; a displacement of any one of
them would result in a lop-sided
composition. The rhythm which is obvious
in a long row of lines becomes more
difficult to discern where each set is of
only five or six lines. And yet the rhythm
is there if our perception, trained by
looking at the earlier pictures, can sense
it, and once this rhythm has been
established it will pulse beyond the frame
of the picture, becoming a part of
permanent reality.

404

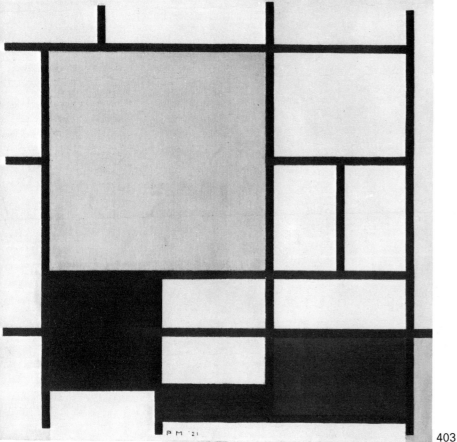

403

402 *Piet Mondrian,* Composition in Grey,
Red, Yellow and Blue, *1920. Tate Gallery,
London*

403 *Piet Mondrian,* Composition with Red,
Yellow, Blue and Black, *1921. Haags
Gemeentemuseum, The Hague*

404 *Rhythmic analysis of* Composition,
1921

It is important to bear always in mind that to Mondrian art was not a rendering of nature or an expression of feelings but a means of achieving inner balance. Man's individuality, so Mondrian reasoned, causes an imbalance between the individual and his environment, which consists of other individuals, the man-made and natural worlds, timeless and eternal values. Traditional art makes great play of this imbalance, but if art is to help man to find his equilibrium it '. . . should directly express the universal within us, that is, the true appearance of that which is outside ourselves.' In other words an art which is outside and beyond mere emotions, not an art which plays on emotions and heightens them. The only emotion which Mondrian would admit is the 'emotion of beauty': a feeling of calm well-being induced by the harmonious balance of art. 'Rising above all suffering and joy is balance. This balance, unconscious and permanent, is the source of art.' The dissonances between what is individual and what is universal give rise to tragedy. Therefore tragedy would be banished by a state of spiritual balance.

This helps to explain Mondrian's single-minded search for visualisations of harmonious balance and his renunciation of even the faintest trace of reality. If the individual and the particular disturb this sought-after ideal state they must be jettisoned. Kandinsky's abstract art may still evoke vague realistic situations or the emotions which they arouse, but in Mondrian's painting such symbols have no place. His abstractions — in the later phases — start in the universal 'above all suffering and joy'. This to him was 'the real abstraction' or going still further 'pure reality' which he could not find in Analytic Cubism.

Since Mondrian's abstract art does not describe anything other than itself and does not allude to anything in the 'real' world, it becomes a new reality, answerable only to its own laws. We have seen that other' artists also produced works which could lay claim to this description. All the same they never completely abandoned some aspect of factual reality, or their own reaction to this reality. Mondrian broke with the art of the past not merely on account of the unmitigated severity of his abstractions but because he postulated a new conception of art, standing outside the reality of nature and creating a new, pure, entirely man-made reality. In Mondrian's art a painting has become a pure product of man's mind and sensibilities It is man's first truly original creation and an entirely new reality, pure reality, not a reflection of an existing one.

Mondrian looked forward to the day when art in the form of pictures would no longer be necessary because the whole human environment would be conceived and built on the principles of universal harmonious balance. Art would then be seen in the quality of the environment rather than in art objects. He deeply influenced later artists, architects and designers and raised several questions which are still far from settled.

These developments towards pure abstraction were not confined to Mondrian's work nor indeed to painting. During the early years of the century a Dutch architect, P. J. Klaarhamer, designed furniture, reminiscent of the English Arts and Crafts Movement, of simple, for the most part unadorned, forms. Klaarhamer's designs were often carried out by a young furniture maker named Gerrit Rietveld. This partnership produced several pieces. Rietveld, a creative craftsman with an understanding of structure, who had been making simple, workmanlike chairs almost since the turn of the century, studied architecture under Klaarhamer. Perhaps as a result of his studies, he produced a series of chairs which were structurally arresting and made no concession to the way people at that time thought a chair should look.

By 1917 Rietveld reached a point in his development corresponding to Mondrian's at the moment when he removed all recognisable traces of reality from his paintings and was ready to combine abstract elements in compositions which abandoned any imitation of nature.

Rietveld's Red-blue Chair of 1917 could be described as the first abstract chair ever made. Although we can detect structural similarities with Godwin's chair of 1885, we are hard put to it to recognise a chair in this structure and Rietveld's contemporaries must have found it even more difficult. In another, deeper sense, the chair is an abstraction, revealing relationship in its basic structure in a way a 'recognisable' or 'real' chair would not.

Having followed the development of Mondrian's work, it should not be too difficult to appreciate the visual balance of this structure in which the dimensions of the individual pieces are carefully related to the spaces between them. Since this is a three-dimensional structure the volumes contained by it are also related, as in a piece of sculpture.

Rietveld was above all a practical cabinet maker and he analysed not only the structural and visual properties of the chair but also its construction. The individual members are not jointed in the usual way; they are allowed to project beyond their point of intersection and are joined with

405

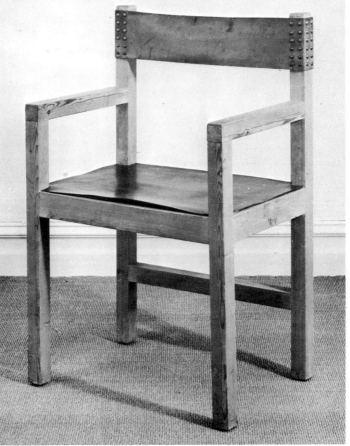

wooden plugs. The dimensions of the individual pieces and of the chair itself are subject to a module – which explains its visual unity. These features of structure, jointing and dimensioning make the chair eminently suitable for mass-production and with this design Rietveld looks far into the future, both in terms of abstract visual balance and of the needs of modern mass-production methods.

The chair has great visual refinement. The function is clearly stated by the colour: bright red and blue for surfaces which will support the human body, black for the structure from which these planes are suspended, and yellow for the end-facets to emphasise the sections. In several places three laths meet and project beyond the point in different directions. These meeting points have a special significance in the structure for it is here that the three-dimensionality of the chair is emphasised. In a traditional joint the three pieces are combined in such a way that the character of each is sacrificed to the whole. In Rietveld's joint each member retains its individuality and stresses the direction in which it runs. The construction, the three-dimensionality of the chair, and of space itself, are emphasised by this device. We have seen how in Frank Lloyd Wright's houses closed and open spaces are combined and balanced, and how the long

cantilevered planes define open spaces which relate the structure of the house to the space surrounding it. The projecting members of the Red-blue Chair serve a similar function, they probe the space immediately surrounding the inner volume of the chair. The space round the chair is moulded where it meets the structure and so is drawn into a relationship with the space contained by it. The phenomenon is somewhat similar to that of Boccioni's walking man which also establishes a relationship with his surrounding space. But the dynamic relationship of Futurism becomes a static relationship in Rietveld's chair.

The similarity of Rietveld's chair of 1917 and Mondrian's work of the same period is remarkable, and this correspondence becomes even more astonishing if the chair is compared with a slightly later work by Mondrian, his *Composition of 1921* for example. Apart from the fact that one is a piece of furniture and the other a painting there can be no doubt that the visual intention was similar: to achieve a relaxed state of balance between the harmonious divisions of space, either two or three dimensional, and between the constituent parts of the composition. Both painter and designer had reduced the problems facing him to the barest essentials.

406

407

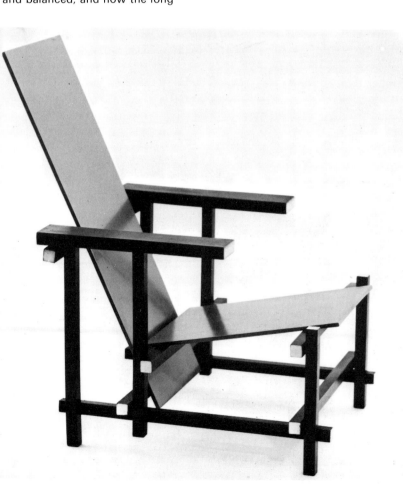

408

405 *Gerriet Rietveld, chair, 1908. Centraal Museum, Utrecht*

406 *Gerrit Rietveld, Red-blue Chair, 1917*

407 *Traditional and Rietveld's corner joint*

408 *Diagram of space-modulation of Rietveld's structure*

Mondrian and Rietveld were not the only people in Holland to have reached this position at that time. The architect Robert van't Hoff had visited America and become acquainted with the architecture of Frank Lloyd Wright. He was particularly impressed by the Unity Chapel in Chicago, built in 1906, and by the Robie House of 1909. He recognised that here were the beginnings of a truly modern architecture. Absorbing and reinterpreting Wright's architectural thinking and adapting his style to the Dutch idiom, he built two houses at Huis ter Heide, in 1916, which were the first tangible result of Wright's influence on the architecture of Europe. Comparing van't Hoff's houses with Wright's, one can see that the Dutch design is tighter and lacks the dramatic cantilevers of the American model.

Nevertheless it has its recessed and overhanging forms, articulating forms and spaces which must have marked it at the time as a most advanced building. It seems logical that Rietveld should have been invited, in the following year, to design furniture for one of van't Hoff's houses for there is an obvious similarity of outlook and purpose between his Red-blue Chair and these houses.

409 *Robert van 't Hoff, Huis ter Heide, 1916*

410 *Frank Lloyd Wright, Robie House, 1909*

411 *Gerrit Rietveld, sideboard, 1919. Stedelijk Museum, Amsterdam*

412 *Detail of 411*

413 *P. J. Klaarhamer, sideboard, 1915. Centraal Museum, Utrecht*

409

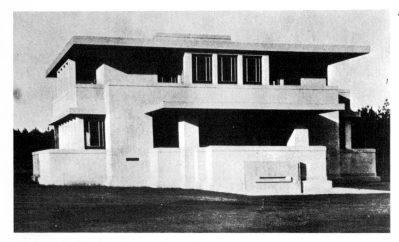

410

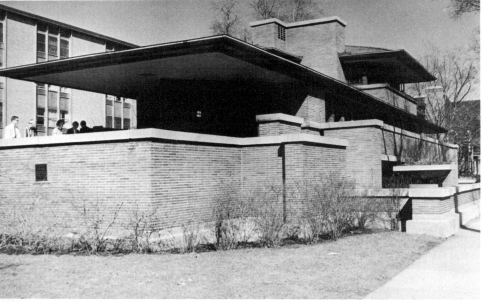

The sideboard which is probably one of the pieces Rietveld designed for Huis ter Heide follows the process of the chair. A traditional object has been broken down into its component parts and reassembled into a structure in which their purpose is clearly stated. Once again the origin of the sideboard can be traced back to Klaarhamer, whose sideboard of 1915, states its structure and purpose in the typical 'modern traditional' style of the Arts and Crafts Movement. The framework and the structure of the cantilevered top shelf are shown. This may have been Rietveld's point of departure and the result of his reappraisal is even more in character with van't Hoff's architecture than his Red-blue Chair. In the chair the theme of the cantilever is used only sparingly but in the sideboard it is used most dramatically in two planes at right angles to each other. The side cabinets, which in Klaarhamer's design are a part of the closed form of the sideboard, have been pushed out sideways, suspended and supported between cantilevers. The top has been cantilevered even farther and the top shelf cantilevered forward from the back battens. Everywhere the surrounding space is implicated in the design, the structural members probing it, the structure itself allowing it to flow freely in and out of the composition. One can sense how Rietveld used space to model the overall form, as in a piece of sculpture. The eye is always induced to relate solids to space.

There were at that time in Holland several artists and designers whose work showed a similar outlook, for instance the painter Bart van der Leck, the designer Vilmos Huszar, of Hungarian origin, the architect J. J. P. Oud, the sculptor Georges Vantongerloo. Theo van Doesburg who founded a magazine to provide a platform where matters of art and architecture could be discussed joined forces with these men of kindred outlook to form a group which adopted the name of the magazine: de Stijl (Style).

De Stijl was a somewhat loose association of artists, designers and architects who subscribed to similar opinions. They had in common, amongst other things, a great respect for the work of Frank Lloyd Wright, whose influence was felt through the houses of van't Hoff, the writings and lectures of van't Hoff and an eminent architect of the older generation, H. P. Berlage, and through several publications which reproduced his designs. Also common to members of de Stijl was a new attitude to the machine, derived partly from Futurism through Sant'Elia and partly from the mainstream of European design practice. In the hands of de Stijl artists these influences solidified into a new vision which became the major contribution of the group to design and to the modern

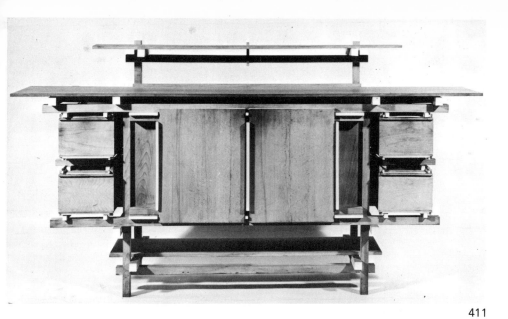

411

412

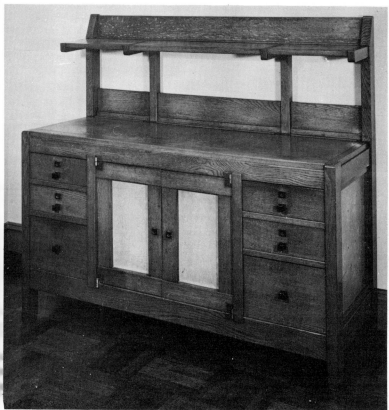

413

environment. Van Doesburg who had ascribed to Rietveld's Red-blue Chair the '. . . silent eloquence of a machine . . .' also wrote: 'The machine is, par excellence, a phenomenon of spiritual discipline. Materialism as a way of life and art took handicraft as its direct psychological expression. The new spiritual artistic sensibility of the twentieth century has not only felt the beauty of the machine, but has also taken cognisance of its unlimited expressive possibilities for the arts.' This is closer to Sant'Elia than to Marinetti. While Futurists saw in the machine the source of the dynamism of modern life the members of de Stijl saw it as a mechanical counterpart to their philosophy of modern life. 'Machinery supplants animal strength, philosophy replaces faith' wrote J. J. P. Oud, thus linking muscular power with faith as out-of-date commodities to be replaced by machinery and philosophy. To the de Stijl artist machinery, by producing the de-particularised, de-personalised finish of manufactured objects, would provide a new abstract appearance for all the arts. The machine, product of the human spirit, was to be the tool through which man would attain his spiritual aspirations. It therefore became the personification of this process.

'The life of contemporary man is gradually turning away from nature, it becomes more and more an a.b.s.t.r.a.c.t. life', so wrote Mondrian in de Stijl. The letters of the word 'abstract' are separated almost in the manner of his paintings or of a Rietveld chair, in which the individual pieces, while joined in a structure, are yet kept separate. What is even more important is the contrast between what is natural and what is abstract. Natural is old-fashioned, abstract is modern. He goes on to say, 'The genuinely modern artist sees the metropolis as abstract living converted into form; it is nearer to him than nature and is more likely to stir in him the sense of beauty.'

Abstraction, taken to its logical conclusion, constitutes a new reality, the reality of Mondrian's paintings, a truly humane world made by man exclusively for man and in opposition to the world of nature. The machine is a part of this reality; it is also the mechanism whereby it may be achieved, the culmination of man's spiritual achievement. Now the new relationship between 'abstract' and 'machine' becomes apparent, and shows why the new machine aesthetic will not admit of naturalistic ornaments.

De Stijl is the first truly modern example of the synthesis of the arts. Such synthesis cannot be produced by a deliberate adherence to certain principles; it can occur only if common aims are distilled through the creative process. This is exemplified in the work of Mondrian and Rietveld. Because both lived at the same time and were actuated by similar motives, they arrived at surprisingly similar solutions to their problems. Neither acted as a model for the other through the example of work or personality; in fact the two men never met. Considering also the work of other members of de Stijl, one is again impressed by their common purpose. It is hard to think of another group of modern artists who produced work of such strikingly similar character in a variety of spheres.

Bart van der Leck was a painter who from his study of natural forms had arrived independently at a kind of abstraction which had as much claim as Mondrian's to its own reality. In the painting of 1918 shown here the geometrical forms are kept separate to make their individual appeals to our attention and perception, but the appeal is also a combined one. This composition has a visual piquancy, resulting from the displacement of a single form from its position in the symmetry of the picture. There is no visual focus, as we normally expect in a traditional painting, and every part of the total area has an equal claim on our attention. As in the case of Mondrian's painting we are forced to extend the scope of our simultaneous visual intake. The painting can be effective only when all the shapes are viewed simultaneously; successive viewing misses the point

Vilmos Huszar, a Hungarian who had come to Holland in 1905, designed two of the covers for the de Stijl magazine. In the second of these a number of black shapes are composed not only in relation to each other but also to the spaces between them, in a manner reminiscent of Rietveld's sideboard. The visual effect of this design depends on the balance between forms and spaces, between dark lines and white lines. There is considerable ambiguity in the composition, for the large white space in the middle may also be read as a white shape with either black rectangular holes or black rectangles superimposed. Similarly the white lines may be read as spaces between the black shapes, or as lines in their own right. This teasing ambiguity creates visual interest. It makes us look harder and extends our perceptive faculties. The same applies to Huszar's first de Stijl cover. It is noteworthy how the very lettering of the main title reflects the constructive principle of the subject matter.

414

415

416

The sculptor Georges Vantongerloo undertook extensive research into the property of space and form, producing abstract sculptures in which volumes intersect and support each other, defining spaces which are an essential part of the whole. This is the exact equivalent in three dimensions of van der Leck's and Huszar's work in two. Being free from the functional and structural requirement of architecture, the play of forms can be even more adventurous than that of Wright's houses: relationships become more involved, and

414 *Bart van der Leck*, Composition, *1918. Tate Gallery, London*

415, 416 *Vilmos Huszar, cover designs for first and sixth issue of De Stijl*

417 *Georges Vantongerloo*, Agreement of Volumes, *1919*

418 *J. J. P. Oud, Café de Unie, Rotterdam, 1925*

419 *J. J. P. Oud, factory at Purmerand, 1919, model*

eloquent; his later works derived from mathematical formulae which make up the titles of the works, are more precise and more expressive. The result of this is not just sculpture but a new awareness of the elements of architecture and design, a spatial and formal consciousness which laid the foundations of much subsequent work.

417

J. J. P. Oud was one of the most important members of de Stijl, not only for his architectural and planning work – he became city architect of Rotterdam – but also for his writings which made a major contribution to de Stijl theory. His Café de Unie in Rotterdam, built in 1925 but now destroyed, showed all the basic characteristics of de Stijl in an architectural context, with contrasting colour masses and textures held in balance. The lettering is not merely a functional addition to the building; it is part of the architectural composition to which it makes a notable contribution. As in a Cubist painting letters become an integral part of the composition. The modelling of the front of the building is kept slight in deference to the two older façades on either side whose building line it continues. Nevertheless, planes recede and advance to make the composition three-dimensional. The formal aspects of de Stijl architecture are even more fully worked out in Oud's project for a factory of 1919, which was never realised. The striking similarity between this project and the work of Rietveld and Vantongerloo may again be appreciated. The psychological

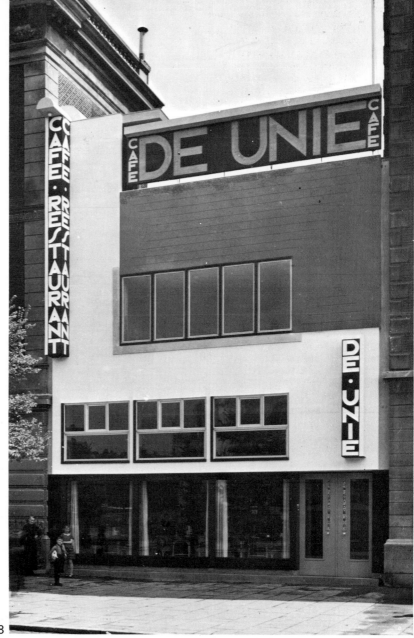

418

419

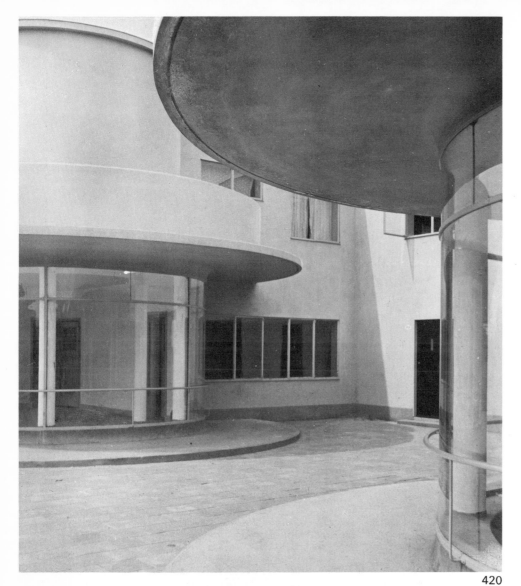

and social implications of de Stijl are demonstrated in Oud's work as city architect, where private and public spaces are carefully balanced, neither being sacrificed to the other. His workers' housing estates at the Hook and at Rotterdam are examples of this type of development for later planners to follow. The introduction of curved forms marks a softening of the uncompromising aspects of de Stijl and heralds the end of the movement as such and its absorption into what was soon to become the International Style.

Van Doesburg himself, founder and guiding spirit of de Stijl, was a man of many parts: writing poetry (under two different assumed names) and critical essays, painting pictures, designing interiors, furniture and houses. Because his interests were so widespread he was less of a zealot than, for example, Mondrian, for whom adherence to the principles of harmonious balance was an article of faith. Van Doesburg's early paintings show a certain similarity to Mondrian's and those of the other de Stijl painters. But always in his work there is an inherent dynamism. For instance in *Rhythm of a Russian Dance*, 1918, the elements are the same as van der Leck might use in some of his compositions, but the effect is one of movement.

Following in Marinetti's footsteps van Doesburg's poetry, too, gave typographic expression to such dynamic subjects as riders approaching, passing and leaving a cloud of dust, or a troop of soldiers marching past to the sound of drums.

420

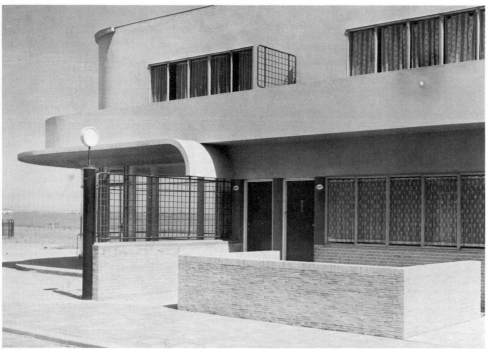

420 *J. J. P. Oud, workers' houses, Hook of Holland, 1924–1927. Rounded shopfronts*

421 *J. J. P. Oud, workers' houses, Hook of Holland, 1924–1927.*

422 *Theo van Doesburg,* Rhythm of a Russian Dance, *1918. Museum of Modern Art, New York*

423 *Bart van der Leck,* Geometrical Composition, *1917. Rijksmuseum Kröller-Müller, Otterlo*

424 *Theo van Doesburg, double page from* Mécano (*periodical*), *1923.* Mécano *was a Dadaist journal, edited and produced by van Doesburg.*

425 *Theo van Doesburg,* Soldaten, *1916, poem*

421

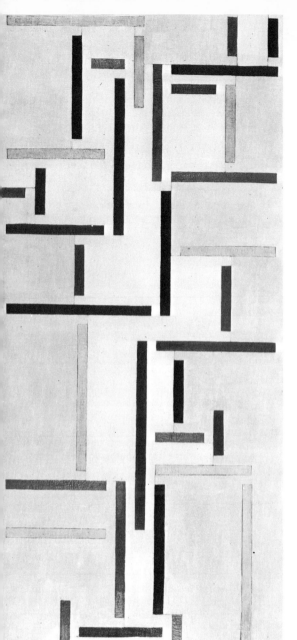

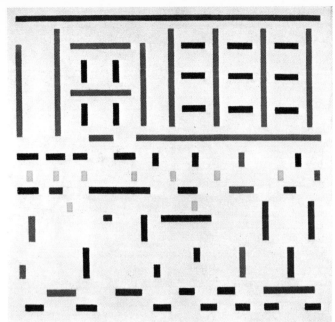

423

424

422

425

(Jit de serie: SOLDATEN 1916)

RUITER

Stap
Paard
STAP
PAARD
Stap
Paard.

STAPPE PAARD
STAPPE PAARD
STAPPE PAARD
STAPPE PAARD STAPPE PAARD
STEPPE PAARD STEPPE PAARD
STEPPE PAARD STEPPE PAARD
TIPPE PAARD STIPPE PAARD STIPPE PAARD
STIP PAARD
STIP PAARD
STIP

WOLK

VOORBIJTREKKENDE TROEP

Ran sel
Ran sel
Ran sel
Ran - sel
Ran - sel
Ran - sel
Ran - sel
Ran - sel

BLik - ken - tr**o**mmel
BLik - ken - tr**o**mmel

BLikken TRommel

RANSEL

BLikken trommel

BLikken trommel

BLikken trommel

RANSEL

Blikken trommel
Blikken trommel
Blikken trommel
RANSEL
BLikken trommel
Blikken trommel
Ransel
Blikken trommel
Ransel
Blikken trommel

RAN

Rui schen
Rui schen
Rui schen
Rui schen
Ruischen
Ruisch...
Rui...
Ru...
Ru...
R...
R...
r...

DE TROM

Rrrrr om

Rrrrr om

Rrrrr - om
DE trom
De drom
De trom
Rrrr - om

BOM

(zeer snel)

Bij den dom
Met den trom
Bij den zwarten dom
Met den hollen trom

Rrrr - om

Marcheeren!
Geweren!
DE zwarte soldaten!
De schuine geweren!

Rrr - om
BOM.

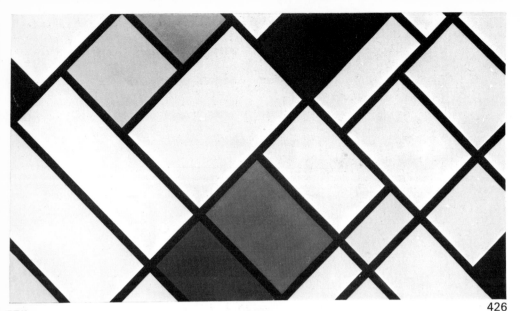

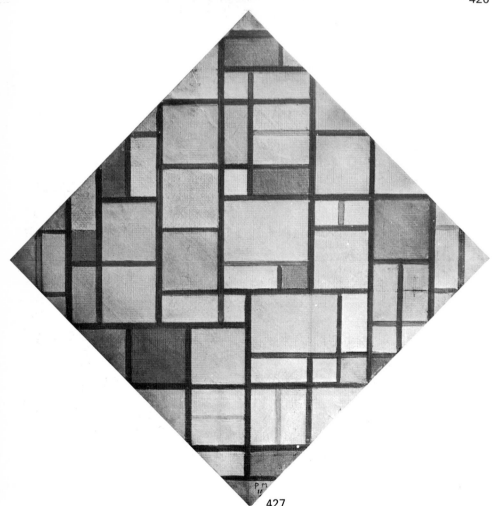

Van Doesburg's leaning to dynamic modes of expression found a more definite outlet in a new kind of composition which he pioneered and which he called *Counter-composition*. This was based on diagonals rather than on horizontals and verticals. Because the diagonals met the edge of the picture at an angle and also because of the residual triangles along the edges the overall effect was dynamic, with a subtly implied movement – visual, not actual – and tension. Mondrian too had painted pictures in which lines formed an angle with the edge, but he had tilted the picture until it seemed to stand on one point. The lines of his composition were still horizontal and vertical; although variety had been introduced the state of balance was unchanged. To an outsider the difference between these two variations on a basic form might have seemed negligible, but in reality they constituted the difference between dynamic tension and static calm. To Mondrian van Doesburg's counter-compositions were nothing less than a betrayal of the original aims and principles of de Stijl. He resigned from the group.

Van Doesburg exploited both forms of composition in the decoration of two interiors in Strasbourg: a dance hall and a café-cinema. In the café-cinema the decoration introduces a definite element of tension and it competes with the shape of the room. This adds excitement which the designer must have considered appropriate for a room of this purpose, while unsuitable for a dance hall, with its own excitement of sound and movement. The dance hall is therefore decorated in a manner which stresses the shape of the room, instead of competing with it, additional interest being provided by panels of light bulbs which enrich the overall pattern with textures of light. By using both methods in such proximity van Doesburg seems to attempt a demonstration of his belief that the counter-composition represented a genuine extension of de Stijl visual language.

Van Doesburg also carried out a number of works in which articulations of three-dimensional spaces were investigated and which contributed to the growth of spatial concepts. The knowledge which he gained from these studies was put to full use in his various projects for houses. It has been shown that the key to Mondrian's paintings lies in the relevance and relationship of the spaces between the structure lines. In some paintings by van Doesburg of about 1918 the total space of the picture area has been similarly organised in a most complex structure but in such a way that nowhere is any space shut off in an isolated enclosure; the structure remains open so that the partial enclosures may communicate with each other in many different ways. Van Doesburg produced many variations on this theme during this period.

426 *Theo van Doesburg,* Counter-composition, *1925. Haags Gemeentemuseum, The Hague*

427 *Piet Mondrian,* Lozenge Composition, *1919, Rijksmuseum Kröller-Müller, Otterlo*

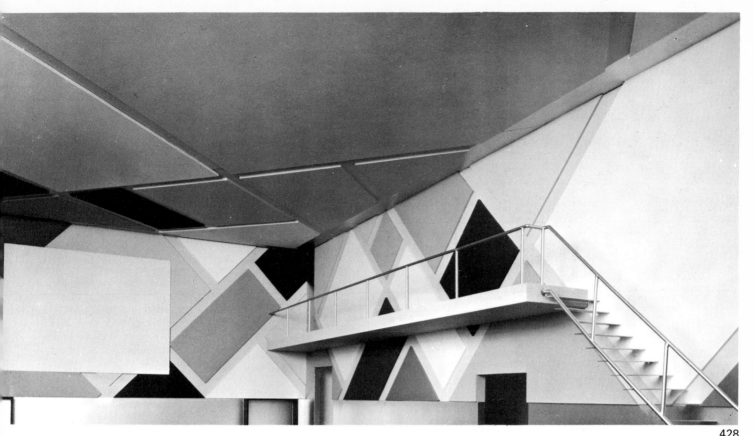

428

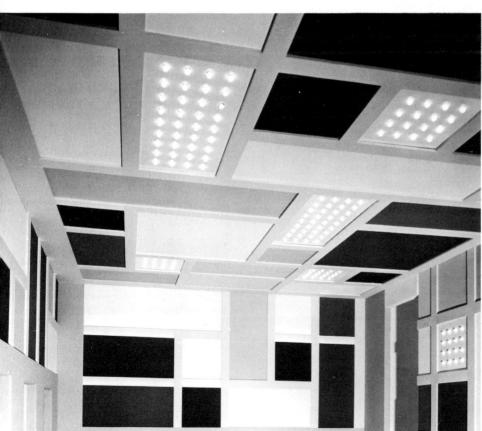

429

430

428 *Theo van Doesburg*, L'Aubette, *café-cinema, 1927, reconstruction*

429 *Theo van Doesburg*, L'Aubette, *dance hall, 1927, reconstruction*

430 *Theo van Doesburg*, Composition in Black and White, *1918. Kunstmuseum Basel*

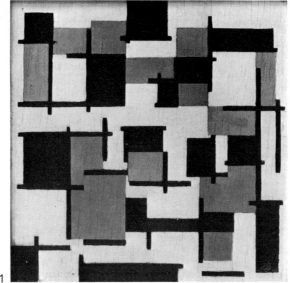

431

432

Another painting by van Doesburg, strongly reminiscent of Mondrian, uses colour to analyse the spaces still further. Some spaces are filled in with colour and become planes. As subdivisions, they harmoniously articulate the total fluid space contained by the structure lines. All this may be said of Mondrian's painting too, but in van Doesburg's work one feels that the interest is rather more architectural. Van Doesburg attempts fewer relationships than does Mondrian, which makes each one more vital in the composition, and they are defined with the precision of an architect rather than that of a painter. Broadly speaking this composition shows how smaller spaces may be carved out of the total fluid space, acquiring their own character and yet remaining a part of the whole. The colour areas do not hold up the flow of space as the structure lines do. The architectural implications of this are clear. Wright's flowing spaces are subjected to an analysis in the modern sense. This is even more evident in a three-dimensional context. Here the principle of fluid, articulated space is applied not only horizontally, as in a picture, but also vertically, so that space may also flow from top to bottom and vice versa. Coloured planes are once again used for the purpose of articulation, as in his paintings.

An architect may design a house by dividing the ground plan into a number of spaces according to his assessment of various functions: living room, kitchen, hall, etc. He may do the same with the first and

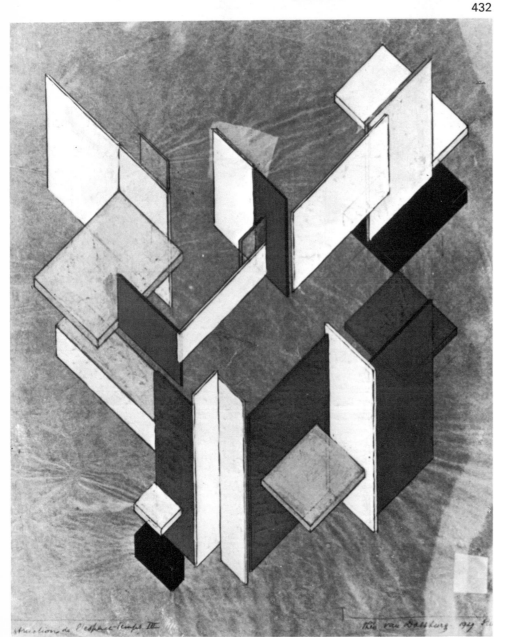

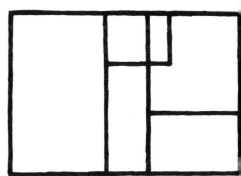

subsequent floors, but even though they may be linked by a staircase or lift, by corridors and doors, the spaces will be subdivisions of the plan, the floors will be layers of a larger volume. He may attempt to relate the spaces of the house and connect them with openings, or even omit some of the dividing planes, both vertical and horizontal, i.e. walls and ceilings. But for a really fluid relationship of the subdivisions of the whole more is required. In a fluid spatial arrangement in two dimensions there are always small areas where the subdivisions seem to overlap and which may therefore be considered as parts of either one or another of the

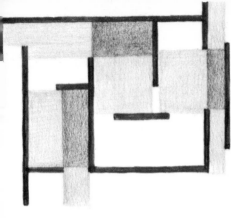

subdivisions. Overlapping in two dimensions becomes interpenetration in three. The two volumes in this drawing are in a very close interlocking relationship. The small volume

between them has the same meaning in relation to either as the overlapped area in the last drawing: it may be considered as part of either volume. In van Doesburg's *Space-Time Construction*, a study of 1923, such relationships are investigated and analysed. They find their first practical application in the two houses which van

433

Doesburg designed, with the architect van Eesteren, in 1923. The model for the later one shows how closely the volumes are interrelated and interlocked to form a complex architectural space. The principle of fluid space, initially explored in two dimensions, has attained architectural meaning by its vertical as well as horizontal articulation. The space is not confined within the house but is allowed to flow outwards onto balcony and porches, thereby, as in Rietveld's chair, entering into a relationship with the surrounding space. The house looks outwards into the world, linking the inhabitants with their environment or, in de Stijl language, the individual with the universal, that which is within us with that which is unlike us.

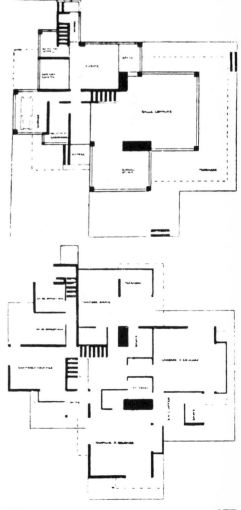

431 *Theo van Doesburg,* Composition XIII. *1918*

432 *Theo van Doesburg,* Space-Time Construction No. 3, *1923. Collection Mr and Mrs Burton Tremaine, Meriden, Conn*

433 *Theo van Doesburg and Cornelis van Eesteren, house, 1923, model*

434 *Theo van Doesburg and Cornelis van Eesteren, house, 1923, plans*

434

M

Van Doesburg never built a true de Stijl house. Neither of these projects came to be built, and had they been it is certain they would have lost their finer spatial points and much of their poetry. They were, after all, theoretical structures and the limited technological means at an architect's disposal in 1923 would have imposed such heavy modifications as to make the designs almost unrecognisable. When van Doesburg did build a house, for himself, it was a much more down-to-earth construction, his idealistic principles having to give way to expediency. The furniture which he designed for the house had lost its de Stijl character and with it its searching and challenging nature. Van Doesburg died in 1931, aged 47, and with him died de Stijl.

It was left to Rietveld to erect the most lasting monument to de Stijl, incorporating in an uncanny way all that the movement stood for spiritually, artistically and socially. If van Doesburg was a theorist and a dreamer, Rietveld was his exact complement: a maker. His practical genius expressed itself in a number of ordinary objects whose design is as simple as it is ingenious. The lamp of 1920 consists of standard fittings. In another arrangement the fittings might be equally functional, but suspended in this particular way they make a spatial statement and claim their position in space. Like the joints of Rietveld's furniture, the three dimensions of space are stressed. The later table lamp is the outcome of his analysis of the function of such a lamp, the need for a weighted base, and for a shaded bulb supported at a certain height. The manner in which bulb and shade are combined in one shape is a truly modern design solution. The base which reflects the cylindrical part of the light fitting at an angle of 90 degrees and so increases its spatial significance is in keeping with de Stijl practice. The radio set, designed in 1925, has a glass case instead of the more usual wooden or plastic one, so that all the parts of the set can be seen: a novel departure to be exploited more fully by later designers and a clear exposition of de Stijl machine aesthetic.

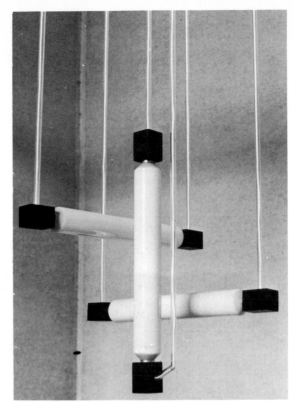

435

436

Where van Doesburg's ideas always find their starting point in tentative drawings, Rietveld's take immediate shape in the physical world. All Rietveld's architectural schemes started life as small models. It must be remembered that he was above all a craftsman, whose creativity grew out of his sensitivity to his craft and to the materials and processes he understood so well. When he turned to architecture he never forgot his early background and his first creative thoughts were always explored initially through small models which he made from a variety of materials: wood, clay, cardboard, glass, plastic and so on. These models were small enough to be moulded between his fingers so that planes, volumes and spaces could literally be felt and their relationships experienced physically (and, if need be, changed) as well as seen. Only at a subsequent stage did he commit his ideas to paper. Perhaps this explains why in the Schröder House, 1924, he was able to bridge the gap between de Stijl aesthetics and the more mundane limitations of building techniques

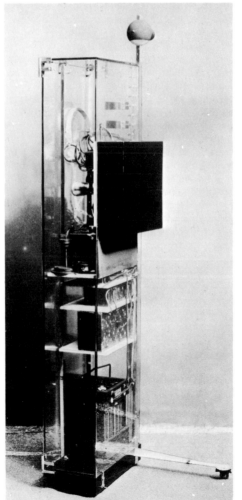

435 *Gerrit Rietveld, hanging lamp, 1920*

436 *Gerrit Rietveld, table lamp, 1925*

437 *Gerrit Rietveld, radio set, 1925*

437

At a first glance the Schröder House looks contrived, yet it is primarily functional. The upper storey is almost entirely given over to the living area whilst the ground floor houses the kitchen and services, as well as the servant's quarters and a study. Moving walls make it possible to partition the (upper) living area into smaller rooms, each with its own water supply and wash basin and cooking facilities, so that they may be used as individual bed-sitting rooms. The walls are so designed that they may be completely folded out of sight and most of the storey used as one large sitting area. This arrangement, like so much else in de Stijl, anticipates many later developments. It is one of the touchstones of modern design that divisions should be as flexible as possible to ensure maximum usefulness of available space. There are not many later houses which achieve this as gracefully as Rietveld's Schröder House.

The articulation of space is achieved in a variety of ways. The staircase with its space-defining hand rails projects into the living area upstairs and plays a more prominent part than staircases normally do. Outside balconies and overhanging planes are used to articulate the space surrounding the house, as in van Doesburg's designs, but to a greater extent, with greater virtuosity, with richer, often astonishing variety, and in closer relationship to the house itself. For instance, the sequence of spatially and structurally related planes on the front of the house could have been taken from a space structure, but here it is applied to the requirements and the structure of the actual house. The addition of other functional elements, metal stanchions and rails, further elaborates the definition of space. The inventive richness of space-articulation gives the Schröder House its character.

The dark painted window frame on the right makes the cantilevered plane of the roof appear even more significant as the eye loses the window frame in the shadow and follows the underside of the roof plane into the interior. When this window is opened, the corner of the house disappears, because the supporting pillar has been moved back from the usual corner position. The frontal balcony slab unifies the two floors and destroys any ideas of two strictly separated layers of space within.

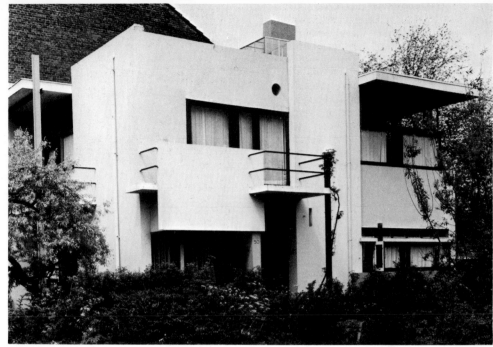

438

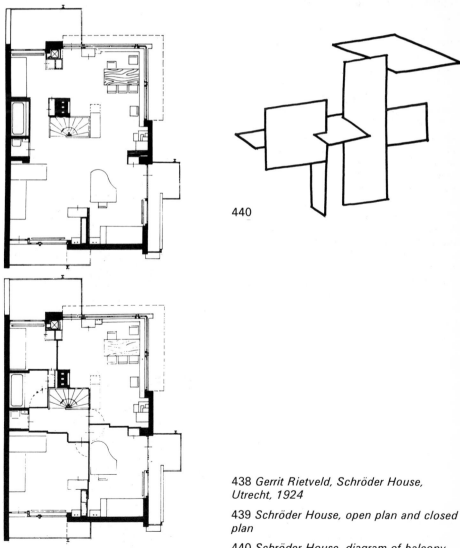

440

439

438 *Gerrit Rietveld, Schröder House, Utrecht, 1924*

439 *Schröder House, open plan and closed plan*

440 *Schröder House, diagram of balcony structure seen from above*

One of the reasons why the house looks contrived, at first glance, is that its mass has been largely broken up into planes. One becomes aware of the space between the planes before taking account of the remaining mass of the house. Mass has given way to space, and this explains the appearance of lightness. It also explains its a.b.s.t.r.a.c.t quality in Mondrian's sense. Frank Lloyd Wright's early manner — which was one of the important influences on de Stijl — developed as an expression of his sympathy with the landscape in which his houses were placed. The thrusting, space-articulating forms are his means of approaching nature; they bring about a union between the man-made house and the natural landscape. The space they enclose is a part of nature. Even his drawings show how he intended house and nature to grow into each other, how the vegetation enters into his architectural thinking. Such extravagantly open forms do not commend themselves to the Dutch climate and were duly transmuted by de Stijl architects. It is also true that such dramatic gestures do not commend themselves to the Dutch mind, particularly those minds connected with de Stijl.

Rietveld's architectural composition of exploded forms and spaces, reclaimed from the limitless space of nature in order that it may be comprehended by the human mind, is as abstract as Mondrian's work. It does not require, nor indeed allow, intimations of nature. It exists, as Mondrian's painting exists, in a reality of its own in which the intrusion of nature would act as a disruptive force on the balance it seeks to achieve. The space which de Stijl architecture articulates and integrates with form and structure is not the space of nature and of landscape, but abstract space, the space of the man-made reality of Mondrian's metropolis. The Schröder House does not commune with nature, as for instance the Martin House, and natural forms do not enhance it. On the contrary, it is an expression of counter-nature, of the reality of man in opposition to that of nature.

The Schröder House is the high water mark in the urge to abstraction from which other architects, including even Rietveld himself, were to retreat. But Rietveld's point needed to be made. The house became one of the most influential landmarks of modern architecture. It has been visited and studied assiduously by architects from all over the world, including Gropius and Le Corbusier. It deserves its description as the 'most modern house in Europe' for its influence is still at work today.

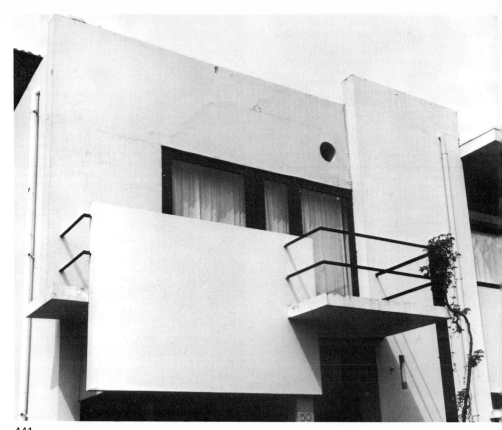

441

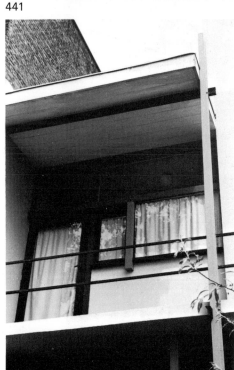

442

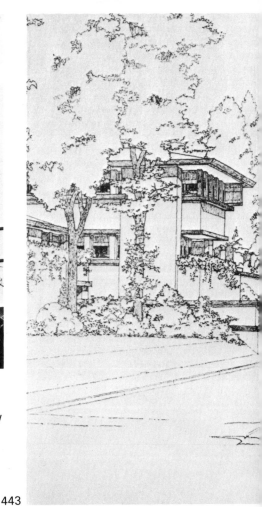

441 *Gerrit Rietveld, Schröder House, detail of front elevation*

442 *Schröder House, detail of side elevation*

443 *Frank Lloyd Wright, Westcott House, Springfield, Ohio, 1907* 443

The Arts and Crafts Movement, Fauvism,
Expressionism, Cubism, Futurism, Purism,
De Stijl, all grew out of the particular
conditions in their countries of origin. It
would be difficult to think of Futurism
originating in Britain or de Stijl in Italy.
There was, however, a great deal of cross-
fertilisation; ideas were often taken up by
artists in other countries, remoulded to
their need and, quite often, sent back in a
vastly changed form. Nowhere was this
process more evident than in Russia. Ideas
were avidly imported from the West,
interpreted in a characteristically Russian
manner, forged into a social and
revolutionary weapon and then disseminated
westwards once more, where – particularly
in Germany – they were absorbed into the
existing artistic climate. Without the
influence of this Russian contribution, the
thinking of artists and designers in western
Europe and the forms of our environment
would undoubtedly have been different.

During the early years of the present
century the dominant influence in Russian
art was that of French Impressionism and
Post-Impressionism. This gave place to
admiration for Cubism, while, at the same
time, Russian artists began like their
western contemporaries to look beyond an
over-ripe and rather flabby European artistic
tradition for fresher and less sophisticated
means of expression. Many Russians, like
the German Expressionists, found this in
their national tradition: Russian icon
painting and peasant culture. Natalia
Goncharova's picture, *Spring Gardening*,
primitive art. A search for new and purer
means of expression – and perhaps also for
purer feeling – seems to permeate this
picture. The primitive leanings are, however,
qualified by modern art theory: Cubist
shapes are in evidence. The traditional and
modern elements combine easily. Mikhail
Larionov, another Russian painter, began
working under a very strong French
Impressionist influence but soon joined the
general return to more primitive forms. His
Soldier on a Horse, 1908, is painted in a
very simple technique, even intentionally
unskilled, with verbal legends added in the
manner of a primitive woodcut.

444 *Natalia Goncharova*, Spring Gardening,
1908. Tate Gallery, London

445 *Mikhail Larionov*, Soldier on a Horse,
1908. Tate Gallery, London

444

445

By 1911 Larionov launched a new movement which he called Rayonnism. He defines this in his Rayonnist Manifesto: '. . . Rayonnist painting . . . is concerned with spatial forms which are obtained through the crossing of reflected rays from various objects and forms which are singled out by the artist.' Rayonnist paintings move away from descriptions of reality to completely abstract structures of imaginary rays. Cubism and Futurism both find a place here. Soon the spatial and structural interest of Larionov's Rayonnist pictures was to give way to a more painterly abstract art – *Rayonnism*, 1912, is an example. This short-lived movement was a necessary pre-conditioning, a loosening up of traditional methods, in preparation for later developments. From the point of view of what was to come, particularly after the Revolution of 1917, the Rayonnist Manifesto makes fascinating reading.

'We declare the genius of our days to be: trousers, jackets, shoes, tramways, buses, aeroplanes, railways, magnificent ships – what an enchantment – what a great epoch unrivalled in world history.
'We deny that individuality has any value in a work of art. One should only call attention to a work of art and look at it according to the means and laws by which it was created.
'. . . we go hand in hand with house painters . . .'

The reference to aeroplanes, railways and ships is Futurist-inspired, but the rest anticipates the social, non-individual art which Russian artists tried to establish after the Revolution. By calling attention to the 'means and laws' of art, Larionov also defines the character which the new art ought to have – not imitative, but abstract.

446 *Mikhail Larionov,* The Glass, *1911. Solomon R. Guggenheim Museum, New York*

447 *Mikhail Larionov,* Rayonnism, *1912. Private Collection*

448 *Kasimir Malevich,* Peasants in Church, *1910. Stedelijk Museum, Amsterdam*

449 *Kasimir Malevich,* The Woodcutter, *1911, Stedelijk Museum, Amsterdam*

450 *Kasimir Malevich,* Woman with Buckets, *1912. Museum of Modern Art, New York*

446

447

asimir Malevich began, like so many of he Russian painters of this period, under he shadow of French painting. From about 909 onwards, he seemed to follow oncharova's lead into a kind of primitivism which was, however, never as descriptive s hers. In *Peasants in Church*, 1910, the egree of simplification is considerable and he mask-like faces can be taken to ndicate a state of mind rather than a escription of the occasion according to he title. The outstanding quality of this icture is its rhythm of basic elements, the ow of faces, of hands, of arms. The ame element of rhythm is developed more eometrically in Malevich's *Woodcutter*, 911. The man's body and head, his ussian shirt and hatchet, are submerged n the general rhythm of the picture and re of no greater consequence than the ogs. The light and shade of the planes have othing to do with the light and shade of he real world, but have become a device o make the rhythm more powerful. *Woman with Buckets*, 1912, has an even nore marked rhythm, with more violent nd dynamic articulations between the lanes. The Cubist element has acquired uturist overtones. Now the influence of

448

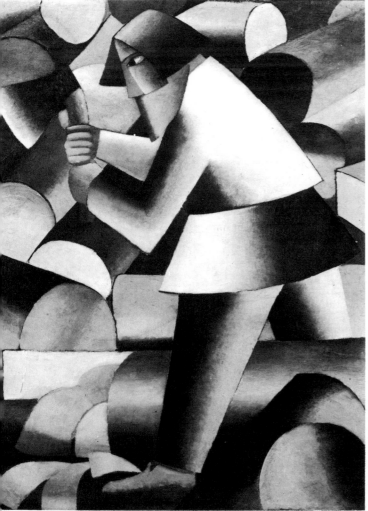

449

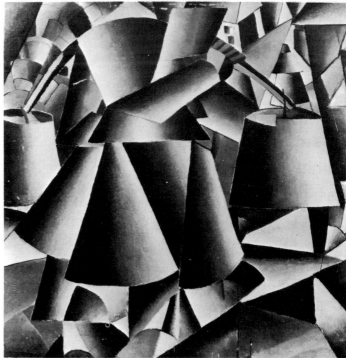

450

Cubism becomes more direct. *Lady on a Tram*, 1912, is a typically Cubist work, with piled-up ambiguous planes and a few recognisable clues. *Woman beside an Advertisement Pillar,* 1914, is equally difficult to decipher in realistic terms. It contains a great deal of collage, with many unrelated shapes, letters, patterns and textures combined in a rhythmic composition. The rhythm gets smaller and tighter towards the top of the picture and, together with the overlapping of shapes, gives an impression of distance. The work is dominated by the relationship of the two large flat shapes. The painting can be seen in such a way that all the smaller details recede into the background and seem to have been placed there solely to elaborate the basic subject: the relationship between the large shape in the bottom left-hand corner and the upright rectangle above. Larionov's appeal to consider the 'means and laws' rather than the content seems to have been heeded.

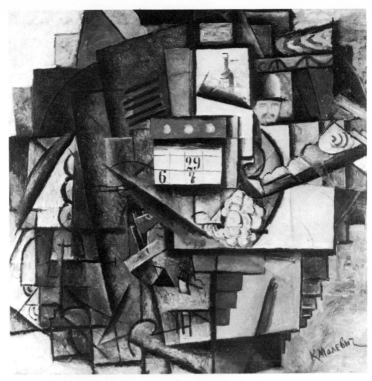

451

45

451 *Kasimir Malevich,* Lady on a tram, *1912. Stedelijk Museum, Amsterdam*

452 *Kasimir Malevich,* Lady beside an Advertisement Pillar, *1914 Stedelijk Museum, Amsterdam*

453 *Analysis of 452*

454, 455 *Kasimir Malevich, two costume designs for* Victory over the Sun, *1913. Theatrical Museum, Leningrad*

456 *Kasimir Malevich, backcloth for* Victory over the Sun, *1913. Theatrical Museum, Leningrad*

452

The Russian artists of this period shared with their Western contemporaries a general dissatisfaction with the state of society and the values which motivated it. Not content with painting pictures which echoed their dislike of their environment, they carried their attack into the offending environment itself, walking about in the streets in outrageous dress, flowers in their hair and their faces painted, provoking scenes and happenings in cafés, making films and devising cabaret shows which hurled abuse and obscenities at bourgeois society. They did everything they could to be offensive, for this was their only weapon against the surrounding philistines until the Bolshevik Revolution gave them the power they desired. Their aim was to destroy the rational ordering of the world which they saw as a symbol of bougeois complacency. The production of the opera *Victory over the Sun*, with stage and costume designs by Malevich, was symptomatic of this movement. In many ways the opera, which had only one performance, summed up the essential features of the artistic climate of the time. The story by the poet Krutchonich (claimed to be the inventor of phonetic poetry) would have been approved by both Futurists and de Stijl. Here is a summary.

'The sun, expressing the old energy of the earth, is ripped out of the heavens by modern man who creates his own sources of energy through the power of his technical mastery.' And the librettist explains '. . . In men's minds there exist certain means of human communication which have been created by human thought. The Futurists wish to free themselves from this ordering of the world, from these means of thought communication, they wish to transform the world into chaos, to break into pieces the established values and from these pieces to create anew.' The use of the term 'Futurists' should be noted, for although certain Russian artists described themselves in this way and many of their activities reflected Futurist practice their relationship with the Italian movement was far from straightforward. When Marinetti visited Russia he was the subject of attack from Russian Futurists, and the aims of the two groups were by no means identical. The worship of speed, which gave Italian Futurism its character, is almost entirely lacking in Russia, but the dominating role accorded to the machine is common to both movements. The Russians like their Dutch near-contemporaries, and unlike the Italians, saw in the machine a means of humanising the environment.

The occasion of the performance of the opera must have been, for 1913, a fantastic affair, whose flavour is conveyed after more than half a century by the words of Krutchonich, the librettist. 'A blinding light from the projectors. The scenery by Malevich was made of big sheets — triangles, circles, bits of machinery. . . . The actors reminded one of moving machines. Malevich's costumes were Cubist-like, made of cardboard and wire. They transformed the human anatomy and the actors moved, held and directed by the rhythm dictated by the artist and director. What particularly struck the audience in the play were the songs of the Frightened One (in vowels) and of the Aviator (entirely in consonants).' The prologue was read by an indescribable personage with bloody hands and a big cigarette. War-like cries accompanied some of the action of masked actors, changing backcloths indicated changes of mood, ear-splitting noises and gun-shots completed the spectacle.

Some of Malevich's designs for the opera are still in existence and live up to these descriptions. The backcloths in particular look 'Cubist-like'. There is one which is different from the rest: a purely geometrical design in which the inner square is divided diagonally. The idea began to grow in Malevich's mind that simple visual means, as for example this square design for *Victory over the Sun,* are perhaps the most powerful and direct available to an artist in describing or inducing mental states. He made experiments with simple

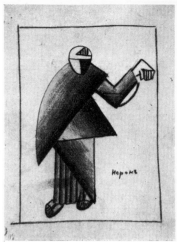

454

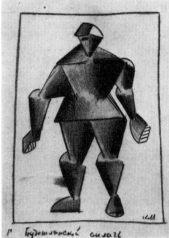

455

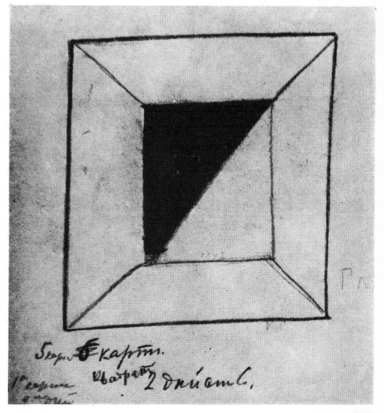

456

geometric shapes, a square, a circle, a cross, in the simplest compositions imaginable. Then he began to combine several such shapes in one composition: two squares, several rectangles, rectangles and circles. From 1915 he used the term *Suprematism* to describe the new art he had invented. Its derivation from a design made for *Victory over the Sun* was to him not merely incidental but highly symbolic, representing man's ascendancy over the traditional life giver. His was the iconoclastic sector of a social revolution, as well as an artistic revolution against the power of nature. 'The new art', he wrote, 'fights against the forms of yesterday, the aesthetics of yesterday and the unshakeable antique notion of beauty. Suprematism had therefore proclaimed non-objectivity (i.e. art without objects, things) from the stage . . . In this way Suprematism wanted to claim its own consciousness and to free the development of art from the imitative forms of the past.'

What was the essence, the core, of the new art? Malevich defined Suprematism as 'the primacy of pure sensation in the visual arts'. If we look at the black square we receive from it a certain sensation, however simple the composition. We may interpret it as a black square lying on top of a white square – the canvas – or as a white frame on a black background. The contrast in colour and size of the two elements of the composition determines the precise nature of the sensation or sensations we receive. A change in the proportions of the white margin in relation to the black square will cause an entirely different sensation. The longer we stare at the square the more decisively it stares back at us. It assumes its character only as the result of visual communication at its most perceptual level, stripped bare of all traditional encumbrances, unfiltered by the conscious mind. From this point, words are powerless to describe or define the effect of visual art. Painting has become truly visual. Move the circle away from the edge with which it has entered into a relationship, and the whole effect changes. A traditional painting is not likely to be affected to such a degree by a slight displacement of one of its elements. The state of tension which exists between the circle and the edge of the canvas can be relaxed or increased by the slightest change of position and the artist must work with greater precision than ever before.

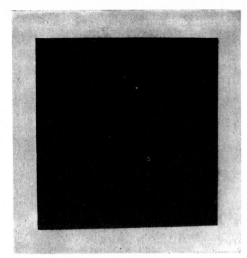

457

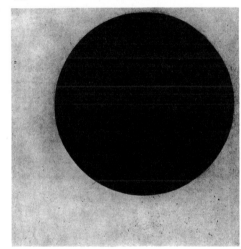

458

457 *Kasimir Malevich*, Black Square, *1914. Russian Museum, Leningrad*

458 *Kasimir Malevich*, Black Circle, *1914. Russian Museum, Leningrad*

459 *Kasimir Malevich*, Suprematist Composition: Red Square and Black Square, *1914. Museum of Modern Art, New York*

460 *Kasimir Malevich*, Eight Red Rectangles, *1915. Stedelijk Museum, Amsterdam*

461 *Kasimir Malevich*, Suprematist Composition, *1915. Stedelijk Museum, Amsterdam*

462 *Kasimir Malevich*, Suprematist Composition, *1916. Stedelijk Museum, Amsterdam*

The picture entitled *Red Square and Black Square* has no meaning other than the perceptual one which resides in the compositional relationship of the two squares. There is even wit and playfulness in their relationship. Has the red square moved out of line from a spirit of rebelliousness or roguishness? The observer is surprised to discover that geometric shapes may express more than their geometry when viewed in this way. Although there is nothing definite to suggest movement, the sensation of movement is inherent in the picture. The Suprematist composition consisting of eight red shapes is most complex. First of all we sense the diagonal movement, but this is qualified by the subtle variations of the individual shapes, none of which are truly parallel. There is a special relationship between the shape on the extreme right and the next square shape below it. These two shapes also contribute to the creation of a space in the middle of the picture. Within the flow of the picture an area of comparative calm is established: a space within which a solitary shape is placed. This shape, because of its position in relation to its near neighbour and in relation to the space in which it exists, is somehow different from the rest, playing its part in the general flow but in a special way, with a different character. The effect is, however, entirely perceptual; verbal descriptions are dangerous. We are reminded of van Doesburg's counter-compositions. Indeed the Suprematist compositions of Malevich may have been of considerable influence on van Doesburg.

Gradually Malevich's compositions grew more and more complex. More shapes were added to diversify spatial relationships. Contrasts of colour and tone, as well as overlapping shapes, added intimations of pictorial space, and faintly painted shapes lent a new richness of tonality and intensity. By 1918 Malevich seems to have reached the maximum negation of objectivity with his painting *White on White*. A white square on a white background must be the purest expression of spiritual experience.

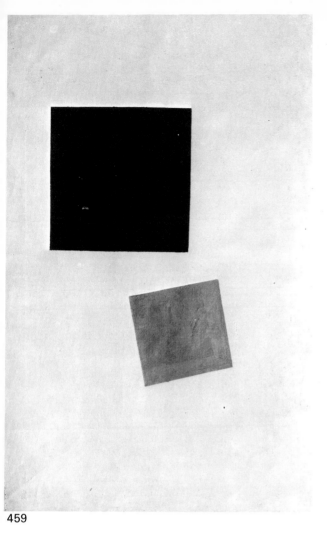

459

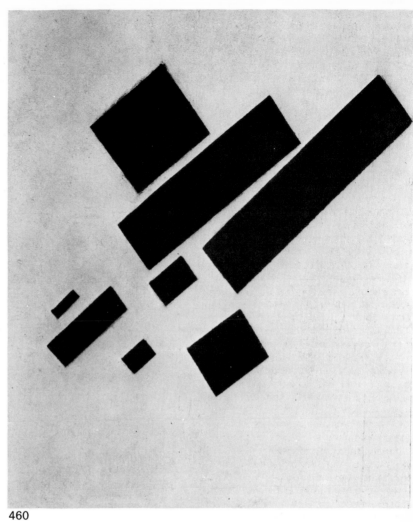

460

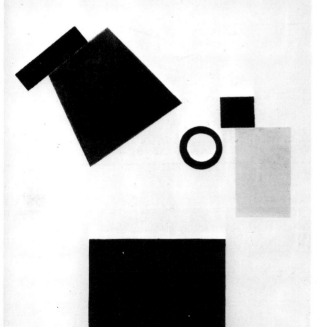

461

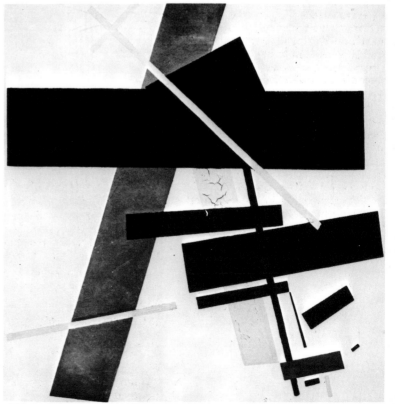

462

Another important figure in the development of Russian art in the early part of the twentieth century is Vladimir Tatlin. Like so many of his compatriots of that period he drew on the twin sources of French painting, particularly Cézanne and the Cubists in his case, and the Russian heritage of peasant art and icon painting. The synthesis of these two elements in his early work is even more complete than in that of Malevich or Goncharova. His *Fishmonger,* 1911, has elements of both influences but so closely are they intermingled that it is not easy to decide from which a particular passage derives.

His stage designs have the clean-cut intersecting forms derived from Cubism. In 1913 Tatlin made his pilgrimage to Paris to see Picasso, whom he held in god-like esteem as the greatest living artist. During a month's stay in Paris and on visits to Picasso's studio, he was particularly impressed by Cubist sculptures which Picasso was producing at that time. When he returned to Russia he immediately began to make similar relief sculptures, and soon his real leaning manifested itself. Whilst Picasso's relief sculptures of this period still dealt, like Cubist painting, with objects of the real world, Tatlin was soon producing sculptures as abstract as Malevich's paintings. Whilst Picasso employed a very narrow range of materials, Tatlin chose from a wide variety. In fact the choice and relationship of materials became the main point of his work at that time. His *Relief,* 1914, contains plaster, wood, metal, glass, wire. Whereas a Cubist relief might have a title like *Violin* or *Still Life* and would give a Cubist version of such objects, Tatlin's sculpture was nothing beyond itself, without outside attachments. It claimed to be nothing more than a composition of different materials. In an attempt to make the spatial content of his sculpture even more significant Tatlin also experimented with corner reliefs suspended from wires. In these works, the space within the sculpture was closely related to the space of the room.

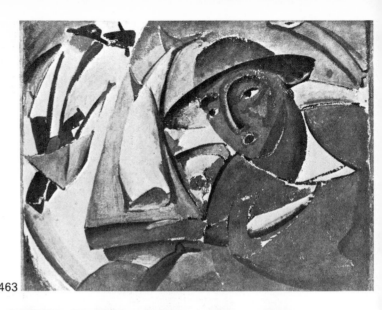

463

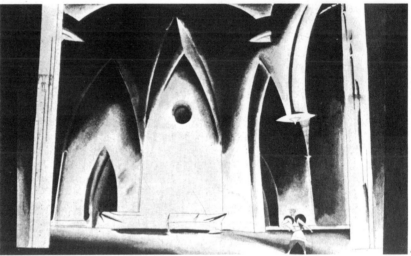

464

465

466

188

467

468

Tatlin's sculptures must be accorded a special historical significance. Since man's first attempts to give expression to his artistic impulse, the objects he made had possessed either a utilitarian or a symbolic value. Now, probably for the first time in human history, objects were produced that were free of either obligation. These sculptures represent nothing other than themselves. They are derived from the potentialities of different materials compositionally and spatially combined. It can be seen that Tatlin's work forms an antithesis to Malevich's. Both may be regarded as equally non-objective, having no pretensions to represent reality in the traditional sense, but Tatlin's derives its main characteristics from the physical world of materials while Malevich's is completely withdrawn from it.

469

463 *Vladimir Tatlin,* Fishmonger, *1911. Tretyakov Gallery, Moscow*

464 *Vladimir Tatlin, Stage design, 1912. Tretyakov Gallery, Moscow*

465, 466 *Vladimir Tatlin,* Relief, *1914*

467 *Vladimir Tatlin,* Composition of Materials, *1917. Tretyakov Gallery, Moscow*

468, 469 *Vladimir Tatlin,* Corner Relief, *1915, reconstruction*

When the Bolshevik Revolution broke out there was hardly a single Russian progressive artist who did not whole-heartedly embrace its ideals. The much-hated bourgeois society which had so stifled the artists' ambitions and social aims had been shattered; a new world, a new society was to be built from the débris. The air of buoyancy enveloped every artistic activity. Leaders of Russian art actually claimed to have anticipated the social revolution by their own artistic revolution. Malevich whose ideas on the relationship of man to nature were not unlike those of Mondrian wrote, 'Let us seize the world from the hands of nature and build a new world belonging to man himself.'

Art was to be taken to the people and not confined to the élite. 'We do not need a dead mausoleum of art', said the poet Mayakovsky, 'where dead works are worshipped, but a living factory of the human spirit — in the streets, in the tramways, in the factories, workshops and workers' homes.' The universality of a non-traditional art, as advocated by the Italian Futurists, can be seen here, but with a difference. The Russian artists regarded themselves as creators with a social function; they now began to speak of the artist's place in medieval society and to wax enthusiastic over their own new role which was to parallel that of their historic predecessors. The positions of power which artists enjoyed in the early days of the Revolution — on committees, within ministries, in academies and colleges — gave rise to an unprecedented artistic activity. Pageants commemorating revolutionary events were devised to the now familiar light-and-sound accompaniment; public buildings were decorated with pictorial banners, posters were designed to explain the aims of the Revolution; meetings were held in which artists explained their aims and methods. The government bought works from these artists and set up travelling exhibitions throughout the country.

Pre-revolutionary academies had been closed down and reconstituted on revolutionary lines. Both the set formal training and the teacher-student relationship were drastically modified. The Vkhutemas (Higher Technical-Artistic Studios) in Moscow had several thousand students. Teaching was informal and carried out partly as workshop activities and partly by seminars and discussions, which included ideological as well as artistic topics. Any member of the general public could drop in to listen; any unattached artist could hold a seminar or give lessons. Teachers maintained private studios. The list looks, in retrospect, like an unlikely cast of stars: Malevich, Tatlin, Gabo, Pevsner, Kandinsky . . .

470

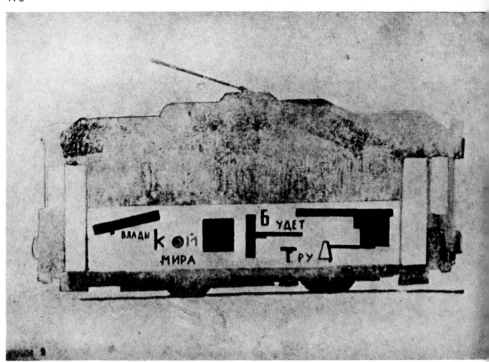

471

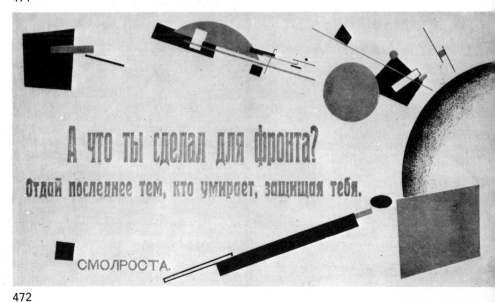

472

The last named had returned to Russia at the outbreak of the 1914 war and his work was now showing signs of change. Where in his initial abstract period shimmering coloured forms would often assume soft organic configurations, with blurred outlines, sometimes merging with each other, these now began to harden at the edges and become more brittle, even geometric in character. This was the result of the influence of Malevich's painting and perhaps also of a desire on Kandinsky's part to make his pictures more explicit by giving them a more precise structure. He prepared a course of training for artists at the Vkhutemas which broke new ground by demanding studies of abstract qualities of visual experience. For instance colour was to be studied from the point of view of 'medical, psychological, chemical and occult knowledge, and of experience of the subject, for example, sensory associations and colour, sound and colour, etc.' Although these ideas were voted down and did not become official policy in art education, similar methods were used by Malevich when he took charge of the Academy at Vitebsk, and in other institutions.

Kandinsky's ideas which related to human sensitivity rather than to material objects failed to win official recognition because Tatlin's beliefs and those of his followers appeared to have more bearing on the situation of a country in desperate need of rehabilitation and reconstruction. Tatlin's method of working with materials, exploiting their natural characteristics and combining them in visually significant constructions, seemed more relevant to immediate problems; it became known as Constructivism. The concept of the artist-engineer was fundamental to it; engineering methods were harnessed to artistic expression.

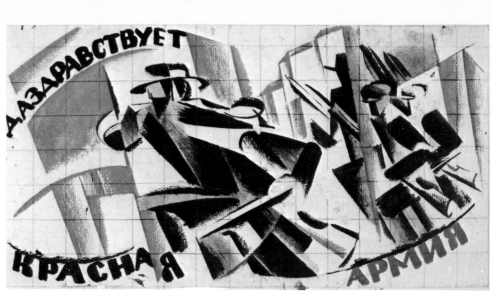

473

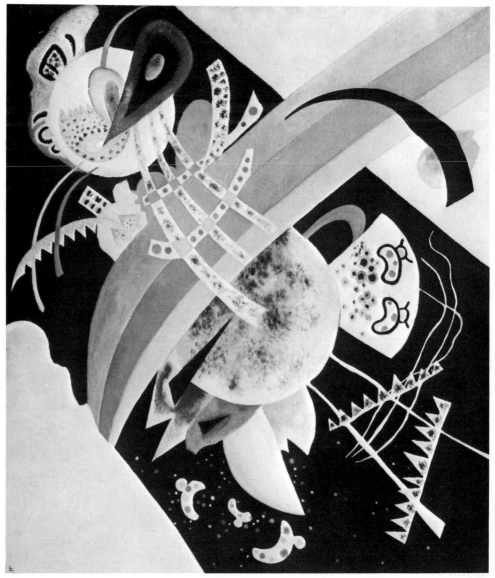

474

470 *Propaganda train, 1919*

471 *Kasimir Malevich (?), design for a propaganda tram, 1918 (?)*

472 *Kasimir Malevich, poster, 1919*

473 *Design for Red Army poster*

474 *Wassily Kandinsky,* Circle on Black, *1921. Solomon R. Guggenheim Museum, New York*

Tatlin's design for a monument to the Third International of 1919 was the most ambitious Constructivist project. As his drawing and model show, it was to have nothing in common with monuments of the past. Classical monuments had usually consisted of an easily recognisable symbolism in a realistic idiom, depicting such qualities as heroism, grandeur, nobility, with no other practical purpose. Tatlin's monument was to have not a realistic symbolism but an abstract one: the double spiral signifying the dynamic soaring progress of society under Bolshevism. It was also to be useful. Inside a structure of iron and glass, 1,300 feet high, considerably higher than the Eiffel Tower, three geometrical 'containers', also made of iron and glass, were to revolve slowly. The highest of these, a

cylinder containing an information centre, was to complete one revolution a day. The cone, housing executive offices, was to perform one revolution a month; and the lowest of the three, a cylinder, with its enclosed lecture and meeting hall, one revolution a year. A lit-up screen was to carry news bulletins at night. This advanced design showed how Constructivist methods could result in functional objects, how visual relevance might be justified. We can sense the spirit of Sant'Elia and of Wagner.

The economical use of materials was the ostensible aim of Constructivism and frequently discussed in Constructivist writings. Nevertheless it produced symbolic visualisations. Tatlin's tower was the first Constructivist poem, the first visual epic of the Revolution, signifying and

symbolising the new dynamic society on a scale worthy of its social content. When Constructivism developed as an architectural theory, the buildings it inspired confirmed the message of its progenitor.

The earliest design for a Constructivist building was that by the Vesnin brothers for the Palace of Labour of 1923. This was to be an enormous complex, housing two assembly halls (the larger for 8,000 people), a museum, a restaurant and several other items. The Vesnins' design embodies these various units in a way which not only displays their function — for instance the round large assembly hall, the separate smaller one raised above a thoroughfare — but also the services — radio masts, air intakes — and the structure. This design is also a Constructivist composition, made up

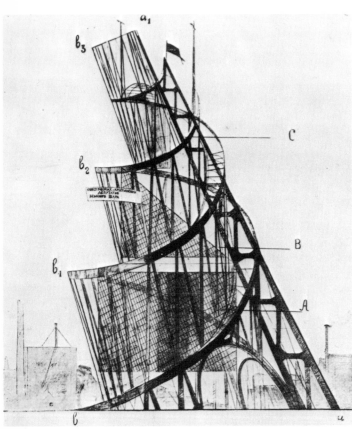

475

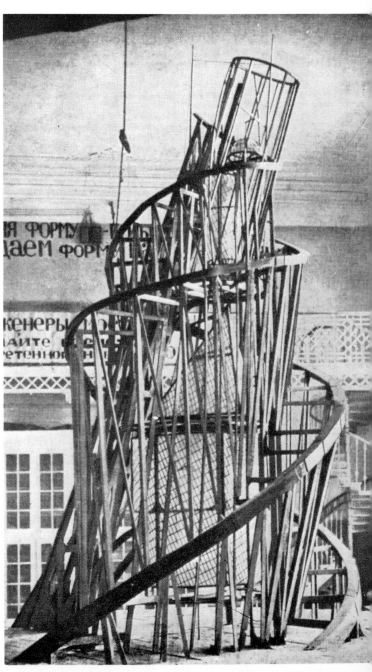

476

of solid forms and open spaces, the latter defined by the taut wires stretched across between the masts – and reminiscent of what we now mean by Constructivist sculpture – and the bare metal structure. Even the air intakes play their part in the architectural composition. Yet in spite of its functional design there is something evocative in the way it displays its structure. Can one detect a certain similarity to a Gothic cathedral? Can the large hall be seen as an enlarged apse, supported by flying buttresses, complete with pinnacles, its walls broken by tall narrow windows? Did the Vesnin brothers, perhaps unconsciously, devise a new symbolic form for the Palace of Labour which might successfully fill the place of the now superseded cathedral?

The Vesnin brothers' design for the Pravda building in Leningrad is equally Constructivist in spirit but here the structure and the composition echo Sant'Elia's Futurist architecture even more profoundly, particularly in the exposed glazed lift shafts. Mechanical services could hardly be a more pronounced and integral part of the architectural expression. A large display board, two stories high, was to carry news and propaganda.

475, 476 *Vladimir Tatlin,* Monument to the Third International, *drawing and model, 1920*

477 *Vesnin brothers, Palace of Labour, 1923*

478 *Vesnin brothers, design for Pravda building, 1923–1924*

477

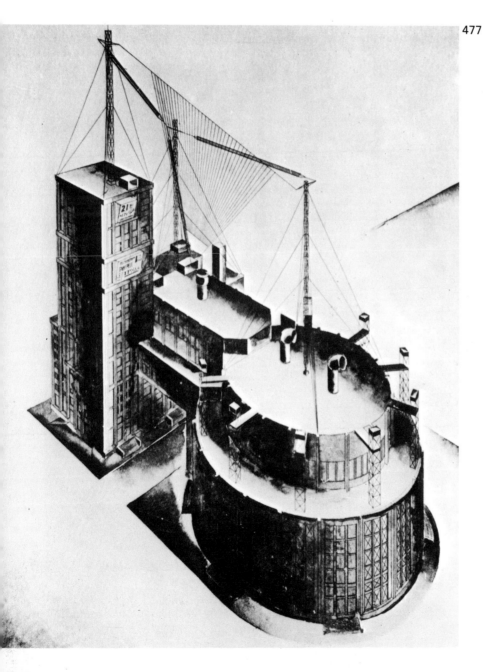

478

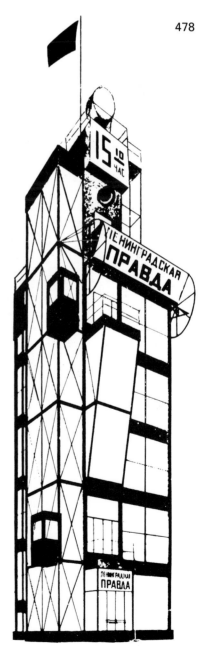

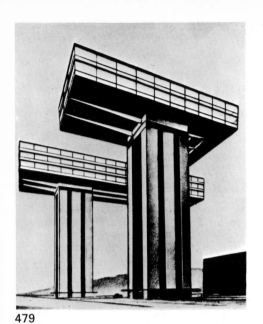

479

480

The design by El Lissitzky and Mart Stam for a series of office buildings is even more forward-looking and imaginative. The buildings were intended to surmount street intersections and to connect with the public transport system by means of lifts, which were to be completely exposed. The service shaft which incorporated the lifts would act as the structure upon which the offices stood. There is a distinct separation of functions. It is an elegant structure which takes up little ground space and therefore gives an impression of lightness. It could be described as a horizontal skyscraper.

Of all the visionary schemes of the Revolutionary years, Leonidov's Lenin Institute is probably the most advanced. Leonidov was a pupil of the Vkhutemas and the first important architect to be trained by the new method of instruction. The whole complex of the Institute is a most sophisticated composition made up of seemingly simple shapes. The large assembly hall was to be a sphere, its upper half glazed, standing on a comparatively small area and, like Lissitzky's and Mart Stam's office buildings, appearing transparent and light, more of a captive balloon than an earth-bound structure.

Alexander Rodchenko was a follower of Tatlin. His early Futurist painting had given way, about 1914, to complete abstraction. This in turn took on suggestions of three-dimensionality in which lines, shapes and tones were closely articulated. When Tatlin asked him to help in the decoration of a café he found it quite natural to adapt some of his flat work as three-dimensional light fittings. In such ways as these artists' abstract experiments found direct application. Even more apposite was the application of abstract ideas, of spatial relationships of planes, to projects of importance to the social revolution. The

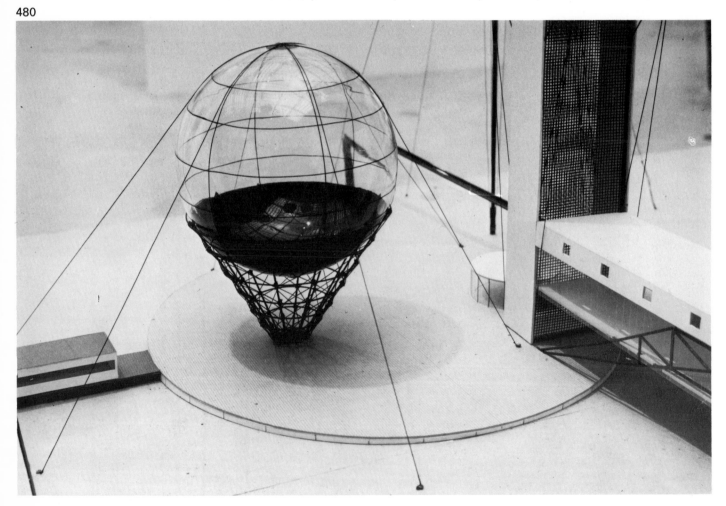

479 *El Lissizky and Mart Stam, office building*

480 *Ivan Leonidov, design for the Lenin Institute, 1927, model*

481 *Detail of decorations in the Café Pittoresque, 1917*

482 *Alexander Rodchenko,* Composition, *1918. Museum of Modern Art, New York*

483 *Alexander Rodchenko, design for a kiosk, 1918*

structure designed by Rodchenko in 1918 includes an office, a speaker's rostrum above, a clock and revolutionary banners and announcements. His abstract composition of 1918 provided the visual stimulus for the structure in much the same way as his earlier work had resulted in the tangible decorations of 1917.

Even more sophisticated structures incorporating more advanced technological propaganda media were devised by Russian Constructivists.

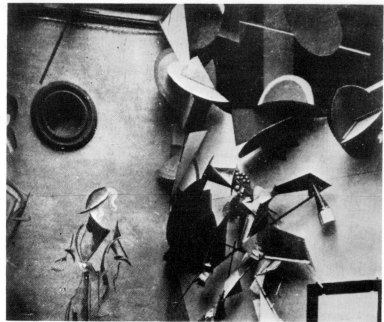

481

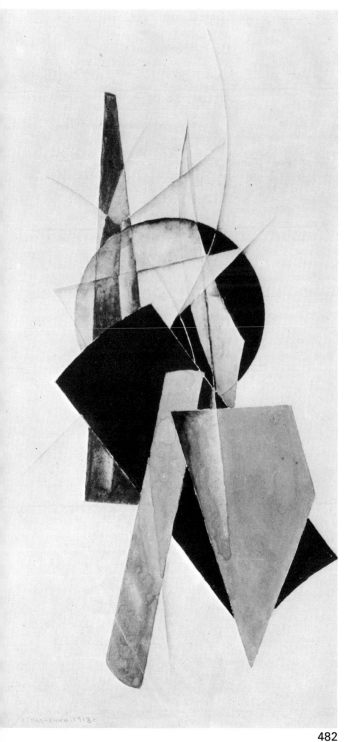

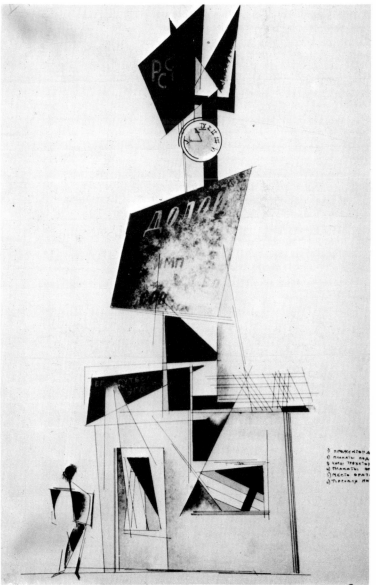

482 483

Generally referred to as 'kiosk', such a structure might be simply an orator's rostrum, a battery of loudspeakers, a set of revolving posters and slogans, or a projector and screen. Some of these structures combine several of these facilities. It is clear that these sculptural ideas were intended to symbolise the new order as well as to serve as propaganda machines. Indeed it could be claimed that propaganda could hardly be efficient without this kind of symbolisation of the idea behind it.

Although Tatlin's tower and many other architectural projects were never carried out Constructivist designers made their mark in other fields. Rodchenko designed furniture for clubs and flats and, once again, light fittings. All these pieces are marked by a desire to make the structure simple and efficient and use the available material to the best advantage. Tatlin designed a chair from bent tubes which is a direct outcome of Constructivist researches into the character of materials. The suspended seat within a curving structure has something in common with his monument; we may also liken it to Constructivist sculpture. We can speak here of functional sculpture and this description may also apply to the various types of structure designed by Russian artists for propaganda purposes.

It is important to stress the pure, uncommitted art which preceded the socially committed work of Russian artists and on which they drew for their visual language. While Rodchenko produced designs of a socially significant nature he could also produce structures which had no immediate relevance to the needs of the moment. Kudriachov might design a van; but he could equally well produce drawings of mysterious delicate planes which had more to do with his own

spiritual world than with the stark realities of social revolution.

It was one of the outstanding characteristics of the period that, while artists, designers and architects worked for their new society and the new human needs, they also produced abstract works which expressed their inner musings. That there is a connection between the two, that their social commitment expressed itself in forms derived from their inner vision can be verified in many instances.

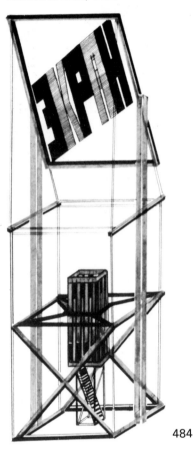

484

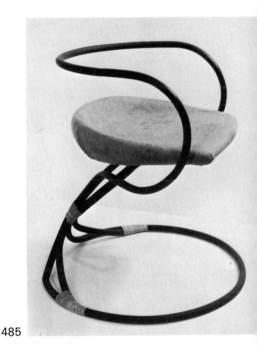

485

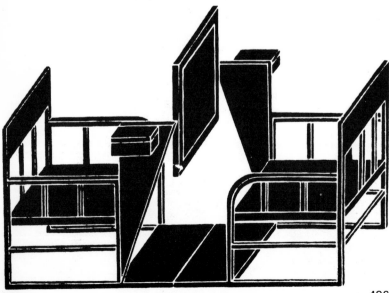

486

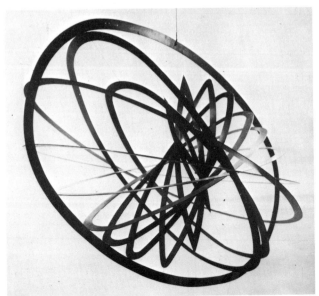

487

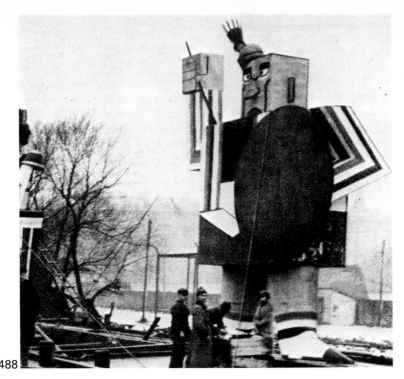

488

489

490

492

491

197

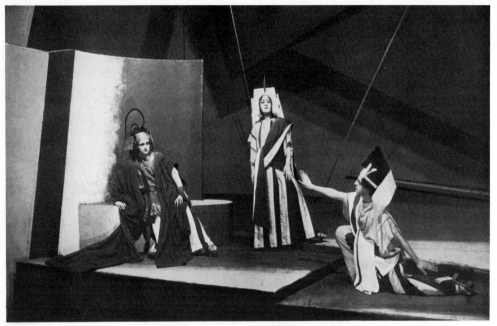

493

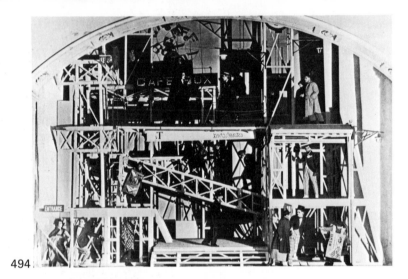

494

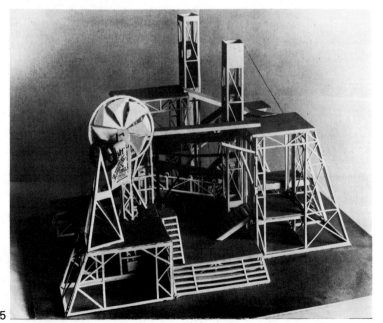

495

The effect of Constructivism on theatre design was largely bound up with the anti-naturalism of the two dominating figures of the twenties, the producers Tairov and Meyerhold. Racine's *Phèdre* was produced by Tairov in 1922; the designs were by Alexander Vesnin. Settings and costumes were reduced to essentials, as in all Constructivist work. The actors' movements sparse and precise, matched the geometry of the sets. Moods and sensations inherent in the play were stressed by abstract devices, for instance the slope of the floor and changes in the lighting. When the production toured Germany and France in the following year it attracted high praise, especially from Fernand Léger.

Tairov's production of *The Man Who Was Thursday,* a dramatisation of G. K. Chesterton's book, made use of sets by Alexander Vesnin once again. This time the Constructivist character is even more evident; there were lifts, stairs and projection screens. The lighting was arranged in pools so that quick changes of scene from one part of the structure to another could be effected. The experience of simultaneity must have been somewhat similar to Léger's large compositions, like *The City*.

Meyerhold's productions of *The Magnanimous Cuckold,* a farce and *Tarelkin's Death,* a satire, also had Constructivist sets. Meyerhold was forced to rely on sets which could be put up at short notice, and so Constructivism could be justified on functional grounds, but the large structure with its complex mechanics which included a windmill had a powerful suggestive effect. Although at the time this was thought to be a misuse of Constructivism which, we must remember, aimed at nothing more than the efficient use of materials and structures, these sets revealed the symbolic power of bare, essential structures.

Tatlin's sets for *Sangezi* are really large-scale adaptations of his smaller sculptures, large sheets of different materials disposed in space. Sculpture has grown to habitable dimensions.

In the cinema Constructivism also made its mark. Outstanding in this field are Alexandra Exter's designs for *Aelita,* a science fiction film with a strong propaganda element.

496

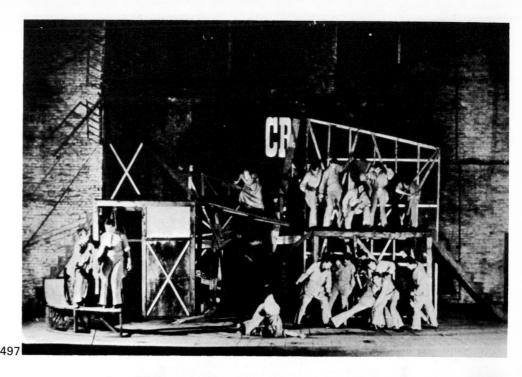

497

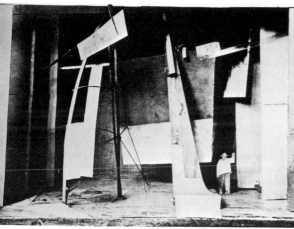

498

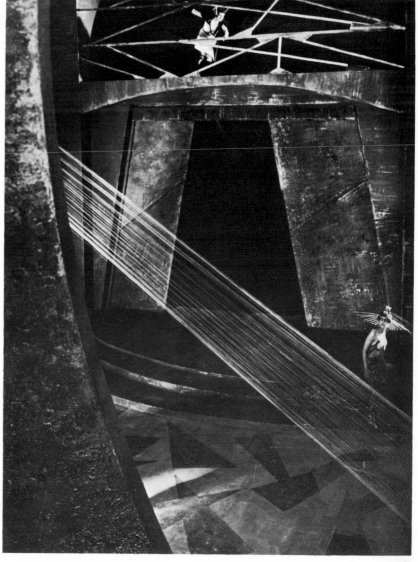

499

493 *Alexander Vesnin, design for* Phèdre, *1922*

494 *Alexander Vesnin, design for* The Man Who Was Thursday, *1923*

495 *Model for Vesnin's set*

496 *Varvara Stepanova, costume designs for* Tarelkin's Death, *1922*

497 *Lyubov Popova, design for* The Magnanimous Cuckold, *1922*

498 *Vladimir Tatlin, design for* Sangezi, *1923*

499 *Alexandra Exter, design for* Aelita, *1924*

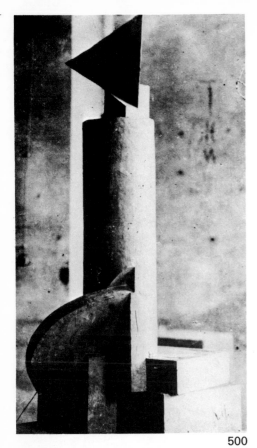

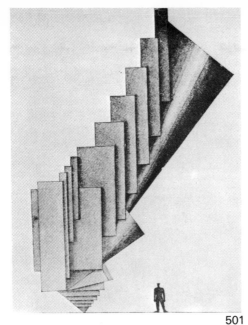

501

At the Vkhutemas Constructivism was supplemented by analytical studies of visual perception. Even though early student work might be abstract — that is useless from the point of view of function — it could soon be channelled into useful projects such as furniture, stoves (a most important item of equipment in Russia), domestic and other utensils, even clothes.

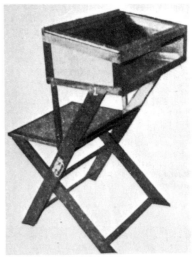

504

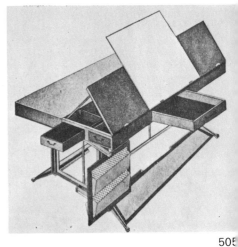

505

500

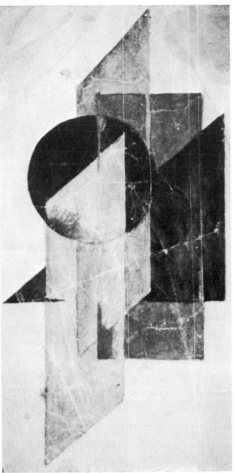

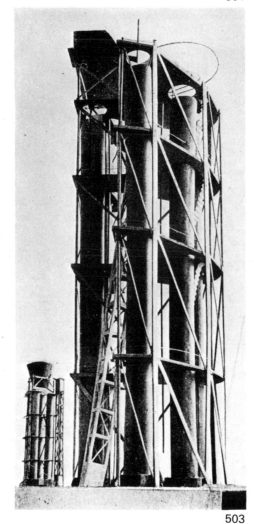

503

500–502 *Work by students at the Vkhutemas, 1922–1925*

503 *Student of Nicolai Ladovsky, design for a chemical works, 1922. Both a study in volumes and spaces, and an industrial project at the same time*

504, 505 *Students of Rodchenko, designs for furniture, 1925*

502

200

Although graphic design of the Russian post-revolutionary period derives mainly from Constructivism, Malevich's researches into human sensations and perception were not without influence in this field. The artist who most successfully effected the fusion of Constructivist with Suprematist tendencies was El Lissitzky.

El Lissitzky's earlier work, like that of Marc Chagall, derives from his Jewish background as well as, once again, from Russian peasant art. Marc Chagall, who became Director of the School of Art at Vitebsk in 1918, appointed Lissitzky as professor of architecture and graphic design. The unusual combination is significant, for Lissitzky had obtained an engineering degree at Darmstadt in 1914 and was also attracted to painting. This dual interest made him the ideal ambassador of Russian art, and it was largely through him that Russia made her contribution to the Modern Movement.

Having seen an exhibition of Malevich's Suprematist pictures in 1919, he began his series of paintings which he named *Proun*, a Russian word meaning 'object'. These examples show that Prouns may be strictly two-dimensional or may include suggestions of a third dimension or may hover between the two. A *Proun* was to Lissitzky a form of research, the findings to be put to practical use. The structural implications, he suggested, could be followed up into the field of architecture while at the same time they served as serious research projects for graphic design. However, quite apart from their use as trial grounds, Prouns may be considered as works of art in their own right. In many of them coloured forms are arranged in such a way that the illusion of three-dimensional form and space is dominant, but the interpretation is always ambiguous and doubtful.

506 *El Lissitzky*, Proun, *1919*
507 *El Lissitzky*, Proun, *1923*

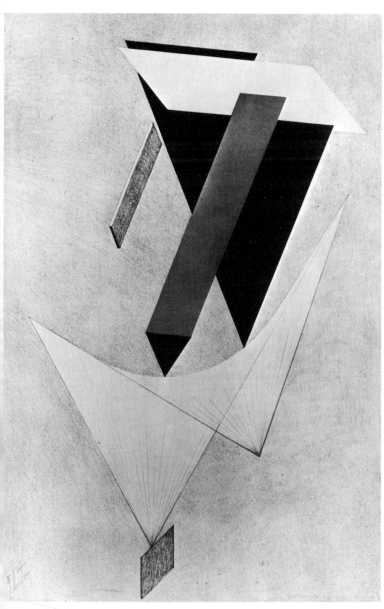

506

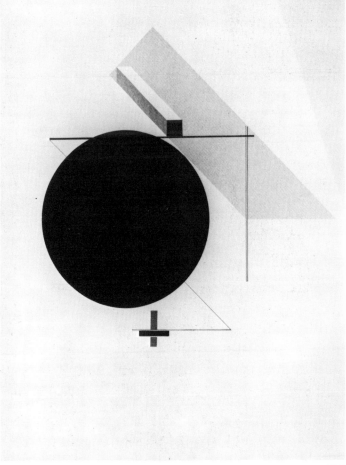

507

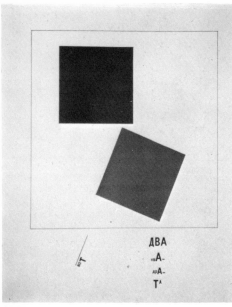

508

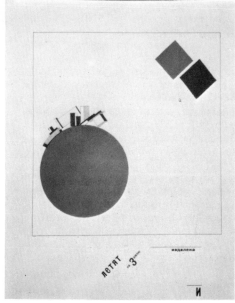

509

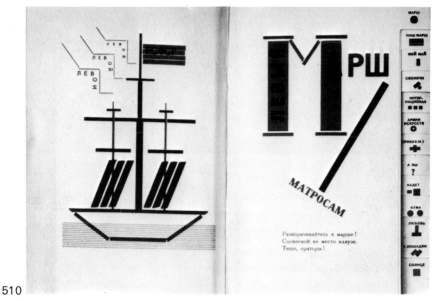

510

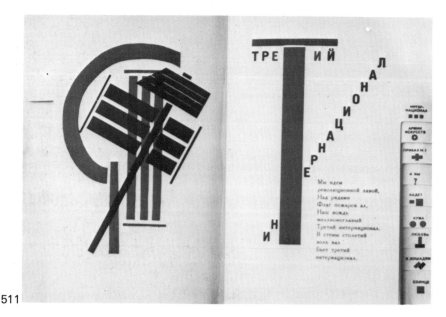

511

A series of designs entitled *The Story of Two Squares* is probably the first abstract story ever told. It is remarkable not only for its abstract dynamic but also for its pioneering use of typography which was soon to find its way into Lissitzky's more 'useful' work: posters and book design.

Up to that time the most successful examples of a combination of pictorial elements and letter forms in graphic design had been the posters of various painters. The letters had, however, invariably been hand-drawn to make a harmonious unity with the pictorial element. Now, with the advent of an art for the machine age it was thought appropriate to use letterforms of printing type as an expression of a machine process. These letterforms, generally without serifs, harmonised better with the Suprematist elements which had replaced more traditional pictures. Artists like Lissitzky were now able to weld type and pictorial material into one whole. In some cases the letters by themselves provided the sole pictorial material.

With his broad artistic interest in graphic design, painting, exhibition design and architecture, Lissitzky became the chief agent in the spread throughout Europe of Russian art and architecture, and its underlying theories. He visited and worked in various European countries. He organised and designed several Russian exhibitions, notably in Berlin in 1922 and Hanover in 1926. He met van Doesburg who promptly devoted two complete issues of de Stijl magazine to Russian art and the work of Lissitzky. He edited, or helped to edit, magazines in several European cities. His book *Russland* was published in Vienna in 1930. It can be seen that he was personally responsible for bringing the new Russian art to the notice of the West, where the new ideas were received with acclaim.

Russian graphic design of the early twenties was, however, not wholly Constructivist and Suprematist, there was also a distinct Dada influence. It was not, of course, difficult for a Russian artist during the early years of the revolution to embrace Dada, a movement which ridiculed and attacked bourgeois society and its attendant values. Rodchenko's photomontage of 1923 seems to confirm this and shows his sympathy with Dadaist methods. He was now in charge of producing the Constructivist magazine *LEF* and some of the covers he designed for it demonstrate how two such apparently unrelated movements as Dada and Constructivism may be combined. The Constructivist element is at once apparent in the bold letter forms which are built up in two different colours. The use of photographs and drawings in a seemingly

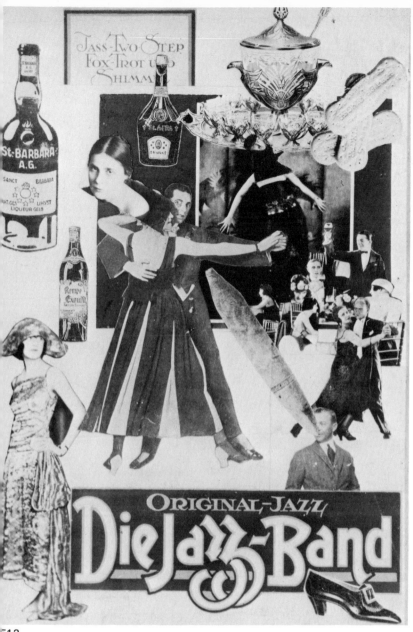

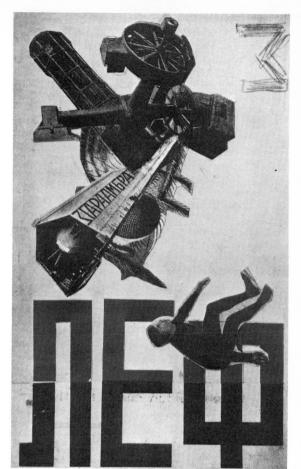

513

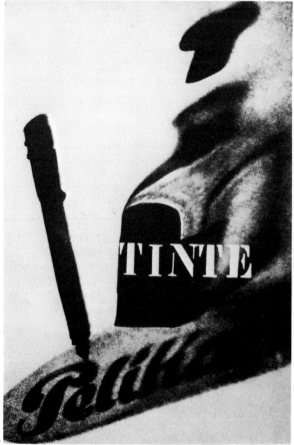

514

512

nonsensical composition is clearly of
Dadaist derivation. The falling figure which
overlaps the letters ensures a fusion of the
Dadaist and Constructivist elements.

508, 509 *El Lissitzky, two pages from* A
Story of Two Squares, *1922*

510, 511 *El Lissitzky, two double pages
from* For the Voice, *a book of poems by
Vladimir Mayakovsky, 1922*

512 *Alexander Rodchenko, photomontage
for* Pro Eto, *a book of poems by Vladimir
Mayakovsky, 1923*

513 *Alexander Rodchenko, design for* LEF

514 *El Lissitzky, advertisement for Pelican
Inks, 1924. The first application of the
photogram, a Dadaist invention, to
advertising*

Russian artists and designers during the early years of the Bolshevik revolution produced objects — and a few buildings — which expressed the ideals of the new society, served the new social functions and made the best use of the scarce materials available to them. Such men must have felt themselves to be an integral part of the new society; they occupied a position artists had not enjoyed for centuries. This seems to account for the feverish artistic activity and the strong sense of social mission of the period in the face of enormous difficulties and little, if any, material reward.

In Russia the 20's were the most exciting and fruitful period in the evolution of modern visual ideas, particularly architectural ideas. Much of the Russian architecture of this period was of a visionary nature and did not go beyond drawings and models. It was a dreaming architecture, envisaging new forms and structures for the new society, many of which — although not by any means all — were at that time far beyond the capacities of existing building techniques. These dreams were wholly contained by the visual language developed by Russian and other artists of the preceding decade.

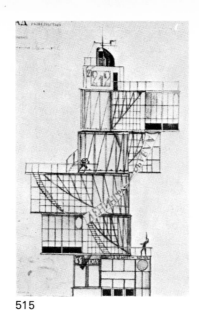
515

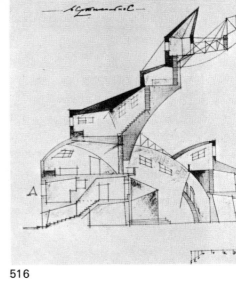
516

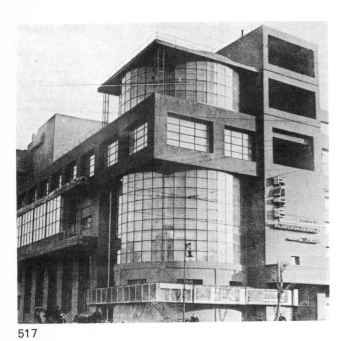
517

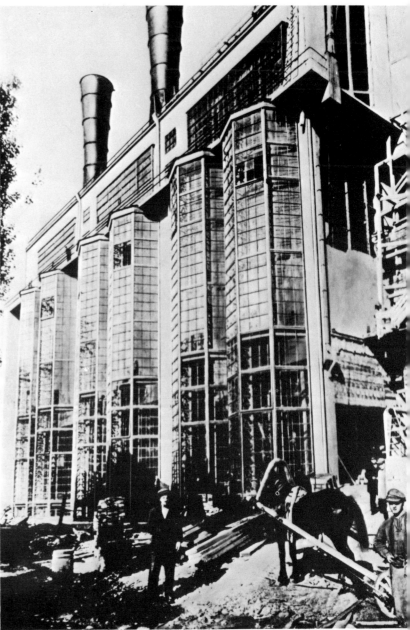
518

515 *Konstantin Melnikov, design for Pravda Building in Moscow, 1923, with independently rotating floors*

516 *Nicolai Ladovsky, design for a housing development, 1921, section*

517 *Ilya Golosov, club building, 1926*

518 *Zoltovsky, power station, 1927*

With certain modifications the buildings actually erected during this period were couched in the same language. The outward appearance of the new Russian architecture is, however, only one aspect of its larger function within the revolutionary context. Russian architects had no doubt whatever about their social mission. Their aim was nothing less than to embody the ideas of the social revolution and to help it come to pass, to change individualistic man into social man. This they hoped to achieve by environmental means. They invented new type forms – as Sullivan had done for Chicago – to ease the changeover to a new society: clubs for workers and for artists; apartment blocks with interior corridor-streets and communal facilities, like libraries and canteens; factories designed for the workers' comfort. Research led to standards of minimum requirements for dwellings. Many of these ideas were new, and were to prove influential also outside Russia. Western eyes were beginning to turn towards the East. In the West modern architecture had not as yet gone much further than the building of private houses, but in Russia during the 20's socially significant schemes in architecture were embarked upon and often realised. The air was teeming with daring projects, nothing was ever ruled out.

These exciting prospects enticed many Western architects to Russia, sometimes as visitors or participants in architectural competitions, sometimes to stay and work there. Among the latter we find such illustrious names as Mart Stam, Bruno Taut and Le Corbusier. They went because they felt that modern architecture was encouraged in Russia – some may even have thought that it was official policy, but this was not so. They must also have felt that only under the conditions then prevailing in Russia could modern architecture make sense. Morris's cri-de-coeur about the swinish luxury of the rich may still have been ringing in their ears. In any event, social commitment was the hallmark of modern art, architecture and design, and nowhere could the artist feel more involved in the society around him than in the Russia of the 20's.

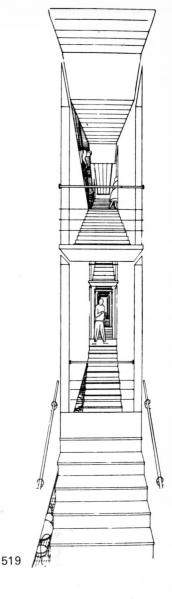
519

520

521

522

519 *Housing development, view of interior staircases and corridors*

520 *Study of housewife's movements inside a kitchen*

521 *Housing development, section showing design of roof for maximum light*

522 *Design of housing units in a modern city*

523 *Design of housing units, section*

523

By the late twenties, however, a totalitarian power structure emerged in Russia and it soon became apparent that modern art and architecture would no longer be tolerated. National pride, the power of the state and what was many years later to be known as 'the cult of personality' became the artist's new themes. The young art and architecture as they had developed in Russia had neither the means nor the desire to express them. Social realism supplanted abstract art, which by the use of verbal acrobatics could now be described as 'formalist' (in opposition to 'realist'), that is tending to irrelevant play with form, and therefore 'bourgeois' and 'capitalist'. Modern architecture which had a common foundation with abstract art was described as 'cubo-futurist' (this was enough to condemn it out of hand) and following from this 'fascist'. A neo-classical massive architecture was to be the new style of the proletarian society, a style derived from the aristocratic villas and episcopal palaces of the past.

The eclipse of modern art and architecture in Russia is difficult to justify or explain and certainly too complex a matter to be investigated here. There is however one interesting marginal cause which seems to suggest itself. When Lenin and his associates lived in Zürich, shortly before the Revolution, they were accommodated in a house opposite the Café Voltaire, meeting place of the Zürich Dada group. The Swiss police took a much dimmer view of the rowdy antics of Dadaists than of the Russian would-be revolutionaries who must have seemed quiet, studious and harmless men. To the Russians themselves the Dada artists with their crazy, noisy and seemingly irresponsible behaviour must have symbolised the very decay of capitalist society. Could this association of ideas, revived perhaps by the strange and incomprehensible new work produced by Russian artists in post-revolution Russia, have had something to do with the Soviet authorities' coming down on the side of the serious and safe traditional art and architecture of the Renaissance, Baroque and Classical eras?

Russia which had been the first country to give a blessing to modern art and architecture, to sponsor exhibitions and to pioneer modern art education, has reaped comparatively little benefit from this early progressiveness, considering the ideal social context and the magnitude of efforts in the 20's. As a result of the change in official policy, many artists and architects, for example Lissitzky and Leonidov, found themselves more and more isolated and entrusted with only minor tasks. Others moved to the West where they could continue their work, and it was therefore the countries of Western Europe which were the chief beneficiaries of the early Russian experiments.

Kandinsky's return to Germany in 1922, long before the change of policy became official, is of particular importance, for he took with him his plans and ideas for the education of artists, designers and architects. Stimulated by conditions in post-revolution Russia, he had explored the depths of his imagination for these ideas. Unwanted in Russia, he took them to the Bauhaus, where he applied them in the unique situation he found there. And this must be the subject of the last part of our survey of the Modern Movement.

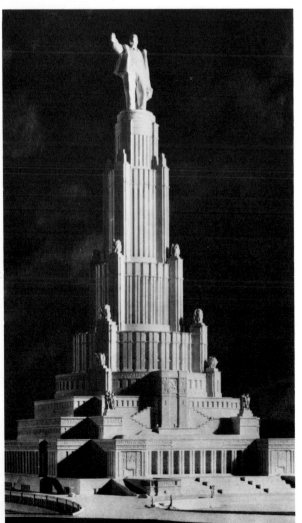

524

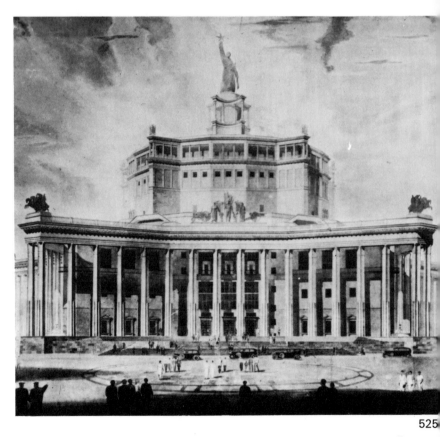

525

524, 525 *Prize-winning entries in architectural competitions, 1930–1932*

Walter Gropius joined Peter Behrens' office in 1908, having duly completed his preliminary architectural training. He says, 'It was Behrens who first introduced me to logical and systematic coordination in the handling of architectural problems . . . my own ideas began to crystallise as to what the essential nature of building ought to be. I became obsessed by the conviction that modern constructional technique could not be denied expression in architecture and that that expression demanded the use of unprecedented forms.' Progressive designers were saying this everywhere, but what exactly were these unprecedented forms to be?

The first clues come in a memorandum written in 1910. Here Gropius' ideas have become much more articulate, no doubt as a result of his experience in architectural practice. The builder, he argues, works for profit; he will always try to save materials and labour. The architect will attempt to keep the cost of building as high as is acceptable because his fee is calculated on the total cost. Between the two the client must always be the loser. The ideal designer would be an artist prepared to sacrifice all for his artistic aims: a very rare person indeed. On the other hand if an architect could work like an engineer, using as much time as is necessary to prepare a design which will be mass-produced and for which in consequence he will be adequately compensated, a high design standard would be possible. Mass-produced industrial buildings, says Gropius, are under-developed and inferior to specially designed buildings. If only architects could give their attention to the field of industrial building, using similar elements in many different combinations to create variety, art and industry could be combined to the client's advantage. Only through mass production can high quality be achieved at economic prices. The best designs would be widely used. In such an architecture, ornament would have to give way to a greater emphasis on the articulation of space.

By 1914 these ideas had coalesced into a form in which the fundamentals of Gropius' later philosophy can already be recognised. In an article in the Werkbund year book of 1914 he begins, 'The art of the last few decades lacks a moral focus and thus the conditions for a fruitful development. During this period of material effort no spiritual ideal of universal meaning emerged, so that the creative artist could not obtain a generally understood model beyond his egocentric imagination. In all fields of spiritual life opinions are fragmented and art . . . became the true mirror image of this confusion. The basic problem of form became an unknown concept. Materialism laid undue stress on purpose and material, it thought of the shell, but forgot the core. But even though a material view of life is still in the ascendancy, nevertheless the beginnings of a strong and unified will to culture are today unmistakable. As the ideas of our time grow beyond what is merely material, so a yearning for a unified form, a style, begins to awaken in art. People recognise once more that the will to form is what gives value to any work of art.'

According to Gropius, materialism, which is concerned only with function and material, cannot lead to a harmoniously balanced world. The total vision which we call form is an unknown concept under materialism, and it is form alone which can overcome the confusion in thought and environment produced by materialism. Only art can reimpose a sense of form on man-made objects, and an overall vision, so that the environment may once more be capable of satisfying human needs. This statement goes considerably farther than those of other artists and in some ways it elucidates theirs. Gropius is thinking not only of individual human beings but of the whole of society and of the totality of life. This becomes even clearer as he continues: 'If the creative will begins to work in those areas where the ideas of our time solidify into universally comprehensible concepts, then it is logical that modern art should from choice turn to those tasks which are essentially connected with the most modern ideas and their demands.' Here, Gropius maintains, imagination can unfold in a technological as well as in a spatial sense, for new type-forms will have to be designed for stations, vehicles and factories. He admits a certain 'poetic overstatement' on the designer's part so that 'any observer can sense the basic idea of the whole.' Poelzig would have agreed; so would Sant'Elia.

Gropius has now established that the true artist must, if he is to escape from the sterile confusion of contemporary life, concentrate on the new field of technology bestowing human values on it. It is not enough, Gropius goes on to say, to rely on the natural beauty of materials; only a 'harmonious congruence' of technological forms with art forms, of mathematical with visual stability, can lead to the ultimate organic form. From the innumerable possibilities only those must be selected which satisfy *in equal measure* the feeling of the artist as well as the knowledge of the technician. The aim of architecture is the creation of solid forms and spaces. Artistic genius alone succeeds in creating an awareness of the sheltering of space and of the solidity of forms even with the help of such 'characterless' materials as glass and iron. Nothing could express more powerfully Gropius' essentially humane purpose. The new materials are not to be revered in their own right, but only as the means to achieving a new all-embracing form. Gropius believed that these materials furnished the artist with the means to combat the formless materialism which had broken up the environment. The closed forms of modern engineering have to him a particular meaning: the elongated torpedo-like forms of motorcars, the casings of machines, in which the power and simplicity are expressive of modern structure. Cars, trains, steamers and planes have – through their form – become symbols of speed. While Futurist doctrine assumes the intrinsic superiority of machine forms, and the subservience to them of individuals and of society, Gropius insists on the importance of the artist as co-creator, and on the subservience of machine forms to the needs, psychic as well as material, of human beings.

While, as Gropius states at the beginning of his 1914 year book article, conditions were still not propitious for the changeover from a materialistic to an artistic environment, he believed that the modern movement would eventually lead to a unification of all expressions of modern life – a modern style. He realised, however, that there was one supreme qualification of his argument. 'Only when the happiness of a new faith descends on men will art achieve its highest aims . . .' He leaves us in no doubt throughout the article that in his view this new faith would have to be of an anti-materialistic nature.

That new faith was soon to emerge. The First World War, which Gropius spent in the German army, and its aftermath had destroyed the world of the pre-war years. The political forces and the bourgeoisie who had been in control were now in disarray. Reform was in everyone's mind, a new world based on the new ideas which

were flooding Germany from abroad, and in particular from Russia; and not only political and social reform, but also artistic reform which would make the rest possible.

As in many parts of Europe, art had acquired in Germany a deeply political and social commitment. Artists were active in many ways: sitting on committees, holding meetings, publishing manifestoes, holding exhibitions, forming associations with radical aims. Gropius too was active in Berlin, like Loos in Vienna and Kandinsky and others in Moscow. Expressionism had become the natural language of most radical elements. The Novembergruppe, an association of artists and architects with progressive aims, had amongst its membership Max Pechstein and the painter César Klein, who were co-founders, Poelzig, Bruno Taut, Schmitt-Rottluff, Mendelsohn – all Expressionists. Gropius was also a member, and it was as mouthpiece of this group – significantly named after the November Revolution – that he set out his Utopian vision of the future in which 'miracles rise to the sky'.

Gropius was, however, much more than a visionary; he was also a practical architect, and as such he soon became aware of the enormity of the task so easily expressed in words. Many years later he recalled: 'I saw that an architect cannot hope to realise his ideas unless he can influence the industry of his country sufficiently for a new school of design to arise as a result; and unless that school succeeds in acquiring authoritative significance. I saw, too, that to make this possible would require a whole staff of collaborators and assistants: men who would work, not automatically as an orchestra obeys its conductor's baton, but independently, although in close co-operation to further a common cause.'

This was not the first time that Gropius had thought of a school of design. In 1914 he had been suggested by van de Velde as his successor in the headship of the Weimar School of Design, and Gropius had been sufficiently interested to send a memorandum to the appropriate Ministry on his ideas for such a school. It was then that his ideas began to take concrete shape. In order to bridge the chasm between art and industry he suggested the encouragement of a lively interchange between the two, even drawing the school's students from the ranks of industry. He took as his model – like Morris, Ashbee and Mackmurdo before him – the medieval communities of artists and craftsmen engaged in the construction of cathedrals. Now in 1919, when his appointment as the director of the school was confirmed, Gropius' ideas, as a result of the radical spirit abroad in post-war Germany and of his own maturing, had so crystallised that he was fully prepared to meet this unique challenge.

In April 1919 Gropius issued the manifesto and programme of the Bauhaus, as his new school was to be called. The frontispiece was a woodcut by Lyonel Feininger, an Expressionist artist he had met in the Novembergruppe. It is a pure image of the early ideals of the Bauhaus. The subject is a cathedral, a symbol of the community of artists, craftsmen and architects which Gropius hoped to gather together, but the execution is in the Expressionist manner, at that time associated with revolutionary change. Gropius' language, too, was in some ways reminiscent of the Middle Ages, but its fervour had an Expressionist tone which is not surprising since part of the Bauhaus Manifesto is an exact repetition of certain passages of Gropius' article for the Novembergruppe.

'Architects, sculptors and painters, we must all return to the crafts. Art is not a profession. There is no essential difference between the artist and the craftsman. The artist is a craftsman raised to a higher level. The grace from heaven may, in rare moments of illumination from beyond the sphere of the will, make the work of his hands blossom into art, but the essentials of workmanship are indispensable for every artist. It is the fountain-head of all creative form-giving. Let us then set up a new guild of craftsmen, without any arrogance of class-division, which would erect a haughty wall between craftsmen and artists. Let us will, conceive and create together the new building of the future, which will comprise all in one form: architecture and sculpture and painting, rising one day towards heaven from the hands of millions of craftsmen, a crystal symbol of a new coming faith.'

526

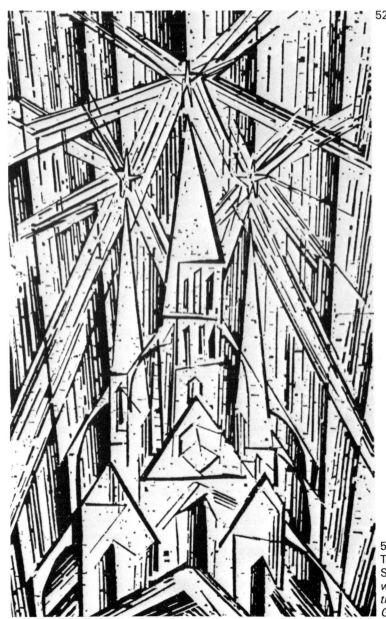

526 *Lyonel Feininger* The Cathedral of Socialism, *1919, woodcut. This was the frontispiece of Gropius' manifesto*

Gropius' 1914 statement had ended with the implied hope that a new faith would make the new world possible. Now in 1919 the tone is more emphatic. The new cathedral has almost become a reality, for the new faith is at hand, even if it is not yet all conquering, and at last there is a practical opportunity to build.

The curriculum itself was no more than tentative in 1919. The plan of instruction never had a definitive form and it underwent continual adjustments. Nevertheless there emerged almost from the beginning certain features reminiscent of the Vkhutemas. An academic teacher-pupil relationship was never contemplated. Students were not to be at the receiving end of a rigid educational process but were encouraged to contribute as much as they received and to influence the development of the Bauhaus. They were invited to take an active part in the work of their teachers and to contribute to the projects and studies undertaken by the Bauhaus for outside clients. The title of 'professor' was not used (although years later it was introduced) and teaching staff were known as 'masters' like their medieval predecessors. Students were either 'apprentices' or 'journeymen' according to their status and again in accordance with medieval precedent. The Bauhaus was therefore an unacademic, indeed one might say an anti-academic, institution. It was regarded with suspicion by the academic establishment and this added in no small measure to the troubles which beset it throughout its life.

In the framework of this new organisation, Gropius began to examine seriously one of the main problems of twentieth century design: the need for teamwork, the creative collaboration of various designers who could each understand the totality of the problem on hand. His social purpose, however, lay deeper. It was 'to prevent man's enslavement by the machine . . . by guarding mass production and homes from mechanical anarchy and filling them with a life-directed purpose. Our intention was to remove the disadvantages of the machine without sacrificing its advantages. We endeavoured to create standards, not short-lived novelties.' And deeper still: 'Our conception of the fundamental unity of all creation with reference to life itself was diametrically opposed to the concept of art for art's sake and the even more dangerous philosophy from which it sprang, namely business as an end in itself . . . The aim of the Bauhaus was not to create a new style, system or dogma but to exert a live influence on design. Our efforts aimed at new approaches to awaken a new creative consciousness amongst the participants, which would eventually lead to a new attitude to life.'

The belief in the humanising effect of art on life was shared by others during that period of cultural revolution, but no one before Gropius had put forward such a comprehensive programme of re-education and restructuring of creative processes. The similarity between Morris and Gropius is underlined by the fact that Gropius' work and writing, like Morris's, was at all levels informed by a total vision and an unflagging idealism. Both always saw the ultimate purpose behind the smallest action. After various painstaking enumerations of educational motives and methods, and practical plans, Gropius would always return to the final goal: the new faith, the totality of creation and of life . . .
Such a belief, although it needed to rely on a thorough grounding in workshop practice, had to take root long before the apprentice found himself face to face with actual design problems.

'Apart from his training in technology and craft the designer must learn the language of forms in order to express his ideas visually. He must acquire a theoretical basis which acts as a guide to the creative hand as well as an objective basis upon which a number of persons may work harmoniously in a team. This is no recipe for the production of works of art, yet it is the most important objective means to any creative group work. It may be compared to the theory of counterpoint which . . . is still a supra-individualistic system for ordering the world of sound. . . . The freedom of creation does not rest on undisciplined expression but on free movement within the limitation of laws. That is why at the Bauhaus we carried on intensive studies to rediscover the grammar of design . . . proportion, optical illusion, colour, and the careful cultivation and further research into these natural laws would contribute more to a continuation of genuine tradition than instruction in imitation of old forms and styles.'

It has been necessary to quote Gropius at length because his complex and in some ways ambiguous views led to numerous misunderstandings among his staff, students and the outside world. Let us re-state his position briefly. Art schools had forgotten the essential qualities of art and architecture and taught only isolated disciplines, so that a student could comprehend no more than his own narrow sector, rather like a factory worker who rarely obtains a view of the total process. This could not lead to the education of the truly creative faculties which the new world demanded — in keeping with the totality of creation and of life. The new student must be encouraged to rediscover the basic visual truths of the visual arts and of visual experience, a visual language. This could be done only by uncovering his inborn

sensitivities. This part of the Bauhaus training concentrated on each student as an individual and encouraged him in his individuality. The acquisition of a visual language would result not only in the liberation of his own creative powers; it would also enable him to communicate with other students — and when fully fledged with other designers — in the great tasks of the future which required the collaboration of a team. Only by this process — so ran Gropius' argument — could each member of the team make an individual creative contribution, instead of merely carrying out the master plan, as adherents to a 'style' would do. During the second stage of his training the student was therefore required to take part in team efforts and to work within standards acceptable to industry.

Gropius' view of the designer in his dual role as an individual and as a member of a team, and his rejection of specialisation based on a narrow field of study, was an obsessive theme which he proclaimed throughout his life. It was open not only to misunderstanding but also to abuse.

Gropius entrusted the preliminary course to a Swiss artist and educationist, Johannes Itten, to whom he had been introduced in Vienna. Itten had run his private art school there on new and decidedly revolutionary lines, largely derived from his own teachers Cizek and Hölzel, both important innovators in the field of art education. Cizek may be claimed to be one of the discoverers of child art; at least he accepted children's art as psychic phenomena and expressions of the deepest layers of awareness which cannot be 'corrected' by the teacher. The exposure of deep psychological states as a result of spontaneous reaction is paralleled in the work of the Zürich Dada group. Itten had developed Cizek's ideas for older students. When Gropius called him to the Bauhaus he brought fourteen of his own students from Vienna to swell the student intake of the Bauhaus.

In his preliminary Bauhaus course Itten sought to confront his students with the essential qualities of materials and their relationships. Most of the work done was in the form of compositions in which different materials were contrasted or harmonised according to their texture and consistency. The chance element of Dada is evident in both the two- and three-dimensional work and there is an obvious similarity to the work of, say, Kurt Schwitters. Itten encouraged the unthinking, automatic working methods of Dada, the impulsive expression of instinctive urges. To appreciate the revolutionary nature of Itten's teaching, one must remember that in those days most art teachers still believed in a correct

model of the world which every student must work up to. Itten's purpose was to educate human beings to be human, and to rely on their senses and instincts for further development. It is not difficult to suppose that a student who had produced 'automatic' work like the drawing shown here, expressing his feeling for abstract movement and the harmony between different movements, would as a result of such work find it easier to see what is essential in other movements — for example in those of people round him. Similarly the study of old masters, from the point of view of composition, masses, balance, would have a liberating effect on his vision. Typography, again in the Dadaist sense, was also included in Itten's course. Examples of his own work, as well as that of his students, show the use of letters, divorced from their usual meaning, in compositions where abstract visual character and psychological effect are the determining forces.

The cultivation of the individual as a being who is endowed with unique sensitivities – allowed for in Gropius' master plan – has nevertheless inherent dangers. It may lead to an isolation of the individual rather than to his greater adaptability to the demands of teamwork, especially if it is too consistently one-sided and inward-looking. Itten's mystic beliefs forced his teaching even further towards excessive individualism, so that students tended to acquire a private visual language rather than a universal one for use in communication on communal projects. Art, believed Itten, was autonomous and not necessarily of direct consequence in spheres other than the individual-spiritual. Sooner or later the tension between the two opposed ideologies had to lead to a break. In 1923 Itten left the Bauhaus.

527

527 *Foundation course Itten, construction for the study of expressive properties of different materials, 1922*

528 *Foundation course Itten, composition of cubes, 1922*

529 *Foundation course Itten, study of rhythm, 1920*

530 *Foundation course Moholy-Nagy, study in balance*

531 *Laszlo Moholy-Nagy, A II, 1925. Solomon R. Guggenheim Museum, New York*

532 *Foundation course Moholy-Nagy, study in balance, 1924*

533 *Foundation course Moholy-Nagy, study in balance, 1923. Equilibrium brought about through the use of woods of different specific weight*

528

529

530

Itten had been the initiator of the preliminary course and the originator of its philosophy, and his departure left a serious gap. Gropius was fortunate in enlisting another artist who was to prove of even greater calibre. Laszlo Moholy-Nagy became chief spokesman for the educational ideas of the Bauhaus, redefining Gropius' philosophy in analytical terms and adding to it. Spurred by the challenge of education, he produced an unending stream of ideas, later to be collected in books which, together with Klee's and Kandinsky's writings, became canonical expositions of the new ideology.

Moholy-Nagy was a Hungarian. After a training in law, and war service at the front (in the course of which he was wounded), he found himself attracted by the challenge of art. By 1921 he was in Berlin, producing abstract paintings somewhat in the manner of Malevich, whose influence reached him by way of El Lissitzky, whom he knew already. He was interested too in de Stijl, Dada and Futurism. Even his earliest work shows a particular interest in the transparency of shapes.

Moholy-Nagy proved himself the ideal Bauhaus man by his understanding of the psychological possibilities of the nature of materials, their structures, forms and spatial relationships. The idea of balance — sometimes achieved by using materials of different weight to allow for different visual weight' — was to him both an intellectual achievement and an outlet for feeling. And similarly the playful constructions with wire, often expressive of joy and exuberance, with their implicit movement and ambiguous volumes, complex and mathematical. He encouraged sculpture which moved, and invented the term 'kinetic sculpture' to describe it.

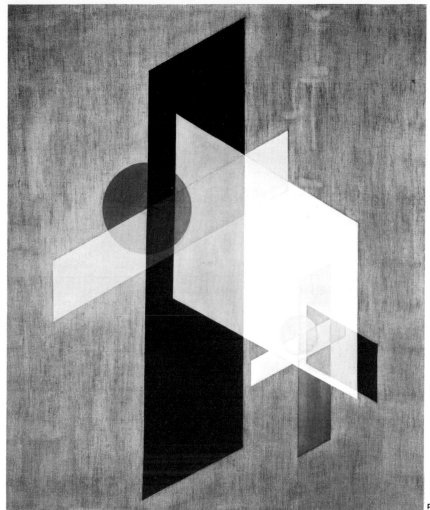

531

533

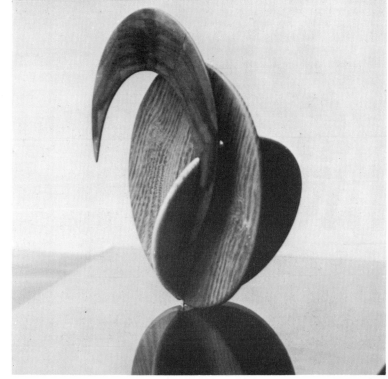

532

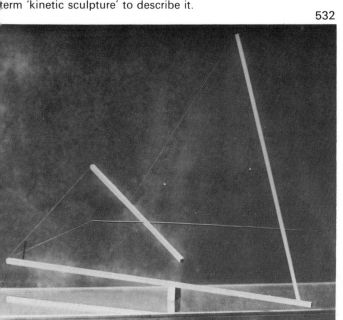

Joseph Albers, another Bauhaus teacher, used paper and cardboard to form structures which drew amazing strength from their fragility. Students had little to guide them, apart from their own inventiveness and their instinctual sense of the property of materials. Albers always stressed the importance of economy: to achieve the maximum effect with the minimum of effort and material. Material left over and not used indicated a flaw in the basic concept, as it would have done to a Russian Constructivist.

A comparison of work done at the Bauhaus before 1923 with that produced under the new regime of Moholy-Nagy and Albers reveals fundamental differences and indicates the direction the Bauhaus programme was now taking. Superficially one may say that a new scientific spirit was now manifest, that the work was more the outcome of reason than feeling. In fact, it was still based on an instinctual 'understanding' of the properties of materials — continuing Ittens' theories — but this 'understanding' was now expressed through an intellectual appreciation of form, structure and space. Ittens' theories had in this way been widened and brought into a realistic relationship with the rest of a designer's education.

535
536

534

538

534 Foundation course Albers, study in movement

535–537 Foundation course Albers, studies in structure, paper and sheet metal

538 Foundation course Moholy-Nagy, study in balance, with solid and transparent materials. Physical and visual balance are matched

Moholy-Nagy's own most absorbing interests were, like those of other abstract artists, the exploration of pictorial space (which he defined as a relationship of shapes) and the psychological states which the manipulation of this space may arouse. These ideas are reflected in the course work of his students. So is his interest in the nature of transparent materials, an extension of the interest in transparency as an abstract phenomenon exemplified in his paintings. Glass is used for its ambiguity in creating volumes and spaces which, while open to visual exploration, yet remain mysterious. Another ambiguity of transparent materials lies, of course, in their combination of apparent immateriality with structural strength. Moholy-Nagy was moved finally to renounce paint and painting in favour of those materials which could convey spiritual and material truths simultaneously so that differentiation became impossible.

This was to have far-reaching effects. If an artist can 'say' what he wishes to say without recourse to any of the traditional methods which many even quite advanced artists still considered necessary and can make statements by a manipulation of manufactured materials, then the difference between artist and designer has been narrowed down to the point where it is irrelevant to distinguish between them. This form of artistic creation is of particular significance for mass-production, for the 'art' lies in the placing, the composition, of parts, whereas traditional arts and crafts which require the imprint of the creator's hand must lose quality if reproduced in quantity.

In 1922 Moholy-Nagy had made the symbolic gesture of ordering a painting by telephone. With the colour chart used by an enamel factory and a squared up design in front of him he transmitted his 'work of art' square by square. The factory then manufactured the picture in several sizes. Art had become industrialised, or to put it another way, art and industry had moved closer together.

One thing leads to another. Moholy-Nagy's interest in transparency as a visual quality led to an interest in light itself and to numerous experiments, including the famous light modulator, designed to produce many richly patterned forms of light when rotated, and the film which had the modulator as its sole star. From this

539 *Laszlo Moholy-Nagy, light modulator, Busch-Reisinger Museum, Cambridge, Mass*

540–543 *Stills from the film* Light Play: Black, White and Grey

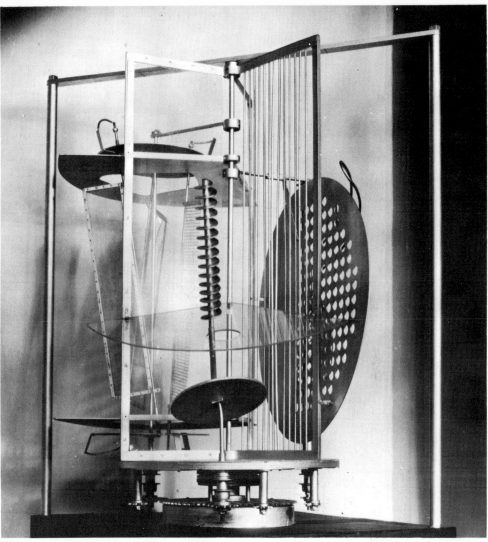

539

540

541

542

543

213

followed Moholy-Nagy's interest in photography and film. The camera was to him not an instrument for recording life but for exploring it. Few of the photographs in his book *Painting, Photography, Film* show modern objects. What *is* modern is the way of looking at things: the angled view of the factory chimney which gives out a sense of massive power; a ghostly hand; the violent pattern of flying birds which the human eye cannot hold for later examination and which only the camera could have fixed. It was about this time that Paul Klee wrote, 'Art does not render the visible, it renders visible.' Many of the photographs in the book are not Moholy-Nagy's own but are taken from magazines. The new art, the new vision had become an extension of life itself, it had become a new method of passing and assimilating information – visual communication. Art had ceased to be 'fine art'.

The new possibilities of seeing and the psychic experiences associated with it are demonstrated by Moholy-Nagy's own work in the field of photography. His *Dolls* is typical in that it presents an abstruse visual message through a commonplace situation. It is a skilfully composed picture of massed shadows and patterns in which the central objects, although familiar, look strikingly unreal. The Dadaist and Constructivist elements are closely related, giving an extra-ordinary dimension to the ordinary and indicating the psychological ramifications of commonplace subject matter.

545

Moholy-Nagy's venture into the world of the film likewise sought to embrace the abstract/visual and the symbolic simultaneously. In a projected film *Dynamic of the Metropolis* he intended to give an impression of the many-sided excitement of a large city, taking 'advantage of the camera to give it its own optical action . . . instead of literary, theatrical action.' By the early twenties, when this film was conceived, these ideas were no longer new, but here, as in photography, Moholy-Nagy was as much an educator as a creative artist. The film was never put into production, but he recorded its structure in a combined verbal/visual form. The visual presentation of the 'book of the film' is part of its content; it is not merely a succession of verbal statements and pictures. It is in every sense a visual structure. By drawing on the methods of Futurism, Constructivism and Dada it pioneers a new form of visual communication from which graphic design was to benefit greatly. Each page is like a visual poem, expressing complex, sometimes simultaneous, actions, movements and happenings as they had never been expressed before. What emerges from it is nothing less than the Nietzschean 'state of being' in modern terms, as any contemporary city dweller might experience it.

548, 549 *Laszlo Moholy-Nagy,* Dynamic of the Metropolis, *double page and single page*

544

Illustrations from Painting, Photography, Film *with a translation of Moholy-Nagy's captions*

544 *Effects as of animal power in a factory chimney*

545 *Camera-less photograph. New use of the material transforms the everyday object into something mysterious*

546 *Flock of cranes in flight. A fine organisation of light and shade, effective in itself, apart from the picture motif*

547 *Dolls. The organisation of light and shade, the criss-crossing of the shadows removes the toy into the realm of the fantastic*

546

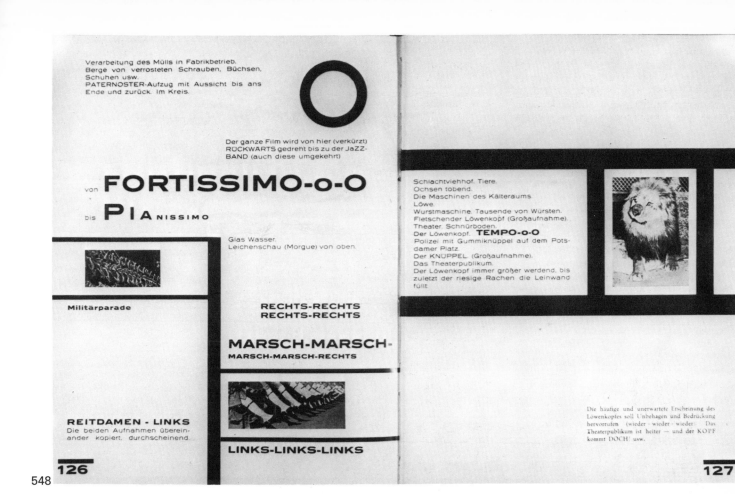

Verarbeitung des Mülls in Fabrikbetrieb.
Berge von verrosteten Schrauben, Büchsen, Schuhen usw.
PATERNOSTER-Aufzug mit Aussicht bis ans Ende und zurück. Im Kreis.

Der ganze Film wird von hier (verkürzt) RÜCKWÄRTS gedreht bis zu der JaZZ-BAND (auch diese umgekehrt)

von FORTISSIMO-o-O
bis PIAnissimo

Glas Wasser.
Leichenschau (Morgue) von oben.

Militärparade

**RECHTS-RECHTS
RECHTS-RECHTS**

MARSCH-MARSCH-
MARSCH-MARSCH-RECHTS

REITDAMEN - LINKS
Die beiden Aufnahmen übereinander kopiert, durchscheinend.

LINKS-LINKS-LINKS

126

Schlachtviehhof. Tiere.
Ochsen tobend.
Die Maschinen des Kälteraums.
Löwe.
Wurstmaschine. Tausende von Würsten.
Fletschender Löwenkopf (Großaufnahme).
Theater. Schnürboden.
Der Löwenkopf. **TEMPO-o-O**
Polizei mit Gummiknüppel auf dem Potsdamer Platz.
Der KNÜPPEL (Großaufnahme).
Das Theaterpublikum.
Der Löwenkopf immer größer werdend, bis zuletzt der riesige Rachen die Leinwand füllt.

Die häufige und unerwartete Erscheinung des Löwenkopfes soll Unbehagen und Bedrückung hervorrufen (wieder - wieder - wieder). Das Theaterpublikum ist heiter — und der KOPF kommt DOCH! usw.

127

548

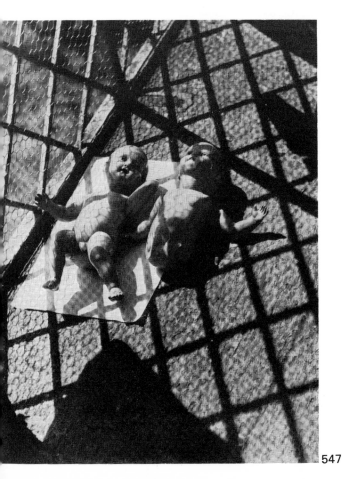

547

549

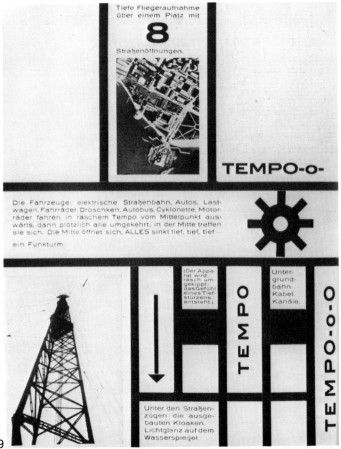

Tiefe Fliegeraufnahme über einem Platz mit **8** Straßenöffnungen.

TEMPO-o-

Die Fahrzeuge: elektrische Straßenbahn, Autos, Lastwagen, Fahrräder, Droschken, Autobus, Cyklonette, Motorräder fahren in raschem Tempo vom Mittelpunkt auswärts, dann plötzlich alle umgekehrt; in der Mitte treffen sie sich. Die Mitte öffnet sich, ALLES sinkt tief, tief, tief —

ein Funkturm.

(Der Apparat wird rasch umgekippt; das Gefühl eines Tiefstürzens entsteht.)

Untergrundbahn. Kabel. Kanäle.

Unter den Straßenzügen die ausgebauten Kloaken. Lichtglanz auf dem Wasserspiegel.

TEMPO

TEMPO-o-O

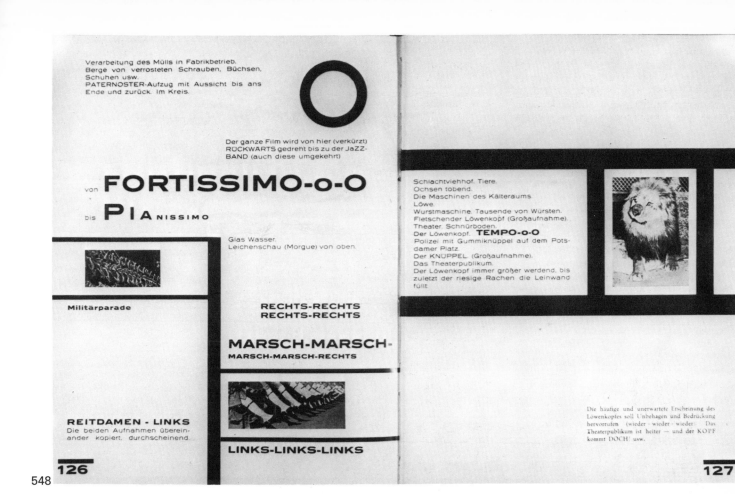

Through such developments as these the findings of twentieth century art began to characterise the forms evolved by designers. The connection was, however, far from straightforward. For instance, in the metal workshops of the Bauhaus, students' main concern, up to 1923, had been the creation of 'modern' forms. Severely styled geometrical forms were very much in evidence, as were certain novelties, such as solid handles. In most cases these modern forms were doing no more than replacing traditional forms, the change seldom resulting from the needs of function or of industrial production. When the metal workshops came under Moholy-Nagy's direction he at once introduced ideas of technological and functional suitability which resulted in several designs being adopted by industry for mass-production. Marianne Brandt's wall lamp is an example. Designed in 1927 for the processes of mass-production — pressing and casting — it is at the same time an aesthetic expression of these processes as well as of its own function. The lamp is adjustable horizontally by the movement of its two articulated arms: the reflector may be turned to give either direct light, or reflected light from the white panel on which it is mounted.

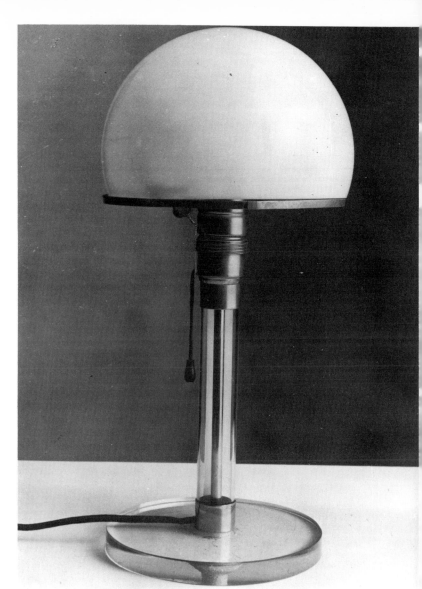

550

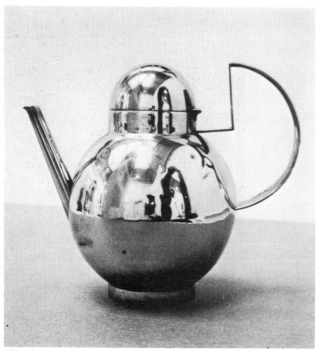

551

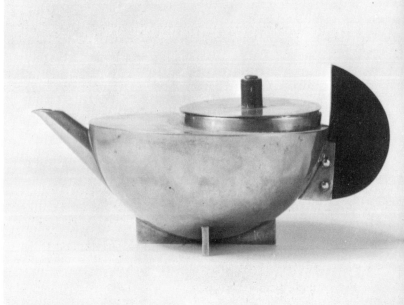

550 *W. Wagenfeld and K. J. Jucker, table lamp, 1923. A design unsuitable to mass-production*

551 *F. Marby, teapot, 1924*

552 *Marianne Brandt, teapot, 1924*

552

216

553

554

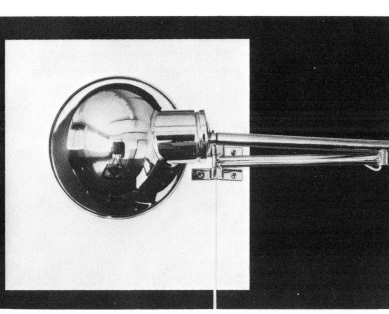

555

553 *K. J. Jucker, extendable wall lamp, 1923. An early attempt at producing functional industrial objects*

554 *Marianne Brandt, bedside table lamp, 1928*

555 *Marianne Brandt, wall lamp, 1927. A reflector panel for indirect light*

556 *Marianne Brandt, globe lamp, 1928. The safety chain holds the globe so that the bulb may be changed*

From 1925 onwards some of the Bauhaus workshops came under the direction of ex-students, men who had been trained there. It was one of the successes of the Bauhaus methods to have produced men capable of continuing the educational methods pioneered there. Events proved that more was achieved by this than merely a continuation of the existing situation.

556

The furniture workshop was headed by Marcel Breuer from 1925 till 1928, when Joseph Albers took over this department, combining it with the metal workshop. Both Breuer and Albers had been students before 1925. The amalgamation of furniture and metal workshops was symptomatic not only of the flexibility of the educational plan and organisation of the Bauhaus, but also of the movement away from wood as the only suitable material for furniture.

557

The furniture workshop, like nearly all the departments, had at first concerned itself with stylistic play. After a short period when folk design was the main influence came a de Stijl period, exemplified by Marcel Breuer's chair of 1922. His club chair of the same year shows the unmistakable Constructivist principles of design. It was not until 1925, with the introduction of a new material, that more positive approaches came to the fore.

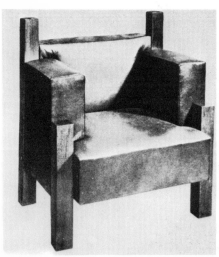

558

Breuer's easy chair, constructed from lengths of metal tube, was the first such chair anywhere. (It was, however, not produced within the Bauhaus but as a private commission.) In 1928 both Breuer and Mart Stam, the Dutch designer and architect who had collaborated with Lissitzky and was now working intermittently at the Bauhaus, designed chairs for mass production which have since become classics and are still being manufactured. In these chairs the new material has influenced the design in a most radical way. The traditional legs have become part of an overall structure which no longer corresponds to the old conceptualisation of legs, seat, back. It is difficult, in retrospect, to realise just how original this new concept of a chair was. One can only say that there was no precedent. To Breuer metal furniture was the natural complement to modern architecture. The modern room, he said, should not be the architect's self-portrait but a functional space. Nothing is as massive and fixed as it used to be. Rooms are now airy and changeable and furniture should follow suit. It should be slender, so that neither vision nor movement are disturbed and, because it is mass-produced, should fit into many different situations. In his opinion furniture made from metal tubes meets these requirements admirably.

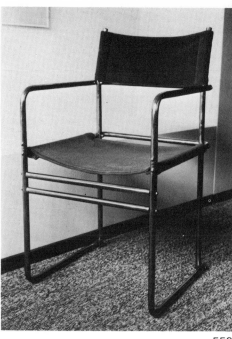

559

557 *Marcel Breuer, chair, 1922*

558 *Marcel Breuer, club chair, 1923*

559 *Marcel Breuer, tubular chair, 1926*

560 *Marcel Breuer, easy chair, 1925*

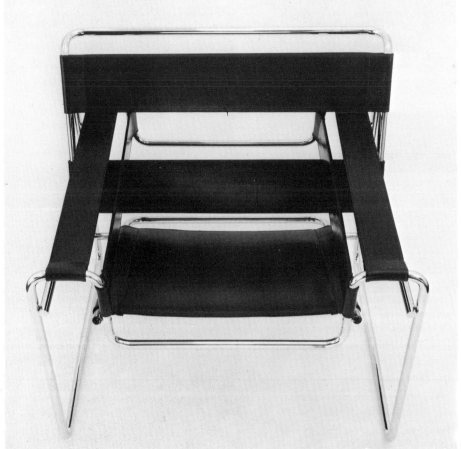

560

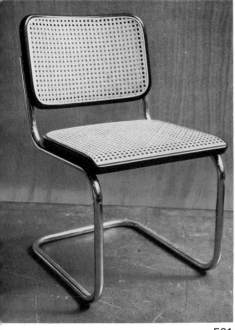

561

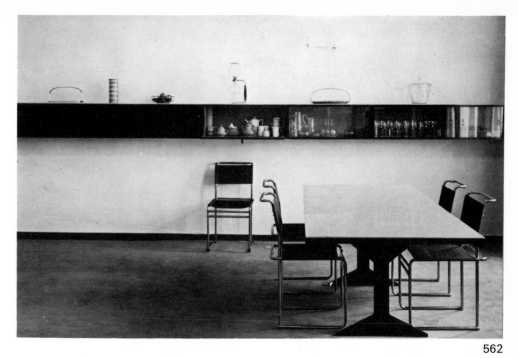

562

Also in 1928 Albers designed a chair which made use of bent, laminated wood. In this chair, as in Breuer's, the inherent character of the material was utilised. The back, which is free from just above the bend, acts as a spring. The structure is made from simple pieces. Again the material has influenced the ultimate form. Both Albers' and Breuer's chairs are style-less, that is to say they do not follow any previously known visualisations nor fall into any recognised ideas of what a chair ought to look like. They are the first fruits of Gropius' training programme.

Both metal and wooden furniture was used in the Bauhaus itself, in the masters' houses and in private commissions.

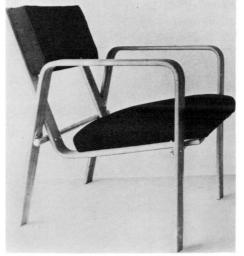

563

564

561 *Marcel Breuer, tubular chair, 1928*

562 *Marcel Breuer, dining room, Berlin, 1926*

563 *Josef Albers, easy chair, 1928*

564 *Josef Albers, easy chair, component parts*

565 *Marcel Breuer, living room in one of the master houses, 1926*

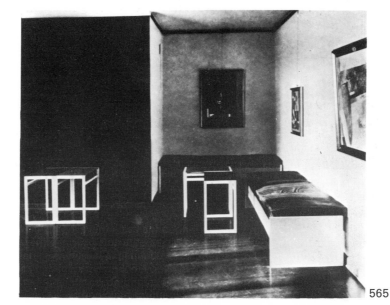

565

566

The Bauhaus Books were Moholy-Nagy's contribution to the work of the department of typography and graphic design. As co-editor of the Bauhaus Books he had a great opportunity to set new standards for book design, as well as to carry out experiments. The Bauhaus series included books written by artists and designers who were not necessarily part of the Bauhaus; any important text qualified for inclusion.

The department was directed by Herbert Bayer, another ex-student. Other notable contributors to its work were Albers and Schmidt, who interacted to develop design in new directions, largely an interplay of Constructivism and Dada. Bayer's design for a Bauhaus prospectus, with its unexpected combination of unusual objects inclines to Dada. The striking Constructivist designs of the middle years

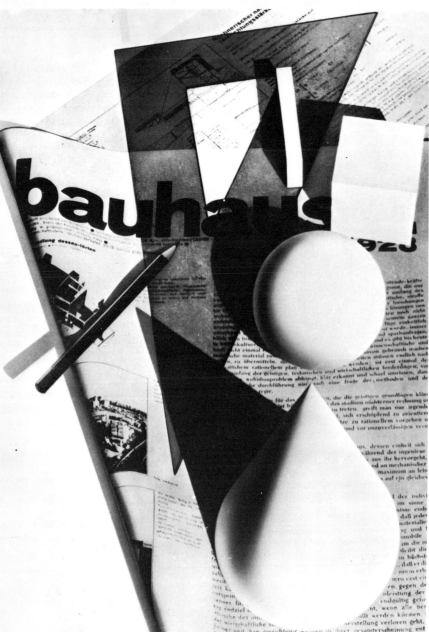

567

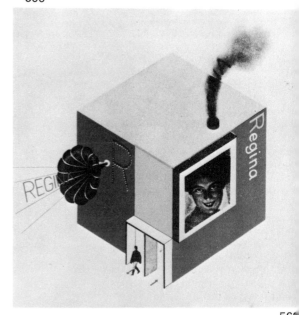

568

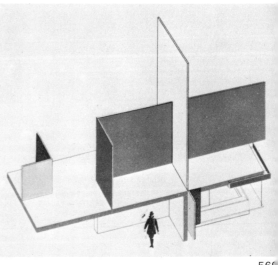

569

of the Bauhaus were epoch-making, as for instance Schmidt's design for YKO. The work of the department also included exhibition design of a three-dimensional nature, in which Bayer's work was outstanding. His tram shelter and newspaper kiosk is a bold de Stijl structure. The exhibition pavilion is a multi-media affair, also in the most modern idiom. It has light and sound as well as flat colour, film, even smoke letters, and derives from the propagandist 'kiosks' of the Russian Constructivists.

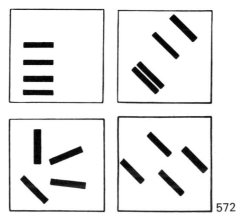

570

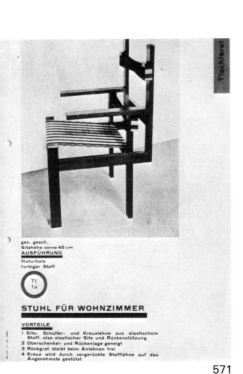

571

Kandinsky's contribution to the Bauhaus curriculum was of an altogether different kind. He was a painter and never wanted to be anything else. But he did believe that analytical studies had a positive value in the Bauhaus programme. 'The most modest or the most powerful dream of an artist,' he wrote, 'has no value so long as his fingertips are unable to follow the dictates of the dream with the greatest precision.' His work at the Bauhaus consisted, apart from an initial period in the department of mural painting, of practical analytical work, a colour seminar, and lectures on theory and visual analysis.

Visual analysis, he maintains, will train the eye to isolate (to abstract) elements from the mass of impressions it receives, and so to experience their power, which would otherwise be obscured. It therefore lets us into the innermost centre of life; it gives us a sense of the pulse of life; it makes it possible for us to receive the full meaning of visual art.

His book *Point to Line and Plane* is a summary of his Bauhaus lectures. It begins with a consideration of the point in its many aspects. He draws on musical parallels to show its function as a punctuation mark – in the visual rather than the grammatical sense. The diagram which accompanies several bars of Symphony No. 5 by Beethoven demonstrates the relative power and

572

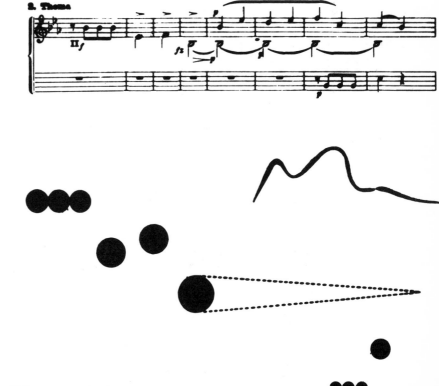

573

dynamics of points. But in art they may be spread over a larger area and enter into a relationship with the plane in which they lie. According to their disposition and

574

relative size points may express states of calm or of movement, as they did in his *Romantic Landscape,* 1911. But here, in these examples, their meaning is not quite so straightforward and more subtle.

575

576

A moving point, like the one introduced at the end of the musical example, becomes a line. A complex curved line is the outcome

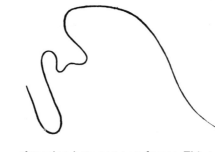

of tension between two forces. This tension can be expressed by thickening the line. A

complex line may contain several stresses in relation to each other. When we look at it we may no longer be aware of the movement which it describes, but only its tension. Thus tension may be counted as one of the qualities of a line. Another

577

quality of line is its direction. To Kandinsky it seems that the horizontal line is cold, the vertical hot and the diagonal tepid. He also attaches different colour values to each orientation of a line and to the nature of each angle between lines. This means that the relationship between lines may also be characterised by a colour: for instance 30° = yellow, 90° = red, and so on. Kandinsky carried out a great deal of research and found many of his theories confirmed by the instinctive reactions of the people he questioned.

As a result of these and other consideration a composition of irregularly orientated lines may be experienced as a spatial compositio (not in the sense of perspective). The lines have different characters and their associated colour values will induce some of them to advance, others to recede, as colours do. On the other hand an even grid of horizontal and vertical lines will indicate balance and lie in the picture plane.

A complex of irregular lines of different tensions and orientations creates a sensatio which arises directly from perceptual effect

578

Nevertheless although Kandinsky often use words as a point of entry into the world of visual experience, the content is purely visual and lies outside the realm of words. Proceeding in a logical fashion from one proposition to the next Kandinsky builds

up a whole theory of visual experience and communication. He eventually arrives at a position where complicated visual 'messages' become possible.

The ideas propounded in his book grew naturally out of his own work. Conversely these ideas may give us an insight into the work he was doing at the time. A painting such as *Abstract*, 1923, can be approached only in those terms.

Paul Klee who had, like Kandinsky, belonged to the *Blaue Reiter* joined the staff of the Bauhaus in 1921. They became close friends. Like Kandinsky, Klee was convinced of the impermanence of the physical and visible world, but in a different sense. 'Peace on earth (i.e. forms at rest and in balance) is an accidental congestion of matter', he says. 'To take this congestion as basic is mistaken.' This has important implications. Everything around us, even though it may look permanent, is the result of certain conditions and will change with these conditions. The permanence of our world is therefore illusory and concern with form for its own sake, as taught by the academies, is quite beside the point, for it no longer tallies with our sense of reality. What matters to us now, in the twentieth century, is not form itself but the conditions which it must obey, the function it serves. These must be studied. A form which has been evolved for a certain purpose may be quite inapplicable in another situation. Klee advises the artist to seek the function, then the space within which the function exists; the form will follow, like the form of a house or a snail's shell.

Klee typifies as no other artist does the modern concern with movement and change, not for their own sakes but as the basis of experience. It is easy to see how such ideas fitted into the scheme of Gropius' Bauhaus, which was also concerned with the evolution of form. To Klee, changing, transforming shapes were the essence of an experience of modern life. He believed that art can no longer confine itself to description, or even analysis, of superficial forms. It must concern itself with experience which is always changing. Art is 'the prehistory of the visible'.

Klee's enquiry into the genesis of form, which was an essential part of his art, relied heavily on a belief in the validity of universal laws, a belief he shared with other artists such as Le Corbusier and Mondrian. In fact his efforts were largely directed to the 'ultimate point where all laws are clear', the ultimate code to which all nature is subject. He said, 'The laws which govern the existence of the whole are contained in the smallest outermost leaves.' The study of nature is therefore not merely

imitative, but has to be born of an understanding of the function of every part. 'Always follow the paths of natural creation, the growth of forms and their functions, that is the best way to learn. Perhaps you may through nature arrive at the point where you can create on your own. . . . Then one day you yourself will be a part of nature; you will be able to create as she does.'

It is important not to misunderstand Klee's meaning here. Art to him was not an *extension* of nature, but an *analogy* of nature. The work of art was an organism of its own, parallel to nature but not a part of it, 'an imitation of the forces of nature, as a child imitates adults'. We are reminded both of Le Corbusier's concept of the artistic machine and Mondrian's counter-nature.

Klee's attitude becomes clearer when we consider his working method. The artist studies nature, that is to say, he tries to understand its workings and phenomena. He becomes absorbed at a deep level. He begins to paint, but he does not paint the natural appearance of nature; he begins with pure forms and colours, for naturalistic forms would bring conscious layers of the personality into play. Pure feeling can subsist only in pure forms as Malevich and Le Corbusier had discovered. Imitative and subjective approaches restrict the artist, while pure methods give limitless possibilities and subtleties. These pure forms which the artist produces must be based on some inner experience, perhaps of long ago, stripped of superficial emotional ties, purified by their passage through the subconscious. The artist must 'listen' to these forms and try to understand their character and their demands; he must allow them to grow freely and even help them in their growth. Then, after a long and often painful artistic process, the truth will emerge, brought to light by the artist's sensitivity. Klee's saying 'art does not render the visible, it renders visible' sums up the whole process, and restates Odilon Redon's definition of Symbolism. The artist may be surprised at his own discoveries. 'Artists know a great deal', Klee wrote, 'but only afterwards'. The artist has made a discovery, as a scientist may discover; art is a method of investigation.

It may now be possible to see the functional aspect of Klee's art more clearly. The academic idea that forms may be taken from nature and incorporated into the work of the artist is fallacious. The artist cannot use pre-existing forms for, as Klee says, 'you cannot start with a result', a point Wagner had already made. New forms must be generated by the artistic process as he describes it. Art is a process, not a product, and it is the *communication of this process* which is the real purpose of art.

Klee's interest in formation rather than form made him an ideal teacher at the Bauhaus. When he discussed a student's work he always stressed the basic problem rather than the aspects of superficial form. His ideas could certainly be paralleled by Moholy-Nagy's, who also taught that the result is conditioned by the problem. Because Klee believed in 'cultivating the purest use of the pictorial means' he could even go along with the emphasis on simple geometrical forms which were the outer signs of Bauhaus design philosophy.

Klee assimilated many of the ideas and approaches of other modern artists and groups of artists. His 'listening' to the inner qualities of forms has a lot in common with Dada, his spatial representation often owes a great deal to Cubism, his analyses of movement to Futurism, and so on. In this too he was reflecting one of the characteristics of the Bauhaus, which absorbed ideas from all over Europe.

When Klee was called to the Bauhaus he felt the need to clarify his ideas in order to be sure of his teaching. His work from that period becomes more clearly defined in its structure, so that the technical means used can be more easily apprehended.

His picture *Runner at the Finishing Line* is typical of this period. The graduated background leads the eye into the mysterious distance but it also has something of the character of the student exercises in tone and colour then common at the Bauhaus. The intimation of movement leans towards Futurism. The figure 1 imprinted on the winning runner's forehead is a witty application of Dadaist methods. The face is a most carefully worked out composition of abstract shapes. Yet despite the disparity of the sources and influences the picture is a complete entity, expressing the joy of winning and also the determination required for it.

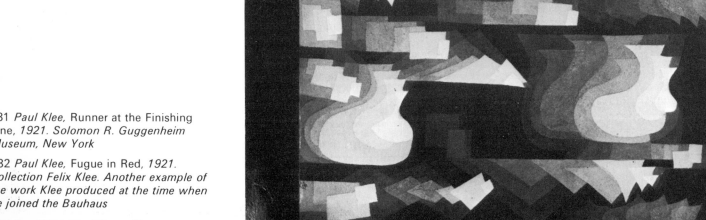

581

581 *Paul Klee*, Runner at the Finishing Line, *1921. Solomon R. Guggenheim Museum, New York*

582 *Paul Klee*, Fugue in Red, *1921. Collection Felix Klee. Another example of the work Klee produced at the time when he joined the Bauhaus*

583 *Paul Klee*, The Watermill

At the Bauhaus Klee set about to codify all his discoveries of pictorial methods, for use in his classes. He felt that these could be taught although he admitted that technique is not everything and genius is a rather special case.

What were these pictorial methods? To begin with an intense observation of nature, in many of its aspects. Studies might be the exact reproduction of even quite small things – for example leaves – or of whole organisms, in either case particular attention to be paid to the function and structure of the object. For instance, plants were considered in these terms: 'An apple tree in blossom, the roots, the rising sap, the trunk, a cross section with annual rings, the blossom, its structure, its sexual functions, the fruit, the core and seeds. An interplay of states of growth.'

To make his students understand this interplay he differentiated between the parts of an organism according to their function as active, medial and passive. In the human anatomy the brain is active, the muscles medial, the bones passive. Almost any functional arrangement of objects,

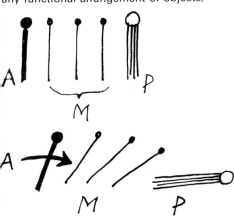

even a row of falling shapes, may be related in this way. For his students he draws a plant and then immediately criticises the

drawing for not explaining the relative function of the constituent parts. His 'corrected' drawing does not look like a plant but has the character of a plant, the natural organism which we normally call a plant. The active force is the soil in which

the seed opens. 'The complex of relations: humus, seed, nourishment, growth, roots.' Then comes the medial element: 'Breathing organs in light and air, leaves.' The passive organ is the flower itself. The graphic representation is drawn from this understanding of the functions of the organism which is a plant. It expresses its functioning and its growth. However, it is not enough merely to understand the articulation of the elements of a working organism; the artist must also have a command of forms to match his understanding. The subject of a watermill provides another example of this. In his first drawing Klee shows an uncomprehending visual statement: the water, the principal element, is not

treated dynamically, it is 'not a striking representation of a principal organ'. A more articulated drawing, which includes the

final link of the functional chain, the hammer, is also criticised from the point of view of form and accent: it does not express the relative importance of functions and the intermediate element is the most prominent. In the last drawing, Klee suggests, the appropriate formation of the elements with proper functional accent is described. I, II and III show the active, medial and passive elements, respectively.

583

Once the artist had understood an organism in these terms, once he had conceived it as an organism and not simply as a series of forms accidentally connected, he would give a rendering of this organism which differs from a superficial picture. A picture of a sleeping man could be simply a picture of a recumbent man with his eyes closed or it could be 'a sleeping man, the circulation of his blood, the measured breathing of his lungs, the delicate function of his kidneys, in his head a world of dreams, related to the powers of fate; an interplay of functions, united in rest.'

All studies in Klee's classes had to start with recognition of the elements of change and growth. A point moves to produce a line, a line moves to produce a plane and

a plane a volume. But the prime mover is always tension. A line results, according to Klee, when a point enters into a relationship with another point and discharges its tension. The process may be reciprocal.

A line may enter into a relationship with another, parallel, line and discharge its tension. The result will be a rectangle or square.

A triangle results from the discharge of tension between a point and a line.

P

But for a more complete expression of tension other lines are also necessary to indicate the whole area or volume in which the tension exists. An increase in the density of the lines indicates increased tension.

Lines may also be employed to indicate the growth of a form from within, like the yearly rings of a tree. They may also be used to emphasise the termination of growth, the edge of a form.

Klee was always able to produce works full of visual poetry from such basic enquiries into the nature of the visible world. The drawing below is entitled *Three Phantom Ships*; it is a composition in which a variety of shapes, charged in various degrees, articulate with each other.

Klee demonstrates rhythm in graphic terms.

584

One may also sense a rhythm uniting two different lines of elements. Again Klee uses

585

such simple ingredients, freely applied, in his work. *Flowers in a Wheatfield* and *Sailing Boats in Gentle Motion* are essentially rhythmic compositions.

586

587

It will be seen that although Klee believed in pure pictorial means and shunned any kind of imitation the pictures and drawings shown so far do in fact bear titles which relate to distinct realistic situations. He believed that although the origin of art must lie in the unconscious, free from superficial thought processes, and reach the artist's consciousness through an artistic process, such pure means may yet be 'revealed' by the artist; he may recognise certain rational subjects in them. However this will normally happen during the last stages of working out the composition and it is then that it may receive its suggestive title. Klee's titles are often of a poetic, rather than a descriptive, nature and are intended to give an added stimulus to the observer's imagination. For instance, *Three Phantom Ships* has not a realistic meaning. The drawing shows three related shapes — which we may accept either as lozenges or rectangles in perspective — with their tension lines. From the insides of these shapes other lines of various lengths have sprouted towards the top. The drawing describes the relationship between shapes and their inner tensions and the offshoots of these tensions. A tense, yet delicately balanced structure has arisen, but a feeling rather than an actual

588

structure, a drawing more of the nature of music than of traditional visual art. It expresses an almost disembodied view of natural forces, universal in its validity. The title, however, tells us that we may, if we wish, apply the vision of this structure to a definite situation. We may see a ship's hull as a form with its inner tension and the rigging as an outgrowth of the hull's inner tension. But to see ships in this way is not merely to analyse them: they also acquire special qualities and overtones of poetry; they are not, in this case, just ships but phantom ships.

Let us return to the line as a point in motion. It may have a complex path and its character may be underlined by other subsidiary lines.

However the concept of a moving line brings with it the concept of a temporal as well as a spatial art. If a line moves it may be treated like a melody, there may be two or more voices and even counterpoint. Like a musician, Klee is able to take a simple melodic strand and, by varying its character and pace, to give it a content which goes far beyond the mere statement of two intertwined movements. The drawing *Symptomatic* seems to sing – in several voices.

One of Klee's most important contributions to the pictorial theory of the twentieth century is his treatment of space. In everyday reality, forms become visible through the light which breaks over them. Traditional illusionist painting imitates this effect of light in order to describe reality. Klee noted that when such a painting is viewed in conditions in which the light source is different from what it was when the picture was painted, the disparity makes the effect rather unpleasant. In traditional painting the space described by the picture could be understood as an extension of the space in which the observer stands. We have seen how modern artists rebelled against the attempt to reproduce nature. They therefore reduced the apparent space behind the picture plane – the Cubists are an example - and approached a completely flat plane. Once the illusionist effect had been abandoned, new effects were detected by human perception: the interaction of adjacent areas of colours, of tones, the optical separation of shapes and structures into their own systems. Klee investigated these phenomena both through his own work and in his teaching. Weight, as he explains it, may be seen as the ability of different densities of tone to advance or to recede from the picture plane.

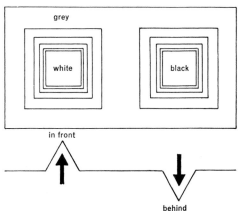

589

Klee used the expressions *endotopic* and *exotopic* to denote the inner and outer space described by an outline.

He concludes that endotopic shapes tend to stand out while exotopic shapes tend to recede. This sensation of space may be further qualified by the vibration of contrasting colours and the effect of superimposed, transparent areas of colour or tone, to which Klee referred as polyphony.

A looped line may describe both inner and outer space at the same time and this ambiguous space, which can be read in different ways, is further complicated because, as Klee says, one cannot always be sure whether certain planes recede or advance in relation to each other. The total sensation of space obtained by such means is most complex, yet it does not employ the usual rational means of describing space. The space of Klee's pictures is not the space in which ordinary physical events can take place; it can be grasped only at a deep level of human perception. Klee refers to it as abstract space and it is interesting to compare this to Mondrian's use of the word 'abstract' in opposition to 'natural'. We may also term it spiritual space, as Kandinsky did, to differentiate it from the concrete, physical space in which we live, the space we can measure and rationalise.

584, 585 *Paul Klee, Studies in rhythm*

586 *Paul Klee,* Flowers in a Wheatfield, *1920. Private Collection*

587 *Paul Klee,* Sailing Boats in Gentle Motion, *1927. Private Collection*

588 *Paul Klee,* Three Phantom Ships, *1928. Paul Klee Foundation, Bern*

589 *Paul Klee,* Symptomatic, *1927. Collection Felix Klee, Bern*

Italian Town may be the result of a dimly-felt memory. Through the transparency of shapes we experience both their inside volumes and their outside forms at the same time. Perspective is contradicted and seems illogical; in fact it enlarges space which Klee described as an artistic aim. The shapes are not illuminated by a consistent light source outside the picture, which would have been wholly against Klee's intention, but produce their own inner light. We may read the whole picture as a polyphonic composition of flat shapes, i.e. overlapping shapes. The poetic content is stressed by the warm-cool colour contrasts which separate the planes even more and give the space a fairy-like quality.

If art is to be not an extension of nature, but, as Klee declared, a parallel and an analogy to it, then it cannot exist in nature's space but must inhabit a space of its own, in which its potential can develop to the full. The concept of space inherited from the Renaissance was expressed by perspective and chiaroscuro. The new spiritual, abstract space in which much of twentieth century art moves relies on perceptual qualities, Klee's 'pure pictorial means'. Le Corbusier had pursued similar aims in his Purism.

Bauhaus teaching was founded on the training of visual and plastic instincts and intuition, for the solving of practical, rational problems. The system developed at the Bauhaus, and in particular by Moholy-Nagy, towards this end may therefore be said to give irrational drives rational forms. This is the most effective and harmonious way of bringing the inner and the outer worlds together, of linking the individual to his environment; it is the basis of all great art. Klee, who always believed in the rationality of the irrational, was a natural contributor to the system, since its basic direction coincided so closely with his own. He took this modern approach to its limit, providing and teaching practical ways of achieving its aims.

In Kandinsky's demand that the work of art should follow the artist's dream with the greatest precision, we may interpret 'dream' as 'spiritual vision'. In Klee's work — both his paintings and his writing — this precision seems to attain the highest fulfilment:

590

590 *Paul Klee, polyphony, individual parts and superimposed parts*

591 *Paul Klee,* Italian Town, *1928. Collection Felix Klee, Bern*

592 *Walter Gropius, The Bauhaus, Dessau, 1925, aerial view*

593 *Walter Gropius, The Bauhaus, view with a corner of the workshop wing in the foreground*

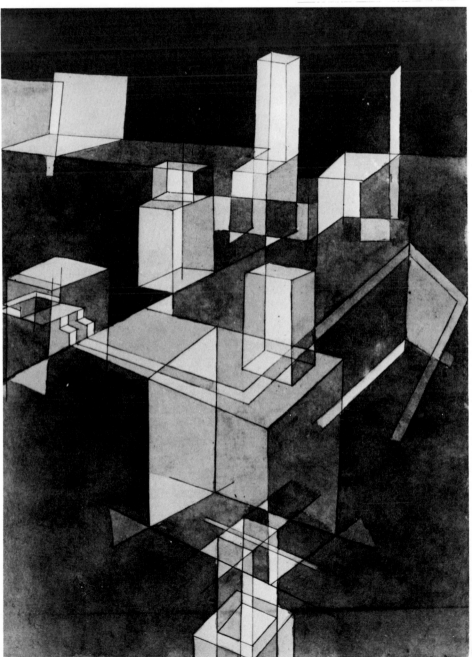

59

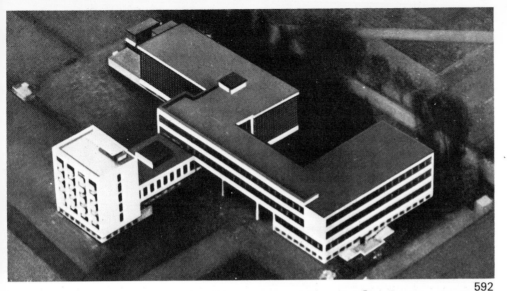

592

By the time Kandinsky and Klee were exploring the intricacies of their teaching programmes and the workshops were entering their second — non-stylistic phase, the Bauhaus was no longer in Weimar. Owing to political pressures its position had become untenable. An offer of a new home for the Bauhaus in Dessau was accepted and the move was completed in 1925. It was at first housed in temporary premises, but the design and building of a new school began almost immediately and the new building was inaugurated in 1926. In this new design Gropius created not only a building worthy of an institution founded on such progressive ideas but the first masterpiece of the new architecture, a crystal symbol, if not of a new faith then at least of new possibilities of ordering life.

With his new building, Gropius completely abandoned the axiality of the Werkbund factory. Functional requirements seem to have dictated the plan, with the complexity of its elevations and spatial articulation, only, as Gropius remarked, to be experienced by walking round it. A modern building can no longer be an object of static contemplation — a principle already established by modern artists in many spheres — for there are no façades, only planes, forms, spaces, textures. The only single view which comes near to doing justice to the complexity of the new building is the aerial one, duly included by Gropius in the first pictures of the building to be published. This aerial view shows the tripartite organisation: the atelier (studio) building, which also includes 28 bedsitting rooms for students, the workshops, and the technical college (the local college attached to the Bauhaus) form the three largest masses. They are connected by two more slender elements: the lower one between workshops and atelier building incorporating the lecture room, the stage and the refectory; and the higher one on stilts, nicknamed 'the bridge', containing the department of architecture and administrative offices. This spatial differentiation of each part of the complex gave Gropius the opportunity to treat each one according to its function. The unification of these seemingly disparate elements is brought about — apart from certain similarities of detail — by the organisation of forms and spaces. In spite of the great variety of treatment — from the large glass walls of the workshop block to the balconies of the residential block — unity is achieved as it had not been at the Werkbund. The different elements penetrate each other. For instance the bridge runs into the technical college and this is made explicit by the pattern of the windows.

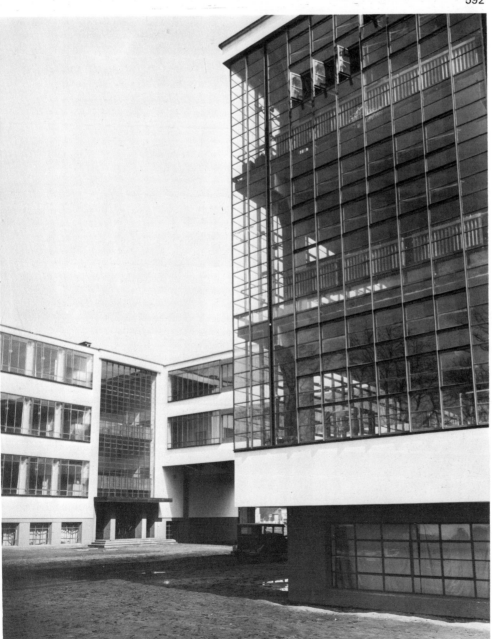

593

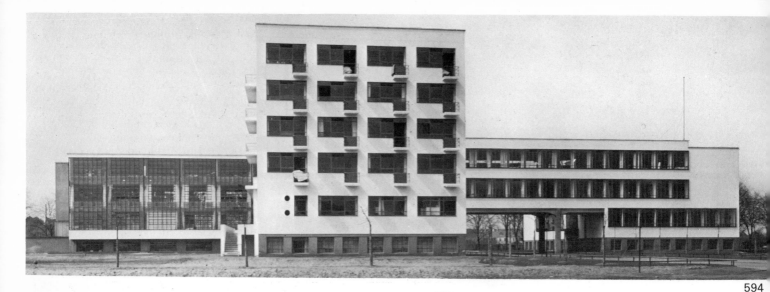

594

594 *Walter Gropius, The Bauhaus, Dessau*

595 *Walter Gropius, Gropius' own house, Dessau, 1925*

596 *Walter Gropius, master houses, Dessau, 1925*

597 *Walter Gropius, settlement at Törten, 1926*

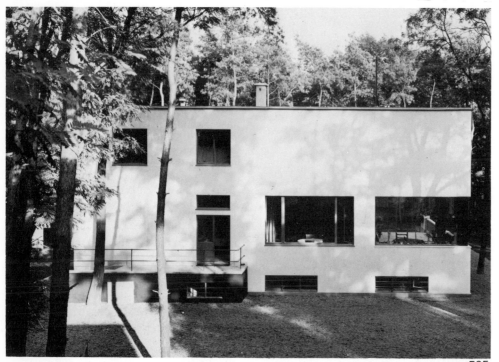

595

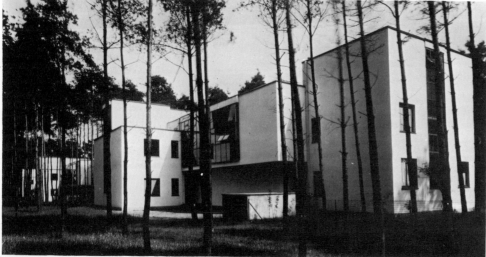

This interpenetration takes place both in a vertical and a horizontal sense, somewhat on the lines attempted — in theory and on a smaller scale, respectively — by van Doesburg and Loos about two years earlier, although there does not seem to be a direct connection between the three projects. In Gropius' building everything is stated with such clarity and mastery that one is aware that modern architecture has come of age.

The houses which Gropius designed for himself and some of the masters are just as remarkable in demonstrating the new architectural ideas. Functional requirements are again obeyed — studios on the north side, living rooms on the south. The interpenetrating forms, the cantilevers, the spaces related to the solid form, the

596

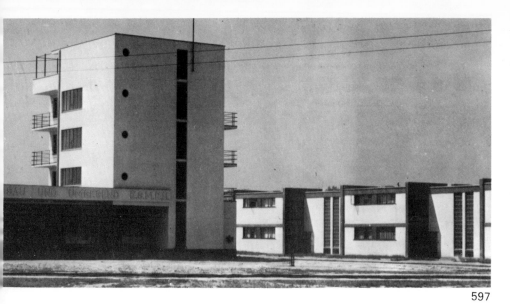

597

windows composed in the functional/
visual manner are all reminiscent of Loos
and de Stijl, but these influences are
brought together in a strong individual
language and used with assurance. Taken
together the buildings are the first
convincing demonstration on a large scale
that the new architecture is not confined to
visions but can actually take form to
provide pleasant, efficient, technologically
advanced environments for twentieth
century people. The whole Bauhaus
complex was one large essay on new
building methods, expressed in a confident
visual language. It also gave a practical
demonstration of Gropius' dream of a
group of designers working together on a
common project; here the building site
became the experimental workshop.

In 1921 Gropius had investigated the
possibility of using similar building elements
in series production, while varying the
visual effect by changes in their composition,
following up the ideas outlined in his
memorandum of 1910. He had made a
number of models to visualise this project.
The master houses were the first concrete
expressions of the method he had evolved.
The plans were in some cases identical,
yet the expression varied. Standardisation
was carried to greater lengths when with
his team Gropius designed a working class
settlement at Törten, near Dessau. Here
were made the first attempts at true mass
production, using local labour and local
materials to prefabricate the building
elements on the site. They were then
hoisted into position by means of cranes.
It was in this connection that Georg Muche
designed his experimental steel house,
made from prefabricated, standardised
parts, which could be added to or simply
changed to allow for variations in the
number and kind of inhabitants. This
advanced idea remained only a project at
the time – 1924–1927 – and was not put
into production.

In 1928 Gropius retired from his post of
Bauhaus director in order to give more
time to his private practice, but other
reasons of a political nature must have
contributed to his decision. Moholy-Nagy,
Breuer and Bayer left at the same time and
from that time on the Bauhaus took on a
somewhat different character. Hannes
Meyer, Gropius' successor, gave greater
emphasis to architectural and technical
aspects of the work and added psychology
and town design to the subjects taught.
After only two years at the head of the
Bauhaus, Meyer was deposed and Mies van
der Rohe took over. Peace was never to
return again to the school. It even had
to move to Berlin, where it was eventually
closed down in 1933, shortly after Hitler
came to power in Germany. Had the
Bauhaus been merely an institution, a
college, this would of course have been the
end. But as Mies said the Bauhaus was an
idea and the dispersal of teachers and
students to all parts of the world ensured
its influence in a way which, Mies declared
'could not have been achieved by
organisation or propaganda. Only an idea
has the power to spread so far and wide.'

Modern ideas in art, architecture and
design were evolved for a world in which
the liberation of human sensibilities rather
than national greatness would be the
highest aim. They do not lend themselves
to the grandiloquent, one-sided statements
which dictatorships require. On the
contrary modern art probes, it expresses
doubts, it admits different interpretations.
The European totalitarian systems therefore
reacted decisively against these ideas. The
Bauhaus was the symbol of all that was
modern and progressive in art, architecture
and design. It was therefore pilloried in
Germany as a hotbed of Bolshevism and at
about the same time Russian artists and
architects – sharing some of the aims of
the Bauhaus – were branded as bourgeois
and reactionary in the USSR.

The importance of the Bauhaus lay in the
fact that it was the first true repository and
testing ground of the new ideas in art,
architecture, and design, and in the
education of designers. The first attempts
to relate the new art to the new pattern of
life, to the new technology and to newly
discovered human sensitivities were made
there.

In assessing its significance we must
realise that its short life was not enough to
prove or disprove the validity of its
theories. It was never free enough from
pressures of many kinds – political,
bureaucratic, financial, aesthetic, and so
on – to allow a normal development.
Furthermore the products of the Bauhaus –
now so eagerly displayed, illustrated and
imitated – must not be judged merely as
products but must be seen as symbols of
educational processes. The preliminary
Bauhaus course has often been
misunderstood and misapplied, and
similarly should be seen as an educational
process with sensitivities as end products
rather than objects.

If we were to mark up a list of Bauhaus
merits, we could start with the books which
Kandinsky, Klee and Moholy-Nagy were
induced to write by the educational
demands of their new situation as
educators. The whole series of Bauhaus
Books helped to spread the ideas which the
Bauhaus symbolised. The concepts of
standardisation and prefabrication in
architecture and architectural design were
explored in the Bauhaus, so that architects
and designers began to look for beauty in
the harmony of elements, of functions and
of processes, rather than in traditional
sources. The concept of teamwork was
explored and tested at the Bauhaus under
realistic conditions, defining the position
of an individual designer within a team and
the responsibility of the team to society.
The skills within each team and the broad
creative processes were isolated as new
concepts.

There was yet another aspect of the work
of the Bauhaus which gave it importance.
During the early part of this century, when
so much was achieved in various fields
of art, when so many new vistas were
opened up, there must have remained a
big question mark hanging over the
possibility of applying this new art to the
new life which was beginning to spring up
everywhere – the new life with its new
ideas and ideals, new technology and new
emotional demands. Was the new art to
take its place alongside traditional art in
the picture galleries? If not, what validity,
what direct applicability did it have to the
new life it professed to express and
enrich?

Early attempts to effect a direct link, to apply art in its pure forms to manufactures and to architecture, were not hopeful. Cubist principles applied direct to buildings and furniture, as in Prague, Suetin's attempt to justify Suprematism by decorating plates with Suprematist patterns, led to nothing constructive and remained a decorative whimsey. The basic concepts had remained untouched; only the outer form had been changed. The idea of the artist-engineer, conceived in Russia, was tried out on small projects; larger schemes, like Tatlin's tower, never became reality. The question still remained: were the new artistic projects simply visions or could they take practical shape in terms of twentieth century technology and society?

and more profoundly – the greater significance of the creative process in relation to the ultimate product, of formation over form. In his teaching course he never criticised his students' work on formal grounds. He always discussed the *problem* and – using a small hand-blackboard – various possible *solutions*. No form could be considered good or bad in itself, but only in relation to a definite problem. There could be no over-all form-recipe for problems; that would have meant a return to 'style'.

During the first years of the Bauhaus, design was still predominantly a stylistic matter. During the years of its maturity, however, the Bauhaus drew nearer to the original aim of form-giving set out by Gropius. This could not be realised until the

language of form-giving had been mastered, the visual language of the new art. Because the new visual language was absorbed at a deep level of consciousness as a true language, to be developed by individuals and enlarged with use, the new approach to the designer's creative processes became possible. It cannot be denied that such processes were also attempted elsewhere, but nowhere could this process of change from *style* to *creativity* be observed more clearly than at the Bauhaus. It was there that the evolution of the process took place in an almost symbolic, ritualistic purity, in spite of the smoke of battle, shaped by upheavals from within and attacks from without. That the Bauhaus could accept these changes without being untrue to its own beliefs reflects the soundness of its ideas. Had it rejected any of these changes – some of which appeared to be leading it astray but which were in reality taking it closer to its appointed path – the next generation would have benefited very little.

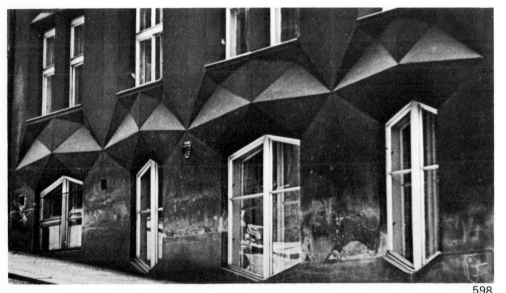

598 *Josef Chochola, house in Prague, 1912*

599 *Pavel Janak, table and chair, Prague, 1913*

600 *Nicolai Suetin, decorated coffee pot, 1923. Suetin was a pupil and follower of Malevich*

598

The truth which gradually emerged was that the new discoveries in art need not necessarily find direct application in the new environment, yet could still make a major contribution to its evolution. The new art had discovered – or rediscovered – new visual elements: space, form, rhythm, movement, structure, colour; the relationships between them and their psychological effect. Their development had brought new perception and sensitivity within human range and this in turn had made possible the new education of designers and later of the public. The new problems of the new environment could now be approached in a more humane spirit, looking for beauty not in 'style' but in a harmony of the elements of function and technological processes: Gropius' original vision.

The new vision of the new art became of value not only in the Bauhaus workshops but – more importantly – in the preliminary course and all allied work, such as that done under the direction of Kandinsky and Klee. Klee recognised before anyone else –

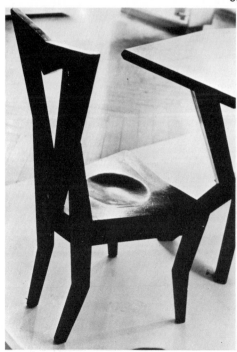

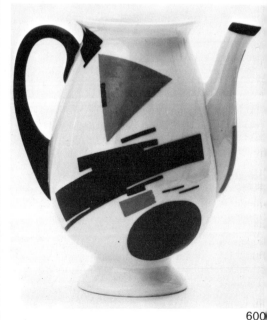

232

599

600

Epilogue: Perception and Feeling

In 1902 Hermann Obrist made a model for a large sculpture. In this model the most conspicuous visual element is a spiral; at the bottom a figure begins his ascent; at the top a rewarding angel awaits him. The spiral form makes its own direct visual impact but still relies on a factual and moral interpretation. The sculpture represents the upward path of a human being towards perfection; it is a simile of human life.

Tatlin's model for the tower of 1920 has a similar subject: the progress of humanity. It is based on a similar form to Obrist's sculpture but nevertheless stands in marked contrast to it. There are no factual clues to meaning and we must interpret it for ourselves. Whatever emotions it arouses come from the play of forms, of abstract elements and the enclosed space, not from any verbal meaning like that of Obrist's work. It is in the traditional sense not a monument, for it has a functional purpose.

An engineering structure has been endowed with a significance far beyond mere engineering.

These two sculptures are separated by about eighteen years. They pinpoint the enormous changes in the artistic climate during the early years of this century. In Obrist's Art Nouveau sculpture sentimentality and factual interpretation in the nineteenth century manner still linger on. Tatlin's monument has a spirit which we recognise as our own. It is a true work of the twentieth century embodying the three ingredients of the Modern Movement: social consciousness, perceptual awareness, machine aesthetic. They are inextricably interwoven; to remove one would be to destroy the rest.

This fundamental changeover from nineteenth to twentieth century art can also be observed, even more dramatically, in the production of a single work of art. *Les Desmoiselles d'Avignon* changed from its nineteenth century intention to a twentieth century fulfilment. It illustrates forcibly the proposition with which this account of the Modern Movement began, that a verbalised and factual content had to give way to a visual content, just as sentimentality had to give way to real feeling, before a new approach to the human environment could take shape.

601 *Hermann Obrist, model for a monument, 1902. Museum Bellerive, Zürich*

602 *Vladimir Tatlin,* Monument to the Third International, *1920*

601

602

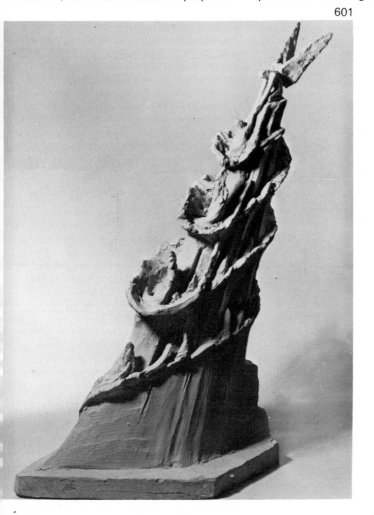

As artists concentrated on visual content and feeling, subject matter lost importance. The rhythm of lines, the character of shapes, the orchestration of colours, these were now the elements through which the artist spoke. Where in a traditional picture the visual focus was normally an object in its conceptual role, in a modern picture the focus might consist of a clash of two colours. Eventually such visual ideas led inevitably to a complete abandonment of subject matter, even if often only temporarily, as part of an ultimate clarifying process. These new visual elements had to be understood in terms of their own expressive qualities and undistorted by conceptual cross-currents.

The advent of abstract painting opened up new possibilities, at the same time posing problems as old as art itself but in a new guise. In a classical composition painted in a traditional manner the factual information contained in the picture is the main point. Normally the painting will have been made for the purpose of communicating certain information: the impressive presence of a commander; a princeling's mercy or magnanimity in the hour of triumph; a woman's beauty; the self-denial of a saint; and so on. In order to express these ideas in their most effective visual forms the artist disposed the shapes in a definite relation to each other: shapes may be in sympathy with each other, or in opposition, in tension or in relaxation. Relationships of this nature can be found in all good paintings. In the picture shown here the relationship between the two main shapes can be readily understood but it is much more evident in the diagram, in which the shapes have lost their naturalistic detail. The deep perceptual and visual relationships are less obvious in the actual painting because we are too much concerned with the 'interpretation' of the two shapes.

This has always been an underlying factor in all painting, but it has never been more potent than in abstraction, where the artist has established the right to strip his work of all traces of realism in order to penetrate depths of experience which cannot be reached on a realistic level.

If the relationship between shapes was clarified as a result of abstract art, the relationship between shapes and the spaces between them was even more thoroughly examined and brought into prominence. In this diagram of a picture by Hans Arp the visual significance of the relationship of the two shapes is easily grasped: a balance of two unequal rhythms, counterposed as in

606

music. Through the particular nature of the individual shapes and the manner of their composition, the space between them has a major significance in the picture. It can be seen as a third shape in the drawing below, its extremes left open and merging into the rest of the surrounding space. It

acts therefore as an additional link between the two main shapes and also links them to the picture plane. There is, as we have seen, a similar interest in relationships between solid shapes and the spaces between them in the architecture of the period, for instance in that of Frank Lloyd Wright.

605

603 *Titian,* Noli Me Tangere, *National Gallery, London*

604 *Analysis of 603*

605 *Hans Arp,* Overturned Blue Shoe with Two Heels under a Black Vault, *1925. Collection Peggy Guggenheim, Venice*

606 *Diagram of middle space in 605*

603

604

In an abstract painting, then, everything seems to matter. In a traditional painting some passages often have no special significance but are included in order to make the factual meaning clearer or because they happen to be part of the realistic situation described by the picture. An abstract painting has no need for such fillers; everything in the picture is there because it was — consciously or unconsciously — required by the artist and not because of some fortuitous circumstance.

Once this position had been reached it was not long before a work of art could be considered in its own right, with its own reality and not necessarily in relation to the natural world. Only then could the Constructivist experiments with materials and structure take place and the machine aesthetic be formulated, only then could art make its contribution in the formation of the environment. Because traditional subject matter had been removed and the content of art became wholly visual, human perception was both broadened and deepened. Abstraction was therefore a humanising influence.

There were parallel developments in other fields, notably in music. The early music of Arnold Schoenberg has a great deal in common with Kandinsky's early improvisations. Highly coloured and emotional, it took traditional means to breaking point, when the old techniques became wholly inadequate for the new meanings. The new musical order which emerged was comparable to the new visual order. Serialism, as Schoenberg's new system came to be called, has no tonality, no keys, no recognisable tunes. A piece of serial music is based on a series of notes related to each other without the 'focus' of a key or a tonic — like the planes of a Cubist painting or the shapes of an abstract painting by Kandinsky or Malevich. We can therefore describe serial music as abstract. Schoenberg made his first approach to abstraction — his String Quartet No. 2 — in the year in which Picasso made his first decisive break with traditional painting — 1907.

Relationships between planes, rhythms of lines and other expressive elements were always inherent and half-felt in the visual arts. The new development in modern art is that these factors were now isolated — through abstraction — and brought into consciousness. Likewise in music. Serialism had been inherent in the music of earlier periods. For instance Mozart at times used a technique which could be described as an early example of Serialism. Schoenberg's extraordinary insight into musical structure — wholly parallel to Kandinsky's and Malevich's insight in another sphere — recognised these musical

relationships and brought them into consciousness in the form of Serialism. Abstraction therefore is a method of elucidating the subtle, half-sensed meanings of our environment and of art, even traditional art. It does not introduce anything intrinsically new, but only a new emphasis. The process of rendering explicit what has been obscure must be undertaken in its own language — visual in the visual arts, aural in music — and not in transliteration.

Although the different movements and different artists and designers who contributed to the Modern Movement had a variety of immediate aims and interests, yet they were united in their social conscience and their anti-establishment and anti-bourgeois tendencies. Futurism, Dada, Expressionism, Suprematism, all attacked the old and the established with a vehemence which belongs more to political than to artistic movements. The manifesto of Die Brücke is typical. It says: 'We believe in the growth of a new generation of creators as well as those who enjoy what has been created. We appeal to them, the youth, the bearers of the future. We want to obtain our freedom in opposition to the well-established, old forces. Everyone who genuinely reflects his creative urge is one of us.'

As the last sentence indicates, the revolution is to be creative and artistic. The new movements, enlarging as they did the scope of human perception and visual imagination, attacked bourgeois society as the great barrier to artistic aspiration. The provocative affronts to bourgeois values, the ridicule of bourgeois institutions and morals, were basically an attack on materialism itself, which was at the heart of the established order. Kandinsky, one of the spiritual guardians of the Modern Movement, speaks of 'the nightmare of materialism which turned life into an evil, senseless game.'

The Bauhaus accepted eagerly many modern visual ideas, but never for the sake of novelty. Gropius and his collaborators were constantly alive to developments in other countries and absorbed many into their own creative work. The diverse and fragmented ideas which were fed into the Bauhaus emerged as a coherent language, philosophy and creed. This could probably have been accomplished nowhere else but at the Bauhaus, where artists and designers, masters and students, working in close proximity — although not necessarily in harmony — writing and arguing, threshed out a multitude of problems concerning design and the education of designers.

Along with these ideas the Bauhaus also absorbed the anti-materialism implicit in the movement from which they sprang.

Because the Bauhaus produced tangible objects, worked with industry, accepted the machine and machine techniques, its underlying anti-materialism has often been overlooked. Gropius' acceptance of the machine must not be confused with Futurist worship of the machine. To Gropius the creative function of the designer was to purge the machine of its 'anti-spirit' (Ungeist), an exact opposite of the Futurist point of view. Gropius saw in the Bauhaus not merely an institution for the encouragement of the design of efficient objects and buildings. He recognised the unique opportunity it afforded 'to educate men and women to understand the world in which they live and to invent and create *forms symbolising that world.*' The machine as he saw it had to be brought into subjection, becoming a sensitive tool in human hands, and an extension of human personality. The apparent contradiction in the aims of the Bauhaus is still shared by industrial designers and architects; the arguments begun at the Werkbund are as far from solution as ever. Can the objects of a designer's attention be really efficient and satisfy technological demands while at the same time serving man's emotional and spiritual needs? Moholy-Nagy's slogan 'Man, not the product, is the aim' is useful in establishing an order of priorities, but does not do very much more. It may be that the position of the Bauhaus — and of the whole Modern Movement — cannot be described in precise, definite terms at all, but only in its own terms, through the sensitivities it tried to teach. What from the outside appears as a contradiction is entirely logical and comprehensible when experienced from within the creative sphere.

In his book *Point to Line and Plane*, which embodies the theory of his courses at the Bauhaus, Kandinsky suggests that abstract points and lines, while retaining their essential character, may also, through their position, produce feelings of relaxation, balance and imbalance, rest and agitation. He also indicates the dual function of the pictorial plane itself — the plane in which a composition is painted — which is not only a plane in the ordinary sense of the word but also an undefined, perspectiveless space, not restricted to the three dimensions of ordinary space or to the exact measurement we apply to them. It can be sensed, rather than defined, like pictorial tension and balance. This means that any composition may be subjected to different interpretations: it may be projected forward into the outer, material world where it has a material presence and may therefore grow into a material manifestation such as industrial design; or it may be projected backwards into the immeasurable, spiritual space of the inner world where its content relates to the working of the human psyche. Rejecting as unenlightened

the view that visual analysis will destroy the very sensitivities which hold the key to visual comprehension, Kandinsky suggests that only *a sensitive and educated eye* will appreciate the visual implications which form the heart of twentieth century art. Kandinsky's pictorial plane with its dual projection may be taken as symbolic of the whole philosophy of the Bauhaus and the Modern Movement. It is the common denominator of the physical and the spiritual world. Like Kandinsky's plane, the Bauhaus idea can be fully grasped in its dual meaning only by the possessor of a sensitive and educated eye, not necessarily of an educated intellect. When Moholy-Nagy says that 'Mathematically harmonious shapes, executed precisely, are filled with emotional quality and they represent the perfect balance between feeling and intellect', he sums up the capacity of the new visual language.

Now that we see a new environment taking shape around us, apparently in the forms proposed by the artists and designers of the Modern Movement, we may be inclined to think that the victory of the Movement has been complete. If, however, we pause to consider the inherent and essential duality of the ideas of the Modern Movement, we come to the sad realisation that although the surface appearance of our environment is often an expression of its ideas, the spirit — Kandinsky's backwards projection — is in most cases absent. To put this failure down to the upsurge of materialism alone, would be a one-sided interpretation of events. It must be recognised that the very fact of the modern visual language being widely accepted and consequently used as a recognisable style has something to do with the denial of its inner world and, as we shall see, with its suppression.

Nietzsche was important not only for his effect on the European consciousness of his time and after. He was also first to define the nature of creativity in more or less modern terms. He conceived creativity as the interaction of two different elements of the human personality: the Apollonian expressed by man's ordering faculty, and the Dionysian by the inarticulate impulses which from time to time reach the surface of his mind. (Today we should use the expressions conscious and unconscious mind to describe these two faculties.) It is in the depths of the Dionysian half of the human personality that the seat of creativity must be sought, for it is here that the shackles of convention are thrown off and creative acts freed from conscious inhibitions. The creations of the irrational faculties will clearly include subject matter and forms which may be highly distasteful to the rational, the Apollonian part of the personality. In the average person these deep feelings are suppressed, but in a few

they are too strong to be subdued and may reach the surface of the mind in the form of works of art. Because this creative process may offend against existing social values, particularly those concerned with morality, it is resisted by society as a whole. But resistance is not permanent; the really great works of art will exert considerable attraction for society in spite of their initial unacceptability. The Dionysian in each of us sympathises while the Apollonian tries to suppress the threatened danger, rather as a government keeps popular discontent in check by censorship and repression. When the pressure becomes too great and a revolution seems to be imminent, the revolutionary is silenced by being given a seat in the government. In office the revolutionary becomes respectable; the white-hot, irrational, immoral Dionysian impulse settles down into a *style* and yesterday's ugliness is today's *beauty*. The immoral undercurrents are no longer recognised as such and life although changed to some extent can go on as before.

This process can be observed with every single important artistic idea and movement. Most new visual ideas are described as ugly when they first appear — in many cases the only real opposition — but are subsequently accepted and acclaimed by society. The very fact that an idea is accepted by the rational mind means that it no longer has power to shock or stir. The new idea is often adapted and incorporated with other ideas. Its original meaning is no longer apparent. It is respectable. When a new idea, a new movement, gains acceptance by the establishment it may seem to be a victory when in fact it is a defeat of its original purpose.

Style may therefore be seen as a suppression of the instinctual, and creative, faculties. When new ideas harden into a style it is necessary to attack and challenge this with newer ideas still, if human sensibilities are not to become fossilised.

At the Bauhaus the Dionysian element was never neglected. Gropius demonstrated this by his faith in the ability of Bauhaus artists to influence the creative imagination of designers. He fought hard to dispel any notions of a conscious 'Bauhaus style', as Wagner had done in Vienna and the Constructivists in Russia. He understood and feared the implications. He never allowed solutions to new problems to be prejudiced by a conscious familiarity with forms which fitted into an easily handled scale — an Apollonian method. One remembers Loos' precept to start with first principles ('Don't think of the roof — think of rain and snow.') In fact the designer must go back even further, into the depths

of his own unconscious, where original solutions are to be discovered in the Dionysian, creative element of the personality.

Gropius was fully aware of the dangers of a new academicism of squared-up 'modern' forms and of the meaningless mechanical arrangements and re-arrangements this would lead to, a situation in which instincts would be as much suppressed as in the years of the old academicism. Nevertheless the inevitable occurred; a style was formed, because Bauhaus followers, falling below the creative level of their masters, found a 'style' easier to follow than the often irrational logic of their own instincts.

The very concept of style is opposed to the aims of the Modern Movement. The leaders of the Modern Movement had no intention of finding a new style to replace the old (in spite of an occasional use of the word). They tried to bring about new conditions in which human faculties, newly revealed and sharpened, could be creatively employed. It has since become apparent that in a rapidly evolving world there is no place for the easy following of past ideas, however creative in their original situations. When we speak of a 'modern style' we admit the defeat of the Modern Movement.

New breadth of perception, sensitivity to visual content and not merely conceptual meaning, the imaginative thinking arising from these newly-liberated faculties — these are the discoveries of the Modern Movement. It has given us the means to find original solutions to our own changing problems, not a set of rules and easily copied forms. If we imitate their products — as is so often done — we dishonour the masters of the Modern Movement, whose concern was the creation of new original forms.

When the débris of old styles had been cleared away, it should have been possible to enter a period of low stylistic concern and high creative effort. This alas has not happened. It is, of course, possible to argue that the ideas of the Modern Movement have been accepted by society — are not our suburban villas and new town houses in a style which marks them as unmistakably modern, are not the products of our industry 'in the modern idiom'? A more informed and critical observer might notice that the forms are debased — as debased as Voysey's forms were debased by speculative builders, as debased as the use made by nineteenth century designers of the forms of earlier periods. Only a small proportion of buildings designed in the last few decades has any real architectural worth; the number of well-designed and sensitively-detailed consume

goods is minute compared to the total output. And so, in spite of being 'based' on ideas derived from the Modern Movement, the quality of the environment is constantly deteriorating. Small budgets and the need for competitive prices are a poor excuse, for prestige buildings and products are amongst the worst offenders. Their sophisticated, often extravagant, self-consciously 'modern' forms, clothed in rich materials, have become the conspicuous reminders of the wealth, the power, the standing, the 'progressiveness' of their owners, whether private individuals or commercial enterprises. Promoted by the very sections of society which the artists and designers of the Modern Movement had tried to disestablish, the 'modern style' now fills the position left vacant by what in the last century might have been called the 'Victorian style'.

The highest aspirations of the Modern Movement, which sought to sharpen and sensitise human perception, to affect the quality of the man-made world, and so of society itself, have remained unfulfilled. In an age which produces goods for the sake of production — reversing Moholy-Nagy's slogan 'Man, not the product, is the aim' — and which is in danger of indiscriminate, unquestioning worship of material wealth, and nothing beyond, such aims are clearly unattainable. Only the material aspects of the ideas of the Modern Movement have been accepted, from motives which range from economics to fashion; indeed, only those aspects can be understood at all, as a suitable frame of reference to the production of goods and the enjoyment of the material acquisitions of our society.

However, a glimmer of hope remains. There must always be artists and designers who avoid the pitfall of style. Such men realise that in a quickly evolving society all forms of art, architecture and design must remain flexible if they are to play a part in this evolution, if they are to make the products of our technology accessible to human emotions and the human spirit. They understand that there can be no 'modern style' but only a well of creativity with open imaginations attuned to the changing conditions of life. The success of the new generation of artists and designers, and their ability to enrich life, will in the last resort depend upon us; and how shall we recognise them, or the quality and meaning of their work, save through a sensitive and educated eye?

Index

The publishers would like to express their gratitude to the following for permission to reproduce works in their collections and/or supplying photographs.

Akademie der Künste, Berlin 284, 285, 286, 298, 299, 300
Allgemeine Elektricitäts-Gesellschaft, Braunschweig 272, 273, 274, 275
Wayne Andrews, Detroit 80, 103
Anneley Juda Gallery, London 348, 349
Architectural Association, London 379, 384
Architectural Press, London 368–373, 376, 377
Art Institute of Chicago 39, 41, 274
Arts Council of Great Britain, London 252, 254, 352, 353, 470, 472, 473, 477, 479, 480, 483, 485, 487, 493, 495, 497, 503, 513, 518, 519, 521

George Barford, Normal, Illinois 84, 86, 87, 88, 91, 92, 93, 94, 97, 99, 108, 109, 410
Bauhaus-Archiv, Berlin 527, 528, 529, 530, 532, 534, 535, 536, 537, 538, 539, 550, 551, 552, 553, 554, 555, 556 557, 563, 564, 565, 567, 571, 572, 592, 596
Herbert Bayer, Aspen, Colorado 568, 569
Giovanni Bernasconi, Lugano 331
Paul Bijtebier, Uccle 73
Bildarchiv Marburg 163, 164, 165, 166
Marcel Breuer, New York 562
British Council, London 136, 137, 138
British Museum, London 235
Brompton Studio, London 341
P. G. Bruguiere, Issy-les-Moulineux 338

Cement and Concrete Association, London 262, 265, 282, 283, 378, 383, 386
Centraal Museum, Utrecht 405, 412
Martyn Chalk, Hull 468, 469
Chevojon, Paris 264
Chicago Architectural Photo Company 82, 83, 85, 89, 90, 107
Courtauld Collection, London 229. 230

Design Council, London 560

Mr and Mrs Eric Estorick, London 304, 305, 316, 320

Fischer Fine Art, London 249
Folkwang Museum, Essen 214
Fondation Le Corbusier, Paris 368–377, 381, 382, 385, 387, 388

Galleria Schwarz, Milan 333, 334, 335
Galerie Beyeler, Basel 367
Galerie Louise Leiris, Paris 237, 242
Ewing Galloway 81
Claus Gebhard 209
Glasgow School of Art 113, 114, 115, 116, 117, 118, 119, 120, 121, 122, 123, 124, 125, 126, 142
Mrs Walter Gropius, Lincoln, Massachusetts 279, 280, 281, 303, 594, 597
Peggy Guggenheim, Venice 340
Solomon R. Guggenheim Museum, New York 259, 308, 363, 395, 399, 446, 474, 531, 581

Haags Gemeentemuseum, The Hague 394, 401, 403, 426
Hamlyn Group Picture Library, London 139, 200, 344, 346, 424, 431, 471, 488, 494, 515
Dr Paul Hänggi, Basel 311
Hermitage Museum, Leningrad 197
Lucien Hervé, Paris 393
Hattula Hug, Zürich 544, 545, 546, 547, 548, 549
Lady Hulton, London 254

Japan National Tourist Organization, London 96
Dr Emilio Jesi, Milan 309

Daniel-Henri Kahnweiler, Paris 238
Mme Nina Kandinsky, Neuilly-sur-Seine 220
Felix Klee, Bern 224, 582, 589, 591
Paul Klee Foundation, Bern 219, 583, 588, pp 225–228
Kunstgewerbemuseum, Zürich 76, 601
Kunsthalle, Hamburg 208
Kunstmuseum Basel 202, 216, 236, 243, 255, 257, 364, 365, 430
Kunstmuseum Bern 240
Kunstsammlung Nordrhein-Westfalen, Düsseldorf 342
Taras Kuscinsky, Prague 598, 599

Graziano Laurini, Milan 307
Rudolf Leopold, Vienna 217
Loos Archive, Vienna 186, 187, 192, 193, 194, 196
Lund Humphries, London pp 225–228

Manchester City Art Galleries 36
Marlborough Fine Art, London 206, 207, 258, 260, 417, 580
Foto Mas, Barcelona 60
Morton D. May Collection, St Louis 215
Ministere des Travaux Publics, Brussels 65, 66, 67, 68, 69, 70, 71, 72
Moderna Museet, Stockholm 347, 463, 464, 465, 467, 475, 476, 481, 498
Lucia Moholy, Zürich 533, 593, 595
Musée des Arts Decoratifs, Paris 48
Musée National d'Art Moderne, Paris 199, 251, 354
Museo Civico, Como 325, 326, 327, 328
Museum des 20. Jahrhunderts, Vienna 160, 463, 464
Museum of Modern Art, New York 100, 234, 422, 450, 459, 482

National Film Archive, London 226, 227, 288, 499
National Gallery, London 203, 241, 244, 310, 603
National Gallery, Oslo 204
National Gallery, Prague 228, 233, 250
National Monuments Record, London 11, 12
Nationalmuseum, Stockholm 256
Neue Galerie am Graben, Vienna 188

Österreichisches Museum für angewandte Kunst, Vienna 150, 151, 153, 155, 157, 167, 168, 225
Österreichische Nationalbibliothek, Vienna 172, 174, 175, 185
Mrs J. M. A. Oud-Dinaux, Wassenaar 418, 419

Sir Roland Penrose, London 339
Philadelphia Museum of Art 355, 359
Phillips Collection, Washington 231
Pablo Picasso 252

Radim Films Inc., New York 540, 541, 542, 543
Rijksmuseum Kröller-Müller, Otterlo 40, 78, 356, 397, 400, 423, 427
Royal Academy of Arts, London 21, 22, 188
Royal Institute of British Architects, London 33, 101, 169, 170, 171, 173, 276, 277, 302, 420, 421, 443, 524, 525
Russian Museum, Leningrad 457, 458

Sant'Elia family, Como 323, 324
Dennis Sharp, London 289, 291, 292, 293
Sotheby, London 20, 62, 63, 218, 447, 489, 492, 600

Herbert Spencer, London 510, 511, 514
Staatliche Kunsthalle, Karlsruhe 205
Staatsgalerie Stuttgart 201, 357
Städtische Galerie, Munich 221, 222
Stedelijk Museum, Amsterdam 411, 435, 436, 437, 448, 449, 451, 452, 460, 461, 462
Stedelijk van Abbemuseum, Eindhoven 428, 429

Tate Gallery, London 34, 212, 213, 232, 261, 290, 306, 318, 402, 414, 444, 445
Technische Hogeschool, Delft 516, 517
Thames and Hudson, London 454, 455, 456
Theatrical Museum, Leningrad 454, 455, 456
Paul Theobald, Chicago 547
Mr and Mrs Burton Tremaine, Meriden, Connecticut 432
Tretyakov Gallery, Moscow 463, 464, 467

University of Glasgow, Birnie Philips Collection 16
 Mackintosh Collection 112, 129, 130, 131, 132, 133, 134, 135, 332
University of Pisa 329, 330

Van-der-Heyt Museum, Wuppertal 360
Mme van Doesburg, Meudon 409, 415, 416, 425, 433
Victoria and Albert Museum, London 7, 8, 9, 13, 14, 15, 17, 19, 24, 25, 26, 46, 49, 50, 51, 56, 61, 77, 102, 104, 105, 106, 110, 111, 141, 146, 147, 159, 211, 319, 321, 322, 351, 406

Wallraf Richarz Museum, Cologne 210
Allan B. Warner, Chorleywood, Hertfordshire 29, 30, 31, 32
William Morris Gallery, London 10, 17, 35, 44, 45, 47
Frank Lloyd Wright Foundation, Taliesin, Wisconsin 98, 101

Mrs Ayala Zacks, Toronto 358

Rights reserved by S.P.A.D.E.M. and A.D.A.G.P.